Art Cities of the Future

21st Century Avant-Gardes

Much has changed since the publication of *Cream* (1998), *Fresh Cream* (2000), *Cream 3* (2003), *Ice Cream* (2007) and *Creamier* (2010), biennials in book form that chronicled the most significant emerging art of the era, introducing now-established names and new ideas that today proliferate from Düsseldorf and Detroit to Dakar. Many artists, including Olafur Eliasson, Tacita Dean and Thomas Hirschhorn, who first found a broad international audience in the pages of these celebrated volumes, have become leading figures of their generation, selected by the most respected curatorial voices of our times.

To skim off the richest 'cream' of contemporary art today is a far more complex task. The art world is more of a world in every sense, with a larger population, a wider territory and a greater number of nationalities. Biennials have sprouted up in every corner of the globe as cheap airfares shrink the distances between them. Emerging technologies have opened up new lines of communication, while art fairs have multiplied into movable feasts, with regular stops on every continent. Historians now reconsider the roots of post-war Conceptual art along networked geographical lines (on either side of the Iron Curtain within Europe, in South America and Japan), and yet critical traffic in contemporary art clings to the major marketplaces and distributional centres of New York, Basel, London and Berlin, even as artists today make their homes and establish communities far beyond these capitals. The prevailing conversation about current modes of production, and the onslaught of cultural globalization, has yet to catch up.

Considering the limitations of an alphabetical list of 100 noteworthy contemporary artists, *Art Cities of the Future: 21st Century Avant-Gardes* wholly reinvents the formula, digging deeper into the source of creativity today and uncovering twelve distinct avant-gardes that have surfaced around the world in recent decades. Twelve international curators actively involved in the artistic centres of Beirut, Bogotá, Cluj, Delhi, Istanbul, Johannesburg, Lagos, San Juan, São Paulo, Seoul, Singapore and Vancouver have each selected eight artists (and collectives) to represent the avant-garde of their particular city. These artists are senior figures, some only known to a few outsiders, or newer faces commencing their careers; artists working in familiar mediums or inventing their own, but they all share two distinct qualities: a commitment to experimental art and a dedication to their local milieu.

Each chapter begins with an introduction to the title city, including a brief background on its artistic and political history in recent decades, and a taste of the conversations taking place there now. The subsequent artist profiles sketch a dynamic and intergenerational portrait of a set of colleagues working under common conditions, with concerns that range from the personal to the political to the global; expressed in a staggering diversity of styles, perspectives and approaches. Historically, the avant-garde has depended upon a productive exchange between artists active during a defined period, and often within a particular urban environment. The Russian Constructivists, Paris Surrealists, New York avant-garde and others shared formal or aesthetic concerns that were mediated by the day-to-day interactions of life lived in proximity to one another, leading to the famous notion that the avant-garde seeks to destroy the division between life and art; that its artists produce work from experience rather than through participation in stylistic trends. The plural form of this term, as it is used here, conjures the specificity and vigour of this mode of aesthetic and intellectual exchange, while alluding to the certainty that other avant-gardes, elsewhere, will eventually surpass those presented. But considering where – and how – the most exciting contemporary art is made today provides a refreshing and necessary reminder that the cultural references artists draw upon, and the art they ultimately produce, stretch far beyond the confines of art history.

Art Cities of the Future offers a focused and precise view of the vast contemporary art landscape, and a window onto the latest artistic developments unfolding around us, anticipating the foremost figures and artistic forms of tomorrow. More than ever, the ability to see across geographical borders is vital to understanding cutting-edge art, but neither can these boundaries be entirely forgotten. The role of each featured city as an enduring backdrop, source of stimulation or counterpoint to creative production becomes eminently clear in video installations featuring the dense modern architecture or industrial infrastructure of Delhi (Gigi Scaria, pp. 104–7; Raqs Media Collective, pp. 102–3), in images of Beirut's battle-scarred resort hotels, contemplative and playful by turns (Ziad Antar, pp. 16–7; Marwa Arsanios, pp. 18–9), in the infectious 'tropical-povera' aesthetic of San Juan artists (Melvin Martínez, pp. 206–7; Jesus 'Bubu' Negron, pp. 208–9), and in the 'post-photoconceptual' inventions of a younger generation reacting to the Vancouver climate (Andrew Dadson, pp. 306–7; Isabelle Pauwels, pp. 312–3); exposing again and again the underlying realities that inform artistic development long before any work is exhibited in the customary art venues, from Documenta and Performa to the Istanbul Biennial.

Of course, the experience of confronting art first-hand is inimitable and there can be no substitute for viewing it full-scale, in its intended context. While the work contained in this volume is undoubtedly specific to the milieu in which it was cultivated, the compelling images, interventions and other projects speak to much wider audiences. Correspondences in motivation and formal execution cut transversally across different chapters; from the activation of performance art as a public tool by Inder Salim in Delhi (pp. 96–7), Jelili Atiku in Lagos (pp. 172–3) and Kemang Wa Lehulere in Johannesburg (pp. 162–3), to varied explorations of gender and sexuality by Alex Miritziu in Cluj (pp. 78–9) and Nilbar Güreş in Istanbul (pp. 130–3), to compelling examinations of contemporary precarity by Johanne Calle in Bogotá (pp. 44–5), Beatriz Santiago Muñoz in San Juan (pp. 214–15) and Part-time Suite in Seoul (pp. 262–3), as well as the reanimation of painting by Marina Rheingantz in São Paulo (pp. 236–7) and Ian Woo in Singapore (pp. 290–1).

By consolidating information that would be impossible to gather without years of study and travel criss-crossing the globe, Art Cities of the Future provides a compact and rich resource that can be revisited time and time again. Lively, thought-provoking, comprehensive, and packed with more than 500 colour images, this book boldly widens the conventional trajectory, allowing us to see a future of diverse aesthetics and shared concerns, articulated in the common language of contemporary art.

Authors

Antawan I. Byrd is a doctoral student in modern and contemporary art history at Northwestern University with a focus on Africa and its Diasporas. From 2009–11 he was based in Lagos at the Centre for Contemporary Art as a Fulbright fellow and curatorial assistant, where he contributed to publication and exhibition projects including 'Moments of Beauty' (2011), the first retrospective of Nigerian photographer J.D. 'Okhai Ojeikere. He was a member of the editorial team for the 2012 Benin Biennial.

Duygu Demir is a programmer at SALT, Istanbul. She co-curated the inaugural exhibition at SALT Beyoğlu, 'Hüseyin Bahri Alptekin' (2011) and edited the companion publication *I am not a Studio Artist.* She helped organize 'Across the Slope: Ahmet Öğüt' (2011) and Hassan Khan's retrospective (2012) at SALT, co-curated 'I Decided Not to Save the World' at Tate Modern (2012) and edited *Cevdet Erek: Room of Rhythms 1* (2012). She contributes to *Art Asia Pacific*, *Art Unlimited*, *Broadsheet* and *Ibraaz*.

Hyun Jung is an art critic and independent curator based in Seoul. His essay 'Intimately Correct: Processes of Multiplicity and Autonomy' was published in the catalogue of the ninth Gwangju Biennial (2012). He organized the public art project 'E+Motion' in Sabuk-Gohan, Korea (2009), and the exhibition 'Bonjour, Mr. Courbet' at Junmiso in Seoul (2010). He received his doctorate from the University of Paris I, Panthéon-Sorbonne.

Geeta Kapur is a Delhi-based critic and curator. Her books include *Contemporary Indian Artists* (1978), *When Was Modernism: Essays on Contemporary Cultural Practice in India* (2000) and *Ends and Means: Critical Inscriptions in Contemporary Art* (2013). She curated 'Bombay/Mumbai' for 'Century City', Tate Modern (2001) and curated 'subTerrain', Haus der Kulturen der Welt, Berlin (2003). A founder-editor of *Journal of Arts & Ideas* and an advisor to *Third Text* and *MARG*, she has been a visiting fellow at several universities and lectured worldwide.

Pablo Léon de la Barra is an independent curator and researcher with a PhD from the Architectural Association, London. He directed the first Tropical Biennial in San Juan (2011) and curated 'Bananas Is My Business: The South American Way' at Museu Carmen Miranda in Rio de Janeiro (2011), 'Incidents of Mirror Travel' at Museo Tamayo in Mexico City (2011), 'MicroclimaS' at Kunsthalle Zürich (2012) and 'Novo Museo Tropical' at Teorética in San José (2012), among other exhibitions. He has lectured internationally, written for numerous magazines and catalogues, and is editor of *Centre for the Aesthetic Revolution* (centreforthe-aestheticrevolution.blogspot.com).

Kiki Mazzucchelli is an independent curator and writer working between London and São Paulo. She curated 'Mythologies/Mitologias' at the Museum of Modern Art São Paulo (2013), 'Beyond the Avant-Garde/Bienal Naïfs do Brasil' (SESC Piracicaba, 2012) and the series of conversational radio programmes OIDARADIO for the 30th São Paulo Biennial (with Mobile Radio and Resonance.fm, 2012). She has written extensively on the work of Brazilian artists including Alexandre da Cunha, Carla Zaccagnini, Erika Verzutti, Marcius Galan and Paulo Nazareth.

Tracy Murinik is an independent writer and curator based in Johannesburg. She has published numerous essays and articles, and contributed to *10 Years 100 Artists: Art in a Democratic South Africa* (2004) and *Personal Affects: Power and Poetics in Contemporary South African Art* (2004). A coordinator of the first and second Johannesburg Biennials, she has curated exhibitions for museums and galleries as well as private and corporate art collections. She is author of the documentary film series *A Country Imagined* (2009–10) and co-editor of *WIDE ANGLE* (2013), a volume on participatory photographic practice.

Jane Neal is an independent critic and curator who has focused on art from Eastern Europe since 2005. She is the former artistic director of the non-profit founddation Calvert 22 in London, where she launched its programme of Russian and Eastern European contemporary art in 2009. She has curated numerous exhibitions including 'Nightfall: New Tendencies in Figurative Painting' at MODEM Centre for Contemporary Arts in Debrecen (2012) and Rudolfinum Gallery in Prague (2013). She contributes to *Art Review*, *Flash Art*, *Res* and *Tataia*, among others.

José Roca is Estrellita B. Brodsky Adjunct Curator of Latin American Art at Tate Modern and Artistic Director of FLORA ars+natura in Bogotá. He co-curated the first Poly/Graphic Triennial in San Juan (2004), 27th São Paulo Biennial (2006) and Encuentro Internacional Medellín (2007). He was artistic director of Philagrafika 2010 in Philadelphia and chief curator of the eighth Mercosul Biennial in Porto Alegre (2011). He has organized solo exhibitions of artists Antoni Muntadas, Oscar Muñoz, Eugenio Dittborn, Regina Silveira and Julio Alpuy, among others.

Reid Shier is the director of Presentation House Gallery in North Vancouver, Canada. He has curated numerous exhibitions including solo presentations of Annette Kelm (2012), Michael Morris (2012), Anne Collier (2008), On Kawara (2006) and Geoffrey Farmer (2006). He has edited the publications *Polaroids: Attila Richard Lukacs and Michael Morris* (2010), *Tim Lee: Remakes, Variations (1741–2092)* (2008) and *Stan Douglas: Every Building on 100 West Hastings* (2002). He is co-editor of the Lynn Valley publication series.

Eugene Tan is Director of the National Art Gallery, Singapore. He is former Director of the Institute of Contemporary Arts Singapore, co-curated the inaugural Singapore Biennial in 2006 and curated the Singapore Pavilion at the 51st Venice Biennale (2005). Recent thematic exhibitions include 'Of Human Scale and Beyond: Experience and Transcendence' (2012), 'The Burden of Representation: Abstraction in Asia Today' (2010) and solo exhibitions of work by Charwei Tsai (2012), Lee Mingwei (2010), Jompet (2010) and Nipan Oranniwesna (2009). He has written for exhibition catalogues and publications including *Art Asia Pacific*, *Art Review*, *Flash Art*, *Metropolis M* and *Modern Painters.*

Kaelen Wilson-Goldie is a writer and critic based in Beirut. She is a contributing editor of *Bidoun*, writes a column for *Frieze*, contributes regularly to *Artforum* and covers contemporary art and culture for the Lebanese newspaper *The Daily Star.* She has written numerous essays for journals, anthologies and exhibition catalogues.

Beirut
by Kaelen Wilson-Goldie

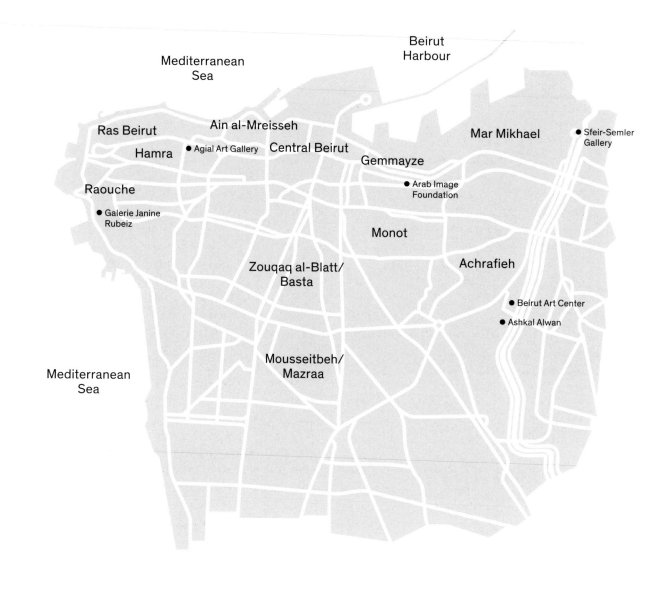

N

Beirut
Harbour

Mediterranean
Sea

Ras Beirut

Ain al-Mreisseh

Hamra

● Agial Art Gallery

Central Beirut

Mar Mikhael

● Sfeir-Semler
Gallery

Gemmayze

Raouche

● Arab Image
Foundation

● Galerie Janine
Rubeiz

Monot

Zouqaq al-Blatt/
Basta

Achrafieh

● Beirut Art Center

● Ashkal Alwan

Mediterranean
Sea

Mousseitbeh/
Mazraa

0 1 km

● Agial Art Gallery
 63 Abdul Aziz Street

● Beirut Art Center
 Jisr El Wati, Street 97, Building 13

● Ashkal Alwan
 Home Workspace Program
 Jisr El Wati, Street 90, Building 110

● Arab Image Foundation
 337 Gouraud Street
 Zoghbi Building

● Galerie Janine Rubeiz
 Charles de Gaulle, 1st Avenue
 Majdalani Building

● Sfeir-Semler Gallery
 Tannous Building, Street 56

Like other cities in the region, Beirut considers its contemporary art scene to have begun in the 1990s rather than the 1970s. Looking at the city in isolation, it's tempting to see this as a logical consequence of Lebanon's fifteen-year civil war coming to an end in or around 1990; that cultural production was horribly interrupted during the war years and then bravely resumed during the reconstruction era would make sense. But this isn't true. On the one hand, artists and their ilk continued to work throughout the conflict. On the other hand, Beirut never regained its prewar stature; it never returned to its golden age. What was lost during the war was lost for good.

And yet, on the level of artistic infrastructure, Beirut shares many attributes with cities such as Cairo and Istanbul, both of which have had their problems, though neither has ever collapsed so completely into violence. The push and pull of superiority and inferiority that exists between Cairo and Beirut is made laughable by their difference in scale. Compare Cairo's population of twenty million, for example, to Beirut's less than two million. For the most part, Istanbul still regards Beirut as an outpost of its former empire. (An irony, given that financing from the Ottoman Bank – to expand the port and extend the railway – transformed Beirut from a provincial backwater into a major Mediterranean metropolis.)

Perhaps the most comparable city in the region – not only in terms of size and scale but also in relation to its faded glamour and threadbare cosmopolitanism – is Alexandria. But where the essence of Alexandria was encapsulated by the sentimentality of C. P. Cavafy and Lawrence Durrell, Beirut inspired the style, verve and literary toughness of Don DeLillo (in *Mao II*) and J. G. Ballard (in the short story *War Fever*). Both writers stuck to the relatively safe terrain of the city's renowned chaos, digging up an important truth that is well known but rarely stated: Beirut is totally and utterly obsessed with itself. Perhaps for this reason, the city exerts an incredible weight on the artwork its residents have produced, particularly on the experimental end of the spectrum, where the material of the city has become at once medium, metaphor and generator of meaning.

Besides an interest in modernist ruins, very little remains to connect the artistic experience of post-war and prewar Beirut. Three women provide the exception. Nadine Begdache is the only gallerist in town with roots in the 1960s. In 1993 she opened Galerie Janine Rubeiz, named in tribute to her mother, who was the force behind the cultural centre Dar al-Fan, which opened in 1967 and staged legendary exhibitions alongside contentious encounters among literary, artistic, religious and political figures.

One of the artists who showed with Dar al-Fan was Etel Adnan, a poet, playwright, novelist and painter with a fondness for depicting mountains in her art and the sea in her writing. The author of one of the most important wartime novels, *Sitt Marie Rose* – about a woman kidnapped by militiamen and killed for her commitment to the Palestinian cause – Adnan's boundless love for Beirut is perfectly counterbalanced by her ruthless criticism of the place. 'What saves you from despair in Beirut is the very difficulty of living in it,' she writes in *Of Cities and Women: Letters to Fawwaz*.

Now in her eighties, Adnan lives primarily in Paris, but she remains very active, and her work is still quite present in Beirut. She is also now beginning to earn the international recognition she deserves, as is her colleague Saloua Raouda Choucair, a sculptor in her nineties whose approach to abstraction makes her the Lygia Pape of Lebanon. (Though the intimacy of her stacked and interlocking 'poems' and 'duals' make her unique.)

That these two great but for decades overlooked artists are finally being honoured at home and abroad – their work has now attained critical import and art-historical weight – is directly due to the work of commercial gallerists such as Andrée Sfeir-Semler, who, in 2005, opened Beirut's first blue-chip gallery for international contemporary art with a strong minimalist and conceptual bent, and Saleh Barakat, who established the Agial Art Gallery in 1990, and whose affinities lie more firmly with modernism, or the one hundred years before the contemporary began in Beirut.

But the new-found attention to Adnan and Choucair is also indirectly due to the work of a generation that began building a nimble, flexible and wholly independent infrastructure for the production, presentation and dissemination of new and often challenging work in the early to mid-1990s. Ashkal Alwan (the Lebanese Association for Plastic Arts) was founded in 1994 and has since produced a groundbreaking series of public projects in and around the city – in gardens, along the seaside Corniche and through the old cosmopolitan causeway that is Hamra Street. The Ayloul Festival, founded in 1997 but defunct since 2001, helped to initiate what the artist Walid Sadek has described as 'a search for places' in the post-war period.[1] Young and fearless artists with no hope or desire for commercial interest in their work began making art for the purpose of either reconfiguring 'the once-embattled terrain'[2] of the city, or for claiming some measure of responsibility for the preceding years of violence.

Around the same time, the photographers Fouad Elkoury and Samer Mohdad started the Arab Image Foundation with a young video artist named Akram Zaatari, who had wanted to become a filmmaker, studied architecture to please his family, and found a job in the television industry and a mentor in Mohamed Soueid. The latter was, by all accounts, Beirut's first video artist, although he never decamped to the art world from the field of documentary film. Ask Soueid today if he considers himself an artist and he will emphatically tell you no. But his heartfelt, essayistic films about love, loss and the former left – as well as his criticism in Beirut's daily newspapers – exert considerable influence to this day on the likes of Ghassan Salhab, Mahmoud Hojeij, Rania Stephan, Ziad Antar, Ali Cherri and more.

Since 1997, the Arab Image Foundation has gathered together more than five hundred thousand photographs and related materials. The composition of the collection was driven almost entirely by artists, and the foundation soon attracted the collaboration of Walid Raad, Jalal Toufic, Lamia Joreige, Joana Hadjithomas and Khalil Joreige, Yto Barrada (from Tangiers), Lara Baladi (from Cairo) and many others. On the discursive side of things, Walid Sadek – who, with the artist Ziad Abillama, penned a 1994 manifesto proposing what contemporary art practice in Beirut should be – began a series of informal weekly discussion sessions with the writer Bilal Khbeiz and the poet Fadi El Abdallah. Nearly all of the aforementioned artists passed through those Tuesday evening meetings. The group fell apart in 2005, after what has been described as a collective explosion of egos that left many friendships in tatters.

In 2002, Ashkal Alwan turned the logic of those informal meetings inside out and began organizing the very open and very public Home Works Forum for Cultural Practices – the closest thing Beirut has to an international biennial, though in many ways better. Home Works happens roughly every few years, or whenever the situation in the city, the country and the wider region allows. After another war in 2006, Ashkal Alwan created Video Works, a production programme for young and emerging artists to test out ideas in a context that has become familiar: the need, desire, obsession or folly to respond to current events as they are unfolding, in art.

After a decade of nonprofit organizations driving the contemporary art scene with many projects but few concrete spaces, the artist Lamia Joreige teamed up with Sandra Dagher, who had just closed the gallery-cum-community centre Espace SD, to open the Beirut Art Center. Galleries, project spaces and other non-profit venues for exhibitions, screenings and performances soon followed. Then in 2011 Ashkal Alwan's director Christine Tohme orchestrated the most ambitious overhaul of her organization to date, opening a modular, experimental art school called Home Workspace in a vast former factory space behind the Beirut Art Center.

By 2012 Beirut had more commercial and non-commercial art spaces than ever before; the layers and complexities of the scene had achieved considerably more density than anything that could be remembered from the so-called golden age. What's more, while the scene may still be factional – and sometimes insidiously reflective of Lebanon's sad, sectarian political system – it has come to accommodate generations of practitioners who rebel, betray and rediscover one another. Many contemporary artists have had their curiosity sparked by the modernists who came before them.

↑ Aerial view of Beirut, facing north

↓ Saloua Raouda Choucair, *Poem of Nine Verses*, 1966–68, 29 × 22 × 7 cm

↘ Gallerist Nadine Begdache at Janine Rubeiz

↓ Ashkal Alwan exterior

↘ Home Workspace Program critique session, 2011

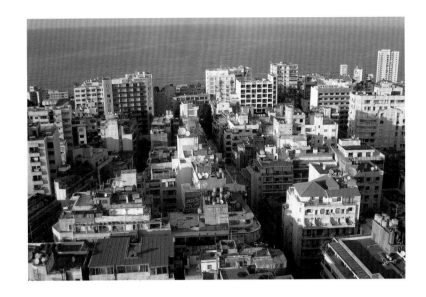

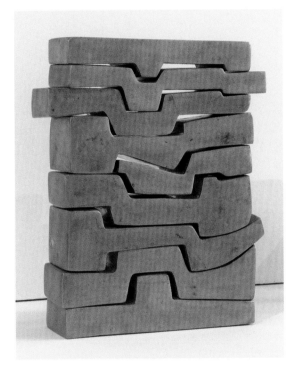

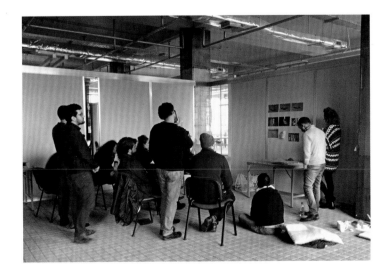

If Beirut's contemporary period came late, then its modernist period was long and requires a great deal more study. Countless political thinkers and policy analysts have likened Lebanon to a laboratory for democracy (and its failures) in the region. Beirut, however, self-absorbed as ever, is something else. 'Beirut was, and is, a very real place, whose playfulness and love of show and spectacle fail to conceal its inner seriousness', wrote journalist Samir Kassir, the city's most probing historian, who was killed in a car bomb blast in 2005. '[Its] value must ultimately be weighed in relation to its place in the history of mentalities and in the history of ideas. For Beirut stands out among the cities of its age not only for having helped to formulate the history of Arab modernity, but also, and still more importantly, for having helped make it a living thing – even if, in doing so, Beirut lured itself into a dead end.'[3]

→ Walid Sadek, *We Do Not Leave Hamra*, for Ashkal Alwan, 2000

↘ 'Etel Adnan: Paintings and Drawings', installation view at Sfeir-Semler, 2005

↓ en route to Sfeir-Semler Gallery

↓ The Arab Image Foundation, from Akram Zaatari's *On Photography, People and Modern Times*, 2010

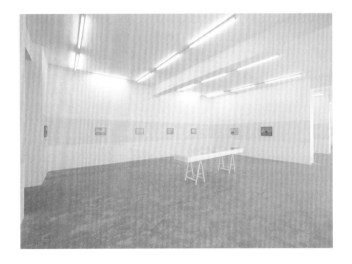

Ziad Antar

Two little kids sing along to a synthesizer in *Wa* (2004). A young man slaps out a drumbeat on his chest while taking a shower in *Tambourro* (2004). Another young man stands naked in a room and begins jumping rope, slowly at first, then faster, in *La Corde* (The Rope, 2007). Farmers approach a camera one by one, lean in and utter 'Tokyo', as if it were a highly sensitive secret, in *Tokyo Tonight* (2003). A pair of hands makes a rustic Levantine dish of lentils, rice and onions in *Mdardara* (2007). Another pounds out a well-known piece of Mozart's music on a piano whose hammers have been damped in *La Marche Turque* (Turkish March, 2006). A young woman, reclining, appears naked from mid-thigh to sternum while the sound of a fly buzzing somewhere off-screen increases in volume until we see (and hear) the thwack of her crudely manicured hand in *La Mouche* (The Fly, 2008). A toy mouse is wound up and directed toward a real mousetrap, over and over again, in *La Souris* (The Mouse, 2009).

Ziad Antar's films and videos have a particular visual syntax. Whether handheld and seemingly accidental or Super 8 and elegantly formal, almost all of them are short, brisk and bordering on the absurd. There is always a catch somewhere. In the slightly longer, twelve-minute *Tank You* (2006), for example, a woman waits in line at a petrol station during the siege of Lebanon in the summer of 2006. The scene is fraught with fear and tension, but she speaks easily with the artist. As it turns out, she doesn't need anything at the station. Her tank is full. She just wants to talk – to someone, anyone – to avoid being alone during the war.

Antar studied agricultural engineering and got into art by accident when he took a workshop with Akram Zaatari and Mahmoud Hojeij, called 'Transit Visa', in 2001. In retrospect, that gathering proved to be a foundational moment not only in the formation of Beirut's contemporary art scene but also in forging links between artists in Lebanon and their counterparts elsewhere around the region.

For the workshop, Antar made a three-minute piece on assignment. A year later, he made a documentary about the artist Jean-Luc Moulène, who had become a friend and mentor, and who no doubt influenced Antar's mounting interest in photography. Some years later, Antar also began acting in the films and performances of other artists, including Mahmoud Hojeij and Rabih Mroué.

He still averages about three video works per year, including animations such as *Famagusta* (2010). But to a certain extent these have been surpassed, more recently, by still images that are conceived as typological series, elaborate processes and extended performances, such as *The Veil Series* (2007), which was done with a group of Palestinian girls in the Ain al-Hilwe refugee camp; *Beirut Bereft* (2009), which was produced in collaboration with the writer and curator Rasha Salti and depicts the strangest Beirut-bound modernist ruins; *Expired* (2000–11), which uses rolls of expired film taken from the studio of the famed portrait photographer Hashem El Madani; and *Portrait of a Territory* (2004–11), which makes current imagery of the Emirati coastline look like vintage prints from a long-lost archive.

Between his interests in food, farming, architectural wrecks and the most minute and mundane details of everyday life during periods of chronic political strife, Antar insists that a fundamental duality runs through all of his work. His videos are light-hearted, humorous and ironic. In his photography, he says, 'Everything becomes sad.'[4]

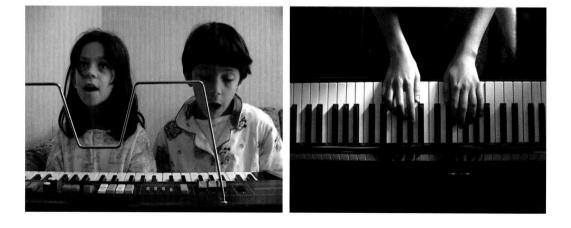

→ *Portrait of a Landscape: Abu Dhabi, UAE*, 2010, C-print

→ *Beirut Bereft: Côte d'Azure Hotel, Jnah Beirut*, 2009 (built 1973)

↑ *Portrait of a Territory: Foujaira, UAE*, 2010, C-print

← *Turkish March*, 2006, black and white video, 3 min.

← *Wa*, 2004, video, 3 min.

Marwa Arsanios

By the time Marwa Arsanios began making videos and installations from the rumours and remnants of Beirut, there was already an established pattern in the city for how such work was to be done. In all likelihood, it would find a crisp and orderly formal language to address war, memory, trauma, amnesia, power, politics and history. On one level or another, Arsanios is concerned with all of these things, but since 2008 she has developed a refreshingly messy, countervailing aesthetic to express everything that tends to leak, spill and escape from the neatness of such terms.

The unruliness of her work stems, in part, from her attention to the erotic, the sensual and the sexually charged – elements largely absent from the work made by her peers a generation back. Arsanios may be committed to many of the same artistic pursuits as her influential predecessors – including archival assemblage and the slippage between fact and fiction – but her interests lie less in the hard mechanisms by which history is written or the cool philosophical functions of photography, and more in the volatility of characters, anecdotes and details that do not quite fit the overarching narratives in which they appear. Not only does she leaven her projects with pop culture, pulp fiction and film noir, she also uses these instances of apparent lightness to expose stories that lead us suddenly elsewhere, away from the most visible or superficial of conflicts towards those that remain buried, unsaid and unseen.

Over the past four years, Arsanios has produced three main clusters of work. Each module is arranged around a cultural relic – a magazine, a hotel, a beach club – for which the artist feels a kind of phantom nostalgia. The multipart project *Words as Silence, Language as Rhymes* (2012–present), for example, threads the story of the artist's grandmother through the history of a once-revolutionary magazine called *Al-Hilal*. Arsanios has annotated old issues and turned them into a book (*Olga's Notes*); cut up an entire archival run to make a costume, choreograph a dance and create a performance (*Read the Titles*); and imagined a meeting between her grandmother and Karl Marx in a famous belle époque Cairo café (*Karl and Olga: A Brief Encounter*).

In the densely accumulative installation *All About Acapulco* (2010), Arsanios considers the fate of a tiny architectural jewel as it tacks between the fantasies of a Lebanese émigré who returns home from Mexico to build a beachside resort (and with it a chimerical, escapist and occasionally questionable cosmopolitanism) and a family of refugees making ends meet while holding fast to an equally impossible dream (of returning to Palestine). The related video animation *I've Heard 3 Stories* (2009) delves into much the same material but then drifts toward the story of a cabaret dancer who disappeared from a nightclub nearby. In two further video animations, *I've Heard Stories 1* (2008) and *I've Heard Stories 2* (2013), Arsanios takes up the mysterious circumstances of two gay men who were murdered in Beirut's glamorous Carlton Hotel, a modernist icon that was recently torn down. (That the men may have been the lovers of powerful politicians adds both intrigue and injustice to the subject.)

The toughest facts of Lebanon's geography, history and lived experience are never absent from Arsanios's work, but her multifaceted projects allow for more delirious visions of the city, where past, present and future, as imagined by all manner of historical and contemporary figures, continue to coexist as fragments waiting to be found and stories ready to be told.

← *I've Heard 3 Stories*, 2009,
 video and 2D animation,
 12 min. 49 sec.

↑ *All About Acapulco*, 2010,
 installation of 3D-model,
 photographs, archival
 photographs, video

↓ *I've Heard Stories 1*, 2008,
 video and 2D animation,
 4 min. 43 sec.

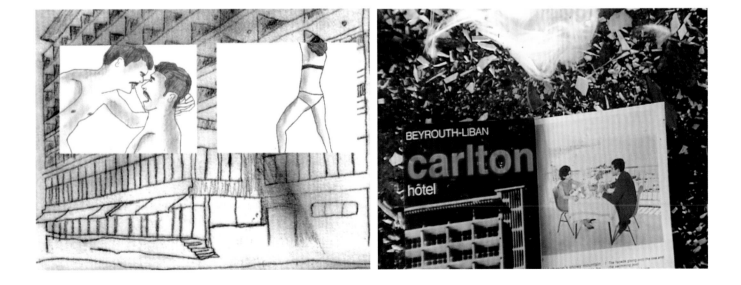

Ali Cherri

In 1987 Syrian president Hafez al-Assad made a historic phone call to a Soviet spaceship that was heading towards the Mir space station. On board was Mohammad Fares, an air force pilot turned astronaut, who was the second Arab and, to this day, the only Syrian ever launched into outer space. For public broadcast, Assad and Fares exchanged a few stiff lines of dialogue, with Fares playing heroic but humble son to Assad's lofty and omniscient father.

Decades later, the artist Ali Cherri came across video footage of the phone call. He was amazed by the heaviness of the symbolism and rhetoric but didn't know what to do with the material – until he found a second piece of video footage. This one, of more recent vintage, shows a small army of construction workers dismantling a statue of Hafez al-Assad in 2011, while protests were erupting throughout the country. Their purpose was to protect the statue of this late, ruthlessly authoritarian leader from the vandalism of demonstrators eager to oust his son, Bashar, from power. In a quick and brilliant move, Cherri fused the two films together to make the video installation *Pipe Dreams* (2011), one of the most evocative and ambiguous artworks to address the so-called Arab Spring.[5]

What makes the piece effective, and also emblematic of his whole oeuvre, is his attention to the vulnerabilities of the body – in this case, a body chiselled from stone that is nonetheless endangered. In other works, such as the video *Dreams in Three Chapters* (2011) and the installations *Now I Feel Whole Again* (2009) and *My Pain is Real* (2010), Cherri explores the more intimate contours of cuts, bruises and scars on his own skin. As such, he brings some of the Arab world's outsized political conflicts down to human scale. He returns again and again to political events – from the Israeli invasion of 1982 to the war in Lebanon in 2006 – to see how they have been impressed on the body, lodged in the mind and filtered through personal experience.

The timeliness of Cherri's work, however, is often surpassed by a more abiding interest in the fragility of photographic images and the precarity of sexual acts that, in Lebanon at least, fall outside the law. In 2005 Cherri was one of the first young artists in Beirut (after the likes of Walid Raad, Akram Zaatari, Rabih Mroué and Jalal Toufic) to have his work included in the Home Works Forum, Ashkal Alwan's raucous platform for contemporary art, which has a reputation for being as formally innovative as it is discursively challenging and occasionally combative. Cherri presented an ambitious multimedia performance titled *Give Me a Body Then*, for which he narrated his way through an impressive collection of allegedly found, gifted and stolen photographs, most of them depicting men who are naked and also dead. It was an auspicious start to the public life of his work, which peaked a second time for Home Works in 2008, where he screened *You* (2008), one of the most controversial videos ever shown in Beirut. Bookended by a urinal and a David Hockney painting with footage of a rather long and lavish blow job featured in between, the work was part of Zaatari's three-part screening program, 'Let It Be', which unified the disparate themes of that edition (sex, disaster, desire and catastrophe) while galvanizing local audiences, including Beirut's close-knit community of artists, pockets of which proved to be less progressive than they had claimed. The rift lasts to this day, and it is to Cherri's credit that he exposed it to light.

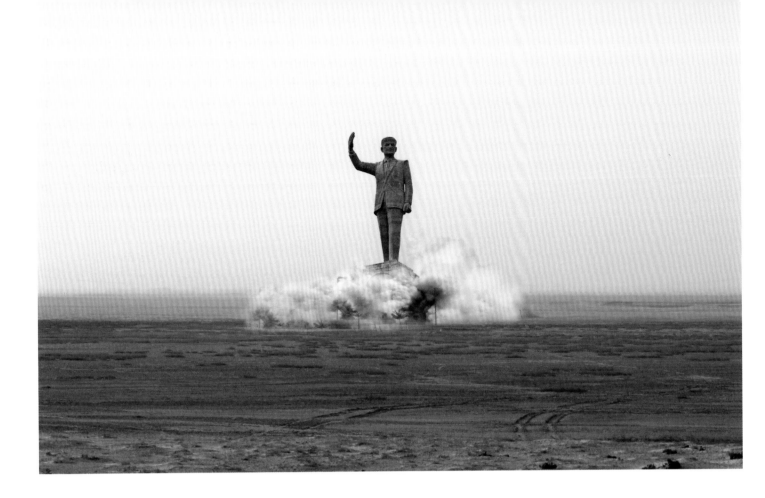

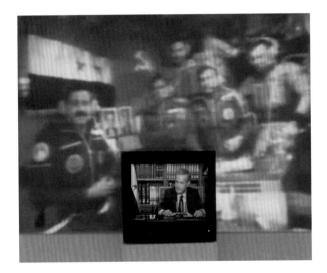

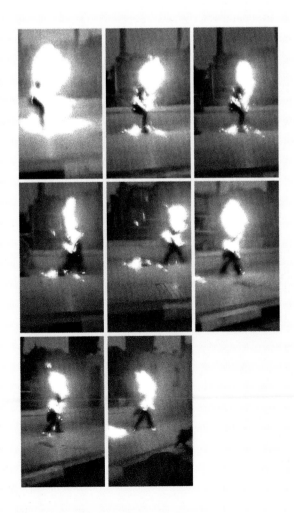

← *You*, 2008, video, 7 min.

← *My Pain is Real*, 2010,
 3-channel video installation

↑ *Pipe Dreams*, 2011,
 2-channel video installation

↑ *Pipe Dreams*, 2011,
 2-channel video installation

→ *A Fleur de Peau: I Carry My Flame*,
 2011, silkscreen, 54 × 74 cm

Rabih Mroué

Rabih Mroué may be known to many as a maker of objects, videos and installations featuring a thousand handwritten index cards (*Grandfather, Father and Son*, 2010) or seventy-two harrowing images (*Double Shooting*, 2012) blown up and arranged on placards on either side of a long, ominous tunnel. But these static and tactile elements entered his oeuvre only lately. Visual art was never Mroué's chosen field. That was theatre, historically a stronger, livelier and more popular art form in Lebanon.

Until the late 1990s, Mroué was considered one of the most promising young playwrights and theatre directors in Beirut. But in 1998 he created a piece in collaboration with artist and architect Tony Chakar, *Come In, Sir, We Will Wait for You Outside,* which so confounded local critics and colleagues that it was effectively deemed a betrayal of theatre at large. Staged at the since-shuttered Théâtre de Beyrouth, the piece made use of what now sounds like an outrageously cumbersome Nam June Paik-like set-up: four actors, three chairs, three TV monitors, three VCRs, three video cameras, three tripods, three rotating lights, microphones slung around the actors' necks, a slide projector, a screen and a towering stack of VHS cassettes.

What emerges from all of the clutter is a highly sophisticated choreography for actors and images, which endures to this day in Mroué's work. In the years since, he has used the space and time of a lecture, a performance or a proper theatre work to question, again and again, the relationship between political conflicts and the cultural materials they produce, from video testimonies of suicide bombers and street posters celebrating martyrs to newspaper pictures of people who disappeared during Lebanon's civil war and the wild rumours tangled around anecdotal incidents reported in the local press.

In *Looking for a Missing Employee* (2003), for example, Mroué sits in the audience and, using a collection of notebooks and newspaper clippings, narrates the increasingly complicated story of a young man who went missing from Lebanon's Ministry of Finance. Mroué's face is projected live onto a screen on stage, but towards the end of the performance he himself disappears, his image seamlessly replaced by prerecorded footage. In *Who's Afraid of Representation* (2005) Mroué and his partner Lina Saneh play a game of re-enacting famous works from the history of performance art, their camaraderie periodically broken by the account of a civil servant – his role played dexterously by Mroué on stage – who gunned down his colleagues at work one day. (In the piece, the civil servant's character argues that his motives were financial, political, psychological and sectarian, but complains that never once during his prosecution was he asked to re-enact his crime.)

Theatre works such as *How Nancy Wished That Everything Was an April Fool's Joke* (2007) and *Photo-Romance* (2009) show Mroué's aptitude for engaging the thorniest corners of Lebanon's sectarian psyche, while his 'non-academic lectures', such as *The Inhabitants of Images* (2009) and *The Pixelated Revolution* (2012), offer a pared-down, crystalline approach to the ethos of Hezbollah and the recent uprisings in Syria.

In addition to being an actor, director and playwright, Mroué is also a musician and one of the founders and board members of the Beirut Art Center. His work may have been rejected long ago by his peers in the local theatre scene (itself moribund for a decade), but it has laid an essential foundation for the local art scene, based on openness, fluidity and flexibilty to accommodate uncomfortable questions without demanding fast answers or fixed meanings.

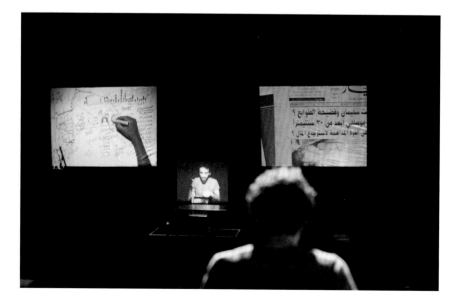

← *Looking For a Missing Employee*, 2003, performance

→ *Who's Afraid of Representation*, 2005, performance

→ *The Pixelated Revolution*, 2012, performance

↑ *The Inhabitants of Images*, 2009, projection still

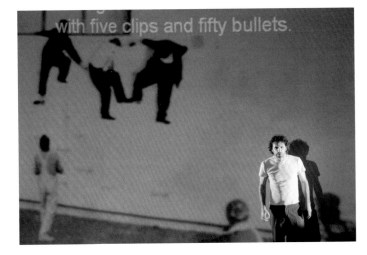

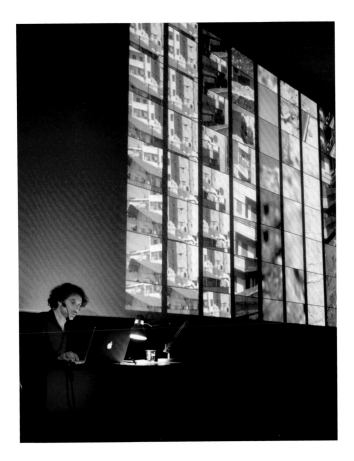

Mounira Al Solh

Among the many characters Mounira Al Solh has embodied over the years – from artists who quit to swimmers who don't and a raft of animals including a dog, a cat, a camel, a goat and a donkey – the most convincing by far is Bassam Ramlawi, a fictional painter who functions as Solh's alter ego and drag double. In 2009, she placed Ramlawi's works in a group exhibition for the first time without any explanation whatsoever. Since then, she has slowly developed his biography (the son of a juice vendor, he is obsessed with the Dutch artist René Daniëls) and has built a substantial body of work for him, including gestural portraits and diary-style watercolours and collages, which tend to be mostly blue or yellow and accompanied by very funny explanations of how and why they came into being.

Every bit of writing that Solh scrawls onto the walls where Ramlawi's works are hung teases out a kind of short story: 'waiting for Souad to undress to be able to sleep with her' or 'waiting for Mounira to sell her clothes so they can go to the Casino in Jounieh' or 'waiting to erase from my memory three basic colours'.

In addition to the paintings and works on paper, Solh has also made a documentary about Ramlawi. On a number of occasions she has appeared in public, mustachioed and dressed in an ill-fitting suit, in what amounts to an intricate and extended performance piece. What creeps into these and other examples of her work – in addition to the earthy jokes, the goofy proverbs, the quirky examples of vernacular speech and the subtle hints of a leftist, feminist agenda – are the lived experiences of anxiety, alienation and precarity among the artists and residents of an unstable city.

In the ongoing series *Waiting Blue to Lingering Yellow (or Vice Versa)* (2010–present), Solh, via Ramlawi, evokes the listlessness caused by both endless political turmoil and the tedious breakdown of Beirut's basic infrastructure. In *While Guy Debord Sleeps* (2011), which she created for the main program of the third Thessaloniki Biennale, Solh expounds brilliantly, without recourse to character, on the meaning and consequence of Beirut's famous three-hour daily power cuts.

Likewise, in earlier videos such as *Rawane's Song* and *As If I Don't Fit There* (both 2006, and both included in Lebanon's first national pavilion for the 52nd Venice Biennale in 2007), Solh digs into the self-doubts of fictional artists who are all, in one way or another, elements of her own persona.

A few years ago, it would have been accurate to say that Solh was best known for her consistently playful and performative video installations. But it's worth noting that she began her career as a painter. She took drawing lessons with one of Lebanon's last living modernists, Hussein Madi. She earned a degree from the Lebanese University's staid Institute of Fine Arts. To this day, she still carries a small case of watercolours in her bag. Occasionally she paints, often while waiting; when that happens, she really *is* Bassam Ramlawi – he has given her an alibi to return, without embarrassment, to the charming awkwardness of painting.

← Bassam Ramlawi, *From Waiting Blue
to Lingering Yellow (or Vice Versa)*,
2010, coloured pencil, pen, ballpoint
pen, watercolour, Chinese ink and
tape on paper and transparent
paper, 21 × 30 cm

← Bassam Ramlawi, *Balcony View*,
2010, acrylics and Chinese ink on
PVC, 1 of 10 drawings, 40 × 49 cm

→ Bassam Ramlawi, *From Waiting Blue
to Lingering Yellow (or Vice Versa)*,
2012, coloured pencil, pen, ballpoint
pen, collage and tape on paper and
transparent paper, 19 × 30 cm

↓ *A Double Burger and Two
Metamorphoses: A proposal for
a Dutch Cat, a Dutch Dog, a Dutch
Donkey, a Dutch Goat and Finally, a
Dutch Camel*, 2011, video installation
with 2 modified cuckoo clocks,
colour and sound, 22 min. 18 sec.

↳ *The Sea is a Stereo, Video Number
3: Let's Not Swim Then!*, 2009, DV
video, sound and colour, 90 min.

Rayyane Tabet

Rayyane Tabet's first exhibition – the group show 'Moving Home(s)', which dealt with the image and architecture of travel – opened in Beirut on 6 July 2006. His contribution consisted of thirteen vintage suitcases covered in concrete and placed on the floor in pairs and trios. One stood off to the side alone.

The installation, then titled *Fossils* and now part of the series *Five Distant Memories: The Suitcase, The Room, The Toys, The Boat and Maradona* (2006–present), was based on a detail the artist remembered from his childhood during the later stages of Lebanon's civil war. The conflict was gruesome before it wore itself out, and Tabet and his family habitually kept their bags packed, just in case. The concrete encasing the artwork was meant to signal that time had passed and things had changed. Six days after the opening, however, another war began, and the need for those packed bags was painfully relevant all over again.

Not surprisingly, the meaning of *Fossils (The Suitcase)* changed utterly as the context exploded around it. For years, Tabet didn't really know what to do with the work. In 2008 he added another layer of concrete to the suitcases, further abstracting their form. But he often said that the piece had become too heavy and couldn't be held in conversation with anything else he'd done before or since. Certainly, his other works have a lighter touch and more playful sense of humour.

How to Play Beirut (2009), for example, assembles a sculpture, a video and a series of prints to consider how the political complexities of the Lebanese capital were reduced to a drinking game popularized by American fraternities in the aftermath of the Marine Barracks bombing in 1983. (The game requires two teams, twenty plastic cups and a relentless bombardment of ping pong balls from either side; like its namesake, it is notable for chaos and lawlessness.) *Home*

on Neutral Ground (2011) is an informal performance, two-screen video installation and set of some seven hundred delicate drawings telling the story of the Afghan national cricket team, which took up temporary residence in a derelict stadium in Sharjah built by an Emirati entrepreneur after he returned from an impressionable stay in Pakistan. A still-untitled work-in-progress delves into the rumours conjured by Diego Maradona's 'Hand of God' during the 1986 World Cup quarter-final in Mexico City, which captivated football fans as far afield as Lebanon in a wartime lull.

And then there is Tabet's ambitious, multipart project on the Trans-Arabian Pipeline, a 1,213 kilometre steel tube that runs three metres underground from Saudi Arabia through Jordan and Syria to Lebanon. At the time of its completion in 1950, it was the world's longest oil pipeline and the largest private investment project in foreign lands by American corporations. Both the pipeline and the company that ran it weathered three decades of regional political turbulence before they were shut down and abandoned in 1983. Since 2007, Tabet has filled his studio with the research materials (from printed ephemera to film footage of attempted sabotage) that informed the production of seven streamlined and notably sculptural installations, which constitute the series *The Shortest Distance Between Two Points*.

Between the rigour of the pipeline project and the irreverence of *How to Play Beirut*, where do those concrete suitcases fit? While working on *1989*, an architectural installation for 'The Ungovernables', the New Museum Triennial in 2012, Tabet realized *Fossils* wasn't an orphan at all but the start of a series that, with its emphasis on dreams, toy blocks and a disassembled fishing boat, appears set to unify the artist's disparate but engaging themes.

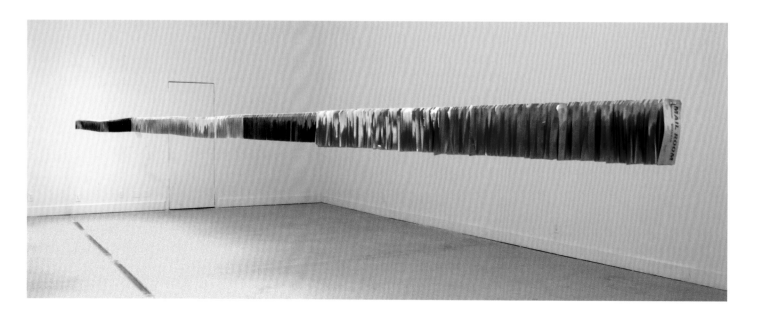

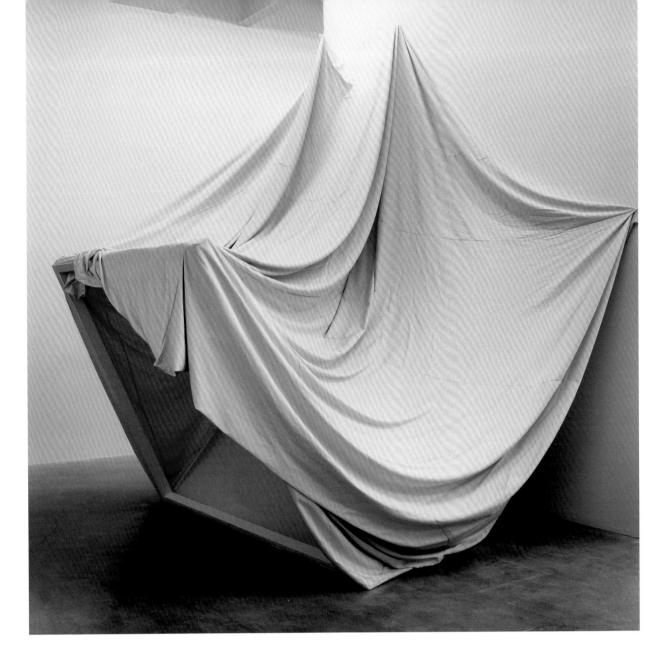

← *The Shortest Distance Between
 Two Points*, 2007–present,
 1,500 original mail tags of the
 Trans-Arabian Pipeline Company,
 steel rod, string, each 15 × 5 cm,
 30 m long overall

↑ *1989 (The Room)*, 2012, from
 the series *Five Distant Memories*,
 2006–present, bedroom
 door and doorframe, window
 and windowframe, sheetrock,
 canvas, wood, hardware,
 320 × 416 × 518 cm

↓ *Fossils (The Suitcase)*, 2006–
 present, from the series *Five
 Distant Memories*, 2006–present,
 suitcases covered in concrete,
 dimensions variable

Raed Yassin

Raed Yassin is a stocky young man with bright eyes and a thin stripe shaved at a rakish angle through the outside arc of his right eyebrow. His physical appearance matters in relation to his art only insofar as he uses it to fortify the humour, irreverence and aptitude for deception that runs through nearly every video, installation and series of photographs he has made to date. Talk to Yassin long enough and he will insist that what he likes most about his works are the lies they tell.

Indeed, Yassin's best-known and most exhibited pieces nudge his biography well into fabulist fiction, suggesting, for example, that he was the confidante to a famous Lebanese pop singer, courtesy of some crude Photoshop in the installation *The Best of Sammy Clark* (2008), or the son of legendary Egyptian film star Mahmoud Yassin, via more enigmatic strategies of delineating presence and absence in the paired videos *Disco Tonight* (2007–09) or the installation of oversized prints with video and book entitled *Who Killed the King of Disco* (2010–11).

When Yassin was an artist-in-residence at de Ateliers in Amsterdam, he made an uproarious series of photographs titled *Self-Portraits with Foreign Fruits and Vegetables* (2008–09). In each image, we see his head and naked torso adorned with asparagus, mushrooms or squash. He wanted to align himself with exotic produce that had been more successfully introduced to the European market than, say, artists from the Arab world.

In early 2013 he orchestrated a one-night performance at the Beirut Art Center, *The Impossible Works of Raed Yassin*, for which he set loose five curators, all women, in an empty exhibition space, as if for an opening, to talk about a collection of works that Yassin had imagined but never made.

This is characteristic of the artist's playfulness, but it also hints at a more serious and subversive agenda. As is the case for many visual artists in Beirut, Yassin occupies a number of different, interdisciplinary positions – he is a musician, he helps organize an experimental music festival and for a time he even managed the career of the Syrian wedding singer Omar Souleyman who became an unlikely international superstar.

As such, he has become a shrewd critic of the art scene, its history and its infrastructure. This sensibility may be best expressed in *China* (2012), a series of seven porcelain vases painted with scenes from the Lebanese civil war, which skewers the well-known but mostly unspoken tendency among artists to capitalize on the country's traumas. Along the same lines but more humorously, Yassin and fellow artists Vartan Avakian and Hatem Imam make up the collective Atfal Ahdath (children of 'the events', as the civil war years are known). Together they play with conceptual strategies that are elsewhere treated with excessive piety. All of this opens up space for Yassin's unabashed love of Arabic pop songs on seven-inch vinyl, his encyclopaedic knowledge of Egyptian movies from the 'Hollywood on the Nile' era of the 1950s to the independent scene of the 1980s, and the guilty pleasures he finds in the lowest-common-denominator comedies that are today's commercial blockbusters. How truthful is his affection for this material? The answer is anyone's guess, but the question keeps the work alive.

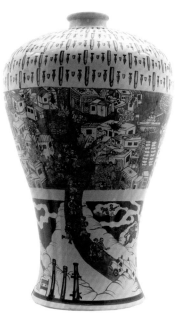
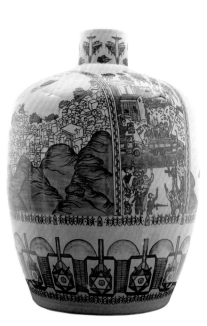
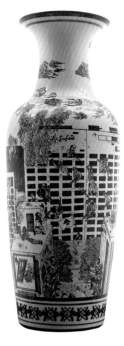

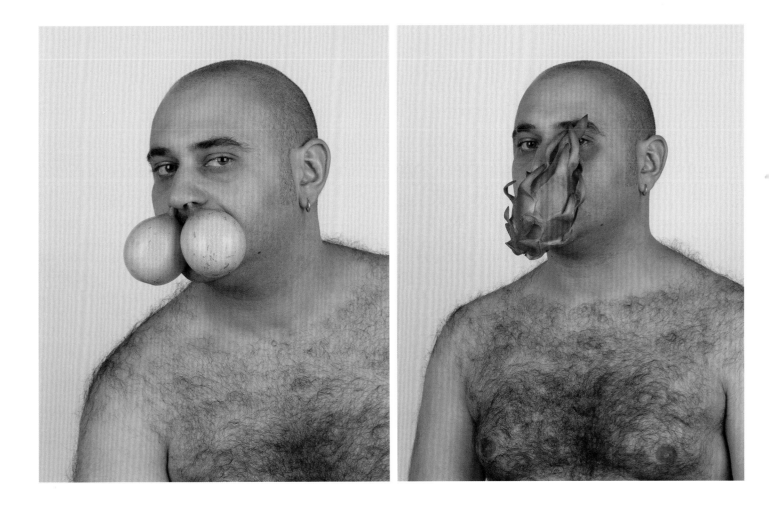

← *China: Tal El Zaatar*, 2012, porcelain vase, 94 × 56 cm (left)

← *China: The Israeli Invasion*, 2012, porcelain vase, 80 × 58 cm (centre)

← *China: The Battle of the Hotels*, 2012, porcelain vase, 96 × 33 cm (right)

↑ *Self Portrait with Foreign Fruits and Vegetables*, 2010, archival ink jet print on archival paper, 70 × 52 cm

↑ *Self Portrait with Foreign Fruits and Vegetables*, 2010, archival ink jet print on archival paper, 70 × 52 cm

↓ *Who Killed the King of Disco*, 2011, archival ink jet print on archival paper, 105 × 101 cm

Akram Zaatari

The End of Time (2012) is a silent, black-and-white 16mm film that gracefully twines together the two disparate strands that have run through Akram Zaatari's practice for nearly twenty years. He describes the piece as 'a choreography for two lovers, enacted by three figures.'[6] In each of the film's three parts, three young men rotate through two roles in which they repeat the same sequence of gestures; they embrace, one staggers and falls, they remove their clothes and then one pushes the other away. Only the third section is punctuated by intertitles explaining the actions as a game of truth or dare. The dare is to fall in love; the truth is to fail in love. At the end of an affair, a romance, a relationship, or time itself, the lover tells his beloved that he is leaving. We see a leather satchel, a hard drive, a box of pictures and a pile of neatly folded clothes. With this final gesture – in a film that is part of a larger time-capsule project that literally buried some effects of the Arab Image Foundation in the ground near the Fulda River in Kassel for Documenta 13 – Zaatari likens a long history of archival practice to failure, heartbreak and emotional collapse.

One of the most active and prolific figures in Beirut's contemporary art scene, Zaatari initially planned to be a film-maker rather than an artist, landing a job with a new tele-vision station in the years after Lebanon's civil war came to an uncertain end. It was a strange time; the Cold War had unravelled, and it looked like an Arab-Israeli peace accord might happen. Somehow in the midst of these events a tiny country's television industry became a hothouse for avant-garde video production. Zaatari lasted two years before leaving to focus on his own work. He also co-founded the Arab Image Foundation, and for a decade his output fell into two general categories: work about photographs, archives and archaeo-logical excavations, and work about desire, sexuality and tenderness among men. Throughout this decade, Zaatari was certain that his work would fall between the cracks of different disciplines and would only find audiences later.

But later came sooner than he thought. These days Zaatari is regarded as one of the most important artists of his generation, not only in Lebanon but also among fore-most practitioners playing with the meaning of photography, the potential of video and research-based practice. Videos exploring the nature of desire – such as *Crazy of You* (1997), *Red Chewing Gum* (2000) and *How I Love You* (2001) – have broken important social ground in Lebanon, paving the way for *Tomorrow Everything Will Be Alright* (2010), a video that conveys a beauty and honesty less evident in his previous works. Large-scale projects conducted as both literal and metaphoric excavations – such as *Objects of Study* (2004–present), his long-term, multifaceted work on Hashem El Madani's Studio Scheherazade, or *Earth of Endless Secrets* (2009), his equally complex investigation of militants, resis-tance and border contestation – have captured the attention of artists, curators and critics far beyond Beirut.

At times, these two threads have crossed – in the silent delicacy evident between two men in the notably cinematic *Nature Morte* (2008), in the homoerotic undertones of several works associated with *Earth of Endless Secrets* and in the archiving and indexing at play in the YouTube extravaganza *Dance to the End of Love* (2011). With *The End of Time*, they come together completely, lending a remarkable sense of unity to Zaatari's oeuvre.

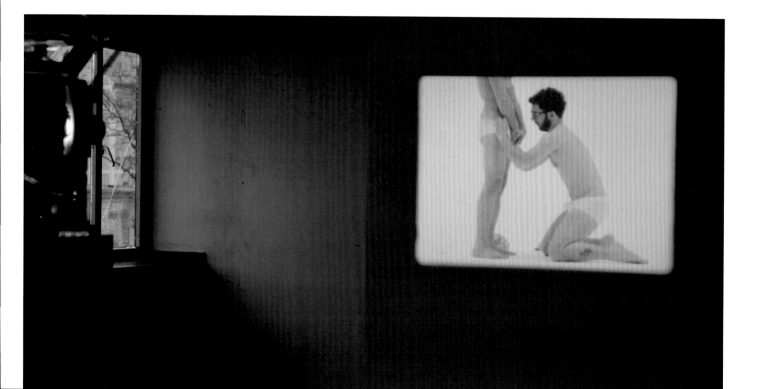

← *The End of Time*, 2012,
16mm film, 13 min., installation
view at Documenta 13

↑ *Dance to the End of Love*,
2011, 4-channel video, 22 min.,
installation view at MUSAC, León

↓ *Tomorrow Everything Will
Be Alright*, 2010, single-channel
video, 12 min.

Bogotá
by José Roca

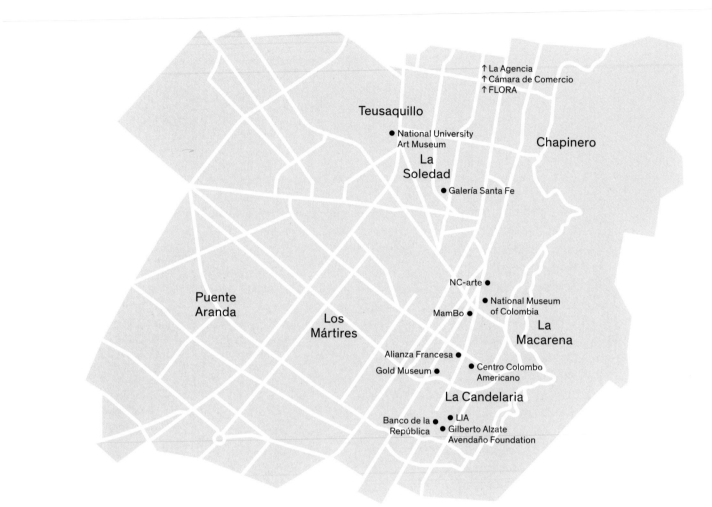

N
▲

↑ La Agencia
↑ Cámara de Comercio
↑ FLORA

Teusaquillo

Chapinero

● National University
Art Museum

La
Soledad

● Galería Santa Fe

NC-arte ●

● National Museum
of Colombia

MamBo ●

Puente
Aranda

Los
Mártires

La
Macarena

Alianza Francesa ●

Gold Museum ● ● Centro Colombo
Americano

La Candelaria

Banco de la ● ● LIA
República ● Gilberto Alzate
Avendaño Foundation

0 ——————— 1 km

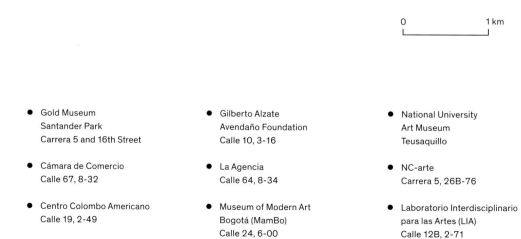

● Alianza Francesa
Sede Centro, Carrera 3, 18-45

● Banco de la República Art Museum
and Botero Museum
Calle 11, 4-41

● FLORA ars+natura
Calle 77, 20C-48

● Gold Museum
Santander Park
Carrera 5 and 16th Street

● Cámara de Comercio
Calle 67, 8-32

● Centro Colombo Americano
Calle 19, 2-49

● Galería Santa Fe
Carrera 16, 39-82

● Gilberto Alzate
Avendaño Foundation
Calle 10, 3-16

● La Agencia
Calle 64, 8-34

● Museum of Modern Art
Bogotá (MamBo)
Calle 24, 6-00

● National University
Art Museum
Teusaquillo

● NC-arte
Carrera 5, 26B-76

● Laboratorio Interdisciplinario
para las Artes (LIA)
Calle 12B, 2-71

Bogotá
by José Roca

With its almost eight million inhabitants, Bogotá contains roughly one-fifth of Colombia's population and is a cross-section of the country as well. Indeed, in most situations you would be hard-pressed to find a majority who were born here or whose families go back more than a generation in the city: we are almost all emigrants from other parts of Colombia.[1] So even if it's true that artists from Bogotá dominate the Colombian art scene, in fact most of these *Bogotanos* come from all over the country. Therefore, when I say 'Colombia' I am often thinking of 'Bogotá' and vice versa.

But one thing that is strictly *Bogotano* is the city's strange geographic environment. Despite being the third-highest capital city in the world (after La Paz, Bolivia and Quito, Ecuador), its climate is tropical due to its nearness to the equator.[2] This accounts for the region's unpredictable weather, with the four seasons sometimes manifesting themselves over the course of a single day: freezing cold in the early morning, scorching sun at midday, wind in the afternoon and scattered but torrential showers in between. The art scene is just as varied, extreme and surprising. After decades of being under the art world's radar – due to the perceived danger the country as a whole has endured because of drug-related violence[3] – Bogotá has been rediscovered; many biennial and institutional curators, museum officials, patrons, artists and collectors have come to check out the local scene.[4] As a child I remember reading a story in which jungle explorers discover a lost civilization that had developed in complete isolation from Western civilization.[5] We might think of Bogotá in similar terms: with no outside intervention, the local scene emerged without the pressures of the market (no production frenzy artificially induced by biennials or galleries). So when outsiders finally visited they were pleasantly surprised to find a very mature scene, with artists that would be major players on the international circuit had they been working in a more connected or more visible environment. The rapid insertion of local artists into the mainstream during the last few years attests to this. Nevertheless, most discoveries are of emerging artists in the thirty- to forty-year-old year range, which means that an entire generation of locally established but older (and probably less trendy) artists was skipped over by international scouts.[6] This is a wrong that should be redressed.

Until the 1980s, the art establishment in Colombia (and the cultural establishment in general) coincided with the social and economic elites, and it aspired to emulate what was happening abroad. Local writer William Ospina has said that in Colombia, the elites dream of Paris, the middle class dream of Miami and the poor dream of Mexico.[7] Latin America – with its own set of cultural values – was not a priority on our cultural agenda, and only recently has it become so. Artists did not want to be local; they wanted to be international. (Ironically, now that locality figures strongly in their practices, the international circuit pays attention.) This attitude changed during the 1990s, for various reasons. In 1992, coinciding with the commemoration of the five hundred years since the discovery of the Americas, questions of identity and anti-colonialism became central in Colombian art. The issue of history – who makes it, who writes it, how is it written and how is it represented – became a main topic of discussion. Many artists, like José Alejandro Restrepo, revisited historical documents and accounts in search of reasons for political instability. And they found the roots of segregation, racism, corruption and violence which have shaped Colombia politically as a country and culturally as a society. Of particular interest were the scientific travellers, or *viajeros*, who canvassed the land in search of new information, especially after the eighteenth century. Shielded by the objective discourse of science, these explorers travelled in the territories of what were then colonies, charting the land, documenting natural and social life, extracting specimens and naming species – appropriating symbolically what was to be exploited physically by the colonial powers that financed these expeditions. *Natural history*, which is anything but natural, thus naturalized racial hierarchies as scientifically proven, and geographical

determinism became the scientific basis for regarding the tropics as a territory doomed to underdevelopment: 'Nature is here, I'm afraid, too generous … a few day's work will last a man for an entire year.'[8] How can a civilized society, many travellers wondered, be born from such conditions? Colombia, despite allegedly being the oldest stable democracy in Latin America (as we like to boast), has in reality been at the mercy of different forms of authoritarianism. This trait – which Montesquieu considered necessary to counteract the environmental complacency of warmer climates – apparently has not been enough to catapult us into the realm of developed countries. Thankfully, art sometimes escapes the logics of state formation and capitalism, and against all odds (scarce criticism and curatorial mediation, weak institutions, few galleries and even fewer collectors, only one art magazine, and so on), the art scene in Bogotá thrived and grew on its own terms; now that better conditions are in place, the scene has exploded to become very strong, varied and sophisticated.

During the last decade, both the institutional and independent art scenes in Bogotá have become more robust and diversified. The Museo de Arte Moderno de Bogotá (MamBo), which was the hub for all things contemporary until the late 1980s, lost its centrality due to the myriad initiatives and institutions that have come to form the contemporary scene: the traditionally conservative Museo Nacional (a museum of history, archaeology and art) had a major architectural and infrastructural overhaul, and began to look programmatically at contemporary art; the Banco de la República renovated its cultural compound, including a new building for temporary exhibitions and an art museum with a programme decidedly oriented towards the contemporary;[9] the city of Bogotá consolidated the Galería Santa Fe as a space for experimental art, with initiatives like the Luis Caballero Prize (dedicated to mid-career artists), Barrio Bienal (for artists from the different neighbourhoods) and other programmes providing visibility to contemporary production; and the Fundación Gilberto Alzate Avendaño, an institution funded by the city, initiated a series of exhibitions recovering important figures of Colombian modernism, and has supported residencies for local artists both in Colombia and abroad. Since 2008, the art museum of the Universidad Nacional has taken the lead in producing large exhibitions of both local and international contemporary art. Many independent spaces have appeared as well: NC-arte, La Agencia, Miami, LIA (Laboratorio Interdisciplinario de Artes), La Peluquería, La Cooperativa and FLORA, to name a few. The Cámara de Comercio has new spaces devoted to young artists, as do the Alianza Francesa and the Centro Colombo Americano. Several Colombian curators working abroad have included local artists in their curatorial projects; many more working from within Bogotá have begun to create a critical mass with their exhibitions and texts.[10] ArtBO, the local art fair, which attracts galleries and collectors from all over Latin America, has established itself firmly as a regional player, and its success has spawned a few alternative fairs. Several galleries regularly attend art fairs in Latin America and Europe, ensuring that the local talent earns international visibility. An expanding group of collectors, many of them young professionals, has created a strong local market for contemporary art, something unthinkable a decade ago. Some even go beyond collecting and sponsor complex projects, edit books and support the participation of artists in international events. A few have shown their collections in museums or have permanent displays that are open occasionally to the public; others plan to create permanent public spaces in the near future.

As historian Mauricio Nieto has remarked, '[if] natural history would constitute a form of appropriation and play a central role in State politics; the work of naturalists in classifying and naming natural objects would facilitate the control not only of nature but of other cultures.'[11] The 1999 commemoration of the two hundred years since Alexander von Humboldt's expedition to the Americas; the 150-year anniversary of the Corographic Commission statistical and geographical surveys in 2000; the 2008 bicentenary of the death of José Celestino Mutis, director of the Royal Botanical Expedition; and the celebration of the bicentennial of Colombian independence in 2010, among other historical landmarks, have brought to the fore issues including the

→ Skyscrapers downtown with
 Monserrate in the background

↓ Banco de la República
 Art Museum

↘ An engraving from *Journey to
 Nueva Granada* (1869) by Charles
 Saffray, which features in José
 Alejandro Restrepo's installation
 Quindio's Pass II (1999)

↓ Installation by Oficina Informal
 and La Agencia at Galería Santa
 Fe, Teusaquillo, 2012

↘ Free School of Plastic
 Experimentation at University
 Jorge Tadeo Lozano, Bario
 Bienal programme, 2012

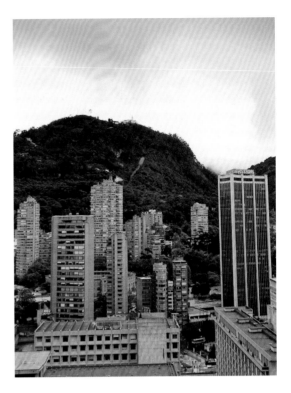

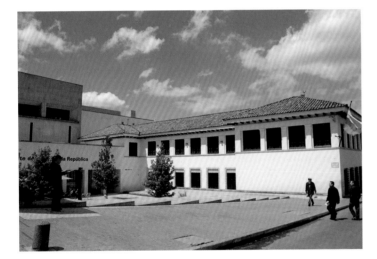

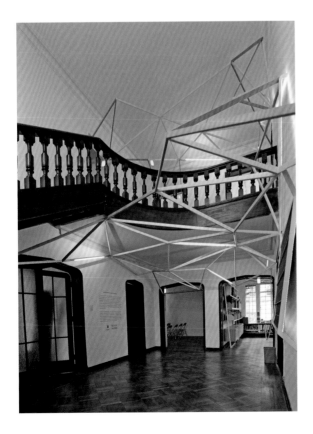

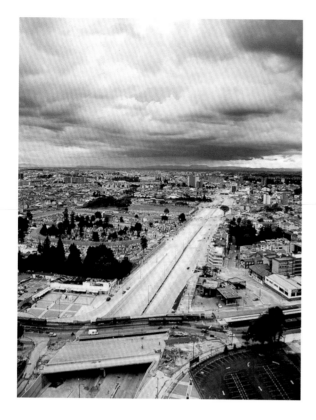

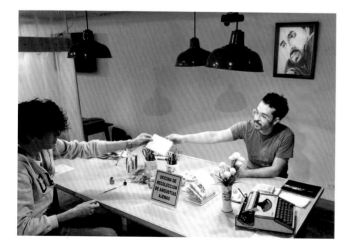

aftermath of the colonial enterprise, the social implications of taxonomy and the quest for a national identity based on critical reassessment of the native – be it natural or cultural. The last two decades, especially the 1990s, were also the bloodiest in Colombia's political history as a result of war with the drug cartels, which reached cities in the form of bombs and terrorism; the intensification of the conflict by the leftist guerrillas M-19 and ELN; and the dramatic spread of paramilitary groups. These years saw drug money permeate all aspects of social and political life in Colombia, to the point that the country was dubbed a 'Narco-Democracy' by a former US government DEA official (to which a local writer wryly retorted: 'Narco, yes, without doubt; democracy, less so').[12] In culture at large, the representation of violence became hegemonic – as it informed literature, film and, of course, art – now commonly known as an aesthetics of violence. Within this strand of art making that reflects on the implications of politics and drug-related violence, a certain phylum emerged in the mid-1990s that has continued through the current decade: a strong relationship between art and nature, particularly the botanical and the political. We might ironically name it 'botanical determinism';[13] let us not forget that in their introduction to *Ideas for a Geography of Plants* (1803), Humboldt and Aimé Bonpland state that 'plants play a role in the moral and political history of mankind; if it is certain that the history of natural objects can only be considered a history of nature, then it is no less certain … that the very changes in nature acquire a legitimately historical character if they exert influence over human events.' Obviously, there are many other subjects and themes that preoccupy the artists working in Bogotá, but I happen to think those delving into the complexities of the botanical issue are among the most interesting. I have chosen eight artists, as the format of this book demanded, but many others share their concerns.[14] The approaches of these *Bogotanics* are wide-ranging: recapitulating scientific exploration and travel; using archival documents as source material; foregrounding the historic and mythical significance of plants; resorting to the naturalist's strategies of collecting and classifying; and looking at how the botanical landscape is both manifest in and transformed by popular culture.

Alberto Baraya

On a late autumn afternoon in 2002, Alberto Baraya noticed some bright green leaves among the seasonal brown and orange foliage on the ground. These turned out to be made of plastic. He began to see artificial flowers everywhere: restaurants, banks, malls, homes. The ubiquity of artificial nature led him to think not only about globalization and cultural penetration, but also the colonial enterprise as articulated through botanical expeditions, which were instrumental in classifying the natural riches of the New World to facilitate their exploitation. He adopted the role of the botanical naturalist, parodying its systems of knowledge and borrowing its methods. Baraya printed flyers inviting people to submit artificial plants to his Herbarium, and asked them to provide three basic pieces of information along with each specimen: the name of the person who discovered the plant, and when and where it had been found. Subject, place and time were needed to establish the cartography of this unlikely herborization. Initially the plants classified by Baraya were treated as objects; like his botanist predecessors, he isolated specimens on a white background to show more clearly the constitutive elements of the plant. Later, he began to photograph them, printing them at the size of botanical plates.

Baraya's photographs highlight the construction of botanical illustrations and their ultimate fiction. Such plates display different stages of the same plant simultaneously, for example flower and fruit, which does not usually occur in the wild due to the natural life cycle; and, in general, the composition is designed in such a way to include as much information about the plant as possible. This marked the beginning of *Herbario de Plantas Artificiales* (Herbarium of Artificial Plants, 2009),

an ongoing work that has enabled Baraya to explore such fields as botany, ethnography, geography and history from an artistic standpoint.

As an ironic commentary on the arbitrary nature of certain taxonomies, Baraya accompanies his herbarium with a file in which, instead of botanical records, there are photographs documenting the catalogued plants in the habitat where they were found. The categories do not necessarily correspond to species, mostly informing the locations where these plants proliferate, an observation that is more sociological than botanical: halls, restaurants, airports, bathrooms, doctors' waiting rooms. The majority are non-places or places of passage, where there is the need for a presence of nature that does not require daily care; signifiers of nature in a world increasingly removed from it.

Baraya is also interested in the process followed by the botanical explorer, namely fieldwork. The *expedition* became a conceptual mechanism to expand the scope of his project. Searching for artificial plants in the heart of the Amazon jungle might seem nonsensical, but the reality confirmed Baraya's intuition: even in what we imagine as the outer edges of civilization, this invasive botanical pest has arrived, mainly imported from China.

The *Herbarium of Artificial Plants* has had ramifications ranging from the thematic to the formal. It is an attempt to critically review the figure of the botanical naturalist and simultaneously escape his net. In the end, Baraya's project is not about botany; it is first and foremost a reflection on power, and on the will to control the world through the act of naming and classifying it.

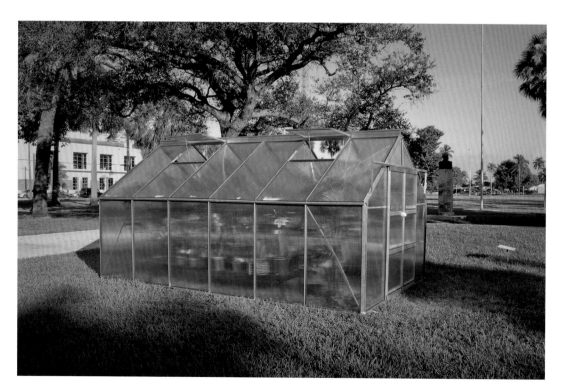

← *Invernadero* (Green House) from *Herbarium of Artificial Plants*, 2009, readymade aluminium and polycarbonate greenhouse with artificial flowers 'made in China' (wire, plastic, silk, foam)

↑ *Amapola Santos* (Poppy Saints), 2012, plastic wire and silk readymade, photography, drawing and stamp on cardboard, 116 × 85 × 9 cm

→ *Green House* from *Herbarium of Artificial Plants*, 2009

→ *Green House* from *Herbarium of Artificial Plants*, 2009

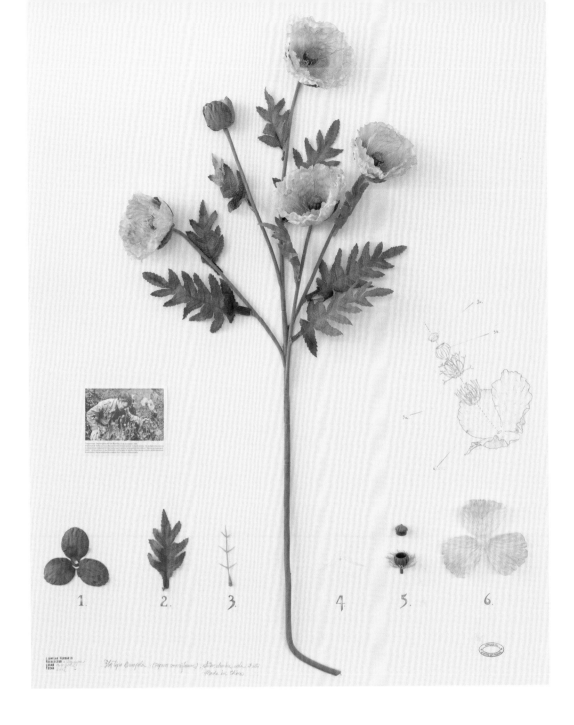

Johanna Calle

Johanna Calle has experimented with many ways of understanding drawing, using diverse media and techniques like sewing and knitting on canvas, burning or piercing wood, bending wire, manually typewriting on paper or using writing as line. Her works usually have profound psychological implications and often allude to social injustice and violence. In recent works Calle has used text as image, copying pages of newspapers in order to make their content illegible, or realizing intricate drawings with texts taken from historic, literary or journalistic sources. In *Letargia* (Lethargy, 2001), she creates portraits by bending wire, attaching it to board and burying it in casein. As the artist sands the entire image, her subjects slowly come to the surface. Detached from the body, these delicate portraits appear to float in an indeterminate state between dream and death. In a country where corpses are often thrown into rivers – which become de facto mass graves – these submerged or emerging portraits have particularly strong overtones.

Wire appears prominently in Calle's work, as it can signify scarcity and poverty, being a humble material often used in makeshift constructions. *Obra Negra* (Black Opus, 2008), is a series of drawings of the precarious dwellings found in poorer areas of the city, conflated with fragments of the bodies of their inhabitants. These individuals appear to be carrying the weight of their houses on their backs while trapped inside them. The idea of the house as forced enclosure is even more direct in works like *Perspectivas* (Perspectives, 2007), done by crushing birdcages with a hydraulic press. Calle forces three-dimensional form back into two dimensions, inverting the usual process of representation and

creating a haunting image wherein the concentrated violence exerted on the material is a metaphor for what are commonly known as the objective causes of violence: poverty, exclusion, segregation and inequality. The drawings in the series *Chambacú Albalá* (2007) appear from a distance to be Moorish geometric motifs. On closer examination the viewer realizes they are made with lines of text, in this case referring to the influence of Arabic words, which entered the Spanish language during centuries of occupation. This series, along with *Perspectivas*, were made in Cartagena, Colombia, and its referent is another displacement: that of the black communities being forced from Chambacú's historic neighbourhood, which has become prime real estate due to recent gentrification.

Plants are central to Calle's imagery. This is not only because war is waged mainly in the countryside of Colombia, but also because the roots of social inequality can be traced back to the moment when the landscape was razed and its people subjugated, their cosmogony and language replaced by the colonizer's. In fact, many of these images are constructed *with* language, in time-consuming processes of transcription-as-drawing. In every case the text has a direct connection with the image, as in *Dominios* (Domains, 2011), where the shape of a tree has been depicted on the pages of old accounting logbooks by a typewriter. This alludes to a recent event in Colombia in which people were displaced by illegal armed forces and unscrupulous notaries assigned their land to large landowners. In *Tejido Foliar* (Foliar Tissue, 2008), a close-up of a leaf is rendered with texts that describe biological mutations due to the spraying of chemicals.

↑ *Domains*, 2011, typed text on old ledger paper, 83 × 42 cm (left)

↑ *Domains*, 2011–12, typed text on old ledger paper, 83 × 42 cm (right)

→ *Perspectives*, 2007, pressed and painted galvanized metallic object, 57 × 50 × 3 cm

← *Foliar Tissue* (detail), 2008, Chinese ink on paper, 31 × 46 cm

Antonio Caro

Antonio Caro has stated that his work is 'like a continuous present'.[15] This explains his recurrent use of a limited repertoire, as if he were both playwright and interpreter. When asked about his meagre output, he famously said that he had only one idea per year. But that was back in the 1970s: time has proven that it was an understatement (or rather that his ideas do not necessarily translate into conventional artworks).

Over half a decade, from 1972 to 1978, he laid out the conceptual and formal base of his artistic practice, and has revisited these images and ideas many times over, reframing them in relation to the temporal and cultural context where a new iteration recurs. The letterpress poster *Todo está muy Caro* (a play of words that can be translated as 'everything is very expensive' or 'everything is very Caro', 1978), for example, has appeared in Bucaramanga (1998), New York (2000), Cali, (2002), Quito (2003), San Juan (2004), Caracas (2006), Medellín (2007) and Montería (2012).

In 1972 he realized *Homenaje a Manuel Quintín Lame* (Homage to Manuel Quintín Lame), which later surfaced in Medellín and New York (2000). Caro learned by heart the signature of Manuel Quintín Lame, an indigenous leader in the first decades of the twentieth century who studied law in order to defend his people from abuses of government. The artist's strategy of appropriation predated its widespread international use by a decade. Through Lame's signature (a striking amalgam of nineteenth-century cursive and indigenous pictogram), he restages the uncomfortable coexistence of two cultural logics in constant struggle, and sheds light on the ongoing plight of Colombian indigenous communities, which remain segregated to this day. He made the first version of

Maíz, a symbol that transcends the local and speaks to the entire American continent, in 1974. This work has appeared as a print in successive editions, stencilled on urban walls throughout Colombia and other Latin American cities, and on a national stamp commemorating the 500 years of the Discovery of the Americas. But his best-known work to date is *Colombia* (1976), the name of his native country done in the style of the Coca-Cola logo. Although borrowing from American Pop Art, the reference to mass culture here becomes a political gesture denouncing cultural colonialism. In referring to the condescending stance of the United States towards Colombia, the work was prescient of the drug-related events that have pervaded the relationship between the two countries for the last three decades.

From 1987 Caro has pared down his practice, shying away from authorship to reflect on the communicative possibilities of art and conditions for its reception. For *Proyecto Quinientos* (Project Five Hundred, 1992) he responded to the commemoration of the discovery of the New World by committing to give five hundred talks on the subject of locality, globalization and cultural colonialism, canvassing the territory to visit as many cities and towns as possible. In 1996 he received a grant to continue this work. He also started *Itinerancia del taller* (Itinerant Workshop, 1998), working with non-artists to explore their creativity and often staging workshop results as collective exhibitions. Caro remains an important figure in Bogotá's art scene; indeed, he is well known for denouncing any kind of institutional manipulation, to the extent that he has become a sort of moral conscience for the artistic milieu.

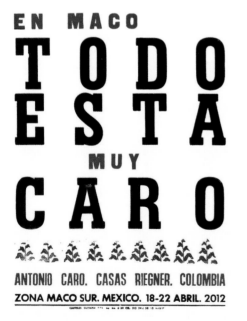

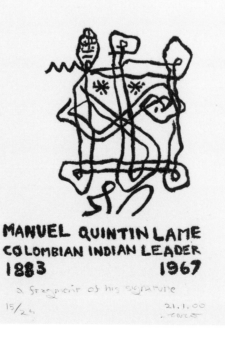

← *En Maco todo está muy Caro* (At Maco Everything is Very Expensive), 2012, silk screen print on paper, 70 × 50 cm

← *Manuel Quintín Lame*, 2000, lithograph, 23 × 28 cm

→ *Colombia*, 2010/1976, enamel on tin, 70 × 100 cm

↓ Zona Maco Sur Project including *Maize, Project Five Hundred* and *Homage to Manuel Quintín Lame*, 2012, silkscreen print on paper, catalogues, magazine sheets, handwritten poem, stamps, photocopies, dimensions variable

María Elvira Escallón

María Elvira Escallón's work draws attention to the contiguity of different moments and states of matter. She has made a column out of ice that slowly melts back into water (*In Memoriam*, 2001), and erected a wall with cement blocks and recycled materials from a construction site, using loose debris from the same site to create a shadow effect (*El Reino de este mundo*, The Kingdom of This World, 2000).

One of her strongest projects to date is *In Vitro*, realized for the National Art Salon in 1997. After years of being held in neutral venues, the chosen site for this Salon was the old train station in Bogotá, which was in very poor condition and had to be thoroughly renovated. Escallón used glass to isolate her allocated space from the rest of the building, otherwise leaving it in its found derelict state. The glass created a *mise en scène* of the architecture in ruins, highlighting years of government neglect. (In Colombia, the train system was dismantled in the second half of the twentieth century.)

This same approach was the impetus for a body of work dealing with the moribund situation of the public health system. Through interventions such as systematically dismantling the interior of a hospital room; cutting up and rearranging discarded steel beds, as in *En estado de coma* (In a Comatose State, 2004–07); or letting sand slowly pour from a hole in the ceiling until it eventually engulfs the entire space, such as for *Emergency Room*, 2010–12; Escallón calls attention to the continuing effects of decades-long mismanagement and corruption.

Recently she has become interested in nature and how various human activities are inflicted on it. *Nuevas floras* (New Florae, 2000–present) is an ongoing project that has been realized in different locations. For the first iteration of the work, she hired a carpenter to carve specific motifs directly onto live trees. The forms were taken from Spanish colonial carvings found in churches around Bogotá. These works speak metaphorically of the colonization process in the New World, in which science and religion were as instrumental as military force.

For the eighth Mercosul Biennial in 2011, Escallón developed the project into *Nuevas Floras del Sur* (New Florae of the South). Working with the remains of the eighteenth-century Jesuit missions at São Miguel das Missões, she had several trees carved with motifs found in the ruins of the church and the museum. Images of the carvings were coupled with contemporary photographs of what were formerly territories of the Guarani tribe, now converted into extensive croplands. For example, the arm of San Isidro, patron saint of farmers, is shown alongside a landscape with one of the last remaining patches of forest, that stands like an oasis in a desert, amid a large expanse of flat farmland. Just as the Jesuits forced a new language and faith on the Guarani, current economic forces are completely changing the face of their ancestral land.

← *In Memoriam*, 2001, ice column
 in glass container of water

↑ *New Florae*, 2003–12, native
 forest around Bogotá, colour
 photograph, 120 × 80 cm

→ *In a Comatose State: Harvest*,
 2007, San Juan de Dios
 Hospital, Bogotá, digital print,
 120 × 180 cm

Miler Lagos

Miler Lagos works primarily in sculpture, usually manipulating a material so that it contradicts the properties intrinsically associated with it. For example, *Levedad insoportable* (Unbearable Lightness, 2005) features what appear to be mylar children's balloons. On close inspection one learns that they are actually stainless steel shells filled with concrete, each placed precariously atop a steel rod. One of these pieces was used some years later in the video *Attraction* (2009), where a balloon seems to float towards a body of water in slow motion; but when it finally reaches the surface, a violent splash reveals the paradoxical and disconcerting nature of the object.

The *Cimiento* series (Foundation, 2007), which consists of sculptural prints in various configurations, fits within this continuing investigation. *Foundation* departs from an observation on the foundations of the print as a way to disseminate knowledge, but also on the material support of the print itself, which for centuries has been primarily paper. When cutting through a block of paper with a power tool, Lagos noticed it released the smell of burnt wood. This led him to reflect on how, although paper represents the transformation into culture and thus seems detached from nature, it still retains many properties of its material origin. The artist started to use stacks of paper printed with reproductions of important engravings, such as Dürer's *Apocalypse* (1497–98) or Hiroshige's nineteenth-century *ukiyo-e* woodblock prints. He painstakingly shapes the material with a fine blade, then finishes the overall form with a sander, which burns the edge of the paper to give it a wooden colour and smell. Some blocks are left unburnt, and diagonal cuts reveal the grain of the paper, while the image, repeated on each sheet, appears three-dimensionally throughout the body of the piece. Each log-like form is an original piece, done with a different engraving. Lagos chose Dürer's woodcuts as a way to establish a connection between the sculptural trunk and one of the most important practitioners of wood-block printing. As an artist from a country where an undeclared civil war plays out in the dense jungle, the relation between Dürer's visions of despair and their embodiment in the form of a wooden stump is also fitting.

Lagos has developed this project further, using other engravings, books, magazines and newspapers. Some works, such as *Soporte Universal* (Universal Support, 2008), which look uncannily like live trees, change the public's perception of the exhibition space with their imposing size and incongruous presence. Other works are created by arranging sheets of newspaper in a circular fashion so they appear to be the rings of a tree (*Tree Rings Dating*, 2010). In recent works Lagos has become interested in architecture, building minimal spaces for dwelling by using books as a construction material, or a retrofitted water tank later set adrift on the ocean (*Home*, 2011).

← *Home*, 2011, single-channel
 video, 2 min. 42 sec.

↑ *Attraction*, 2009, single-
 channel video, 5 min. 49 sec.

↗ *Unbearable Lightness*,
 2005, steel, concrete and
 rubber, 65 × 25 × 15 cm

→ *Foundation*, 2007, carved
 sheets of printed paper,
 20 × 40 × 35 cm

Mateo López

Drawing drives Mateo López's artistic practice, but he does not dwell on his remarkable technical ability; on the contrary, his drawing always serves a conceptual programme. Regarding his work, one can speak of drawing as installation, in the sense that it appropriates the exhibition space as a sculptural presence, providing the spectator with a bodily as well as visual experience. On many occasions he creates a *mise en scène* of the artist's studio, showing what appears to be the desk of a draughtsman; close scrutiny reveals that the elements on the table – from tools to materials, leftovers and the usual worktable clutter – have been patiently drawn and constructed with paper and other simple materials. In recent works like *Motorcycle Diaries* (2007), *Topografía anecdótica* (Anecdotal Topography, 2007), *Viajando sin movimiento* (Travelling Without Movement, 2008) and *Adrift* (2009), López invokes the figure of the travelling artist, crossing territories by bus, motorcycle or other means of transport. These travels are ripe with cultural references; from scientific expeditions of the eighteenth and nineteenth centuries to Che Guevara's mythical motorcycle trip. López makes drawings, objects, architectural models and annotations that rearticulate travel as a kind of knowledge.

One such itinerant project is *Nowhere Man* (2011), originally conceived for an exhibition presented at the Drawing Room in London, which afterwards travelled to several venues in both Europe and Latin America. *Nowhere Man* is typical of López's approach. The installation appears to be a small office tucked behind a room divider, containing a desk with its drawers open, a chair, a bed, a box and a bag. In the tradition of Duchamp's *Boîte-en-valise* (1935–40), most of the elements that López created for the installation travel inside the suitcase which is shown alongside them. On the table there are notebooks with López's drawings and a series of disparate objects that seem to tell a story – one that we as viewers do not know, but have to decipher, by combining the visual references and proposing a plot line based on mental juxtaposition. The story thus varies from individual to individual depending on the meanings we invest in what we see: the remnants of an apple, several polyhedra, an eraser, a roll of tape, a glass with a pencil, a map, an invoice, a piece of stone, a razor blade. Is this the office of a land surveyor? Or are we looking at the desktop clutter of a bored clerk at a frontier outpost? Inside the drawers other equally banal but enigmatic objects suggest more possible conversations: a flower, a cassette tape, an old photograph, a wristwatch, some keys, a playing card. All are drawn and constructed by the artist out of coloured paper and cardboard. In every place the installation is exhibited, López creates new drawings and objects, so that the work reflects its nomadic exhibition life through the sheer accumulation of materials inspired by the locations where it is shown.

← *Anecdotal Topography*, 2007,
installation of drawings,
found and modified objects,
paper sculptures and plants,
dimensions variable

↑ *Nowhere Man*, 2011, installation
comprised of approximately
60 drawings and objects,
190 × 320 × 281 cm

→ *Motorcycle Diaries* (detail),
2007, mixed media installation
with drawings, paper sculptures,
dimensions variable

↓ *Motorcycle Diaries* (detail), 2007

↪ *Nowhere Man*, 2011

José Alejandro Restrepo

José Alejandro Restrepo is one of the most influential artists of his generation in Colombia, not only for his artistic work (his critical use of historical documents has sparked a similar attitude among many younger artists), but also for his work as a teacher, curator and writer. He studied medicine for a brief period, then turned to studio art, but became disgusted by the hierarchies put in place by academia and never finished his degree. He travelled to Paris to study engraving and became acquainted with contemporary art, in particular video. He has said that historical engravings and video have many things in common: both are composed of lines that render form and image (a video is a print of 525 lines per image, at thirty images per second). Both are time-based art forms: in video, the electron scan creates an image that erases the previous one, like the successive stages of a print. Besides this formal coincidence, both are ways to record history. Before the advent of photography, scientific findings were illustrated with engravings, usually by professional artists in Europe based on the sketches of travellers and the specimens they submitted, which arrived deformed by time and distance. The draughtsmen and engravers rendered in detail geography, fauna and flora they had never seen, from a continent they had never set foot upon. Thus natural history (and history in general) was illustrated from an existential schism between experience and interpretation. This is the basis for two important works by Restrepo: *El paso del Quindío* (The Quindío Pass, 1992), where he contrasts the contradictory accounts of different travellers who crossed this important path in Colombia over the centuries, emphasizing through his own observations the highly subjective nature of the historical record; and *El cocodrilo de Hegel no es el cocodrilo de Humboldt* (Humboldt's Crocodile Is Not Hegel's, 1994), which consists of the title displayed on a wall along with excerpted texts by each German savant, the scientist and the philosopher, differing on the size and strength of the American crocodile. This work shows how European prejudice was projected onto the New World, which was seen as a rich depository of natural products but inferior to the old continent in every other respect.

Paulo Herkenhoff has remarked that Restrepo is an *iconophage*, devouring images from history past and present to regurgitate them as critical commentaries on contemporary society. In the last decade he has delved into Christian imagery, signalling the role that the Catholic Church has played in the subjugation of peoples worldwide. Religion and myth serve as lenses through which to analyze the complex political situation of current-day Colombia, a country riddled with problems such as pre-modern land structures, still-unresolved indigenous issues, the powerful influence of the church on governmental policy and a societal attitude towards images that oscillates between fascination (*iconophilia*) and the will to destroy them (*iconophobia*).

Restrepo has created contemporary versions of the liturgical calendar or *santoral*, as in the video installations *Saint Lucia* (2006) and *Saint Job* (2006), the latter of which projects the image of a man onto a bundle of tree branches where silkworms grow. Over several weeks the insects wrap the branches with silk; referencing the hardships Job endured to prove his love for God and reflecting on the incredible resilience of Colombian peasants, who have endured the violence and desolation of political conflict for almost half a century. Projected on a piece of hanging cloth, *Video-Verónica* (2000) shows at first a painting of the saint holding the shroud imprinted with the face of Christ. As the camera zooms out, other women become visible in the frame; they hold photos of their loved ones, husbands or sons, kidnapped by guerrillas or else 'disappeared'.

← *Video-Verónica*, 2000–03, video projection, 100 × 100 cm

↑ *Saint Job*, 2006, floor projection over live silk worms, 300 × 250 cm

↗ *Saint Lucia*, 2006, video installation with 2 monitors and unattributed 17th century painting

→ *Variation on the Purgatory No. 4*, 2011, video installation, 12 × 5.6 m

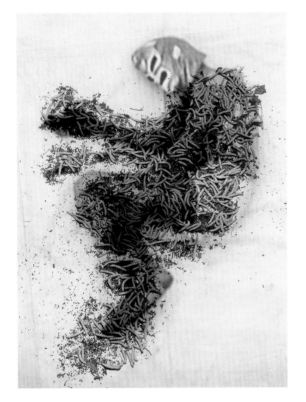

Gabriel Sierra

Trained as an industrial designer, Gabriel Sierra swiftly transitioned to the artistic realm through objects that straddle art, design and architecture. These paradoxical and enigmatic works are often born of his acute observation of cultural particularities, customs, gestures and tropes. His objects combine erudite references to the history of art and design with vernacular traditions, and are imbued with humour and a certain sense of the absurd. For example, *Horno para calentar gatos* (Oven to Warm Cats, 2004) is a papier-mâché enclosure which brings to mind the papery nests built by wasps that attach to the corners of trees and buildings; in terms of function, the owner's body provides the heat for the pet. *Apurador-horno para madurar frutas* (Hastener-Oven to Ripen Fruit, 2004) resorts to a similar formal principle, but this time invokes a long-standing Colombian tradition of wrapping fruit in newsprint to accelerate its ripening. *His Hang It All – Stepmother Nature* series (2006) takes Charles and Ray Eames's iconic modernist design and turns it into a fruit rack; whereas *Sombra para bombillo que acompaña individuos solitarios* (Shadow For a Light Bulb That Accompanies Solitary People, 2003) playfully eases the lone person's proverbial fear of shadow by placing a cardboard stencil over a simple light bulb to provide a reassuring presence.

On several occasions, Sierra has architecturally overhauled entire spaces (usually art related, like the exhibition design for the Encuentro de Medellín MDE07 in Colombia, 2007, and the 28th São Paulo Biennial in Brazil, 2008), conceiving furniture that is both simple and extremely sophisticated in its formal refinement and careful treatment of materials and details. For Medellín, the artist tried to invoke a (fictive) design genealogy in a country that lacks a tradition of applied arts. His most recent projects often involve highlighting the functional or formal elements of the exhibition space by means of alterations, sometimes subtle but often radical, like removing and reshaping part of the baseboard of an exhibition space as in *Untitled (Marginalia)* (2011), or cutting a portion of the wooden floor and lifting it at a steep angle, turning the materials of the exhibition space into a sculptural element that alters the viewer's perception and use of space, as for *Untitled (The Day as a Hole in the Middle of the Night)* (2011). In recent years, Sierra's work has become increasingly minimal and restrained. He creates simple forms that on closer inspection reveal themselves as something altogether different: wooden reliefs unfold to become shelves with the aid of hidden hinges and magnets (*Untitled: Interrupted Shelf*, 2009); a series of vertical and horizontal wooden slats are in fact large wall-mounted clasps for holding paper and other objects (*Particular Infinite*, 2010); vertical dark forms on a white wall turn out to be nooks carved by the artist to hide tools and fragments such as a piece of wood, a ladder, a carpenter's level and a folding table, in a work composed of several interventions collectively titled *Untitled (The Devil in the Shape of a 2 × 4), Untitled (The Devil in the Shape of a Ladder), Untitled (The Devil in Shape of a Table), Untitled (The Devil in the Shape of a Level)* (2012). In all of Sierra's projects there is an element of playfulness that prevents his architectural gestures from appearing pretentious or heavy-handed. The artist's current work continues to delve into his longtime interests: functional archetypes, how to measure the world, how to alter the perception of space as well as modify how we inhabit it.

← *Untitled (The Devil in the Shape of a 2 × 4), Untitled (The Devil in the Shape of a Ladder), Untitled (The Devil in the Shape of a Table), Untitled (The Devil in the Shape of a Level)*, 2012, ladder, wood, folding table, level, MDF, plaster and paint, dimensions variable

↑ *Particular Infinite*, 2009, wood, apple, dimensions variable

→ *Oven to Warm Cats*, 2004, newspaper and wood, 74 × 40 × 60 cm

↓ *Untitled (Marginalia)*, 2011, wood, plaster and paint, dimensions variable

Cluj
by Jane Neal

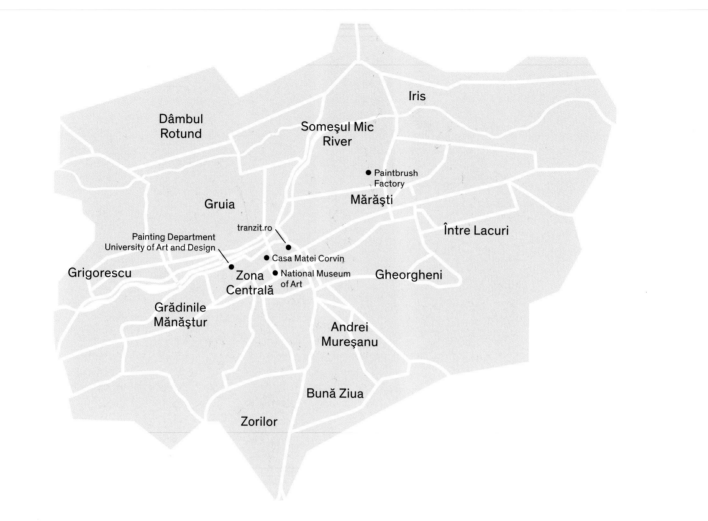

N

Dâmbul
Rotund

Iris

Someşul Mic
River

● Paintbrush
Factory

Gruia

Mărăşti

Între Lacuri

tranzit.ro

Painting Department
University of Art and Design

● Casa Matei Corvin

Grigorescu

● National Museum
of Art

Gheorgheni

Zona
Centrală

Grădinile
Mănăştur

Andrei
Mureşanu

Bună Ziua

Zorilor

0 1 km

● Bazis, Plan B, Sabot Gallery and
 others at the Paintbrush Factory
 59–61 Henri Barbusse

● Casa Matei Corvin
 University of Art and Design
 6 Matei Corvin

● National Museum of Art
 30 Piaţa Unirii

● tranzit.ro
 5 Strada Brassai

● The Painting Department
 University of Art and Design
 Cluj Central Park

Cluj
by Jane Neal

There was a time when, if you had declared Cluj a contender to become an internationally regarded centre for contemporary art, people may have raised an eyebrow. If you had gone on to proclaim that soon many of the city's artists would be described as rising stars of the international art scene in the pages of *Artforum*, *Art Review*, *Flash Art* and *The New York Times*, your enthusiasm may have been considered charming but your vision improbable. Yet Cluj has succeeded in coming to the attention of the art world, and its artists have managed a feat that ten years ago would have seemed like the fulfilment of a dream. Several contributory factors have combined to make the city an ideal breeding ground for avant-garde artistic production that in turn has fostered international success for its artists.

Cluj is not the capital of Romania. This might initially seem a hindrance rather than a positive factor for the city's creatives. Yet for several reasons this fact seems to have worked in its artists' favour. Neither is Cluj a backwater; it is an important centre with a rich and interesting history. Home to Romania's largest university, Babeş-Bolyai, Cluj has a thriving student population of around 49,000, numbering almost a sixth of the 309,000 people who live within the inner city. The proportionately high number of students contributes greatly to the urban vibrancy. Compared to established art capitals such as London, Paris and New York, Cluj is an inexpensive place to live and work, and it offers a good standard of living even for emerging artists.

Historically, Cluj has always been multicultural, challenging and labile. With a diverse population of Hungarians, Saxons and Jews as well as Romanians, it's important to note that ethnic Romanians did not make up the majority in the city until 1966; this should be remembered both in terms of cultural output and in regard to Bucharest's habit of looking down on Cluj and its province, Transylvania, a latecomer to the Romanian project.

As the current generation of Cluj artists were growing up, they knew — even at a subconscious level — that it would be much more difficult for them to achieve national recognition and success than their Bucharest counterparts. They felt they would always battle with the 'provincial' label. They saw the necessity of fostering a thriving community of artists in Cluj, and this was coupled with the understanding that to achieve fame and recognition they would first have to break into the international market and receive validation that Bucharest's art taste-makers could not ignore. These twin goals combined together to provide a fertile environment for artistic exchange and development.

In one sense, this attitude of looking outside for validation is inherent in Transylvanian tradition. Cluj is situated approximately halfway between Bucharest and Budapest, but its ethnically diverse inhabitants have historically looked west (principally to Budapest and to Vienna) for artistic inspiration and recognition. Cluj's café culture also finds its roots in the Austro-Hungarian tradition. This, coupled with its relatively small size (its area is approximately one-fifth that of Bucharest, which has a population of about 1,678,000), means that, once you're in the centre of Cluj, most places are within walking distance. The scale of Cluj lends itself to frequent meetings and communications well served by thriving cafés and bars.

Rather than describing Cluj as home to one homogeneous group of artists, however, it would be more accurate to describe it as host to a number of different circles. Certain artists may be part of several groups or collectives, but often the lines of demarcation are pronounced. Adrian Ghenie comments, 'There's been a fair amount of tension at times between groups, which is natural. We might have different ideas about what constitutes "good" art, which can result in discord or fallings-out, but the one thing we've all come to realize is that we have to create a cultural platform in Cluj; we have to communicate to the world that something interesting is happening here. So we all turn up to each other's openings and initiatives and thereby support each other. The city is too small to excuse someone from simply not showing up.'[1]

Showing up at openings has become a great deal easier since the majority of Cluj's artists, galleries and cultural initiatives came together in one place. The Fabrica de Pensule (Paintbrush Factory) opened in the autumn of 2009, after the building was spotted by Daria D. Pervain, owner of Sabot Gallery, early that year. Together with Mihai Pop, one of the co-founders of Plan B Gallery, and a number of other artists and creatives, the Paintbrush Factory was transformed into a centre for the arts, with artists' studios, workshops and galleries on site, including Plan B, Bazis and Sabot.[2]

As the first successful gallery to foster, sustain and promote Cluj's young artists on the home front, Plan B provided an inspiring model for other Romanian galleries.[3] It opened with a solo exhibition of Victor Man's work in 2005, which marked the first time an American art magazine, *Art in America*, covered a commercial Romanian show. Despite its success, the gallery has lost none of its experimental edge. Alongside his programmed exhibitions, Mihai Pop seeks to provide a kind of laboratory for both his roster of artists and a wider circle that mainly originate from Cluj.

Where Plan B started, others followed.[4] Each of the artist-run galleries housed in the Paintbrush Factory has its own clear-cut profile. Though financial as well as critical success has come young to many of the artists exhibited by Cluj galleries, they share the knowledge that the integrity of both artist and curatorial vision must be maintained. Plan B, Bazis and other galleries and initiatives such as the former Studio Protokoll, Sabot and Peles Empire are all concerned with enabling access to art, preserving records of events through documentation, and in turn enabling a process of education not only in contemporary art but also in cultural theory.[5]

Recognition of the significant role of the 'curator-gallerist' on the national and international stage has made itself manifest in relation to several Cluj galleries and international events.[6] These galleries also use the existing platform of the international art market to create forms of intervention. The activities of Attila Tordai-S have been key in promoting critical approaches to the market.[7] Like the young critic and curator Cosmin Costinaş (who was part of the Documenta 13 team), Tordai-S is a former editor of the influential *IDEA arts + society* magazine, which maintains an important international network and covers the shows of many Cluj artists both at home and abroad.[8]

All these initiatives notwithstanding, at the heart of the success story of the Cluj art scene is a series of friendships forged at the University in the late 1990s. Artist-curator-gallerist Mihai Pop was at the centre of many of these groups. A childhood friend of Man, Pop studied painting along with Serban Savu, Adrian Ghenie, Marius Bercea, Mircea Suciu, Radu Comşa and Oana Farcas. Unusually for the time, because the departments didn't mix, Pop was also very interested in what was happening in sculpture, photography and media. He was innovative in his efforts to bring these different groups together by initiating pop-up exhibitions and projects.

Through Ciprian Mureşan, Pop became friends with Mircea Cantor. One of the first Cluj artists to attract international attention, Cantor's prolific output and impressive list of public exhibition venues and awards belie the fact that he is still only in his thirties.[9] In 2005, critic Christy Lange noted in *Frieze* magazine that his life and work were already the stuff of myth.[10] Cantor does much to profile the work of older artists from Romania on the international art scene. He comments, 'Due to our history, these artists didn't get the chance to benefit from international exposure. They grew like marvellous flowers and gave these flowers to show their colours and fragrances in the global garden. These artists … should be recognized.'

Cantor is married to Gabriela Vanga, one of his art school classmates. With a strong international reputation for her own multimedia practice, Vanga, like Cantor, has been extremely influential in Cluj in terms of initiating avant-garde cultural activity. While students, they launched an artist-run magazine (still extant) together with Ciprian Mureşan and Nicolae Baciu, called *Version*. Though they're proud of their individual artistic practices, Cantor, Vanga and Mureşan prize this long-held initiative. Along with Pop, their influence on Cluj cannot be overstated. Though Paris is now their home, their continued commitment to the Cluj art scene is evident, and they can often be found there,

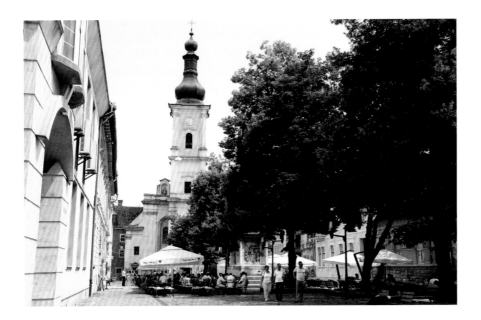

IDEA
artă + societate / arts + society
#29, 2008 20 lei / 11 €, 14 USD

*20% OF REASONS WHY WE DON'T LIKE
80% OF POLITICAL ART*

- *IT'S PREACHING TO THE CONVERTED*
- *IT NEVER REACHES THOSE IN QUESTION
 ANYWAY*
- *IT FORGETS TO BE ARTISTIC*
- *A POLITICAL TOUCH ALWAYS MAKES A GOOD
 COVER-UP FOR OTHER DEFICIENCIES*
- *IT EMPOWERS THE CRITICIZED SUBJECT*
- *IT'S PREDICTABLE*
- *IT'S BORING*
- *IT'S IMPOTENT (IT DOESN'T CHANGE A THING)*

↑ Museum Square

↑ *IDEA arts + society*
 no. 29, 2008

↗ Lia Perjovschi, *Sense*,
 installation at Protokoll
 Studio, 2004

↓ The University of Art and
 Design in Central Park, 2012

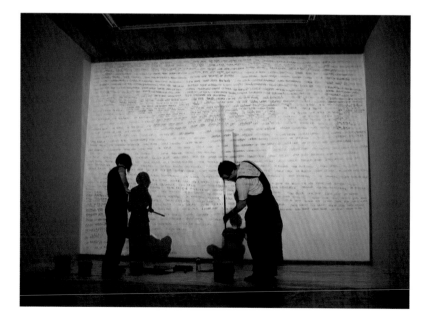

↖ Aerial view of Cluj looking past the modernist Telephone Palace

↑ The Paintbrush Factory

↑ Adrian Ghenie in the studio

← Performance by Ciprian Mureşan and Mădălina Dan at the Paintbrush Factory

with Vanga on Pop's roster of artists and Cantor frequently using Plan B as a kind of workshop for many of his museum projects. Cantor has also curated several significant exhibitions for the gallery.

Ciprian Mureşan continues to live and work in Cluj. Besides his connection to Pop, Cantor and Vanga, Mureşan has collaborated with painter Ghenie in making a film, and has tutored several of Cluj's internationally recognized sculptors and mixed-media artists, such as Cristi Pogăcean and Mihai Iepure. Ghenie, in turn, has mentored the young multimedia artist Mihuţ Boşcu Kafchin, who now shares a gallery with Ghenie's academic colleague Comşa.

While it's beyond doubt that these artists are linked, the question of when artists with common backgrounds and origins can be grouped together and described as a movement is more problematic, particularly when the artists are young and achieving international recognition at varying speeds. The answer may be simply when people from outside start describing it as such. Recent comments on *ARTINFO.com* and in the *Financial Times* have mentioned the 'Cluj School' and the 'Cluj Scene'.[11] Thematically, too, the artists share an interest in historical events from the last century, which they express from a distanced, watchful perspective.

The tension that used to surround the relationship between Cluj's young successful artists and the University of Art and Design is dissipating. When Ghenie and Pop founded Plan B in 2005, they were keen to put distance between themselves and the art school, largely because they felt it was not supportive of their independent initiative. This seems to be changing; several of the artists have returned to their alma mater to teach. Critical pedagogy is vital for helping future generations find their own way. Good teaching can communicate the philosophies and motivations conducive to avant-garde thinking while steering youngsters away from the temptation of stylistic repetition. This in turn will sustain the reputation and infrastructure currently establishing Cluj as an attractive centre for artists and art lovers.

It cannot be ignored that women are less common among those successful artists who continue to live and work in Cluj. However, this reflects the relative scarcity of women in the Cluj visual arts scene at the postgraduate level. An exception is Farcas. Younger than most of her contemporaries by several years, Farcas first showed outside Romania in 2003 at Mestna Galerija in Ljubljana. She continued to spend time abroad until she moved back to Cluj on a permanent basis in late 2010.

Many of Farcas's colleagues have followed a similar path. Almost without exception, the most dynamic Cluj artists spent their formative years there, followed by a period away before returning. The key to the success of this formula would seem to be timing. The painters speak nostalgically of the moment when, from 2004 to 2005, they returned from residencies in Italy, France, Belgium, Austria or Israel. According to Bercea, 'By chance everybody decided to come back. We started to meet often, day and night. It was one of the most beautiful times I had.' Suciu continues, 'The talks were meaningful in shaping what's going on now. Our friendships and discussions improved our art.' Savu comments, 'It was interesting to meet again with my colleagues. I found my way here, digesting all the information I had accumulated in those years away.'

Though it's undoubtedly romantic to suggest that the artists had a sense they were living through a special time, there is perhaps a chemistry that produces a strong and exciting community. The key is there in Savu's words; reconnecting with the group sparked a conflagration of each individual's experience, resulting in a powerful coming-of-age and experience.

Marius Bercea

Marius Bercea's work is the most vibrantly expressionistic of the over-thirty generation of Cluj painters. He is increasingly regarded for his boldly intuitive use of colour, which distinguishes his paintings from the more muted palettes of his peers and reveals his growing appreciation for the avant-garde experiments of Pierre Bonnard and Paul Gauguin. An active member of Cluj's artistic community, Bercea studied and taught at the University of Art and Design and has a studio in the Paintbrush Factory. Along with Vlad Olariu, Mircea Suciu and Serban Savu, he was one of the founding members of the experimental artist-run project Laika (2008–11), which aimed to promote emerging artists and to provide established artists an opportunity to produce work atypical of their practice. Though Laika has ceased, Bercea maintains an avid interest in the artistic development of former painting students such as Robert Fekete and Sergiu Toma, and to champion the young sculptor Vlad Olariu, a Laika colleague.

Bercea came to the attention of the international art scene through his first solo exhibition in the United States, at Los Angeles's François Ghebaly Gallery in 2009. The show was given the wistful title 'Time will Tell' and featured bleached-out dreamlike scenes that deliberately addressed the power of nostalgia – not for communism, in Bercea's case, but for heady childhood summers in the lush Carpathian landscape.

Although Bercea has a deep appreciation of his native landscape, he does not pander to sentimentality; instead, his work evokes a healthy respect for the power of nature. The skies in his paintings are particularly remarkable, even other-worldly, and he often uses them as a metaphor for previous or impending calamity. What he describes as their 'logic' is derived from experience: living in a mountainous landscape and observing a sky in an almost constant state of flux that can heighten or darken at a moment's notice, with potentially dramatic consequences. An example of this is *Casting Nonsense* (2012). Here the oppressive sky is so heavy it seems to be squashing the houses and river beneath it. Sometimes the air that hovers over the landscapes of his paintings takes on a poisonous yellow hue, in reference to the cloud that engulfed Romania after the Chernobyl disaster of 1986.

Bercea's practice has evolved considerably since 2009. The point of departure was his undertaking of a series of 'portraits' of modernist utopian architecture. Captivated by the bizarre nature of many space-age buildings erected across Eastern Europe, the Balkans and South America during the 1960s and 1970s, Bercea has developed a unique way of working that can be described as a kind of reverse archaeology. His often thickly impastoed paint encrusts the pillars of the buildings he depicts, as in *The Copper Bath* (2010). Despite the delightful scene, this treatment serves as a device to alert the viewer to Bercea's conceptual concern over the obtuse nature of the totalitarian ideologies that created his subject matter. He pushes his experimentation further by furiously exploiting geometry in the form of multiple perspectives, as can be seen in *Truths With Multiple Masks* (2011), which pulls the viewer's eye helter-skelter around the painting.

At the crux of Bercea's investigations is the paradox of looking back at the past to see what people believed the future would be. His works are sincere, but he is clearly aware of the irony inherent in futuristic buildings that, forty years on, could not look more archaic. This insight is expressed in the title that the artist used for his first solo exhibition at London's Blain Southern Gallery in 2011: 'Remains of Tomorrow'. Bercea reminds us of the vanity of modernity; the ruins of the 'future' are already relics of the past.

← *The Copper Bath*, 2010, oil on canvas, 150 × 150 cm

↑ *Casting Nonsense*, 2012, oil on canvas, 193 × 150 cm

→ *Eastern Wind*, 2011, oil on canvas, 176 × 180 cm

↓ *A Tree, a Concrete, a Cloud*, 2012, oil on canvas, 27 × 39 cm

Mihuţ Boşcu Kafchin

Mihuţ Boşcu Kafchin is one of the most promising of Cluj's younger generation of artists. Born in Galaţi in the southeast of Romania, he was encouraged by his parents to draw from a young age. He grew up surrounded by artists, and he credits his bohemian childhood with fostering his artistic activities. He has lived and worked in Cluj since graduating from the University of Art and Design (BA 2008, MA 2010). Though enrolled in the department of ceramics and sculpture, he used his student years to experiment intensely with other mediums. Even during his undergraduate years he acquired a reputation as one of Cluj's most innovative artists. He is unfailingly passionate about science, space exploration and science fiction. In this sense it is more appropriate to describe his place of work as a laboratory, bubbling over with new and ongoing experiments, than as a studio. His 2012 assemblage *Idiosyncratic Birds* – a bricolage of different linguistic sequences, comprised of disparate substances including feathers and lighting tripods – attests to his experimental sensibility.

Boşcu Kafchin's first solo exhibition, 'Long Gone Future', curated by Bogdan Iacob, took place at the National Museum of Art in Cluj in 2009. Thereafter invited to show at Laika, the artist created 'How It's Made' in 2010, a site-specific installation in which he re-imagined the space capsule that transported the original Laika, a dog the Russians sent into orbit in 1957. The artist's metal, Plexiglas and white plastic replica of Laika's airtight compartment was so convincing that some people wondered if it might have been a spare capsule from 1957. In 2011 the Cluj gallery Sabot invited Boşcu Kafchin to create a laboratory-like presentation of his practice, resulting in the solo show 'A Prologue to Vanity and Self-Adoration'. Later works, including *Preparatory Study For Self-Sufficient Garden*

(2011), part of a series of nature sketches, continue his scenographic experiments in building worlds by means of the prospective installation. These projects helped facilitate Boşcu Kafchin's international emergence; a studio visit by curator Okwui Enwezor and his team led to participation in the 2012 Paris Triennal.

Boşcu Kafchin has fought to keep his vision unique, but he credits interactions with his fellow artists from the Paintbrush Factory – Adrian Ghenie in particular – as helping his ideas and career progress. He describes it thus: 'The artists in the Paintbrush Factory played engineer with me. I entered the community a damaged cyborg, and they fixed my software. Adrian Ghenie has made a huge contribution to my anti-virus shield and to my laser beam. He is the main witness of my artistic life.'[12] When Ghenie relocated studios, he offered Boşcu Kafchin the use of his vacated space and leftover materials.

Boşcu Kafchin is open to working with whatever he feels is most appropriate to the execution of a particular idea. He draws inspiration from the conflict between what he describes as the polluted but addictive world of contemporary media and his own ideas and revelations. This is evident in the 2011 video *Personal Hawking*, which was exhibited at the Paris Triennial. Here the artist transforms himself into a hybrid creature, alternating between angel and demon, and pontificates (in a synthesized voice) on a 'grand tour' of neutrons, electrons and atoms by way of India and Ancient Greece. Interspersed with handmade versions of iconic scenarios purloined from art history's greats, such as Henry Fuseli, Jan Van Eyck and Jacques Louis David, and accompanied by a barrage of his own special effects, Boşcu Kafchin's strange yet consistently constructed universe leaves the viewer spellbound.

← *Personal Hawking*, 2011, HD video with sound, 7 min.

↑ *Death Intercourse*, 2011, preparatory study for abstract scenery, mixed media on plywood

→ *Preparatory Study for Self-Sufficient Garden*, 2011 bricolage, dimensions variable

↓ *Idiosyncratic Birds*, 2012, bricolage, dimensions variable

Răzvan Botiş

Until recently, mixed-media artist Răzvan Botiş was largely under the radar among Cluj's artists. Though committed to his practice, he is not a careerist, and has said, in an oblique reference to the New Museum's 'Younger than Jesus' show, that he has no plans to become a 'star' by the time he's thirty-three. Instead, Botiş hopes to stay 'open' and 'fresh' as long as he can; he believes fame can rob an artist of these qualities.

That said, his work is starting to attract the interest of international audiences. He was invited to participate in the 2012 group exhibition 'European Travellers: Art from Cluj Today' at Kunsthalle Budapest, and in 2011 he mounted a solo exhibition at Krinzinger Projekte in Vienna, 'Trying to Purchase What I Once Wanted to Forget'. Atypically for a Cluj artist, the work in this show did not refer to the Romanian context. Instead Botiş exhibited works that address the increasing meaninglessness of tradition across global contemporary culture. A good example is *Bushido* (2010), which is comprised of a *katana* sword covered with a necktie. By bringing together these two evocative symbols of masculinity, Botiş negates their significance. Now removed from their original contexts, they are rendered pointless.

Botiş's practice follows in the tradition of his slightly older peers Mircea Cantor and Ciprian Mureşan. His work is often more obviously ironic than Cantor's, and Mureşan's is often more politically minded, though all share a sense of humour. Botiş's own humorous streak is apparent in *Hit the Road Jack* (2010), a walking stick that is a contradiction in terms because it is made of glass. However, the artist has rendered it somewhat functional by filling the hollow interior with Johnnie Walker whisky.

There is a retro-utopian idealism running through Botiş's work that links him to avant-garde artists of the mid-twentieth century. He greatly admires the French Fluxus artist Robert Filliou, whom he calls the 'big/small artist'. Filliou believed that art could be a form of play that did not necessarily have to express itself through the realization of objects. Botiş's form of play is primarily concerned with the journey of an idea. In *One Way* (2011) he created an insert for the Cluj-based cultural magazine *IDEA arts + society*. Each copy of that issue included a replica of a one-way ticket to Novosibirsk in Siberia; all except one, which held the genuine item. The winner could decide whether she wanted to accept the offer of this free one-way trip or keep the ticket as a work of art; the outcome was left open. Botiş therefore transformed the negative perception of a one-way trip to Siberia, long associated with deportation, into a holiday. Moreover, the recipient is invited – not commanded – and is selected by chance.

Botiş likes to change our reading of symbols by playing with our expectations. *King in Exile* (2011) depicts the most unprepossessing crown. Cut crudely from unfired clay and dimpled with fingermarks, it captures the poignant redundancy of a deposed monarch running from his own land. Botiş encapsulates the essence of things but balances it with a poetic sensitivity that critic Oliver Basciano describes as 'beguiling'.[13]

← *Bushido*, 2010, sword,
 tie, 70 × 100 × 10 cm

↑ *King in Exile*, 2011,
 unfired clay, 31 × 26 cm

↓ *Hit the Road Jack*, 2010, whisky,
 glass, rubber, 90 × 15 × 5 cm

→ *Learning to Dwell*, 2011,
 gold necklace, brick, 43 × 11 cm

Adrian Ghenie

Adrian Ghenie's career to date has been stellar. Its trajectory – marked by his emergence on the international art scene in Haunch of Venison's group show 'Cluj Connection' in Zürich in 2006 to his current position as one of the most respected young artists in the world – is perhaps the steepest of all the Cluj artists. Often described as the 'history painter', Ghenie creates powerfully arresting works that demonstrate his fascination with the twentieth century. Many of his most important paintings address humiliation through the depiction of slapstick. In *Nickelodeon* (2008), a row of people have been pelted with custard pies. In paint, this takes on a sinister reading; the protagonists' faces are obliterated or merge with the cream, as if their skin is melting. Ghenie returned to the pie fight theme in 2012, this time focusing on the female subject in works such as *Pie Fight Study*.

Ghenie is wont to explore how the seeds of discovery in the nineteenth century were corrupted in the twentieth. He doesn't judge so much as leave viewers to draw their own conclusions – for example, by placing *Self Portrait as Charles Darwin* (2011) near a portrait of Josef Mengele (*Dr. Josef*, 2011), the German scientist notorious for sadistic eugenic experiments on concentration camp prisoners. Looking at Ghenie's oeuvre, one question seems to underpin his practice: 'How does evil begin?' In this sense he is fundamentally concerned with addressing a universal philosophical problem.

If Ghenie looks back in time for inspiration for his subject matter, his attitude towards painting could not be more avant-garde. He is a champion of the medium, waving away suggestions that painting today is irrelevant. For him, painting is a perpetual Lazarus. Like no other medium, it can draw together different time periods and languages – fiction, reality, figuration, abstraction – into one cohesive space. Ghenie has created a particular technique that involves squeezing and scraping paint to open up the spatial field. This is clearly apparent in the painting *The Devil 3* (2010), in which the whole surface – depicting an atomic bomb explosion and dogs in a desert landscape – is in a state of suspended animation.

Ghenie's modus operandi hovers between fine artist, architect and set designer. He sources images from YouTube, Google, cinema, history and art books, as well as his own archives, imagination and memory; then he creates collages of printed images that he overworks in paint. Sometimes he makes cardboard models to ensure that his paintings are grounded in tangible physicality.

It is obvious from Ghenie's works that he is a planner. This is no less true for his significant role in the development of the Cluj art scene. It was the congenial Ghenie who in 2005 persuaded a local Cluj financier to fund his and Mihai Pop's independent artist-run Plan B Gallery. Ghenie supports many of the artists and creatives in the Paintbrush Factory, and he has consistently pursued a vision for Cluj as both a cultural centre and a destination for the international art market. He continues to take his civic responsibilities seriously. Besides numerous museum shows and a solo exhibition at the Pace Gallery in New York in 2012, Ghenie is now focusing on creating a library and archive in Cluj. He is also a visiting professor in the painting department of the University of Art and Design.

↑ *The Devil 3*, 2010, oil
 on canvas, 200 × 230 cm

← *Self Portrait as Charles
 Darwin*, 2011, oil on
 canvas, 200 × 230 cm

→ *Pie Fight Study*, 2012, oil
 on canvas, 55 × 75 cm

← *Pie Fight Study 2*, 2008,
 oil on canvas, 55 × 59 cm

Victor Man

Victor Man is one of the most enigmatic and widely recognized of all Cluj artists. He came to international attention through the 2005 Prague Biennial and the 2007 Venice Biennale, where he represented Romania. The trajectory of his career mirrors that of Plan B Gallery, which opened in 2005 with an exhibition of his work. Man's success opened the door for his colleagues and brought an outside focus onto the city's art scene. Like other Cluj artists, he uses his position of influence to draw attention to the work of earlier Romanian artists, such as Florin Mitroi and Ștefan Bertalan.

Initially there were aspects of his painting, such as his (then) predominately grey palette, that critics believed were rooted in the artist's personal experience of growing up in communist Romania. Aside from a consistent leaning towards darkness and expressive curiosity, however, no single style defines his practice. Paintings make up the majority of his works, but are interspersed with found objects, photographs and sculptural assemblages. The close tones of his sombre palette are derived from the effects of the Claude glass, a dark mirror used by eighteenth-century landscape painters to transform colour into monochrome.

Although Man is familiar with the tropes of painters past, he is increasingly recognized for creating a new kind of figuration, which negotiates between representation and sign. The result is an elegant but taut interplay between symbols, motifs and alternately stylized and lifelike human forms. He offers the viewer signs and symbols, but his deliberate obfuscation of meaning is disquieting – an effect heightened by his provocative subject matter and challenging juxtaposition.

Man forges an intellectual contrapposto between desire, reason, feeling and narrative, as in the exhibition 'The White Shadow of His Talent' (2012) at Blum and Poe Gallery in Los Angeles. Here he created non-linear scenarios, loosely based on nine fictional texts he commissioned from artists, curators and writers for the book *If Mind Were All There Was* (2011). Two previous exhibitions connected to this body of work, first at London's Hayward Gallery in 2009 and then at Glasgow's Transmission in 2011, were inspired by the subject of Giuseppe Sacchi, an unknown seventeenth-century Italian painter. Though scant evidence remains of Sacchi's life, Man's imagination was captured by the mystery of how the young artist's name came to be graffitied onto the forehead of a horse in Piero della Francesca's fifteenth-century frescoes in the Basilica di San Francesco, Arezzo. Man saw it as a metaphor for issues of ambition and failure, evincing his own preoccupation with the position of the artist as someone paradoxically engaged with and isolated from the world.

More recently, he has become interested in James Joyce's writings, particularly the gender issues surrounding the anti-hero Stephen Dedalus. Man evokes the sense of loneliness and disconnection experienced by this character in the epic painting *Untitled (The Lotus Eaters)* (2009–12). The shadowed or distanced protagonist is a persistent motif in Man's practice. The voyeuristic nature of his work seems born of the dichotomy between wanting to remain the discreet observer and a longing to touch what is in front of him. The tactile pleasure of painting or the feel of soft fur or polished wood is deliciously tangible, but the viewer, like the artist, feels awkward in acknowledging open enjoyment. Man has subtly but adeptly tapped into modern humanity's wanton scopophilia and increasing dislocation from empiricism via the denial of direct sensory experience.

← *Virgacs (St. Nicholas)*, 2011, oil on linen mounted on wood, 33.5 × 46cm, exhibited in 'The White Shadow of His Talent'

↑ *Untitled (portrait of S.D.)*, 2011, oil on canvas, 50 × 40 cm

↗ *Untitled (Shaman II)*, 2008, oil on linen mounted on wood, 45 × 30 cm

↓ *Untitled (The Lotus Eaters)*, 2009–12, oil on canvas, 219 × 320 cm

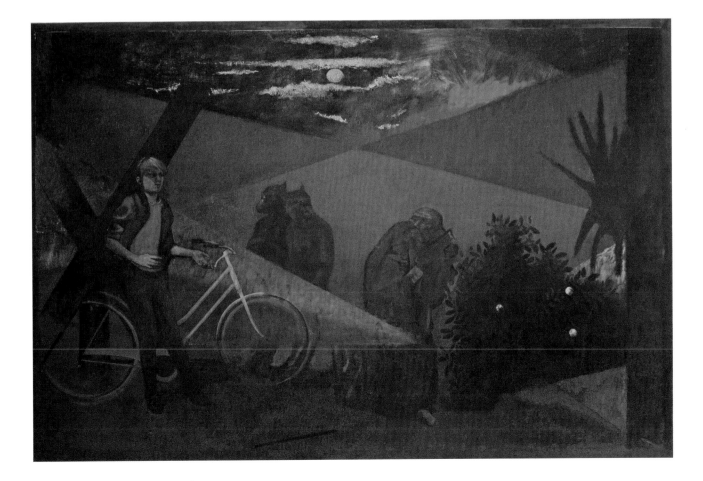

Alex Mirutziu

Alex Mirutziu is Romania's leading young performance artist. His arresting practice hovers at the limits of self-exploration, experimentation and extreme personal discomfort. There is a retro quality to his work; its dark, ironic humour and masochistic edge evokes the oeuvre of Viennese Actionist Arnulf Rainer or seminal performance artist Vito Acconci. What distinguishes Mirutziu is his focus on 'when' rather than 'what'. He is fascinated by the chronicling of time and how it determines the significance of events. This is best expressed in the series *Pending Works*, which Mirutziu originated in 2009. But what must be understood is that each work is as much about its promise as its occurrence. For *Pending Work #4* (2011–12), for example, a block of clay was buried on a mountain in Uetliberg, above Zürich. At the site, Mirutziu recorded data such as radiation and humidity and installed a CCTV camera, which he later controlled from his studio thousands of miles away. In one sense the work could be considered dormant and invisible, but it also functions as a kind of satellite, collecting information about itself and its surroundings, which are then broadcast to the artist. These covert behaviours and distancing tactics call into question whether *Pending Work #4* is a private act or a public work.

The politics of performance has been a constant in his practice. Mirutziu can turn from using explicit homoerotic imagery in a performance context to using video to depict the Srebrenica Genocide (*Moment of Silence*, 2011). His biography states, 'Mirutziu is the only artist to have made a group with a hyper-object (namely with himself at twenty-nine) and exhibit as a collective.' That is, he represents his twenty-nine-year-old self time and again, as if freezing this version of himself, by using photographs and videos shot during his twenty-ninth year. The relationship that forms between the artist in the instantaneous present and the artist at twenty-nine forms a rhetoric, though an unusual one. Unsurprisingly, Miutziu's striking individualism and chameleon-like approach have gained him increasing visibility on the world stage.

Mirutziu was featured in 'Ars Homo Erotica', curated by Pavel Leskowicz at Warsaw's National Museum, in 2010. In 2012 he participated in 'European Travellers: Art From Cluj Today', curated by Judit Angel at Kunsthalle Budapest. One year previous, Rüdiger Schöttle invited Mirutziu to make a solo exhibition comprised of *Pending Works* and the 2011 work entitled *Scotopolitic Object*. The latter features an attractively decorated vase wired up to a speaker and projector. As the viewers are drawn to the object of their gaze, it in turn is affected by their presence; if they touch it they disturb the image projected from its interior and change the amplified sound. It is an acutely observed demonstration of the strained relationship between the love of looking and the obsessive invasion of the object's space.

Mirutziu's insightfulness enables him to take what he needs from a given situation. This in no way detracts from the consistency of his practice; it simply suggests an artist who, independent of his peers, seeks to find ways to work within specific frameworks. During his studies at the University of Art and Design, he was affiliated with the painting department. There he encountered more difficulty than support, but the experience encouraged him to work independently. Though he found his studies frustrating, he remembers productive exchanges with photographer and video artist Grit Hachmeister, and he cites poet Angela Marinescu and filmmaker Lucian Pintilie (known as the creator of 'corrosive cinema') as influences. Mirutziu's difficult, elegant work suggests he has in fact taken a cue from Marinescu, who has said, 'Everything will be poetry if you are good at seeing it.'[14]

← *The Artist and Himself at 29-Note #2 to Pending Work #6*, 2012, house dust, paper box, metal pin, 4 × 4 × 2 cm

← *Scotopolitic Object #1*, 2011, ceramic vase, video camera, projector, microphone and speakers

↗ *Runway Spill #2*, 2011, HD video, 1 min. 31 sec.

↑ *Pending Work #1*, 2011, lambda print on aluminium, 42 × 33 × 2 cm

↓ *Action is Guilt*, 2011, performance

Ciprian Mureşan

Ciprian Mureşan came to international attention in 2006 as part of the seminal group exhibition 'Cluj Connection' at Haunch of Venison in Zürich, and he has since become one of the most widely exhibited of Cluj's artists. In 2011 alone, his works were shown at the San Francisco Museum of Modern Art, Tate Modern in London, the Jewish Museum in Vienna, the Staatliche Kunsthalle in Karlsruhe and Kunsthalle Budapest.

Mureşan makes powerfully insightful works that address and re-contextualize aspects of the wider world's (but mostly Romania's) social and cultural history before and after communism. Its frequently dark subject matter is balanced by a strongly ironic sense of humour and drama. This comes through particularly in his drawings and videos, such as *Dog Luv* (2009), which he first showed in the Romanian Pavilion at the 2009 Venice Biennale. One of Mureşan's favourite practices is to take someone else's ideas and continue them. The most extreme example of this may be *A Closer Look: Deceptions and Discoveries* (2011), for which he used a pencil to hand-copy a monograph on Vermeer – including all the image plates and text – to make a new bound book.

In the case of *Dog Luv*, Mureşan re-interpreted a text by Romanian playwright Saviana Stănescu that explores how human nature can descend into acts of brutality. In Mureşan's version, the cast is comprised of monochromatic canine puppets, which are theatrically lit against a shadowy stage. The cosy title and animal puppetry disarm viewers, only to discomfort them as the dark tale unfolds.

Mureşan again collaborated with theatre director and puppeteer Gianina Cărbunariu for the 2011 video *I'm Protesting Against Myself*, which raises the uncomfortable question of the value of an ordinary life when social and economic stability break down. It is not uncommon for Mureşan to extend his collaborations to friends and relatives. His son, Vlad, and Cluj gallerist Mihai Pop are his most frequent protagonists. Vlad is featured in the 2006 video *Choose*. Here Pepsi and Coca-Cola are mixed together in a glass; no longer distinguishable, the warring brands' battle for supremacy is rendered nonsense by a child.

Mureşan is shy and self-effacing, but his friends regard him as a stalwart of the Cluj scene. He is perhaps the most avant-garde of his peers. From his time in the sculpture department of the University of Art and Design until now, Mureşan has been a pioneer of innovative artistic production. In 2000, he started the group 'Super Us' (named after a 1996 work by Maurizio Cattelan) with Mircea Cantor, Gabriela Vanga and Nicolae Baciu. The group later changed its name to 'Version'. Through its series of eponymous publications, *Version* functioned as an experimental platform for creative and scientific initiative: raising awareness, showcasing talent and stimulating dialogue. Two years later, Mureşan founded the group 'Supernova' with Cristi Pogăcean and István Laszlo. Its mission was to step away from the divisive pronouncements of the post-Wall generation and to engage with the world through personal experience and conceptual accident. Mureşan cites the tradition of avant-garde art groups including subREAL, Cutter and Rostopasca as inspiration.

Mureşan's activities drew him to the attention of Attila Tordai-S, the founder of Studio Protokoll and an editor of the internationally respected Cluj-based art and philosophy magazine *IDEA arts + society*. Having collaborated with both Protokoll and Plan B galleries, Mureşan was invited to join *IDEA*'s editorial board in 2005 and continues to contribute to the magazine despite his increasing presence in the international arena.

← *Our Playground*, 2011, 5 garbage bins, metal tracks, engine, dimensions variable

↗ *A Closer Look: Deceptions & Discoveries*, 2011, pencil on paper in bound book, 21 × 15 cm

↑ *Choose*, 2005, video, 1 min.

↓ *Dog Luv*, 2009, 30 min. 56 sec.

Serban Savu

Serban Savu's meticulously rendered paintings of contemporary Romanians at work or at leisure are disarmingly poetic. Their subject matter has invited comparisons with Edward Hopper, and, like Hopper's scenes, Savu's realist depictions of his countrymen in urban and rural landscapes evoke the essence of a rapidly changing society. Unlike Hopper's work, the paintings Savu has been producing since 2005 were born out of a conceptual focus on the ongoing legacy of one of the most destructive episodes in Eastern European social history: the Stalinist social experiment in Romania in the 1950s known as the creation of the 'New Man'. This project saw huge numbers of the predominantly rural population forced to move en masse into concrete blocks that had been erected in the cities' peripheries, thereby destroying centuries-old communities and traditions.

The catalyst for this new direction in Savu's work was his 2004 return from a two-year scholarship in Venice. He describes how leaving his familiar world and returning with fresh eyes enabled him to grasp the scope of this experiment. The first result of this epiphany was *Labour Protection* (2005), which depicts a lone worker wearing protective headphones that not only isolate him from noise but also separate him from the Poussin-like sky. This poignant painting marked Savu's debut onto the international scene; it was the first of his works to be exhibited by Plan B Gallery at the 2006 Vienna Fair. Since then, the quietly contemplative Savu has gone on to become one of the most internationally respected of Cluj's painters. A crucial figure in the local scene, he is much loved by his peers and the younger generation alike, and his studio in the Paintbrush Factory is often the destination of choice for coffee and conversation. Savu was one of the first artists

to be promoted by Plan B and, like Bercea, he was a founding member of the former experimental art space Laika.

Savu's protagonists are often solitary figures taking a moment to gaze at the horizon from their apartment or, as in *The Lazy Fisherman* (2010) to nap on a riverbank under the dappled shade of a tree. The wistful longing for Arcadia contrasts sharply with the realities of urban living. It's possible to read Savu's rural depictions as recurrent leitmotifs – with nature the benign and redeeming force – or to interpret them as dreams in which his subjects are not actually present but rather where they wish to be.

Though Savu is tender towards his protagonists, he shuns sentimentality; his paintings reveal him as a pragmatist who believes in man's ability to survive and find pleasure amidst challenging circumstances, as can be seen in *The Bathers* (2010). Like Seurat, whose 1884 painting of the same title depicts a timeless pleasure while simultaneously acknowledging the growing industrialization of Europe (see the smoke from the factory chimneys in the background), or harking even further back to the Brueghels, Savu is captivated by the everyday occurrences of ordinary life. He typically divides his practice between two scales: very small windows into everyday life and long-held traditions, such as the religious procession depicted in the delicately atmospheric landscape of *Procession* (2011), and large-scale genre paintings that usually feature tiny figures in panoramic space, as in *Blocks and Gardens*, 2012. Like Brueghel the Elder, whose use of peasant life as subject matter was radical for its time, Savu flies in the face of the global obsession with celebrity, preferring instead to emphasize the humanity of his ordinary subjects, and their needs, without turning them into heroes.

Delhi
by Geeta Kapur

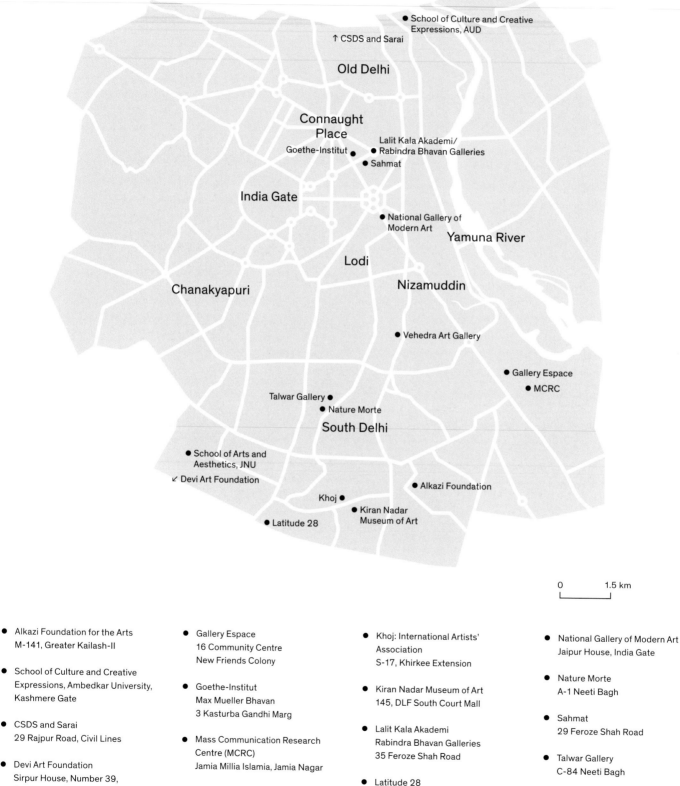

N

School of Culture and Creative
Expressions, AUD

↑ CSDS and Sarai

Old Delhi

Connaught
Place

Lalit Kala Akademi/
Goethe-Institut ● ● Rabindra Bhavan Galleries

● Sahmat

India Gate

● National Gallery of
Modern Art

Yamuna River

Lodi

Chanakyapuri

Nizamuddin

● Vehedra Art Gallery

● Gallery Espace

● MCRC

Talwar Gallery ●

● Nature Morte

South Delhi

● School of Arts and
Aesthetics, JNU

↙ Devi Art Foundation

● Alkazi Foundation

Khoj ●

● Kiran Nadar
Museum of Art

● Latitude 28

0 1.5 km

● Alkazi Foundation for the Arts
 M-141, Greater Kailash-II

● School of Culture and Creative
 Expressions, Ambedkar University,
 Kashmere Gate

● CSDS and Sarai
 29 Rajpur Road, Civil Lines

● Devi Art Foundation
 Sirpur House, Number 39,
 Sector 44, Gurgaon

● Gallery Espace
 16 Community Centre
 New Friends Colony

● Goethe-Institut
 Max Mueller Bhavan
 3 Kasturba Gandhi Marg

● Mass Communication Research
 Centre (MCRC)
 Jamia Millia Islamia, Jamia Nagar

● School of Arts and Aesthetics
 Jawaharlal Nehru University (JNU)
 New Mehrauli Road

● Khoj: International Artists'
 Association
 S-17, Khirkee Extension

● Kiran Nadar Museum of Art
 145, DLF South Court Mall

● Lalit Kala Akademi
 Rabindra Bhavan Galleries
 35 Feroze Shah Road

● Latitude 28
 F 208 Ground Floor, Lado Sarai

● National Gallery of Modern Art
 Jaipur House, India Gate

● Nature Morte
 A-1 Neeti Bagh

● Sahmat
 29 Feroze Shah Road

● Talwar Gallery
 C-84 Neeti Bagh

● Vadehra Art Gallery
 D-53 Defence Colony

◧ Delhi
by Geeta Kapur

Developed within post-coloniality, the avant-garde apprehends the politics of new national formations, mass migration and diaspora. This radically re-oriented geography offers new site imaginaries in hitherto marginalized countries, regions and cities. No longer determined by historical convergence, the avant-garde today navigates historical fault lines and lost trails of cultural articulation, transposing notions of promise and contestation within the contemporary.

Delhi has not undergone the historical process of industrialization that makes Mumbai India's prime metropolis; but it has cultivated centuries of imperial cosmopolitanism.[1] In August 1947, Delhi became the capital of independent India. At the culmination of the struggle for freedom, the city was engulfed by the trauma of partition, which drove Hindu, Muslim and Sikh populations across the new border of India and Pakistan.[2] In the aftermath of this violence, Delhi was homeland to refugees and the seat of a new republic. Here, the nation's democratic concerns unfolded according to Prime Minister Jawaharlal Nehru's modernizing ethics.

If we begin by considering the pedagogical field, it becomes clear how Delhi can claim, besides state platforms, a public sphere for the critically engaged discourse needed to sustain an avant-garde. The liberalism of Delhi University (founded in 1922) is matched by Jamia Millia Islamia's mandate to provide Muslim youth with progressive education. The left-wing Jawaharlal Nehru University (JNU, inaugurated in the late 1960s) is now complemented by Ambedkar University Delhi (AUD, established in 2007). Named for Dr. B. R. Ambedkar, Dalit jurist and author of the Indian Constitution, AUD provides institutional backing for subaltern radicalism in the city's intellectual life.

The state supports advanced research in humanities and social sciences; the Nehru Memorial Museum and Library (initiated in 1964) privileges a developmental history of modern India while the Centre for the Study of Developing Societies (CSDS, founded in 1963) examines issues of nation and state, and the success and failure of Indian modernity. CSDS's new urban research centre, Sarai (founded in 2001), approaches Delhi in an openly anti-statist mode.

In its first decade of independence, Delhi gained an institutional infrastructure to conduct cultural modernization with progressive and secular commitments. In 1954, the National Gallery of Modern Art (NGMA) was established; it now houses a substantial collection of twentieth-century Indian art. The National Academies of Art (also founded in 1954)[3] undertake exhibitions and publications, and provide community studios in Delhi and other cities. The National Museum (founded in 1949) has large holdings of Indian classical and medieval art; the modest Crafts Museum (founded in 1956) is a repository of India's folk and tribal arts.[4] Delhi manages with two minor art schools but has an important School for Planning and Architecture (reconstituted in 1959) and a range of mid-twentieth-century modernist buildings broadly related to Corbusier's.

Delhi's National School of Drama (initiated in 1959) is one of India's foremost institutions for avant-garde practice; its national outreach and international theatre festival are unrivalled. The Mass Communication Research Centre (MCRC, established in 1982) based at Jamia Millia Islamia produces some of India's best documentary filmmakers (including Amar Kanwar and Raqs Media Collective). The School for Arts and Aesthetics (founded in 2001 at JNU) offers postgraduate study in visual culture, performance and film; its larger academic programme makes Delhi India's centre for advanced discourse in art. Delhi's photography scene acquired archival depth through the Alkazi Collection of Photography (ACP, launched in 1995). And two private institutions established by enlightened collectors of modern and contemporary Indian art: the Devi Art Foundation (founded in 2008)[5] and the rapidly growing Kiran Nadar Museum of Art (inaugurated in 2010),[6] have set a new curatorial agenda in the city by consistently producing exhibitions that are both elegant and cutting-edge.[7] While the state-run NGMA continues

to organize important retrospectives; private galleries now support installation, new media and public art projects.

Modernism was addressed in Kolkata and Mumbai during the colonial period; Delhi came into the picture after independence. Artists who animated the scene in the 1950s were modernists, among them Satish Gujral and Ram Kumar; joined in the 1960s by Krishen Khanna, Tyeb Mehta and the matchless Maqbool Fida Husain, who was both vagabond and artist laureate of the Indian state. Delhi's art scene took a combative turn with the entry of J. Swaminathan. Traversing left-wing politics, journalism and art, he co-founded Group 1890, which held its first show in the city in 1963. Swaminathan's anarchist friend Octavio Paz (then Mexico's ambassador to India) wrote the catalogue, and Nehru himself opened the show. With the 1968 inauguration of Triennale-India by leftist writer Mulk Raj Anand (then chair of the Akademi), the Delhi scene, bohemian and statist by turns, acquired international status.[8] By the late 1980s, with India at the threshold of globalization, an art market burgeoned. Today Delhi's art world works through dealers but also through collective, collaborative and radically charged spaces such as Sahmat, Khoj and Sarai.

Formed in 1989, Sahmat (Safdar Hashmi Memorial Trust) is named after a young theatre activist who was killed by political opponents while campaigning for the Communist Party of India (Marxist) at a performance site. Sahmat's first open call, 'Artists Alert', encouraged Indian artists to claim their democratic freedoms within civil society. Following the nationwide campaign it staged in 1991, 'Artists Against Communalism',[9] Sahmat protested the demolition of the sixteenth-century Babri mosque in the following year with several daring projects; and later defied bans by taking exhibitions, music, performance, film and street theatre to mammoth gatherings across the country.[10] After the communal carnage in Gujarat in 2002, Sahmat conducted public enquiries, hosted symposia on education policies and staged concerts and exhibitions on embattled ground. Seeking to secure the rights of minorities within a secular nation-space, Sahmat has organized solidarity campaigns for Salman Rushdie, M. F. Husain[11] and communist theatre director Habib Tanvir. Challenging the government, the parliament and the judiciary on issues of freedom and social dignity, Sahmat has given the artistic community a rhetorical form of address and a place in public culture from which to critique and reshape the national imaginary.

Khoj: International Artists' Association opens up transcultural spaces largely through workshops, residencies and other interactive and virtual modes of practice.[12] Initiated by artists in 1997, Khoj is now more institutionalized, with a director (Pooja Sood), a board of advisors and a hands-on crew. It acquired permanent studio space in 2002 through the Triangle Arts Trust, which also arranges international residencies for artists visiting from Africa and South Asia. Khoj has developed parallel artist initiatives in Pakistan (Vasl), Sri Lanka (Teertha), Bangladesh (Britto) and Nepal (Sutra); and partially supports autonomous, project-based nodes across India including Khoj Calcutta, Desire Machine at Khoj Guwahati, Khoj Kasheer in Srinagar, 1 Shanthi Road in Bangalore and CAMP Mumbai.

Khoj offers a staggering roster of activities. It has initiated digital networks, communication hubs, sonic experiments, as well as dialogues between art and science, old and new technology, design and fashion, architecture and ecology. Among its most remarkable achievements is the international festival *Performance: Khoj Live 08*, in which, for example, Steven Cohen's political grotesqueries confronted Delhi audiences with the crueller aspect of avant-garde art.[13] Khoj is committed to supporting public art initiatives that address Delhi's environment, habitation and community, often through the middle- and working-class neighbourhood of Khirkee 'Village', where it is located. Having completed a major infrastructural expansion in 2013, Khoj plans to further diversify its agenda, complicating alternative practice through curatorial and discursive interactions.

Sarai (a temporary resting place for caravans), co-founded by Raqs Media Collective and housed at CSDS, is committed to urban studies with a special emphasis on Delhi.

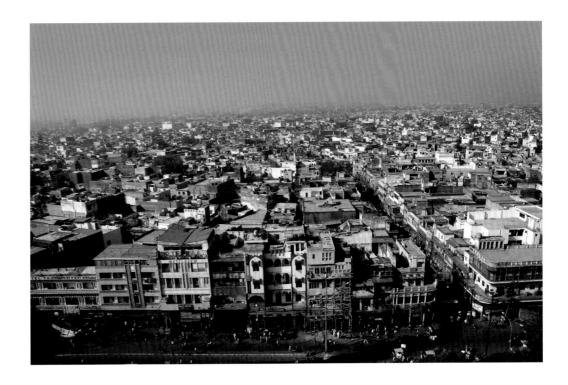

↑ from Gigi Scaria, *Absence of
An Architect*, 2007, digital
photograph of Delhi

↑ The National Gallery of
Modern Art (NGMA), New Delhi

→ Cybermohalla Ensemble
discussing its Bureau of
Contemporary Jobs during
'Sarai Reader 09: The Exhibition'
at Devi Art Foundation,
Gurgaon, 2012

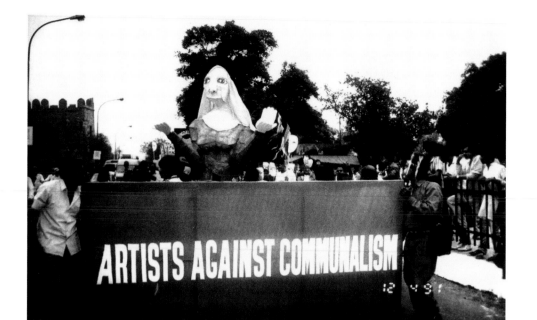

← The Sahmat campaign
'Artists Against Communalism',
Delhi, 12 April 1991

↙ Sahmat artists protesting right-
wing attacks on the School of
Fine Art in Baroda, Delhi,
14 May 2007

↓ Swiss Ensemble Da Motus
performs in Delhi for *Khoj Live 08*

↓ Subodh Gupta, *The Spirit
Eaters*, choreographed
performance for *Khoj Live 12*

The Sarai Media Lab engages cultural practice and thematizes globally networked ideas in the annual *Sarai Reader*. One of Sarai's best sustained projects, Cybermohalla (cyberneighbourhood, active since 2001) involves a system of media laboratories operated by proletarian 'urbanists' living in resettlement colonies, who together devise means of self-inscription within the city. For example, Cybermohalla's study group read together, in translation, *The Nights of Labour* by Jacques Ranciere (who also met them while in Delhi) and later contributed to a Raqs video-script that referenced the philosopher's text. In 2010 Sarai Media Lab's 'City as Studio' project granted year-long fellowships to young artist-researchers and invited them to use old, new and social media to navigate the layered city of Delhi, rethinking categories like 'studio', 'collaboration', 'context' and 'exhibition'. This investigation carried over in the curatorial project 'Sarai Reader 09: The Exhibition' (2012–13) held at Devi Art Foundation, Gurgaon. Over nine months, more than a hundred practitioners worked at the site, drawing, installing structures and staging talks, performance and music. Delhi's performer-activists, including Inder Salim, featured; as did architect and theorist Nikolaus Hirsch and veteran poet Anne Waldman. The Sarai-Raqs rhetoric of indeterminate templates and structured hospitality transformed Devi's quasi-museum space into a meeting place for mavericks at large.

With the city as context, I discuss in the following pages non-narrative documentary videos by artists Amar Kanwar and Raqs Media Collective. I examine, in particular, their contradictory takes on time and history. I consider Dayanita Singh's shift from an aesthetic of affect to metaphorical voids and empty tropes; and Gigi Scaria's stacked, multimedia images of the urban that figure the foreshortened history and flattened worldview of the global city. I look at erotics as articulated by Anita Dube's reflexive text/image performances, and Mithu Sen's visceral drawings and exhibitionist bricolage that tease out the black woman's double marginality. I speak about Sonia Khurana, who transposes resistance, refusal and agency in her performative stance; and about Inder Salim, who positions the body as a site of vulnerability within the social.

There are others, like Atul Bhalla and Sheba Chhachhi, who I would have liked to introduce for their nuanced involvement with the city's ecology; or Ranbir Kaleka, who 'decodes' digital imagery to render new urban mythologies. As an indication of the diversity of contemporary practice in Delhi, I will conclude here with the provocative pairing of Vivan Sundaram and Subodh Gupta. An activist art student in Europe during 1968, Sundaram is arguably the longest-standing contributor to avant-garde art in India, interpolating anarchism within classical Marxism; individual agency within collectivist utopias. In contrast, Gupta audaciously works with popular prejudices of identity politics. Through a spectacular use of material and scale, he allegorizes his own artistic journey from small town India to the ranks of the global contemporary.

Far from being a consensual, conservative city of a nationally constituted middle class, Delhi is a fraught place. While accommodating provincial parliamentarians, diplomats, middle-class bureaucrats and many millions of others seeking a future, the capital has remained a migrant's city where a majority of the poor live in unauthorized settlements, and there are a hundred thousand homeless. The poor population is permanently under threat of eviction due to the elite's paranoia of crime and pollution issuing from the slums. In Delhi, citizens in close proximity to the government (thus highly conscious of the terms of governance) actually live in extemporized conditions. Artists in Delhi, too, have migrated from all parts of the country and are beginning to recognize the means and relations of art production, and to engage in a discourse on ecology and ideology in relation to culture. A growing number explore the underbelly of this *new* New Delhi in order to comprehend the conjunctural nature of the contemporary and make radical use of the platforms and organizations described above. A Delhi avant-garde may see itself developing art practice across sites of informal labour and sites of statist anxiety – and perhaps subverting the high protocol of India's capital city.

Anita Dube

Anita Dube adheres to a radical position within a particular twentieth-century legacy derived from Andre Breton and Georges Bataille: the artist must 'work' the unconscious to destabilize reason. She sees the coupling of the erotic with the death instinct as foundational to aesthetics, and an awakening of these drives as the necessary condition for a practice that is based on a frisson between word and image.

In 1997, Dube crafted a trousseau of macabre beauty to mark the closure of a trauma following the suicide of her revolutionary friend.[14] A surgeon's daughter, she collected human bones, then cleaned and covered them with red velvet trimmed with beads and lace to create a suite of 'counter-fetishes', entitled Silence (Blood Wedding) (1997) after Federico Garciá Lorca's drama of love and fraternal violence. As a discursive bookend to that early display of vulnerability, she presented the performance Keywords (Meat) in 2005, for which she carved text from slabs of raw meat for a period of several hours. Her lexicon of radical thought – ethics, avant-garde, sexual love, permanent revolution – references Raymond Williams's Marxist 'textbook' (Keywords: A Vocabulary of Culture and Society, 1985) while evoking a visceral sublime in flesh and blood. Staging the didactic event in laboratory-like conditions circumvented the sacrificial aspect of ritual, yet messed with abject matter according to the principles of informe in keeping with a surrealist legacy of restorative gestures.[15]

Much of Dube's work involves textual inscriptions into a symbolic realm, where actual writing (as opposed to speech) becomes a form of écriture in which an interjected word disrupts the circulation of simulacra. For example, Dube traces on the wall the words of Goya's title, The Sleep of Reason Produces Monsters, by encrusting the forms of the letters with miniature metal and enamel eyes – 'prostheses' crafted in India for idols who supposedly require this gift (chaksudaan) from humans to gain divine consciousness! For Intimations of Mortality (1997), she clustered these eyes into a beehive in the upper corner of a room to create a vaginal form alluding to the erotics of sight;[16] later stringing them against the wall in a meditational Yantra for Neti Neti (Not this, Not This Either) (2009) or letting them slip into the seam where two walls meet for Ache (2012). This play on eyes also recurred in her performance A Touch of Moon (2012), where, fitted with a pair of silver eyes (glinting contact lenses), she walked the streets as a hermaphroditic dandy, her silver begging bowl refracting invisible moonbeams in an act (and an offer) of shared madness.

Dube began her career as a critic-comrade and returned to the scene as a self-taught artist. She understands the risks of demagogy and coercion in radical collectives and has become, instead, a mentor for experimental initiatives within free-form institutions like Khoj. Even as it is now difficult to demonstrate a politics of praxis through the work of art, Dube, an artist and writer favouring dual gender, offers her loyalty to radical causes and envisions subjective and social renewal under the ever-enticing sign of liberation.

← Keywords (Meat), 2005, performance with wooden stools, jute sacks, ice, gauze bandages, slabs of beef, surgical scalpel, bowl of rose water, blank canvas pinned to the wall, red and blank ink, paintbrushes

↑ Silence (Blood Wedding), 1997 a set of human bones covered in red velvet, beads, lace, semi-precious stones, glass and thread

↗ Intimations of Mortality, 1997, votive enameled eyes on copper base in different sizes, blue tack putty, 60 × 75 × 35 cm

→ A Touch of Moon, 2012, performance along a 1 km stretch of highway in Gurgaon, with mirrored contact lenses and chrome begging bowl

Inder Salim

With over fifteen years of his performance-presence in Delhi, Inder Salim has produced two distinct profiles: one singularly eccentric, the other convivial and open to forms of collectivity. As an individual performer in public sites, he offers simple gestures with political overtones. When he performs in solidarity against institutions of power, his demonstration bears the hope that dissident positions, inscribed in history, will rework societal norms.

Because so much of Inder Salim's address is intended for the Indian State and its claim of democracy, there is no better place for his performances than Delhi. His interventions take place in art galleries, museums and experimental platforms (such as Khoj, Sahmat and Sarai, among others); in Delhi's public forums, its streets and the polluted Yamuna River; and on the Indian highways radiating to and from the city where his *Caravan* project (2010) rolled out a changing ensemble of (international) performers.

His name is itself intended to provoke and reconcile: he changed it from Inder Tikku, a recognized Kashmiri Hindu name, to Inder Salim, a mixed Hindu-Muslim name. Kashmir is a tragic outpost of the Indian Partition of 1947; the then-newly independent nations of India and Pakistan, unable to resolve their strategic territorial claims, have repeatedly resorted to aggression, deploying armed forces or militants. A decimated Kashmir barely sustains its civil society today, and its two religious communities have borne decades of violence, torture, exile, disappearance and death. The ingestion of this cruel condition is key to Salim's performance practice. For example, in *I Protest* (2010), the artist joined a Kashmiri citizens' protest on a public site a few kilometres from the seat of the Indian Republic and the Parliament. While raising slogans demanding 'freedom', he gestured as if to throw a stone (a scrunched-up protest leaflet) in the manner of Kashmiri youth, who, for all their rage, sometimes meet their deaths in the mere act of stone-throwing. The artist's indictment of a grossly unequal battle (where civilians, seen as militants, are randomly targeted by Indian armed forces with shoot-on-sight orders) was repeated at a high-profile meeting between Kashmiri dissidents and Delhi intellectuals, where it produced an electric effect. The entire audience stood up and spontaneously enacted his gesture, mocking and defying the role of the Indian State in suppressing, in the name of militancy, the democratic aspirations of the Kashmiri people.

Assuming a character allegorizing the injury that his enchanted valley suffers, Inder Salim persistently performs in the nude, valorizes narcissistic and sometimes masochistic acts, yet maintains a restraint that his politics teach him. He often plays the fool – inspired by literature (Sanskrit, Shakespeare) and the mystic Sufi tradition from the northern reaches of the subcontinent (crowned by Kashmir). He is Majnun, the maddened lover of Arab-Persian lore; he is the archetypal martyr of valorous communities; he is the man who will protect fish and fowl and children, even as he identifies with street rebels and men on death row. Transforming the mystic into a subaltern figure, he dares authority and, after Brecht, signals the folly of power: the petit-bourgeois bureaucrat, the police officer and the politician 'manning' the state.

Despite his tender affinities, Inder Salim's performance rituals are no outcome of neo-liberal sentiment, nor of its relational aesthetics. He determinedly inhabits the space of real politics that holds participant-interlocutors committed to declared concerns and confrontations.

← *Basant*, 2012, performance
for *Khoj Live 12* on theatre
censorship from the colonial
period to the present

↑ *My River in Delhi*, 2007,
performance for which the artist
fed a bit of his finger to the dying
fish of the polluted Yamuna River

→ *I Protest*, 2010, performance at
Jantar Mantar, Delhi in solidarity
with Kashimri youth

Amar Kanwar

A substantial part of Amar Kanwar's cinematic practice addresses the Indian nation and the partition trauma suffered by India (and Pakistan) since independence in 1947. This requires him to unravel the evidentiary core of the documentary form, touch the wound, develop an ethics of representation and handle a (flawed) symbolic order. He raises the stakes on the documentary's forsworn concern with trace and mimesis, and puts in place a hermeneutic: of remembering, annotating and interpreting the historical in clearly contestable terms.

In his first major work, *A Season Outside* (2000), mythology becomes a resource of the imaginary, and the figure of Gandhi an icon of redemption within the historical. In *The Lightning Testimonies* (2007), he presents India's independence through an archive of chronicles relentlessly exposing public violence against women. The cumulative pressure of moving images in the eight-channel video installation blasts open a passage of pain and produces a cathartic denouement of social memory for the viewer.

In *A Night of Prophesy* (2002), poetry imbues documentary with rhetorical cadence. The people, their region, language, community and everyday struggles occupy a space between memory and utopia; the future, contiguous with historical time, takes the form of prophesy. The pace of the image changes according to the cultural characteristics of the poets – folk bards, rural pedagogues, insurgents, urban middle-class intelligentsia, Dalits – with different traditions of performance. And though the poet may be interpellated into the hypothesized nation-space, Kanwar foregrounds forms of transgression in the act of enunciation.

Through sustained intervention, he investigates the increasing collusion of Indian and global capital, the ravaging of land resources and the virtual suspension of democratic rights for rural and tribal communities. Identifying with struggles within civil society, he focuses on forms of praxis in peoples' movements. *The Sovereign Forest* (2011–12) is a project that maps the terrain of Orissa by revealing, cinematically, the enchanted body of nature (a film provocatively titled *The Scene of Crime*); its cultivated bounty (an installation with hundreds of rice samples from the region); and handcrafted books where the viewer turns the page and 'reads' the illuminated images together with a text. One book chronicles the martyrdom of a legendary labour leader; others bespeak land-related fictions and the poetry of betrayed survivors.[17]

For many years Kanwar has engaged with Burma, its relentless dictatorships and the little-known resistance by its citizens and exiles living across the world. In *The Torn First Pages* (2004–08), he finds an exhibition strategy for image fragments (a photomontage of a schoolgirl shot in the street, a split-screen mirroring of a tender-faced martyr, the revved-up action of the dictator as farce). Sheets of paper mounted on steel grids serve as screens with back projection, and the delicate nine-channel film installation becomes a flickering shadow play that reflects the fugitive lives of the Burmese, redeemed at last, and so recently, by the possible restoration of democracy under opposition leader Aung San Suu Kyi.

In Fredric Jameson's definition, utopia is not an impossibly deferred promise but a response to the demands of concrete historical circumstance;[18] Kanwar's exemplary practice attempts to open the blockages of history and locate human struggles. He navigates ethical regimes of the documentary, the phenomenology of the museum space and the experimental format of video installations; and he reorients the dialogue between poetics and politics, going beyond the profligacy of the mediatic image – towards *praxis*.

← *The Sovereign Forest*, 2012, mixed-media installation with films, books and seeds, variable dimensions

↑ *The Sovereign Forest*, 2008, 4 digital colour videos with sound, 150 colour photographs, 49 light boxes, text and text banner

→ *A Night of Prophecy*, 2002, digital video with colour and sound, 77 min.

Sonia Khurana

Trained as a painter in Delhi, Sonia Khurana became a lens-based performance artist during her studies at the Royal College of Art in London. From the start, she gauged proximity and distance in relation to her differently shaped body, acted out to startling effect in her earliest video/performance *Bird* (1999). She has now devised a form of performed passivity – a condition of Narcissus as well as a state of abjection and even a certain sense of baseness (in theory, poetics, performance) – wherein her body is heaped in beggarly sleep. She calls this project *Lying Down on the Ground* (2000–present), an act she continues in *Logic of Birds* (2006) and *Somnambulist's Song* (2008–present). Her choice of the horizontal axis rebuffs, in feminist terms, the verticality of the male totem. For the video loop *Head-Hand* (2004) she replaces the conventional model-muse (who sleeps to arouse the male artist's desire) and caresses the sleeping head of a black male, reversing normative erotics.

In a succession of photo-video works, Khurana stamps the earth with her footprints (*The World*, 2002; *Flower Carrier*, 2000–06; *Tramping*, 2006–11) then rests her corporeal bulk and the substantive shadow of her prone form upon the earth. The space itself is made liminal; it becomes conducive to recording closely calibrated states of singularity, autonomy, dereliction and dissidence.[19]

Khurana pursues the tropes of the flâneur and the tramp inherited from the modernist pantheon – both figures that have since been killed by consumer capitalism.[20] Her horizontal form interrupts the passage of a new breed of consumer-flâneurs – as well as the trot of business-bodies and even the buzz of fly-by-night artists. Instead, she performs the waiting time of the migrant in the (never-ending) phase of unbelonging.

What form of citizenship is available when the attributes of subjectivity – from abject to sanguine to grave – are framed by the *unhomely*? Her lying down tactic seems to invite embarrassed or indifferent glances, or sometimes an enquiry by a concerned citizen as to the artist-tramp's means of survival. Occasionally, using the lure of a confessional poem, Khurana invites others to commune and join her in a rudimentary ballet of rolling bodies that leaves behind a primitive drawing made from the chalked contour of one or many such participants. Performing this secular ritual in cities ranging from Barcelona and Paris to Hyderabad, Delhi and Aichi, she asks if the very world that is the cause of her staged abandonment may become a *mise en scène* for sympathetic citizenry tuned in to the call of non-violent resistance.

A flamboyant presence in Delhi art circles, Khurana is an inveterate traveller, participating in exhibitions, residencies and conferences across the world. Her preference for a poverty of means – she carries casual baggage, uses simple skills, has little to sell – facilitates the play of a self-invented category as an artist-refugee on the 'dole' in relation to 'art as institution'. Her work enacts refusal – of curatorial conditionalities imposed by exhibition circuits as well as flag-bearing activism in a standardized public sphere – but while this is her way of fighting demands for adherence, she simultaneously adopts obdurate claims on the professional infrastructure of global art. And it is such continuous and contrarian battles that signal her unique claim on the contemporary.

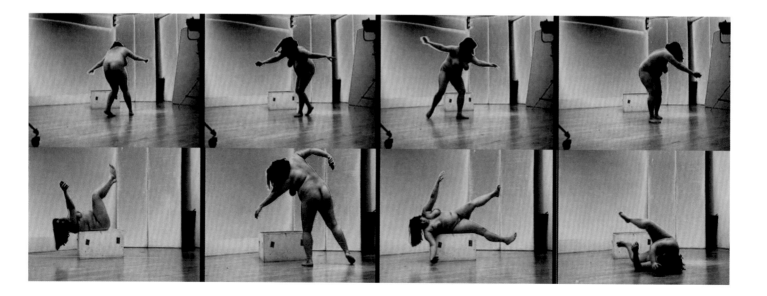

← *Bird*,1999, video documentation of performance, black and white, silent

↑ *Lying Down on the Ground*, 2010, photodocumentation of public participatory performance for the Aichi Triennial, Japan

↑ *Somnabulists III*, 2010, duratrans print on lightbox, part of diptych installation

→ *Tramping II*, 2006–11, series of 12 prints shown as installation, video or storyboard

Raqs Media Collective

Trained as documentary filmmakers in Delhi, Jeebesh Bagchi, Shuddhabrata Sengupta and Monica Narula of Raqs Media Collective devise forms of enunciation in contrapuntal rhythms that confirm their collectivity, navigate today's radically democratized commons and enter multitudinous imaginaries. Their work consists of visual arts practice, theoretical renderings, speech performances, pedagogy and innovative curating. This productivity (labour and play) is to be shared; and if excess is a type of hubris, Raqs flaunt it with the understanding that gifts must survive coercions of capital.

The two-channel video *Capital of Accumulation* (2010), set in Warsaw, Berlin and Mumbai, is a spectral rendezvous with a singular figure who lived and died ahead of her time. The enigma of Rosa Luxemburg – her dark death and the mystery surrounding the remains of her body; her material and metaphoric invocation of organic life to illuminate the paradoxical allegories of accumulation in the age of capital; her refusal of historical determinism (and the disciplinarian aspect of vanguard politics) – lures Raqs into matching utopian immanence with the catastrophic contingency of history. Like many of their works, *Capital of Accumulation* has a forensic drive; the artists enter the unconscious of twentieth-century revolutionary thought to invert and rework it (as in the work's title) into a conceptually pitched anti-narrative.

The Knots That Bind are the Knots That Fray (2010) uses seven small screens to present found footage of a Liverpool ship's journey to the Indian west coast with a cargo of cranes no longer in use in postindustrial Britain. Raqs plot the navigational manoeuvre of the illuminated ship; subliminal imagery offers a poetics of the nautical. The work recuperates the history of trade routes during colonial time and the

accompanying text elaborates what binds and frays the fabric of nations within the regimes of early and late capitalism. Their two-channel video *Strikes at Time* (2011) annotates Rancière's *The Nights of Labour*. From a modest core – the diary excerpts of an Indian labourer[21] – the work ambitiously examines the here and now of industry: the deserts of capital and the globalizing economies of the 'Third World.' A remote view shows a phantom vehicle ferrying raw material and goods, host to the figure of labour – sentient through the long night.

Dealing with time rather than history (too well hierarchized in their view as concept, prognosis, praxis), one of Raqs's metaphors is the twenty-four-hour revolution of the earth that brings up night – their principle motif and *mise en scène* – and a distantly perceived, barely comprehended day. In their rendering of new and old media, Raqs allow real time, slowed time, tangled and lapsed time to overlap; where subject and history intersect, time itself is seen to be out of joint. And if time's apotheosis brought forth the heartbreaking grandeur of modernity, it now lies prone among other disqualified tropes of history, such as the 'new' – once thought to define the contemporary.

While Raqs's persistent textuality, described by the hermeneutic loop, favours semantic subterfuge, anamorphic images and gratuitous puzzles, theirs is a dialogue with/in history; it engages living politics in the public domain. As co-founders of Sarai, Raqs investigate the city of Delhi and the territorial ambitions of the nation-space in activist and contestatory terms; thus, also, constitutional democracy, modernity and the state's pact with global capital. Working in an agonistic style, they ask: What might, after all, be avant-garde for the twenty-first century?

← *The Knots That Bind are the Knots That Fray*, 2010, 7-screen digital film installation

↑ *The Capital of Accumulation*, 2010, 2 synchronized video projections with sound, 2 books in vitrines, 50 min.

→ *Strikes at Time*, 2011, 2 synchronized video projections with sound, 18 min. 32 sec.

→ *Strikes at Time*, 2011 2 synchronized video projections with sound, 18 min. 32 sec.

Gigi Scaria

Gigi Scaria's visual lexicon responds to a relatively new and hectic urbanism in Delhi that provides a context for his participation in collective activities (including debates and public art projects at Khoj and elsewhere) and a point of departure for his global travels.

Rendered as schematic cityscapes, Scaria's paintings seem at first to be structured like ornamental maps of imagined cities. On second glance they appear more like plans by urban designers, gridded in terms of inclusion and exclusion. He also compresses housing complexes into sculptural constructions that stand somewhere between gigantic toys and portable settlements: housing units stacked into the form of a Ferris wheel (*Wheel*, 2009) or a Trojan horse with its hidden cargo (*Someone Left a Horse on the Shore*, 2007). His playful references to urban demographics – constantly compelling citizens to 'move on' – are duly dramatized as these structures are physically transported from the gallery to the riverfront to barren frontiers – much as the illegal occupants of Delhi are shifted around to mitigate the fears of crime and pollution that haunt the city's elite.

His photographs and videos use Delhi skylines – the stacked horizons of a builders' city – for animated fantasies: the symphonic rise and fall of towers in *Panic City* (2006) or their balletic rotation in *Amusement Park* (2009). If Delhi is a developing 'Third-World' metropolis, Scaria, proposing parallels in style and surveillance, sees it in generic terms as a *global city*. His programmatic renderings match postmodern tropes: foreshortened history, flattened worldview, reduced forms of subjective existence and citizenship. Thus, Delhi's aspired-for sameness is inducted into the dystopia of global capitalism.

In his ambitious video work *Elevator from the Subcontinent* (2011), Scaria invites the viewer to penetrate the architectural façade and enter domestic interiors. You press a button to enter an elevator installed on the exhibition floor and go for an illusory ride through a Delhi apartment building. Trapped by a live stream of wraparound imagery, the elevator climbs past two levels of a basement car park, then up along half a dozen middle-class homes to reach the roof terrace, ascending one level more to a cityscape expanding without horizon. A faster descent drops the lift three floors below the car park, past a basement gym to an underground tenement; the journey terminates with a short clamber up to a dark street. The ascent and descent contain the work's revelatory power – the confined space destroys any phenomenological experience of subject-object, instead projecting the viewer into a simulacrum that is claustrophobic and explosive. At the same time, the exhilaration of levitating through a set of illuminated decks becomes a hallucinatory passage to a habitable beyond.

Scaria has made several performative videos cueing talking heads from different political cultures – Trinidad, China, India – to both mimic and subvert present-day 'post-ideology'. His photo and video installation of Mohandas Karamchand Gandhi and Mao Zedong, *No Parallel* (2010), addresses the enigma of public iconography. Internet-sourced photos of these twentieth-century icons are sequenced in tandem; the images, slotted into a grid, open and shut with a patter of clicks in the roll-over video. The two figures are so positioned by the representational protocols of media and state that their image-aura seems to subsume the very people who constitute their awakened nations. On the other hand, the lived politics of Gandhi and Mao transcend such complicity, and each figure provides an affirmative rendering of twentieth-century history. In this double take, Scaria at once questions and radicalizes the place of utopia at the heart of non-western modernity.

← *Elevator From the Subcontinent*, 2011, elevator cabin with 3 backlit projections, automatic door system with microcontroller, 275 × 214 × 244 cm and video, 9 min. 30 sec.

↑ *No Parallel*, 2010, 2 channel video with sound, 6 min.

→ *Amusement Park*, 2009, single channel video with sound, 5 min.

↳ *Someone Left a Horse on the Shore*, 2007, digital print on archival paper, 109 × 164 cm

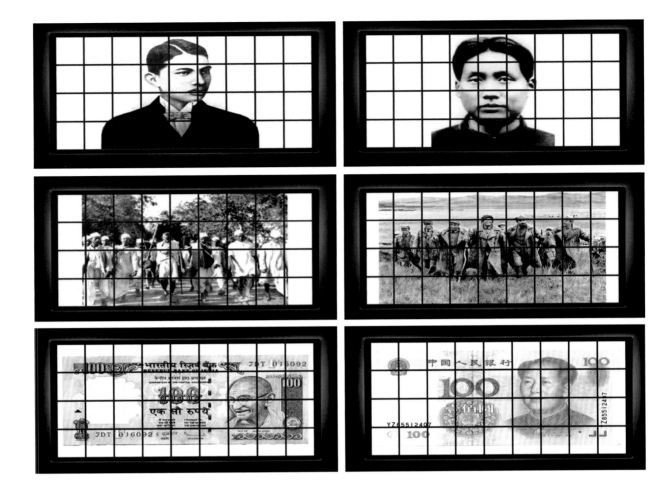

Mithu Sen

Rank exhibitionism characterizes Mithu Sen's work. The surfaces of her drawings and paintings appear as if smeared with spit, semen, piss and menstrual blood. There are secretions, accretions, tumours and abscesses, blooming genitalia, mutilated monsters heaped in gore, and a mix of limbs and organs in morphed combinations.[22]

The category of the erotic involves elaborate psychosexual codes and meanings peculiar to every culture. In the modernist period, female artists (with Louise Bourgeois as high priestess) scaled erotic spaces based on biographical causality. Their handling of object and image reshaped the categories of taboo and fetish, providing fresh understanding of plural, gay and transgender sexualities and redefining pornography. Feminist art imbues female desire with self-reflection, articulates feminist agency in distinct social systems and, more provocatively, turns the symbolic order inside-out.

Sen references castration fantasies and mocks the mythologized phobia of *vagina dentatae* by manufacturing a variety of tooth-studded objects, among them, a wall relief of pink gums arranged in the shape of a spine that curls into a jaw at the tail end, and a pair of simple cloth shoes (*Biting*, 2006). Her images of anal sex and fellatio (from her 2009 exhibition 'Black Candy') are both exuberant and abrasive, just as her female obscenities can be surrogates for human cruelty.[23] Her mimicry of Manga cult-comics – an inscription of the mangled figurines of a seemingly alien erotica – on large free-hanging paper scrolls is cleverly titled *Nothing*

Lost in Translation (made and exhibited in Japan, 2008). The work accentuates her loose-limbed drawings, rendered with penetrative and persistent manoeuvres; her stylus is like the tip of an erect penis worn on the finger, and her precociously perfected *ecriture* a form of surrealist writing.

In Delhi, her home and studio are a mini-museum. Like a kleptomaniac, Sen hoards fetishes, porno trash and other precious artefacts. Her installation *Museum of Unbelongings* (2011) contains hundreds of these erotic toys and midget monsters; its voodoo figurines, skulls and skeletons feature as memento mori. Meticulously arranged in a large circular vitrine ringed with swishy grey curtains, the artist, as ring mistress of the doll circus, is only willing to part with the menagerie in its entirety – as if her already orphaned creatures, dislocated from their magical museum, would perish if separated into twos and fours.

Female eroticism alone cannot constitute an avant-garde. But Sen carries in her genes the bloodthirsty goddess Kali of her cultural motherland, Bengal.[24] She deploys the black mask of her beauty, with its wide grin, to both recuperate the lineage of the grotesque goddesses and to let the contact go viral, infecting the world with a mythologized lust. Through her vagabond residencies (from Brazil and South Africa to Japan), Sen makes an expansive claim on love but also cultivates secret affinities and canny liaisons. Never short of affect, her audacious South-South embrace of the world ups the ante on identity questions.

← *Biting*, 2006, acrylic teeth, dental polymer, cotton shoe, transparent glue, 30 × 25 × 10 cm

↑ *Nothing Lost in Translation*, 2008, drawing with ink, water colour, collage, gold and silver leaf and embedded digital prints on Japanese kozo paper, 5 panels, 400 × 300 cm each, installation view at The National Museum of Modern Art, Tokyo

→ *Museum of Unbelongings*, 2011, found objects collected over 35 years installed in round vitrine, 152 cm × 457 cm diameter

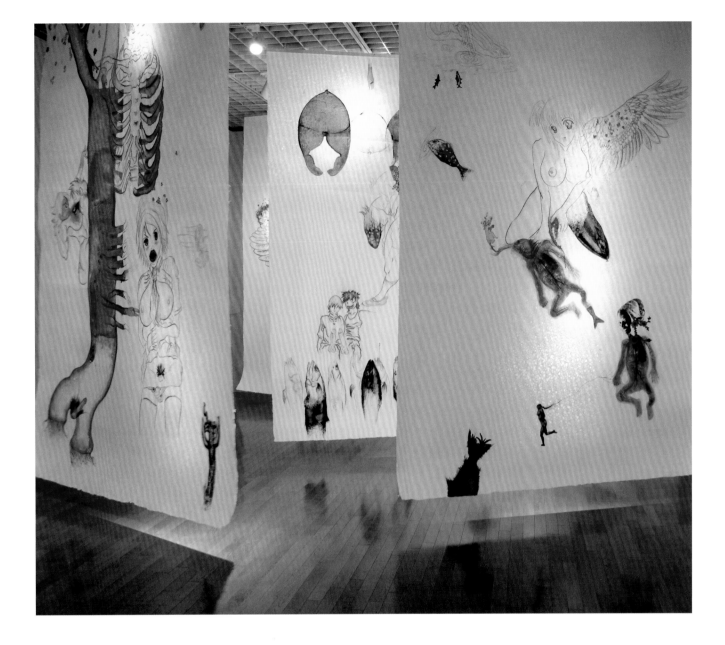

Dayanita Singh

Dayanita Singh cannily converts her privileged upbringing among Delhi's elite into the hubris needed to contest the leading male photographers of India and the world. She has determined her genre, perfected her composition and recorded a fully signified space for the human subject that includes the homeless, the vagrant and the migrant at the fringes of institutionalized local-global contexts. Her work is about a denial of the decisive moment, and about disavowing meaning attributable to the world-as-image. With an editing sensibility that defies representational and narrative pressure, she continues to shoot on film and make prints from thousands of contact sheets

In her recent work, the social field has been pared down. *File Room/File Museum* (2011/2012) is a series of evidentiary photos where a bleak labyrinth of rooms – office, library, archive – spell obsolescence: buried histories, laid-off clerks, a redundancy of data and civic loss. These black-and-white photographs complement her long-explored project on empty spaces, where she affirms formalist repetition and, at the same time, photography's (now discounted) principle of indexicality.

For another recent exhibition and book, *House of Love* (2011), city-nocturnes in fluorescent colours compose image chapters without a story. Because love so persistently eludes, she 'figures' it here liminally, with a sense of dread bordering on the sublime. Any single photograph serves as a lurid sign, stumbled upon in a remote image-space; the house of love is a work of fiction. In this disparate selection, Singh frequently includes images of the Taj Mahal as kitsch, allegorizing love's mausoleum with an irony that resonates with the thematic of image as absence and death.

Persisting with her contrarian position, Singh makes photo books because the book defuses the aura of the image, yet turns it into a handy, graspable object. Besides a recent retrospective volume and other conventional books, she has produced a mock biography (*Myself, Mona Ahmad*, 2001); a modest booklet without text or titles (*Go Away Closer*, 2007); a book of postcards that perversely minimize modernity's great industrial complexes as twilight ruins (*Blue Book*, 2009); and a slim edition of glossy images she also shows as wallpaper (*Dream Villa*, 2010).

The series of images in her set of accordion books, *Sent a Letter* (2007), were drawn from serendipitous photo shoots in proximate and distant worlds. Indifferent to place names, maps and geography, Singh was oddly personal with the dispatch – as if it had to be her hand to paste the pictures, pack the box and send the letter beckoning a singular addressee. In addition to her accordion books and boxes, she extends her iconoclastic impulse by presenting clues within the image-field, in the unframed image or the framing device itself. She now invests conceptual energy in fabricating supports that rescue her works from being mere wall displays.

Consider Singh's edge-to-edge layouts, the structural interface between images; contrast this with their (dis)orienting spatiality and their hints of image liaisons; return to her acts of scaling and de-scaling, reformatting and reframing: would Derrida's concept of the 'parergon' be useful here? (As something that stands out both from the 'ergon', the work, and from the milieu; something that is against, beside and in addition to the work: figure on ground, an aesthetic surround, a sort of architecture.) The parergon is neither simply outside nor simply inside, and might indeed be a suitable trope for Singh's ambiguous projects: looping around her denial of conventional representation, spurning both the tedious quest for a worthy signified and the lure of the punctum, and endorsing semiotic slippage, whereby the inside-outside conundrum of her work radically reorients the viewer's subject position.

← *Sent a Letter*, 2007, gelatin
 silver print, 25 × 25 cm (left)

← *House of Love*, 2011,
 ink jet print, 50 × 50 cm (right)

↑ *File Room*, 2011,
 ink jet print, 60 × 60 cm

↓ *Blue Book*, 2009,
 C-print, 45 × 45 cm

Istanbul
by Duygu Demir

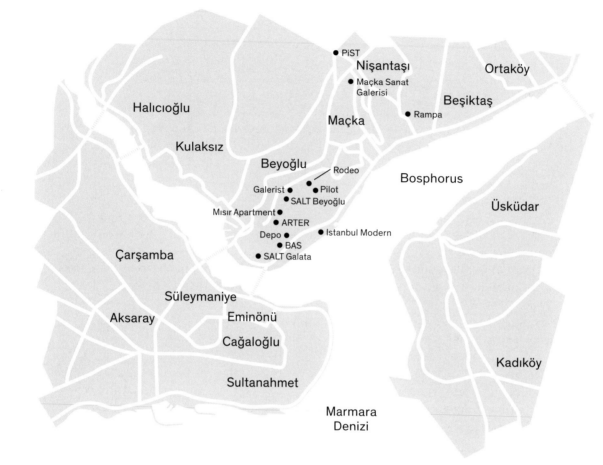

N

PiST

Nişantaşı

Ortaköy

Maçka Sanat
Galerisi

Beşiktaş

Halıcıoğlu

Maçka

Rampa

Kulaksız

Beyoğlu

Rodeo

Bosphorus

Galerist

Pilot

SALT Beyoğlu

Üsküdar

Mısır Apartment

ARTER

Depo

Istanbul Modern

BAS

SALT Galata

Çarşamba

Süleymaniye

Aksaray

Eminönü

Cağaloğlu

Kadıköy

Sultanahmet

Marmara
Denizi

0 1 km

Arter
Istiklal Caddesi 211

BAS
Necatibey Caddesi 32/2

Depo
Lüleci Hendek Caddesi 12

Galerist
Meşrutiyet Caddesi 67/1

Galeri Nev and Galeri Non
Mısır Apartment
Istiklal Caddesi 163

Istanbul Modern
Meclis-i Mebusan Caddesi,
Liman İşletmeleri, 4 Sahası Antrepo

Maçka Sanat Galerisi
Mim Kemal Öke Caddesi 31/A

Pilot Galeri
Sıraselviler Caddesi 83/2

PiST
Dolapdere Caddesi
Pangaltı Dere Sokak 8A/B/C
Pangaltı

Rampa
Şair Nedim Caddesi 21A

Rodeo
Yeni Hayat Apartment
Sıraselviler Caddesi 49

SALT Beyoğlu
Istiklal Caddesi 136

SALT Galata
Bankalar Caddesi 11

Istanbul
by Duygu Demir

Did Istanbul become an international art hub before it was fully a Turkish one? In recent years, its art scene has grown at an unprecedented rate. Private and corporate-funded cultural institutions and museums have opened in newly renovated, multimillion-dollar historical buildings – often former homes of the city's aristocracy. There are at least two competing art fairs; reports of record-breaking auction sales (both domestically and abroad); proliferating nonprofit spaces, artist residency programmes and independent artist initiatives; not to mention the many galleries popping up in neighbourhoods on the city's European side.

In this post-junta era, the productive energy of continuing economic liberalization is finding an outlet in contemporary art, which enjoys a greater share of public attention and private financial support than ever before. The invigorated cultural landscape of Istanbul now is incongruous with the melancholic, deprived city depicted in novels and films of the late twentieth century. It is too early to say whether the increased visibility and interest in contemporary culture will culminate in a parallel new awakening in politics, history and society.

Nevertheless, the cultural legacy of Istanbul and the art scene in Turkey at large are indubitably intertwined with the country's political life. The art-historical narrative of Turkey spans a national past that less than one hundred years ago experienced a sudden break from six centuries of rule by the Ottoman Empire, and three ensuing military coups d'état, in 1960, 1971 and 1980. These ruptures have led to a fragmented historicity and the repeated erasure, or repression, of cultural memories. This condensed account traces the evolution of the local avant-garde, whose largely autonomous development and self-sustaining ethos in the twentieth century continues to characterize Istanbul's artistic community.

The disintegration of the Ottoman Empire was followed by the 'civilization project' that led to the formation of a class of state artists. Beginning with the 1909 Second Constitutional Era, minority and Levantine (longtime European residents of Turkey) professors at the Academy of Fine Arts were removed from their posts, and Istanbul regressed into a provincial city as Ankara became the new capital. Following a model similar to the strategies of Soviet Russia, artists were instrumental in moulding the citizens of the new Turkish Republic as part of a top-down cosmetic westernization of the entire society, which included the conversion of the alphabet from Arabic to Latin script in 1928 and the planning of cities according to European principles of efficiency and comfort. Young Turkish artists were sent to Europe, especially Paris, with state funds; they came back inspired by then-current trends such as Fauvism, Cubism and even Expressionism.[1] The practice of sending artists to Paris on state scholarship, which continued well into the 1970s, resulted in Europe's war-fuelled avant-gardism arriving to Turkey in a transformed state, often through borrowed visual languages and a superficial formal engagement with the more radical underpinnings of European Modernism. Under the Turkish Republican project, which was quickly naturalized, most artists held an unwavering belief in, and commitment to, ideologies of the state and the ideals of progress associated with modernization – quite in contrast to many European Modernist peers, who were battling the authoritarian tendencies of both Stalinism and Fascism.[2]

The first artist to combine the visual strategies of Western avant-garde movements with a critical perspective on events in Turkey was Altan Gürman (1935–76).[3] After serving in the Turkish military during the first coup in 1960 and later witnessing the legacy of World War II during his education in Paris, Gürman adopted dadaist methods of collage and assemblage to question militarist and bureaucratic mentalities – using materials and subjects that went against the accepted norms of the time. The 1960s also saw the emergence of Turkey's hopeful and modest middle class, as well as the

introduction of the term *çağdaş sanat* (contemporary art) by Bülent Ecevit, champion of Turkey's 'left of centre' political movement and a four-time prime minister. As a term, *çağdaş sanat* was still loaded with the country's belated desire to be of its time.

The 1970s witnessed the emergence of several quiet but adamant stances. Füsun Onur, after finishing her postgraduate studies in the United States, pushed the boundaries of sculpture, working initially with painted wood, Plexiglas and mirror. Later installations incorporated everyday objects and the readymade, often hinting at female sexuality. In 1977 the pioneering artist initiative *Sanat Tanım Topluluğu* (Art Definition Society) was founded by Şükrü Aysan, Serhat Kiraz, Ahmet Öktem and Avni Yamaner (who left the group a year later) in a gesture of opposition to the domination of painting, both commercially and at the Fine Arts Academy. In addition to creating environments both inside and outside the exhibition space, STT's most significant contribution is the concept of *Sanat Olarak Betik* (Written Document/Book as Art), for which they invited the viewer to sit and examine books in lieu of looking at art installed on walls or in three-dimensional space.[4]

The 1980 coup severely limited exchange with the outside world, not only for artists, but for the country as a whole. This complete isolation made it very difficult to follow developments in contemporary art abroad.[5] However, a series of annual exhibitions entitled 'Yeni Eğilimler' (New Tendencies, 1977–87), hosted by the Fine Arts Academy in Istanbul, brought together the country's leading avant-gardists including Füsun Onur, Şükrü Aysan, Serhat Kiraz, Cengiz Çekil, Canan Beykal, Ayşe Erkmen and Gülsün Karamustafa.[6] These exhibitions mark the last moment of state support for innovative art, as the experimental nature of the Academy slowly settled into entrenched conservatism.

Beginning in the late 1980s, artist-run exhibitions and later the Istanbul Biennial took the lead for risk-taking productions. The term 'avant-garde' was first officially used for the artist-organized series of exhibitions 'Öncü Türk Sanatı'ndan bir Kesit' (A Cross-Section From Avant-Garde Turkish Art, 1984–88), which presented a disparate set of practices and even included the Paris-based artists Sarkis and Nil Yalter. A more conceptually oriented group of artists later split off to organize their own exhibition series, titled 'A', 'B', 'C' and 'D', respectively (1989–93), among them Ayşe Erkmen, who remains the foremost practitioner of site-specific interventions. With the establishment of the Istanbul Biennial in 1987, and the end of the Cold War in 1989, stronger ties were established between artists living in Turkey and the rest of the world, as channels of communication and an influx of material histories from East and West created fertile ground for artistic experimentation.

Growing in fits and spurts in the 1990s, the Istanbul art scene became less elitist and more engaged with the current state of affairs, acting as a microcosm of the greater frictions within the country. Still, there was a lack of institutional presence and support. Collective and non-commercial initiatives by artists focused on collaboration and the exchange of ideas by mounting exhibitions at alternative spaces. There were very few galleries, besides Maçka Sanat Galerisi and Galeri Nev, that risked showing commercially nonviable work. Younger artists exhibited in the self-organized series 'Today's Artists' in the hopes of being selected for the Biennial.

The Istanbul Biennial facilitated a new generation of artists whose work tackled pressing social issues such as Turkey's creeping Islamization, the struggle for gender equality and the Kurdish conflict. Hale Tenger's wall installation in the shape of a crescent and star, *I Know People Like This 2* (1992) – included in the third Istanbul Biennial, curated by Vasıf Kortun – critiqued state violence and power. Aydan Murtezaoğlu questioned the Kemalist obliteration of memory through works such as *Karatahta* (1992–93), a blackboard with Arabic and Latin script. The fourth Istanbul Biennial, curated by influential German gallerist René Block (who later championed Turkish artists abroad), included Hüseyin Bahri Alptekin and Michael Morris's *Turk Truck* (1995), a red vehicle with an Istanbul license plate and a mountainous load of plastic soccer balls in the colours of the Kurdish flag.

Even through the early 2000s, very few spaces in the city supported contemporary art practice. LOFT, established by Alptekin, and the magazine *art-ist*, published by Halil

→ The Bosphorus Strait from the European side

↓ Artist books at BAS, run by Banu Cennetoğlu, 2012

↘ Doris Salcedo, *Untitled*, installed in Karaköy for the 8th Istanbul Biennial, 2004

↓ Istanbul Modern

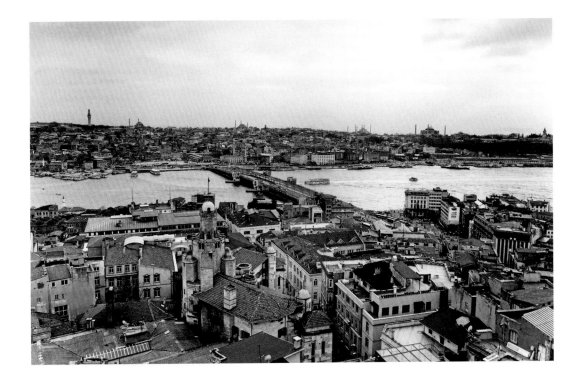

Altındere, were among the few discursive outlets for artists. Founded in 2001, Platform Garanti Art Centre in Beyoğlu quickly became a primary venue for debate, research and production, hosting residencies and mounting exhi-bitions by Turkish as well as international artists. Finally, Turkish artists were being invited to participate in exhibitions in Europe, Asia and the United States. However until very recently, artists such as Kutluğ Ataman (based in London) and Ayşe Erkmen (based in Berlin) showed mostly abroad, and have had to be reintroduced to Turkish audiences via large-scale exhibitions.[7]

Many of the themes that preoccupy contemporary artists were first raised in the early 2000s. Bülent Şangar pointed out discrepancies between local traditions and public space in the metropolis, hinting at the opposition between Muslim and secular groups, in his photographic series *Move Forward* (2004–05). Artists who came to Istanbul from Diyarbakır in southeastern Turkey established a mode of production concerning issues of identity and local context, evident in seminal video works by Şener Özmen (with Erkan Özgen, *Road to Tate Modern*, 2003) and Fikret Atay (*Bang! Bang!*, 2003). At the same time, Kutluğ Ataman began his project to portray diverse segments of society, bringing taboo issues of poverty, sexuality and gender to the fore.

Today, the commercial sector continues to expand and support is growing for innovative projects in the absence of state-sponsored contemporary art institutions. Run by the Istanbul Foundation for Culture and Arts (IKSV, established 1973) and funded by Koç Holding, the Istanbul Biennial is still the country's premier art event. Istanbul Modern, a private museum founded in 2004, maintains the city's only permanent display of contemporary art, however incomplete. Founded in 2010, Arter – Space for Art, located on Istiklal Caddesi, mounts significant exhibitions of Turkish and international artists, and Yapı Kredi Publications (YKY), continues to publish extensive monographs on established Turkish artists. SALT, a reincarnation and expansion of Platform Garanti, acts as a research institution with a special focus on archival exhibitions of art, design and material culture. Among the influential nonprofits and artist-run spaces is Depo, located in Tophane, and artist Banu Cennetoğlu's BAS, which publishes and displays artists' books. PiST, a small interdisciplinary project by artists Didem Özbek and Osman Bozkurt, operates an artist residency programme. Istanbul's commercial galleries are clustered in the districts of Beyoğlu, Tophane and further north in Nişantaşı and Beşiktaş. Among the mainstays are Galerist, founded in the 1990s; Rodeo and Pilot, both recently relocated near Taksim Square; Derya Demir's Galeri Non on Istiklal Caddesi; and Rampa, further up the Bosphorus in Akaretler.

Istanbul is unquestionably the cultural capital of Turkey, and already a regional art destination for European and Middle-Eastern visitors. As the contemporary art field undergoes greater professionalization and economization, in contrast to twentieth-century deprivations, it will be important to observe how the avant-garde, which finds motivation in adversity, takes shape. Total government arts funding was stated to be more than $850 million in 2011, with little going to contemporary art institutions; the number of national arts programs at the university level remains at twenty-five.[8] Young artists still resort to going abroad for training, often without state funds but with private support. Despite the lack of strong educational resources, which threatens to hinder growth, artists and art professionals continue to self-organize, and Istanbul's art scene remains a motivated, tightly knit and self-reliant community.

In the coming years, it is likely that Turkey's uniquely hybrid nonprofits, supported by industrial families and their corporations, will expand and gain more influence, while artists from Istanbul will increasingly participate in international biennials and show their work in museums around the world, giving younger generations much to look forward to. As galleries take root and the city mounts an internationally viable art fair, whether artists continue to look critically at identity formation, unexcavated histories and local complexities, or succumb to the comforts of commercial patronage, remains to be seen.

Halil Altındere

Halil Altındere is an artist, curator, dedicated publisher and editor in chief of *art-ist*, a magazine that has provided Istanbul's artistic community with an animated platform for debate and exchange since the early 2000s.

Born in a small village near Mardin in southeast Turkey, Altındere moved to Istanbul in 1996. Carrying the periphery to the centre with the mission of transforming it from the inside, his practice is based on exposing and inverting the means by which prevalent ideologies assert themselves. His early works, which are often criticized for their directness, agitate the sensitivities of Turkish society, from Kemalism to militarism to liberalism. *Dance with Taboos* (1997), shown at the fifth Istanbul Biennial, featured an enlarged one-million-lira Turkish banknote on which Atatürk was shown covering his face with both hands. A number of works employing similar tactics to manipulate vessels of official representation point to the artist's interest in civil disobedience; he treats issues pertaining to his Kurdish identity, and that of other marginalized minorities, with simple gestures of affirmation, as in *Untitled*, 2004. For *Me, Not Me, But Me Not* (1998–2007), Altındere animated the static headshot used for the Turkish national identity card by means of a video close-up, transforming the fixed image into a living, breathing person; the work addresses the inadequacy of standard indicators such as surname, birthplace, gender and religion typically listed below the image. Inspired by the creative resistance that he admired in the 'Saturday mothers' – a group of women who organized weekly sit-ins on Istanbul's busiest pedestrian avenue in honour of their disappeared children, to protest the erasure of memory – the artist created a series of postage stamps adorned with faces of the disappeared (*Welcome to the Land of the Lost*, 1998). The stamp, symbolic of the state's promise that a package sent by mail will reach its destination, suggests the poignant failure of the government to look after its own. A more recent series of photo-realistic paintings, *Presidents* (2010–11) – based on photographs of Turkish prime ministers and first ladies pictured with guns or in military settings – reveal the artist's determination to illustrate the inherent chauvinism of military and political glory, a tension arguably released in the wry sculptural intervention *The Monument of Direct Democracy* (2009).

Infiltrating national and nationalist symbols, Altındere's practice as an artist, curator and publisher corresponds to his own political history in Turkey. At the expense of being tried in court multiple times for an unwavering stance against oppressive structures, he has his finger on the pulse of sociopolitical tensions. His curatorial projects are as daring as his artworks, and even their exhibition titles testify to a determined opposition: 'I am Too Sad to Kill You' (2003), 'Free Kick' (2006), and 'When Ideas Become Crime' (2010).

A confrontational cultural producer and keen observer of sociopolitical mechanisms, Altındere also humorously scrutinizes art history and the art world in general. Two photographs from 1998, *My Mother Likes Fluxus Because Fluxus is Anti-Art* and *My Mother Likes Pop Art Because Pop Art is Colorful*, show his mother in her provincial home, leafing through books on Fluxus and Pop Art. His provocative performances – which have included spontaneous dancing with abstract paintings during an exhibition opening (*Valse with Doğançay*, with Serkan Özkaya, 1998), spray-painting a dollar sign over the work of a painter he considered too commercial (à la friend and collaborator Alexander Brener, for *Performance*, 1998), as well as plotting to steal Bellini's portrait of Sultan Fatih (1480) in collaboration with the Turkish police when it travelled from London to Istanbul for an exhibition (*Miss Turkey*, 2005) – signify the passion, bravery and criticality of the artist's oeuvre.

← *The Monument of Direct Democracy*, 2009, flipped police car

← *My Mother Likes Fluxus Because Fluxus is Anti-Art*, 1998, C-print mounted on aluminium dibond Plexi, 100 × 150 cm

↑ From left to right: *First Lady*, 2010, 100 × 150 cm, oil on canvas; *Prime Minister*, 2011, oil on canvas, 120 × 180 cm; *President*, 2010, oil on canvas, 100 × 150 cm

↓ *Untitled*, 2004, C-print mounted on aluminium dibond, 100 × 150 cm

Aslı Çavuşoğlu

Aslı Çavuşoğlu collapses visual modes and narrative methodologies from both everyday life and history into choreographed yet open-ended performances. Expressive and interpretative activities from across time, geography and various media – such as fortune telling, rapping, writing a thesis or filming a crime-scene investigation – are adapted to specific but sometimes unlikely subjects. This absurdist tendency creates an effect of teleportation, exposing those methodologies that make sense of the world rather than comfortably arriving at new knowledge, and denying the viewer resolution.

On 11 November at 11:11 AM, for the 2011 edition of Performa, Çavuşoğlu led a tour of New York City. The performance, entitled *Words Dash Against the Facade*, involved a pedicab ride through Manhattan with the goal of interpreting the ornamental facades of select buildings as musical scores, or by means of ancient Sumerian fortune-telling rituals. After gathering in Central Park by Cleopatra's Needle, an Egyptian obelisk transported from Ottoman Egypt in the late nineteenth century, some book burning and hymn singing ensued, followed by visits to Hearst Tower, Club 21 and the building at 55 Central Park West where *Ghostbusters* (1984) was filmed. Movie references are a recurring motif; for Frieze Projects in London the artist staged *Murder in Three Acts* (2012), a performance for which Çavuşoğlu produced three episodes of a crime drama within the setting of the fair. Rehearsed and filmed with a professional crew, actors and advisors, Çavuşoğlu recontextualized the exhibited artworks into a popular media format to create a set within a set, destabilizing the sense of coherency that art fairs and genre television shows otherwise successfully achieve, while at the same time blurring the line between art and prop; and using forensics to produce meaning via evidence.

Her works frequently involve the withdrawal of authorship, and are activated through a series of orchestrations that result in nonsensical outcomes. To complete her artist book *Delivery 6* (2009), Çavuşoğlu found an 'essay mill' in Istanbul by word of mouth, as such companies neither advertise in yellow pages nor display signs outside their offices. For a certain fee she was put in touch with a ghostwriter, who, upon the receipt of subject matter and chapter titles, produced a thesis on seren-dipity, complete with statistics and source materials. In a similar fashion the artist worked with Turkish hip-hop artist MC Fuat for *191/205* (2010), producing a rap song using 191 of 205 words that were banned by the Turkish Radio and Television Corporation (TRT) in 1985, on the grounds that they did not comply with the general structure and operation of the Turkish language. Although later reinstated, these words included: memory, remember, recollection, experimental, motion, revolution, nature, dream, theory, possibility, history, freedom, example, conversation, whole and life.

For another musical collaboration, Çavuşoğlu worked with the congregation and gospel choir of an African Evangelical Church in Bilbao. The resulting performance of *She Who Is Salt-White* (2012) conveyed the Biblical story of Lot's wife, who was punished and transformed into a salt sculpture; according to the artist's interpretation, for witnessing God in the act of making art. Through a sermon and reggae-inspired songs, the piece ended with the audience singing along to the chorus: 'everything in heaven is sculpted'.

There is a sense of madcap nomadism across time and place in Çavuşoğlu's projects. Constantly teetering between the coherent and the absurd, they embody a fragmentation of references that in totality mimic channel surfing or browsing online. It is hard to say whether the artist is critical of such activities of contemporary rupture or if she fully embraces them, but her consistent exposure of these conditions and her persistence in denying resolution makes her practice continuously compelling.

← *A Few Hours After the Revolution*, 2010, neon installation, 40 × 170 cm

↑ *Murder in Three Acts*, 2012, film and performance

↓ *She Who is Salt-White*, 2012, performance

↓ *She Who is Salt-White*, 2012, performance

→ *Delivery 6*, 2009, artist book, 610 pages, Turkish/English

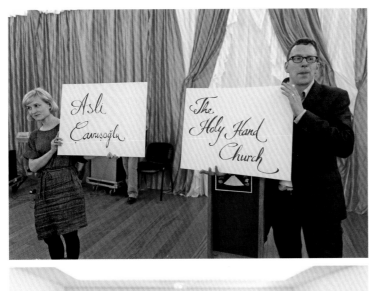

XX
XXXXXXXXXXXXXXXXXXXXXXXXXXXXXXXXXXX
XXXXXXXXXXXXXXXXXXXXXXXXXXX
XXXXXXXXXXXXXXX

Xxxxxx Xxxx

DELIVERY 6

Aslı ÇAVUŞOĞLU

Xxxx Xxxxxxxxxx
Xx Xxxxxxx Xxxxxxxxx

Istanbul
2009

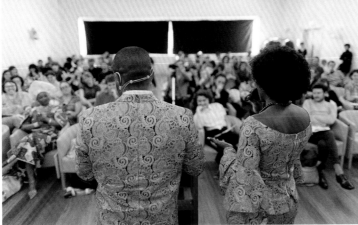

Cevdet Erek

Cevdet Erek composes and re-composes works that investigate sound, architecture, rhythm, measured time, dance music and site-specificity. With degrees in architecture, sound engineering and design, and an ongoing gig as drummer of Nekropsi (an avant-garde rock band), his visual practice borrows strategically from music; while his videos, time-based installations and objects often employ musical forms such as variation and improvisation. The *Ruler* series (2007–present) presents a collection of tools for interpreting personal timelines and originated from a conversation between the artist and his father. Erek's rulers are not conventional instruments for measuring but rather departure points for reconsidering the cyclical nature of events as well as personal and variable meanings of concepts such as past and present, day and night, beginning and end.

For *Week*, a site-specific work presented at Kunsthalle Basel in 2012, Erek isolated a space under the skylight of the exhibition hall with white curtains. The rectangular area defined by the curtain created a void flooded with natural light, at the end of which stood a single speaker on a stand. This speaker emitted five regular beats followed by two accented ones, interrupted every once in a while by a computer-generated voice pronouncing the days of the week: 'Mon-day, Tues-day, Wednes-day, Thurs-day, Fri-day, Satur-day, Sun-day', followed by: 'tick-day, tick-day, tick-day, tick-day, tick-day, tock-day, tock-day.' Evoking the sense of an empty dance hall, the natural light and white space remained inviting, while the monotone beat fell short of a rhythmic tempo, instead teasing the viewer with its all-too-familiar cycle.

For Erek, vessels of standardization – particularly the radical rationalizations of modernism – become subjects for contemplation rather than static or reliable tropes. His architectural training also informs a dialogue between his work and the exhibition space. *Stedelijk Waterfalls CS* (2006) consists of a simple map showing the best 'listening points' where meaning might be reassigned to the incredibly loud vents of the Stedelijk Museum building's air conditioning system; at these locations, visitors are invited to imagine an invisible but audible waterfall. Other interventions internalize the given architectural language by employing aspects within the work. For *Kolon* (Column, 2010), he built a column and placed it on a structural axis between two already existing columns, creating a fake architectural element that visually imitated the exhibition space. A deceptive strategy, the column hosted a sound installation through which its non-structural character was divulged. For Documenta 13, he created *Room of Rhythms* (2010–12) on an empty floor of a Kassel department store. The installation consisted of a series of rooms delineated not by walls but by variations on rhythms. The main sixty-beats-per-minute rhythm, reminiscent of a techno beat, was accompanied by other temporal units both sonic as well as graphic, such as a borrowed signal beeper from a pedestrian crossing in the city or a cross-section from a tree, its rings providing a natural wooden ruler referring to the period and duration of Documenta itself. *Room of Rhythms* came alive during repeat performances in which the artist transformed the installation, changing areas of rhythm to become faster, slower, louder, quieter; or else occasionally interrupting the sound with live drumming that echoed through the large space.

Erek's compositions of sound and rhythm, borrowed and constructed architectural elements and readymade forms ultimately point to the construction of the rational, and attempt to create new associations between the naturally human and synthetically absolute.

← *Week*, 2012, 7 oak and metal
fittings from the floor of
Kunsthalle Basel

↑ *Room of Rhythms*, 2010–12,
mixed media and architectural
additions, looped 14-channel
sound, 1 min. 46 sec.

↑ *Ruler Coup (mini)*, 2011, laser
and black ink on perspex

→ *Kolon*, 2010, wood construction,
plaster, white paint, loudspeakers
and looped 4-channel sound,
3 min. 27 sec., installation view
at Arter, Istanbul

Köken Ergun

Köken Ergun is an observer of rituals. His most recent work, *Ashura* (2011), documents the preparations of Caferi Shiites in Istanbul for Ashura, a day of annual mourning commemorating the martyrdom of Imam Hussein during the Battle of Karbala, a central event in Shi'a Muslim belief. *Ashura* is mostly comprised of rehearsals for the re-enactment of Hussein's murder by amateur community members, set to a voiceover track prerecorded by professional actors. The video is anticlimactic; it focuses on the preparations for a play performed so that its nonprofessional actors can personally experience a historical moment. The intricacies of human interaction during this collective procedure are the principle feature. While it is no surprise that Ergun's background is theatre, having left the stage, he now finds, collects and recomposes performative situations in real life. By using a cubist strategy of seeing something from different angles and multiple perspectives, he clarifies the substance of each performance through an emphatic deconstruction of the beauty contest, wedding or religious ceremony in which individuals perform prescribed roles or groups play their parts.

Ergun's shaky hand-held camera can be described as voyeuristic in such early videos as *I, Soldier* (2005) and *The Flag* (2006). Both works document mass public celebrations in which grandiose poems are recited in awkward socialist realist style in a stadium setting (by a soldier and by a young girl, in each respective work); the banality of the physical surroundings, an expressed utopian aspiration and national delusion are caught within the same frame. In later works the camera becomes more and more integrated with the event it records, and more steady; more a point of access than a marker of exclusion in *Wedding* (2009), for which the artist filmed the marriage ceremonies of Turkish and Kurdish immigrants in Berlin.

Taking its name from the city's predominantly Turkish neighbourhood where most of the footage for the three-channel video was shot, *Wedding* is a meta-wedding, a narrative of a traditional ritual in flux. From the preparations in the beauty salon to the counting of cash given by elders as a present to the couple, to the running around of children, the ecstatic collective dancing and the alienation of the German guests, Ergun's camera captures not only a ritual transformed to its extreme in a foreign land, but also the multiple layers of social ascription lived through a collective immigrant fantasy. The experience of attending these weddings in Berlin almost every week for numerous months led Ergun to transform his research into a PhD thesis on emotion and ritual at the Freie Universität Berlin with the working title, *Rituals of Isolation: Emotional Bonding in Wedding Ceremonies of the Turkish-German Society in Berlin*.

The artist's degree of involvement increases with each project and becomes more readily apparent in later works such as *Binibining Promised Land* (2010), for which he is no longer an attached observer but instead a full participant in staging a beauty contest for young overseas Filipino workers, held in a nightclub at Tel Aviv Central Bus Station. *Binibining Promised Land* is not only a multiple-channel video installation recounting a context-specific ritual on film, but an entire environment which also contains interviews with the protagonists, paraphernalia such as special covers and spreads from magazines published by the community, as well as a series of photographs of the protagonists with the artist, attesting to his full insertion into the tightly knit group. Described by Ergun himself as a reaction to the elitism of his upbringing, his artworks use his identity as an artist as a passport to confound social boundaries of inclusion and exclusion.

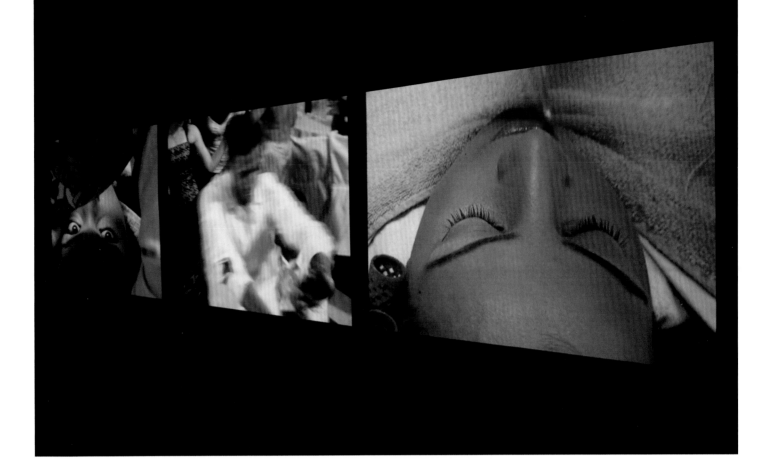

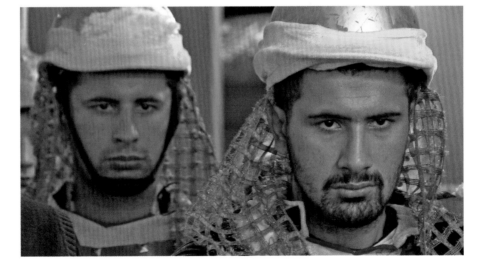

← *Bininbining Promised Land*,
2009–10, installation with
3 video interviews on monitors,
poster, magazine covers,
furniture and film projection,
37 min.

↑ *Wedding*, 2008–09,
3-channel video, 12 min.

→ *Ashura*, 2010–11,
3-channel video, 28 min.

↓ *I, Soldier*, 2005,
2-channel video, 7 min.

Esra Ersen

In Turkey, it is not uncommon for a member of parliament, a spokesperson for a political party, an NGO leader, trade union representative, high ranking military official or even a terrorist group to emphasize the severity of his cause or the gravity of her institutional organization by saying: 'We are not just a canary lovers society.' This rhetorical construct becomes a real protagonist in Esra Ersen's video *Casting for a Canary Opera* (2011). Known for working closely with marginalized groups, the artist persuaded members of a canary lovers society to read clippings from political statements that figuratively invoke the society's name. Set in the group's headquarters against a backdrop of hundreds of singing canaries in cages, the statements are delivered as if each reader is rehearsing for a role. The absurd comedy is interspersed with documentary-style recordings of the daily activities of the society, including a canary auction.

Ersen's interest in the marginal is rooted in her preoccupation with societal constructs that cannot contain what they cannot rationalize. Most often, her installations and videos focus on groups outside the limits of cultural compliance: immigrants, the displaced and outcast. Thus education, integration and social engineering are the main actors in her productions. In most of her works, the end result is not a carefully crafted artistic statement but an almost communal production. After living in Europe and travelling to various projects and residencies on the continent, her observations of immigration policies in various cities led her to issues of assimilation and what it means to be Turkish in such contexts. The artist's resulting gesture might be as simple as asking the immigrants who attend Swedish classes at a suburban language centre to confide what they would say if they could actually speak the second language fluently (*If You Could Speak Swedish*, 2001); or convincing students in Münster, Gwangju and Linz to wear the school uniforms of Turkish youth, then recording their thoughts on the experience (*I am Turkish, I am Honest, I am Diligent*, 1998–2005); or asking the inmates of a prison in Graz-Karlau to express their private dreams of utopia on the outer walls of the detention facility (*Testimony*, 2003). In each case, her intuitive questions or simple prompts create chain reactions which reveal more layers than anticipated.

Ersen, who was only twenty-five years old when she was invited to participate in the fourth Istanbul Biennial curated by René Block in 1995, chose to open a window in the former customs building in which the exhibition took place. This window overlooked the still-functioning nearby port where workers were loading and unloading cargo. Shown alongside images of the workers' sweat, she invited viewers to acknowledge the invisible human forces of production, as well as an often disregarded segment of society.

Opening up a space for peripheral experiences, Ersen not only highlights overlooked sociopolitical issues but also acknowledges representational shortcomings, problematizing documentary-style videomaking through the collective aspect of her projects. She engages with various groups at a level beyond the artist-subject relationship, integrating herself into the context as fully as possible. Her projects are not conceived as aestheticized renderings of marginal experience for the consumption of the contemporary art world, but instead as modest yet transformative exercises for the artist as well as her collaborators.

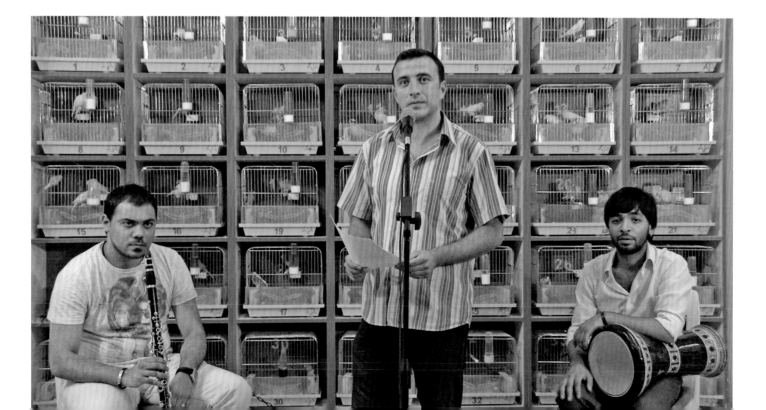

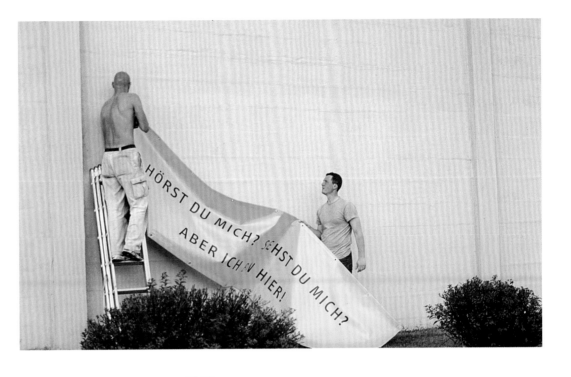

← *Casting for a Canary Opera*, 2011,
 video with sound, 18 min.

↗ *Testimony*, 2003, 24 banners,
 silk prints on PVC foil,
 450 × 100 cm each

↑ *I am Turkish, I am Honest, I
 am Diligent*, 2005, video with
 sound, 45 min.

↓ *Passengers*, 2009, 2-channel
 video installation with sound,
 28 min. and 21 min.

Nilbar Güreş

Nilbar Güreş is an oddball in the best possible sense. Her drawings, collages, performances as well as photography and video dismantle cultural, social and sexual constructs in theatrical settings that border on the surreal. Targeting patriarchal norms, she visually expresses her resentment of the taming of bodies, the denial of sexual desire and a host of other intangible constraints and arbitrary deprivations. The works are not graceful, but neither are they clumsy; purposefully uncomfortable, the *mise en scènes* she produces subvert the image of the well-mannered woman and the uncomplicated serenity of the domestic environment.

Unknown Sports (2008–10) is a series comprised of video, photography and public actions. Set in a kind of domesticated gym, its point of departure is the question of which sport best represents a woman's daily experience. The gym itself evokes the exhibitionist tendencies of a male-dominated competitive environment bordering on the primal, where muscular strength and athletic ability are prized. The patrons of the artist's gym, however, demonstrate different types of exercise, ranging from personal grooming to housekeeping.

Her cast of characters is as important as their absurdist poses. Working mainly with women, Güreş creates controversy not only by staging private acts within public spaces, but also through the juxtaposition of her models, who come from dramatically different social backgrounds. She fosters unlikely pairings of family, friends, distant relatives and neighbours as well as activists and volunteers from various women's groups and lesbian, gay, bisexual and trans-gender organizations, bringing together participants who are usually separated neatly into societal compartments, literally and figuratively.

Her own performances, staged in central locations or conservative neighbourhoods in Istanbul and intentionally during their busiest hours, feature the artist herself undressing to transform from bride into boxer, or find her hybridized between the figures of runner preparing to sprint and provincial house-wife. Taking her cue from Article 29 of the Turkish Criminal Code related to unfair provocation – in which a woman is considered an accessory to a crime or may be arrested for wearing a miniskirt because it is seen as an aggressive act – Güreş unquestionably sets out to provoke.

At other times, the shooting locations she chooses provide readymade compositions. For her project *Open Phone Booth* (2007–11), the artist worked in the setting of her father's hometown, a Kurdish-Alevite village in East Anatolia. Taking a documentary approach, she turned her observations of the grim living conditions into a series of photographs and a three-channel video. She spent long periods of time in this village, sharing the difficulties and isolation of an infrastructurally disregarded area where water shortages, power cuts and the lack of a telephone network hinder everyday life. The latter disabled ties with the outside world completely until the development of mobile phone technologies; now, instead of going to the mayor's office, villagers go to hilltops in search of a mobile phone signal. By following these villagers, sometimes across green mountains and sometimes blanketing snow, she illustrates the daily ramifications of a greater political problem between the Kurdish community and the state.

An activist as well as an artist, Güreş's practice is rooted in an awareness of injustice. With heartfelt intensity, her confrontational yet carefully composed works push the suppressed and the willfully ignored in society a little closer to the surface.

← *Wish*, from the series *Unknown Sports*, 2009, mixed media on paper, 70 × 100 cm

↑ *Gülten is Calling*, from the series *Open Phone Booth*, 2011, C-print, 50 × 70 cm

↑ *Performance in Üsküdar*, from the series *Unknown Sports*, 2009, with book, egg and bread

→ *Overhead*, from the series *TrabZONE*, 2010, C-print, 150 × 100 cm

↳ *The Living Room*, from the series *çırçır*, 2010, C-print, 120 × 180 cm

Gülsün Karamustafa

With Istanbul as her treasure chest, Gülsün Karamustafa is a storyteller who interweaves politics, history and collective and personal memory into intricate narratives. Grade-school notebooks, black-and-white photographs from personal archives, etiquette books, carpets and porcelain figures act as departure points for her multifaceted oeuvre, which has expanded from an early emphasis on painting to include sculpture, installation and video.

Once characterized as 'Queen Mother of the Istanbul art scene'[9] by critic and curator Erden Kosova, Karamustafa was a politically active student in the 1960s and 1970s, and was incarcerated during the 1971 military coup. Her work *Bühne* (Stage, 1998) consists of a black-and-white photograph of the artist and her husband at court, taken during their sentencing. It is presented together with a device that projects the words 'State Regime Control Ideology' around the exhibition space in a manner that recalls the circling of police searchlights. Her much later two-channel video *Memory of a Square* (2005) similarly reflects on the historical separation between public and private life in Turkey.

As an ardent observer, and subject, of sociopolitical developments in Istanbul and the greater region, the artist's biography parallels this complex history. Denied a passport until 1986, her life and work were confined to her immediate vicinity. She quickly adopted the visual culture of newcomers from rural Anatolia, for example, merging it with that of metropolitan Istanbul to form a new culture of 'arabesque' infused with kitsch. Her examination of the shifts in visual language brought on by the cohabitation of different communities and classes from the low-budget trade circulation that emerged around the Black Sea resulted in her now famous fabric collages (*Motorcycle*, 1986; *Fallen Variation of the Last Supper*, 1984;

Prayer Rug with Elvis, 1986). More recent works such as *The City and the Secret Panther Fashion* (2007) and her installation *The Monument and the Child* (2011) continue these visual-cultural studies by playing off perceived stylistic or aesthetic clichés.

When Karamustafa showed *Mystic Transport* (1992) at the third Istanbul Biennial, the fall of the Soviet Union and the Berlin Wall had blurred the line between centre and periphery. 'Transport' thus signifies the movement from rural to urban, but also from East to West. It consists of satin quilts in vibrant colours placed in twenty rolling metal baskets, modelled after those used by porters at public bazaars, which can be moved around as the viewer wishes. Evoking associations with migration, cheap labour and the baggage we all carry, the intimacy of the quilts also hints at sexuality.

In typical Karamustafa fashion, *The Apartment Building* (2012) is an act of personal archaeology that simultaneously exposes a facet of Istanbul's convoluted heritage. The artist, who has lived on the first floor of the Bazlamaci Building in the Cihangir neighbourhood since 1991, exhibited a two-metre-tall scale model of the apartment building in Athens along with archival findings on the Vaslamatzis family, wealthy Greek minorities who left their mansion (now the Bazlamaci Building) behind when fleeing the Istanbul riots in 1955. A rehabilitative gesture as well as the deliverance of a historical moment, *The Apartment* exposes a point of intersection between human life and the sociopolitical.

A towering figure for the younger generation, Karamustafa sets the bar high by constantly internalizing and adapting to changing social, technological and material conditions. Bringing forgotten histories to the fore while addressing displacement, nomadism and nostalgia, her transformative visual language is as diverse as her stories.

← *Motorcycle*, 1986, fabric, synthetic cotton, 110 × 75 cm

↑ *Memory of a Square*, 2005, 2-channel video, 16 min.

→ *The Apartment Building*, 2012, installation view at the National Museum of Contemporary Art, Athens

↓ *The Monument and the Child* (detail), 2011, installation view at the Academy of Fine Arts, Vienna

Ahmet Öğüt

Ahmet Öğüt isolates and explores instances of restricted freedom, typically in the form of absurd encounters between the political and the personal. He produces work in a range of media – drawing, sculpture, installation, video and artist books – that embody modest gestures, whimsical irony and a subtle but strong resistance. His sense of humour, inspired especially by Jacques Tati's slapstick, combines playfulness, daily experience, the power and reach of state control, national pride and the poignancy often inherent in misfortune.

In an early slide-projection work, *Somebody Else's Car* (2005), the artist targets two civilian parked cars, and within seconds transforms one into a taxicab, the other a police car, using coloured paper cut-outs. A small gesture one might even call painterly, Öğüt mischievously hints at codes of identification and the ways in which public space is activated by these codes. The jester performs a friendly act of vandalism, leaving behind intact makeovers until their eventual discovery by the astonished owners. Cars and roads feature prominently in his practice, not only because they reflect an interest in public space and how it is organized, but also because they signify the fast transformation of a country like Turkey – slapped in the faced with modernity, nationalism and economic growth all at once. His installation *Across the Slope* (2007) consists of a modified Fiat 131 Mirafiori balanced precariously across an artificial slope constructed in the gallery space. Elongated to resemble a limousine, this locally assembled middle-class car hints at the invisible obstructions to naive bourgeois aspirations. In 2008, Öğüt subtly transformed the main exhibition hall at Kunst-Werke in Berlin by covering its 400-square-metre floor with asphalt for *Ground Control*. This seemingly minimalist gesture created a chain of ass-

ociations: a sense of public space continuing into private; the state's presence through infrastructure in both physical space and the collective psyche; and a reference to the symbolic power of road building in rural areas of Turkey, implying improved access, security and increased government control.

Öğüt's critical practice is not limited to the political, historical and economical issues of his native country; his eye for invisible yet powerful structures transcends borders. Commissioned by S.M.A.K., *The Castle of Vooruit* (2012) literally inflates the Vooruit building, a now defunct working-class cooperative in Ghent dating from the late nineteenth century, as a Magritte-inspired weather balloon. For Art Dubai Projects, he circumvented the structure of the fair with with *Intern VIP Lounge* (2013), an exclusive space for unpaid volunteers with its own programme of talks, screenings and even a chocolate fountain. His on-going project, *The Silent University* (2012), is a collaboration with immigrants in the UK who are unable to perform their professional occupation of teaching due to visa status or lack of a work permit. In this way he forms a community of people allied by frustration at their inability to teach. An intricate bureaucratic exercise involving classrooms, schedules, lecture notes and students is created yet remains unfulfilled: the lectures are not delivered, the teachers remain silent. The artist's scheme points gracefully to the shortcomings of state systems.

A clever conceptualist, a tactful deliverer of jokes and a bearer of local but often internationally recognizable historical references, Öğüt never steers away from the potency of a visual riddle; his works always function as performance mechanisms in which the viewer is asked to play the game, to think fast and to be witty alongside the artist.

← *Ground Control*, 2007–08, asphalt, 400 sq m, installation view at Kunst-Werke, Berlin

↑ *The Castle of Vooruit*, 2012, inflated helium balloon floating 11 m above the ground, 8 m diameter

↓ *Across the Slope*, 2008–11, Modified Mirafiori and constructed floor, installation view at SALT Beyoğlu

Johannesburg
by Tracy Murinik

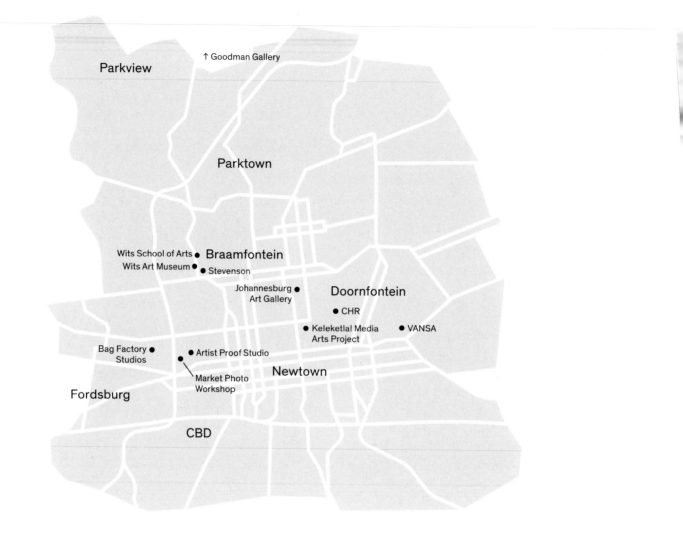

N

↑ Goodman Gallery

Parkview

Parktown

Wits School of Arts ● Braamfontein
Wits Art Museum ● ● Stevenson

Johannesburg ● Doornfontein
Art Gallery
● CHR

● Keleketla! Media ● VANSA
Arts Project

Bag Factory ● ● Artist Proof Studio
Studios ● Newtown
Market Photo
Workshop
Fordsburg

CBD

0 1 km

● Artist Proof Studio
 The Bus Factory
 3 President Street, Newtown

● Bag Factory Studios
 10 Mahlatini Street, Fordsburg

● The Center for Historical
 Reenactments (CHR)
 32 August House, 76–82 End
 Street, Doornfontein

● Goodman Gallery
 163 Jan Smuts Avenue, Parkwood

● Johannesburg Art Gallery
 Joubert Park

● Keleketla! Media Arts Project
 The Drill Hall Precinct
 Twist Street and Plein Street
 Joubert Park

● Market Photo Workshop
 2 President Street, Newtown

● Stevenson
 62 Juta Street, Braamfontein

● VANSA
 King Kong Building, 6 Verwey
 Street, New Doornfontein

● Wits Art Museum
 University Corner, Bertha and
 Jorissen Streets, Braamfontein

● Wits School of Arts
 Bertha Street, Braamfontein

Johannesburg
by Tracy Murinik

Sprawling, colourful and unexpectedly beautiful; gauche, hardcore and yet amazingly soulful; despite a bad reputation for crime and a legacy marred by social and economic inequality even well after the fully inclusive democratic elections of 1994, Johannesburg is, nevertheless, surprisingly human. Home to over 3.8 million people and the world's largest man-made forest of around eight million trees, the city is constantly inventing and re-inventing itself. In his salient novel *Portrait with Keys*,[1] writer Ivan Vladislavić muses: "[In] the Venice of the South, the backdrop is always a manmade one. We have planted a forest the birds endorse. For hills, we have mine dumps covered in grass. We do not wait for time and the elements to weather us. We change the scenery ourselves to suit our moods; nature is for other people, in other places."

Considering the depth and intensity of its history, at 130 years Johannesburg is relatively young. A gold mining town in 1886 that attracted fortune-seekers from around the world, it was substantially cosmopolitan from the outset, despite falling under the rule of the conservative Boer Republic.[2] The city rapidly became the largest in the Transvaal Province, quickly outgrowing Pretoria, the nation's capital. Fondly referred to as Jozi or *Egoli* ('City of Gold'), the golden promise of Johannesburg still holds sway today. Arguably the most powerful commercial centre in Africa, it remains a beacon to those in search of economic freedom, with the majority of immigrants to the city originating from elsewhere on the continent. Refugees and tens of thousands of political asylum-seekers hope to find a better life for themselves here; whether they do is difficult to appraise. In parallel to these migratory waves, a significant informal economy of vendors and street traders has flourished, and is estimated to rank behind the informal sector of Beijing, the largest globally.

Johannesburg is a hard and demanding environment that stimulates an engaged and creative response. Vibrating with a tangible and provocative energy, it does not tolerate indifference well. In their introduction to *Johannesburg: The Elusive Metropolis*, academics Sarah Nuttall and Achille Mbembe propose that today's global cities are composed by flows of not only money, knowledge, machinery and technology, but also people, ideas and images – the latter comprising a cultural economy. The strength of this cultural economy informs 'the capacity to generate one's own cultural forms, institutions and lifeways', but also 'the ability to foreground, translate, fragment and disrupt realities and imaginaries originating elsewhere, and in the process place these forms and processes in the service of one's own making'.[3]

As a physical entity Johannesburg tends towards the schizoid, made manifest in part by its segregationist planning, which divided at social as well as economic levels. Its structure also spans several strata: from the mines below ground to the vast metropolis sprawling above, and the notorious zones layered in between that remain unacknowledged by a broader public. Numerous Johannesburg artists have made it their work to disrupt this pattern, to make visible social and political contradictions. While artists internationally also work in this way, in the case of South Africa and especially during the years of apartheid – which saw a strictly monitored press and a twenty-year cultural boycott – responses were diverse and powerful.[4] Documentary photography was particularly evocative. David Goldblatt's visual archive, dating from the 1950s, focuses particularly on Johannesburg and the surrounding mining towns. His use of searing natural light and refusal to couch subjects (buildings, landscapes or people) in a gentle haze made way for the harsh reality and zero sentiment that characterizes aesthetic representation in much contemporary South African art. The concurrent yet divided worlds in his photographs trace the grammar of ideological separation through architecture and urban space. Many other photographers vividly captured the horror and humanity of city life during this period,[5] also evident in Durant Sihlali's watercolours of Soweto, Sam Nhlengethwa's montages of mining conditions and David Koloane's peripheral

images of the inner city by night, which allude to the curfew requiring that blacks return to the townships at sunset. The work of veteran photographer Santu Mofokeng breaks with the overtly political documentation of that era to consider instead the existential in everyday ironies.

Jane Alexander, Paul Stopforth and Robert Hodgins each developed eloquent imagery to describe the brutality of the 1980s; these works have since become important and iconic referents.[6] Many others, including Penny Siopis, William Kentridge, Clive van den Berg and Marco Cianfanelli, turned to the land to explore identity or excavate buried histories. And the diverse conceptual practices of artists such as Willem Boshoff, Kendell Geers, Moshekwa Langa, Alan Alborough, Jo Ractliffe, Candice Breitz, Wayne Barker, Minnette Vári, Wim Botha, Sandile Zulu, Dorothee Kreutzfeldt, Colin Richards, Usha Seejarim, Kathryn Smith and Senzeni Marasela have challenged both the perception and nature of art in South Africa, from the 1990s through today. Broadening the scope of (evidentiary) political imagery, these artists began to explore the politics of representation and to reflect on 'the now' of an emerging democracy.[7] One of the city's most radical protagonists of performance art, and its potential for political activism, is Steven Cohen.[8] His brave, in-your-face annotations on the injustices suffered by the marginalized (voiced as a gay, Jewish, white male artist) have influenced younger artists Tracey Rose, Athi-Patra Ruga, and even Nicholas Hlobo. Choreographer Robyn Orlin has been a cornerstone of Johannesburg's performance art sphere for more than two decades,[9] defining a space for herself outside the 'traditional' dance scene and regularly interfacing with the visual arts through provocative and uncomfortable works addressing issues of hypocrisy and violence.

Until the late 1980s, commercial galleries and the collection of the Johannesburg Art Gallery were largely geared towards white patrons and dedicated to an 'international' (in other words, North American or Western European) style.[10] With a few notable exceptions, local exhibitions predominantly showed work by white artists.[11] Major transformation in the South African art world came only after the cultural boycott lifted in 1993. The euphoric energy following the democratic elections inspired bold innovation for the first ever Johannesburg Biennale in 1995. But after the critically acclaimed second Biennale, directed by Okwui Enwezor in 1997, funding was abruptly terminated by the city. No subsequent biennials have taken place despite several attempts to revitalize the initiative. But what remains is an ongoing commitment – sparked by the refurbishment of the Newtown Precinct during the first Biennale – to provide infrastructure for the arts and to regenerate art activity in the inner city. The Johannesburg Development Agency (JDA) has been crucial in this regard, as have The Trinity Session (founded by artists Stephen Hobbs and Marcus Neustetter with Kathryn Smith), an independent art production team that advocates for local urban initiatives with the aim of taking art to the broader public, rather than to an exclusive elite.[12]

Avenues for contemporary art in Johannesburg are numerous and diverse today. Several critical forums regularly profile the arts; both the quarterly *Art South Africa* and the online magazine *Artthrob* (www.artthrob.co.za) have contributed to the growing discourse around South African art among local and international audiences. The Wits School of Arts, the Department of Visual Art at the University of Johannesburg and the Market Photo Workshop are producing strong, intelligent and energized graduates. New galleries, both commercial and non-profit, exhibit a broad variety of Johannesburg-based and emerging South African and international artists, among them Stevenson, Gallery AOP, Wits Art Museum, Goodman, Gallery MOMO and The Parking Gallery. The Visual Arts Network of South Africa (VANSA) fosters connection by running regular events in the city that complement its online resources. Established in 2008, the Joburg Art Fair annually convenes galleries from the region and beyond, with a focus on modern and contemporary African art.

Since the first Johannesburg Biennale, and the subsequent flurry of international exhibitions eager to profile South African art, the exposure of arts practitioners and thinkers to their counterparts on the continent and abroad has been extensive. Artists

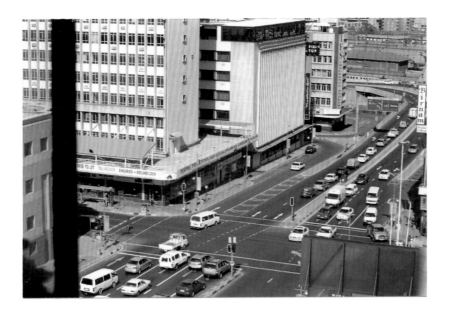

↑ Serge Alain Nitegeka, *The 24hr Project*, 2006, Braamfontein

↑ Artist Proof Studio's HIV/AIDS Advocacy mural promoting the VCT (voluntary counselling and testing) Campaign, Newtown, 2010

→ Rethinking Public Sculpture workshop, Wits School of Arts

↓ Avant Car Guard, *We're Not Just Props We're People Too*, 2007, inkjet print on cotton paper, 1072 × 738 cm

→ Wits Art Museum extension

↓ Stevenson Johannesburg

↘ Tracey Rose, 'Waiting for God',
2011, installation view at
Johannesburg Art Gallery

↓ Kemang Wa Lehulere,
Cat Got Your Tongue, 2011,
performance for The Center for
Historical Reenactments

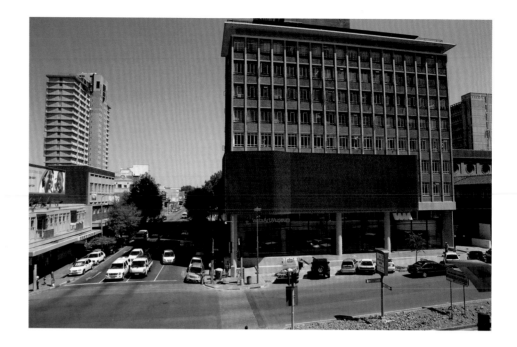

in the country have shifted from the predominantly parochial position of the early 1990s to find a nuanced voice in the global conversation; residencies through independent projects such as NIROX, cultural organizations including the Goethe-Institut, French Institute, Pro Helvetia and the British Council, institutions like the Bag Factory and many others invite reciprocal exchange. New forums to accommodate the growing diversity of artistic concerns and encourage research into broader possibilities for civic engagement have also expanded dramatically. The Center for Historical Reenactments (CHR), founded in 2010 by artist and curator Gabi Ngcobo with Kemang wa Lehulere, Sohrab Mohebbi and Donna Kukama, is one such platform that supports creative initiatives aiming to 'deconstruct particular readings of history' and how historical context informs artistic creation. The CHR project *Xenoglossia* (2010), for example, explored the pivotal and often tragic role that language has played in South Africa, considering events such as the 1976 Soweto student uprisings (violently suppressed protests against Afrikaans as the medium of instruction in state schools) as well as contemporary derogatory terms like *kwerekwere*, used to denote the foreignness of non-South African blacks.

Corporate and private art collections have substantially expanded their investments in recent decades, as have national collections such as that of the Johannesburg Art Gallery, which is refining its focus to better represent the city's artists historically as well as going forward. Meanwhile, the inner city, especially Braamfontein, has developed into a thriving visual arts and creative district in and around Juta Street, with galleries clustered at the foot of the Nelson Mandela bridge such as Stevenson, The Parking Gallery, ROOM Urban Art Project and Kalashnikovv Gallery, nearby the newly relocated Wits Art Museum – a vast and elegant space housing the university's holdings of historical and contemporary art from West, Central and South Africa. Further downtown, the gentrifying Maboneng Precinct now boasts Arts on Main, a development completed in 2009 that transformed an early 1900s bonded warehouse into a conglomerate of artist studios, project spaces and creative retail entities. Another key gallery zone stretches along Jan Smuts Avenue in more suburban Parkwood to the north; 44 Stanley in Milpark buzzes with creative energy; and Fordsburg (which borders Newtown), home to the Bag Factory artist studios, remains an active district for art production.

Johannesburg has always been malleable to imaginative (and sociopolitical) reinvention; its artists, still dependent on this catalytic energy, are eloquent testimony to a particularly spirited muse. Zander Blom declares himself to 'feed off the energy' of the city, while Serge Alain Nitegeka is stirred by its rhythms and structure: 'the long and broad highways, complex flyovers [and] elaborate … cast concrete roads and skyscrapers'.[13] Johannesburg's young generation of artists are acutely aware of what has come before them; yet they feel no compulsion to replicate or be defined by those cultural and creative legacies. They build new collectives, choosing to disassemble them once their point is made. There is no permanent space for sentimentality; when you realize that even the foundations of the city are mined and hollow, and constantly rebuilt in an ongoing cycle of physical extraction and reconstruction, the only conceivable choice is to redefine the space of engagement. By its nature, the avant-garde innovates or redefines the boundaries of what is known, familiar or anticipated; in Johannesburg, the only established convention is the restless change that drives creation and reconsideration. And in the art of this city, that remains the only concrete benchmark.

Zander Blom

Zander Blom's art production to date is mildly paradoxical. Both via his individual practice, and as part of the former collective Avant Car Guard (with Michael MacGarry and Jan-Henri Booyens), his choices and negotiation of subject matter have been ironic and, in some cases, impertinent in their experimentation with art history (especially modernism and modernist abstraction) as well as the perceived hierarchies within the South African art world. Yet his references to and explorations of these different legacies also pay them sincere homage.

The Drain of Progress (2004–07), *The Travels of Bad* (2007–09) and *The Black Hole Universe* (2009–present) are investigations Blom subsequently refers to as 'a kind of science of the picture plane', which he pursues by consistently altering perspective and technical means. These varied productions have found their key expression in extraordinarily restrained yet luscious explorations in oil paint, which reflect on Blom's early encounters with (Western) art history. In South Africa this education was mediated through textbook reproductions – photographs of original artworks – distinctively experienced through variations in quality of light, colour and size. This feature of the reproduction as the only point of access is crucial to understanding Blom's conceptual project, in which he endlessly creates contextual and aesthetic problems to solve.

In *The Black Hole Universe*, the difference between a photograph of a work and the work itself is a proposition for both the artist and his audience. The 'original' becomes a secondary notion, and, in Blom's hands, something malleable to interpretation. He playfully mimics abstract-modernist styles and motifs with makeshift materials (cardboard, tape and paint),

to build striking interventions into the corners of his home studio and occasional exhibition spaces. These temporary constructions, which echo Tatlin's *Corner Reliefs* (1914–15), he then photographs; afterwards altering or destroying them and circulating the photograph as the work. Blom's process is unsentimental; but his carefully staged interventions retain a certain immediacy and palpable edge, marked by a 'perverse seriousness juxtaposed with a charged sense of irony'.[14]

His paintings echo this approach. Many, such as *1.2 Untitled* (2010) and *1.38 Untitled* (2011) tease the depth of canvas or raw linen: oil, graphite dabs, lines and markings sculpt layers that emphasize surface while alluding to other perceptual planes. In *1.100 Untitled* (2012), the stain of separated oil bleeds onto an otherwise clean ground. The name of this series is at once specific and arbitrary; historically, the painting denotes an original, but for Blom it is clustered into a series of 'untitled' creative moments, definitive only in variation from other studies, and by means of a unique cataloguing number.

Blom's relationship to modernism is equally contradictory; he claims few things to be 'less relevant to his life than a Mondrian or Jackson Pollock'.[15] Yet these remain strong points of connection, which he works through self-reflexively. Recalling how the 'exotic' cultures and artefacts of Africa influenced the European avant-garde from the end of the nineteenth century, Blom astutely inverts the trend, claiming Western art as his 'exotic'. The artist's Brixton studio is littered with visual references from which he randomly selects, discards or draws influence, for both personal amusement and to push the possibilities of his own production.

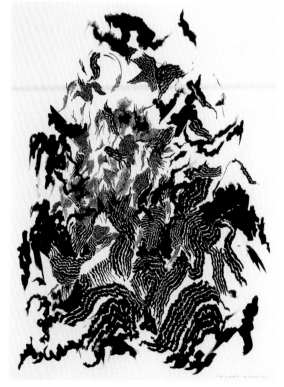

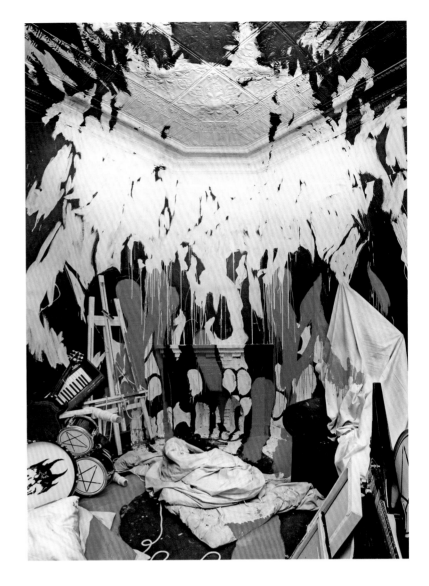

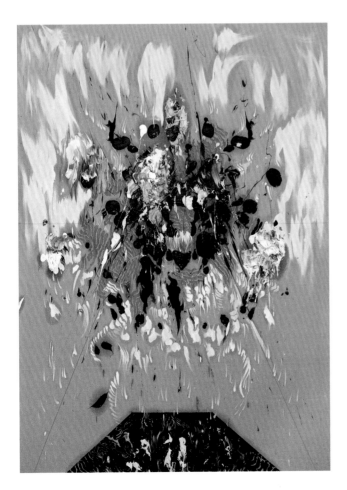

Dineo Seshee Bopape

Dineo Seshee Bopape's dense, accumulative and super-saturated aesthetic hums like a kind of disco surrealism: rich, eclectic collections and collisions of objects, sounds and images, spliced carefully yet incongruously together, culminate in vast, effusive installations.

The narrative threads to these elaborate manifestations are often tenuous. Just as they appear to hint at progressive storytelling, Bopape employs mechanisms to disrupt or distort coherence; time refuses linear containment, and prominent elements realize their dissolution. With an idiosyncratic visual language, Bopape delves into a quantum engagement with space, bounding between the densities of plane and surface, and constantly refracting between the thing and its fantasy; between the sensual experience of the here and now and the realm of possibility and imagination. She asks: 'If there is space within the virtual, how deep does it go? How far can a sound or an image recede?'[16]

Her video work *the eclipse will not be visible to the naked eye* (2009) plays entrancingly with these possibilities. Through what feels like a deep-space wormhole, Bopape zooms her viewer in to the relative blandness and two-dimensionality of a monotonous suburban landscape. It is the city where she was born, Polokwane, situated on the Tropic of Capricorn, and here revisited as an alien destination; nothing is stable about the representational plane in terms of how either time or space operate. The protagonist, a woman smartly turned out in a matching red ensemble of dress, hat and suitcase, is introduced coming around a dusty street corner to the sudden clucking of chickens. A striking anomaly in this terrain, she tries urgently to escape its dull continuity, moving hurriedly along windy, palm-tree-studded streets without obvious progression. Time speeds up, slows down, repeats endlessly. This activity is constantly interrupted by a variety of jarring inserts: radically oversaturated colour, glare and other visual effects, and occasional text or sound; which fracture and distort linear development, gradually becoming more insistent. Like *The Rocky Horror Picture Show's* final blast-off, in all of its B-grade psychedelia, something of a nuclear disintegration finally rends open a portal in the structure of the film to conclude the work's action. The only semblance of dull suburbia that remains is the urgent trill of a telephone ringing, visually subsumed into nothingness.

Bopape's three-channel video work *they act as lovers: microwave cosmic background: so massive that its decay opened the ultimate hole from which the universe emerged: effect no.55, 2 ends of a bent mirror* (2011) finds in the idea of the portal parallels to the zoom lens, peephole and tunnel. The work seems to reveal a Big Bang process of creation, with hallucinogenic, dreamlike sequences that ebb at its surface: organic images of water, growth and plant life modified by trippy colour effects. A conflation of cells, colours and amorphous forms, joining and dividing, uncoil into the image of an eye, omnisciently centred, radiating waves of metaphysical all-knowingness. The text 'RENDER!' appears on screen. An instruction usually manifest from the digital editing source, also repeated in her other video works, it echoes the artist's potential (and need) to create, to translate or otherwise cause to be. Bopape's rendering of space oscillates between organic and digital realms. Her sourced imagery and sounds together produce an edgy, uncircumscribed mélange of documentary, sci-fi and home-movie styles that depict things both free of and displaced by history – not entirely unlike her own frenetic movement in and out of Johannesburg and South Africa, and back again.

← *the problem of beauty*, 2009,
video, 7 min. 18 sec.

↑ *the eclipse will not be visible to
the naked eye*, 2009, video,
11 min 38 sec.

→ *they act as lovers: microwave
cosmic background: so massive-
that its decay opened the ultimate
hole from which the universe
emerged: effect no. 55: 2 ends
of a bent mirror*, 2010, 3-channel
video shown within an object
installation, 12 min. 14 sec.

→ *they act as lovers: microwave
cosmic background: so massive-
that its decay opened the ultimate
hole from which the universe
emerged: effect no. 55: 2 ends
of a bent mirror*, 2010

↳ Detail from *the eclipse will not
be visible to the naked eye*,
2010, installation with television,
rotating mirrors, linoleum,
dibond photographs, real plants
and artificial flowers, feathers,
plaster sculptures, fabric, ribbon
and other objects, dimensions
variable

Nicholas Hlobo

During the last decade, Nicholas Hlobo's creative vocabulary has had a substantial impact on the South African art landscape. His rich and intricate aesthetic language prompts reflection and discussion of sexual and cultural identity, through which he has adeptly expanded the nature of art as performance; a key component of his practice. In its most apparent guise, it is the occasional insertion of his own body into the work, to animate sculptures and sculptural environments, that is performative. But his pieces are performative also in terms of process – in their labour-intensive making as well as through the suggestion of performance that they display.

Born in Cape Town and raised in the rural Eastern Cape, Hlobo has worked in Johannesburg throughout his career, and consciously draws from these distinctive worlds and experiences in his work. Incorporating references of an auto-biographical nature, interpretations of cultural particularities (largely related to Xhosa heritage and queer identity[17]), as well as imaginative renderings and sociopolitical reflections, Hlobo weaves together these disparate threads through an unlikely combination of materials. His now-signature eclectic couplings of rubber inner tubes, ribbon, lace, leather, silicon, organza, satin, hosepipes and packaging material, among other things (which he also uses for his vast paper and canvas works) are at once allusive, imaginatively flamboyant and metaphorical at many levels.

Hlobo's recent series *Balindile I–V* (2012) is a case in point. Often invoking vernacular Xhosa idioms to title his works, here *Balindile* – which translates as 'those in waiting', or in his words, 'waiting with anticipation, fully charged with energy … ready for a command to set them free'[18] – introduces a series of five sculptural installations. While Hlobo's elaboration of the title infuses the reading of the work with a provocative charge, its suggestive materiality and complex structure provoke still further. Comprised by (in each serial variation) vertically draped, sultry drifts of rubber – alluringly rich and tactile, like skin – from which long and winding black rubber pipes protrude, these sculptures are evocative of fetish clothing and objects. Adorned with ribbons hanging from extending sections like long tasselled fringe; with embroidered seams which extrude along the pipe in several places; and hung with long steel chain, all the forms remain ambiguous. While they appear organic, humanoid and even sexual, playing with potentially masculine phallic forms, the simultaneous juxtaposition with fine materials, such as ribbon, disrupts the supple bulk of black rubber. Hlobo's is a delicate innuendo: a tangible tension between the surfaces and what might be revealed beneath its stitches. The relationship of form and material in *Balindile* seems to anticipate enactment or an undoing (a wheel of hosepipe attached to each form may turn or be turned). The works entice, stimulating desire, imagination and a potential for transformation. Who or what holds power or agency in these sculptural scenarios is not apparent; their power seems to exist along the seam between the real and the imagined, the tangible and the ethereal, yearning and fulfilment.

← *Imnkile*, 2012, mixed media
on Belgian linen canvas,
120 × 180 cm

↑ *Balindile I*, 2012, rubber
inner tube, ribbon, hosepipe,
steel, 160 × 50 cm

→ *Balindile IV*, 2012, rubber
inner tube, ribbon, hosepipe,
steel, 160 × 50 cm

↓ *Balindile V*, 2012, rubber
inner tube, ribbon, hosepipe,
steel, 160 × 50 cm

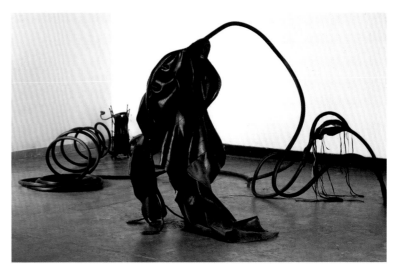

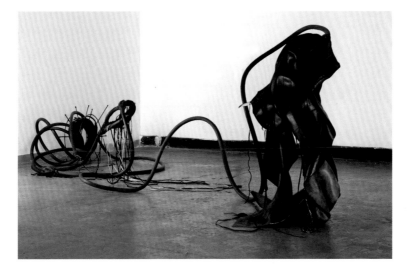

Moshekwa Langa

Moshekwa Langa's work marks a critical shift in the history of South African contemporary art. Diversely experimental, conceptual and self-reflexive, his output since the 1990s – and the end of the cultural boycott in the country, on the cusp of democracy – has not simply echoed the euphoric and promissory energy of the moment, but rather chartered new possibilities and conceived new visual languages for artistic expression.

He likes to call this style of expression 'baroque'. Not, of course, without a conscious (and ironic) nod to Western definitions of art, and the expectations brought to bear on his own project in relation to the continent where he was born and raised. While his medium shifts continually; through drawing, painting, installation, photography, three-dimensional mapping and landscaping, his consistent methodology is ultimately biographical.

Langa's astute practice is an existential one: a deeply personal register of himself as an individual, in the world. Moving between bases in Johannesburg, Amsterdam and many other cities internationally, his artworks reference this constant relocation, providing a singular point of consistency and connection. A key conceit that marks this interconnectedness is mapping, which manifests either as a physical intervention over standard geographical maps that lay claim to places of importance for the artist (as in *It came from outer space*, undated), via the convoluted linguistic trails that inhabit his

thought maps (*Archive*, 2002), as video (*Where do I begin?*, 2001), or as densely composed cityscapes fashioned from thread, bottles and other found paraphernalia (*Temporal distance (with a criminal intent), you will find us in the best places*, 1997–2009). All are complex means of journaling a diasporic way of life marked by longing and a subtle pathos. These works negotiate the artist's continual shifts across physical distance and across media, both emotionally and conceptually.

But it is in the various treatments of his portrait and landscape studies that Langa so remarkably pushes the parameters of a visual grammar. His brooding and darkly ambiguous self-portraits are profound psychological studies of human nature – whether the drawing is densely or thinly layered, or uncompromising and empty (as in *Lalie – for a loving father*, 2007–08 and *About Yesterday*, 2008). In works such as *Somebody is Always Willing to Tell* (2011), *Phenomene* (2008) and *Untitled (Boxer and Palm Trees)* (2011), the regular overlay of line, pigment and the occasional collaged element makes scrupulous reference to the unmasking of the surface. He has said: 'Appearances can be deceiving, as one learns. So I have been making a history of an unknown world, perhaps rather an uncharted territory… writing down remembrances of things past, people I left behind, as a kind of hybrid language showing this other space where there is really no narration, no sequence; where it is very subjective, and yet inextricable.'[19]

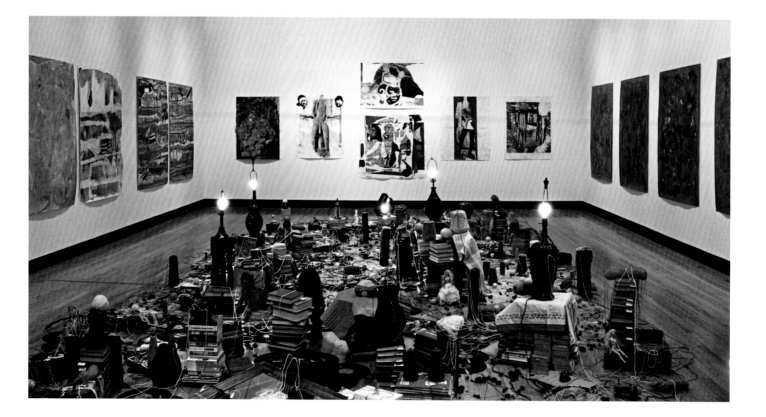

← 'Mogalakwena', 2012, installation
view at Krannert Art Museum,
University of Illinois at Urbana-
Champaign

→ *Somebody is Always Willing to
Tell*, 2011, mixed media on paper,
140 × 100 cm

↓ *Untitled (Boxer and Palm Trees)*,
2011, mixed media on paper,
140 × 100 cm

↘ *About Yesterday*, 2008, mixed
media on paper, 106 × 76 cm

Serge Alain Nitegeka

Serge Alain Nitegeka's art practice is an ongoing study of abstract space and transitional place. In a powerfully developing series of visual metaphors, he constructs a poetics of displacement that relates conceptually to forced migrations due to political and military conflict, especially within Africa.

Nitegeka was born in Rwanda and moved to Johannesburg in 2003. While personal narrative certainly informs the work, his overall thesis goes beyond biography to consider the nature of survival, contingency, dislocation, fracture and human gesture. Formally, he provocatively engages line and the picture plane. He works primarily with wood from packing crates to create sculptures, paintings and installations, using the minimalist colour palette of black, white and red paint, and more recently the pale gold of raw, exposed wood. His painted panels, including *Door Installation: Alternate Entry V* (2012), are exquisite plays on the reading of space: access versus opacity, recess versus barrier. His boxy sculptures contemplate containment and transit, while his large-scale interventions into physical space – complex wooden tunnels or entangled black beams – are deliberate disruptions, or 'obstacles' as he frequently titles them, that performatively disclose his extended visual metaphor.

While Nitegeka uses the language of minimalism, he consciously repositions it within the sociopolitical. Recurring titles such as *Fragile Cargo*, *Black Subjects*, and *Obstacle*, in tandem with his persistent black line, shift a clean and logical aesthetic into less stable territory. In a broad sense, his is a politics of line: that which simultaneously delineates and divides, disrupts and discloses; invites, directs, but also blocks progression. A border that excludes the 'foreign', the line, for Nitegeka, also alludes to those powerful invisible structuring devices – of bureaucracy, political administration and social bias – that establish territories in space and a sense of belonging.

The artist's first film work provides another take on the *Obstacle* series. These sculptural interventions compel viewers to navigate a precarious trajectory through cross hatched beams in the contained space of a gallery, and also provide impetus for his painted spatial studies. For *BLACK SUBJECTS* (2012), a group of performers are seen traversing the sculpture, enacting their bodily displacement and improvising a tortuous way through. Nitegeka describes the liminal space and unstable identity with which the performers contend as 'the in-between space of former selves and unknown would-be selves … a space where no plans are made and there is no luxury of hope'. Other works explore the sense of community that may arise in the face of such adversity, as in the sculptural intervention *100 Stools* (2011) at the Refugee Reception Centre in Marabastad, Pretoria, for which the artist delivered one hundred simple, handmade wooden stools to distribute among the many hundreds of displaced asylum-seekers waiting in line to become 'official' within the system.

The small, unassuming sculpture *Fragile Cargo VI* (2012) powerfully captures the weight of such displacement. In making this work, Nitegeka poured many litres of black paint onto the floor of his studio and left it to plasticize; he then folded up the resulting large, leathery skin, ultimately fixing it tightly within a rectangular wooden frame. The small package of the work thus belies its actual weight, compressing immense value and bodily 'baggage' into an appearance of minimalism.

↑ *Black Subjects vs Tunnel III*,
 2011, paint on wood, 2 panels,
 238 × 123 cm each

→ *BLACK SUBJECTS*, 2012,
 HD video

← *Fragile Cargo VI*, 2012, wood
 and paint, 22 × 49 × 22 cm

↓ *Door Installation: Alternate
 Entry V*, 2012, paint on wood,
 3 panels, 245 × 371 cm overall

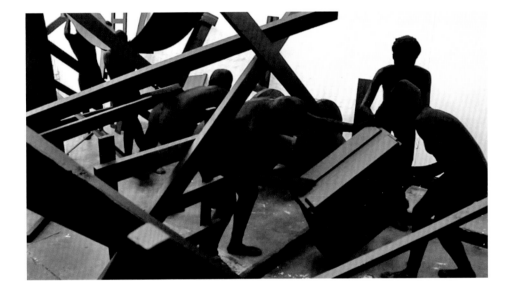

Tracey Rose

Tracey Rose is not afraid to act out. With an astute sense of timing, she is as playfully, angrily, emphatically, politically, stubbornly, ironically yet always unapologetically in-your-face as she chooses. An exhibitionist, unstinting performance artist and activist at many levels, she is at heart unashamedly humanist. She has been a live electric current on the Johannesburg art circuit (and resonating well beyond) since 1997, when she gracefully and incisively laid bare art history, racial and gender politics and social history in the works *Span I* and *Span II* for the second Johannesburg Biennale.[20] While performance remains central to her work, Rose is perhaps best-known for her elaborate videos, featuring multiple and multifaceted performances, often accompanied by photographic documentation and occasionally text paintings.

Rose makes no pretension for her work to feel comfortable, and it never does. Her serious themes may be couched in ironic humour or absurd pantomime, courting crass vulgarity as part of their critical means (leaving viewers to cringe or chuckle awkwardly) but there is no light touch in her treatment of a subject. She gleefully taunts popular sacred cows to expose injustices and other issues, showing contempt for hegemony in any form she perceives it to exist.

The Cunt Show (2007–08), a video documenting a performance Rose gave for 'Global Feminisms' at the Brooklyn Museum in New York, is one such example. So-called feminist artists from more than fifty countries selected for the exhibition were invited to discuss their work in an accompanying forum. Taking exception to the final outcome of the exhibition, its framing and the injunction to explain her work to an audience, Rose, dressed as the prudish headmistress Mami (from *Ciao Bella*, 2001), presented a caustic critique of institutional feminism, channelled through the voices of two sock puppets.

Produced as part of a televised art-making challenge to create a new digital film work in a mere five days,[21] *The Cockpit* (2008) puts God on trial. Patriarchal religion, a favourite *bête noire*, is accompanied in this instance by Rose's horror and disgust at a spate of then-current xenophobic attacks against immigrants to South Africa from other parts of the continent, which provides a sombre context to the film. Uncharacteristically, the artist is physically absent as a player in the tableau, yet completely present in every detail it embodies, from the panto-like costumes to the mildly absurd chaos that ensues. Rose designed, scripted and directed a group of actors in this eclectic dark parody. Assembled on the gaudy set of a soap opera, her characters, including Police Officer Jokerman, Jesus Potter Plotter, Brutus, Space Man, Lil' Bo Peep and the wise Redd Injun – culturally stereotypical parodies that have recurred in her work over the years – leisurely arraign God for the multiple charges laid against him, while gossiping amongst themselves about the artist's sexual exploits. *The Cockpit* is a world of murder, revenge and petty jealousy; where the mob ultimately sets upon the defendant to punish him with execution by the macabre South African means of 'necklacing' with a burning tyre.

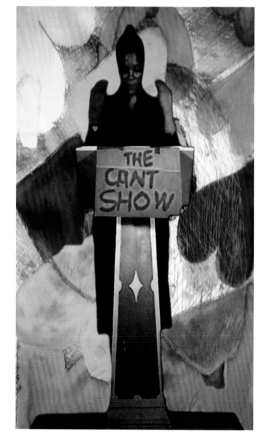

← *The Cunt Show Version 1.2.1*, 2008, diptych film

↑ *Lucie's Fur: The Prelude*, 2004, video installation

→ Police Officer Jokerman, from *The Cockpit*, 2008

Minnette Vári

Master of every medium she employs, be it installation, performance, sculpture, photography or digital video, Minnette Vári's oeuvre is profoundly imaginative and immaculately crafted. Traversing politics, mythology and trauma, her work steers viewers down unexpected paths. The body of the artist often functions as a key expressive instrument; and while other female South African artists have physically incorporated themselves in their works (Tracey Rose, Nandipha Mntambo, Senzeni Marasela and Penny Siopis), Vári specifically employs her own body as an amorphous cypher or receptive avatar, to explore new realms of being through tiers of visual data.

Vári's reflections on the sociopolitical history of South Africa also capture the chilling capacity for humans to transform into agents of brutality and political greed, as in *Alien* (1998) and *Oracle* (1999) (both re-examined in the *Remastered* series, 2011). These acute studies visually register the tumultuous 1990s but also comment on the sinister potential of human nature that lingers. Interpolating a vast mass of digital material in her videos, like a type of visual encryption too dense to take in yet residual within our consciousness, she constructs constantly morphing subjects from hundreds and hundreds of amalgamated images. Like an ectoplasm, this sea of data becomes momentarily eclipsed in a digital membrane that embodies Vári's constantly shifting projected form. The result is complex and penetrating. Still other video works, composed from spliced and assimilated footage, consider human behaviour through physicalized social structures, like cities, and their shifting power bases and populations over time (as in *Quake*, 2007).

More recent works push broadly recognizable human imagery – particularly digital news media – further, to explore global archetypes and collective mythologies. Earlier alluding to actual events, places and art-historical moments (such as the clear reference in *Oracle* to Goya's *Saturn Devouring His Son*, 1820–23), Vári's newer meditations seem to reach to the core of human consciousness. The buzz of digital imagery forms a background canvas in these works which cleverly echoes the action of consciousness itself: a process of absorbing, comparing, filtering and editing out surrounding stimuli and data, such that what remains at the edges has the capacity to morph into dreams, ideas or eventual action. In this way she uses technology as a means of performance, to explore what can be made visible through metaphor.

Totem (2010) is a digital construction of an amorphously conjoined body representing the different ages of woman: maiden, mother and crone. Projected as a writhing, towering form, this symbolically coded entity invokes a powerful lineage. Framed between swaying cypresses, symbolic of death or mourning, the mystical *Totem* represents the goddess triad, embodying the continuity of these female archetypes, and their collective and individual identity and power. Similarly, *Life of Baubo* (from the *Apotrope* series, 2011–12) imagines the pre-pagan goddess Baubo as a wise and sexually liberated female force. This familiar yet bizarre figure is awkwardly, and outrageously, comprised of a large head perched on a pair of legs. Interpreted as a physical manifestation of the human psyche, her legs and exposed genitals may be thought of as the id, her head and face the superego and absent middle the ego: the site of experience, personal narrative and social organization. *Baubo* thus becomes an ideal embodiment of the unconscious: free of inhibition and completely invested in her own intuitive power.

← *Quake*, 2007, single-channel digital video, 3 min., with stereo audio, 6 min. 23 sec.

↑ *Life of Baubo: Apotrope Series I–VII*, 2011–12, ink on Fabriano, 56 × 76 cm each

↓ *Oracle (Remastered)*, 2011, ink on Fabriano, 77 × 57 cm

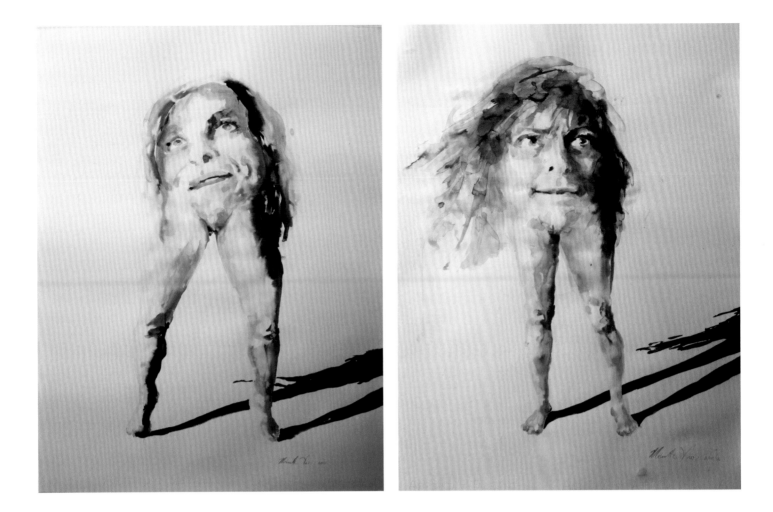

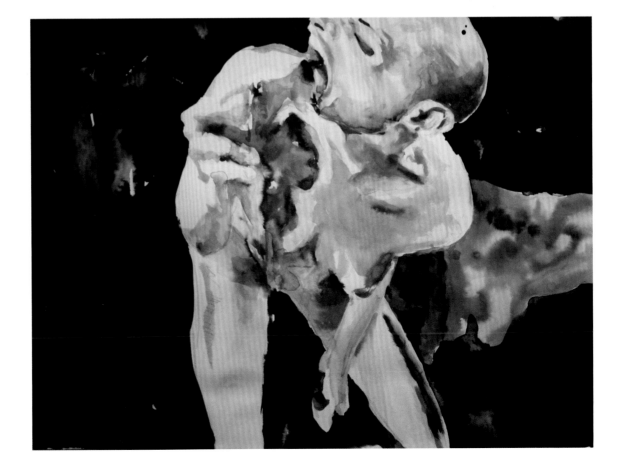

Kemang Wa Lehulere

Kemang Wa Lehulere has brought a thoughtful and rousing energy to the South African art scene in recent years. His interest in the potential of artist collectives, and in unearthing aspects of the country's sociopolitical history, has led him to play a key role in establishing creative projects and new means of telling history. In 2006 he co-founded the artist-led collective resource project Gugulective in Cape Town, where he grew up. Since relocating to Johannesburg in 2008, he has been a driving force behind The Center for Historical Reenactments (CHR), an independent research platform founded with artist and curator Gabi Ngcobo in 2010.

The early performance *Ukuguqula iBatyi 3* (2008)[22], which inspired an entire related body of work, was a symbolic act of exhumation for which Wa Lehulere dug out a hole in the ground over a period of three days using only an Afro-comb. Initially intended as a gesture of protest against the absurdity of racial identity classification – which remains a depressing reality even after apartheid – he came upon a buried skeleton, the remains of a cow, on the final day of digging (cattle had previously been kept on the property). This was a pivotal moment, as the find resulted in various family members and neighbours coming over to share their stories of the household and the area; revealing details Wa Lehulere had never before discussed with an older generation. The topic of South African history was strictly taboo in his childhood (his aunt was the first student shot in Cape Town during the 1976 student uprisings, a trauma that remained indelibly with the family). His work since has dealt with uncovering some of these lost or silenced narratives to create a form of archive; yet one that is imaginatively explored and simultaneously undone through the chafing of revelation and erasure within the realm of fiction.

His 2012 solo show at Stevenson gallery in Johannesburg, 'Some Deleted Scenes Too', delved into Wa Lehulere's interest in that which remains undeclared, or what has been edited out of the narrative to create or perpetuate a type of historical amnesia. The exhibition comprised the performance *Some Deleted Scenes* in conjunction with numerous small sketches and an elaborate wall drawing in white chalk on black paint, *Remembering the Future of a Hole as a Verb 2.1*.

Scripted by the artist, *Some Deleted Scenes* tells the story of a man capable of restoring images to now-blank pages after 'the fall of the stars', an event that erased all the memories in his community. Because a single star fell onto the man's arm, he became bearer of the history witnessed by that star. People from all over gather to have him restore their memories; but while trying to read the recovered texts and images his mouth suddenly fills with safety pins, so that the narratives are inaudible. The work ultimately presents a crisis of storytelling wherein the performance inhibits the script, leaving history open-ended and the archive incomplete. While there is a strong tradition of artists in South Africa who work with marginalized narratives,[23] and while CHR research projects question the nature of history to further the creation of an archive, Wa Lehulere offers a complicated stance on the nature of narrative in relation to historical fact. The confluence between drawn mark, filmed event, dramatized performance and written narrative in his work pushes his audience to consider history not as singular fact, but as a compilation of emotive and objective elements that are brought together, interpreted and often interpolated.

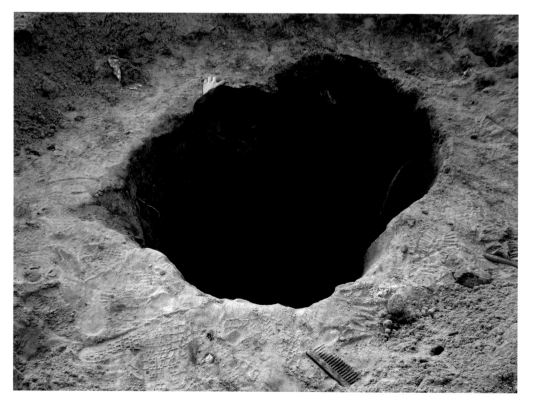

← *Ukuguqula iBatyi 3*, 2008, photographic documentation of performance

↑ *Remembering the Future of a Hole as a Verb 2.1*, 2012, white chalk on black paint, 273 × 1570 cm

↓ *Bearings for a Second Visit (4th Draft)*, 2012, ink on paper, from a set of 4 drawings, 41 × 31 cm

→ *Another Familiar Face*, 2012, ink on paper, from a set of 4 drawings, 41 × 31 cm

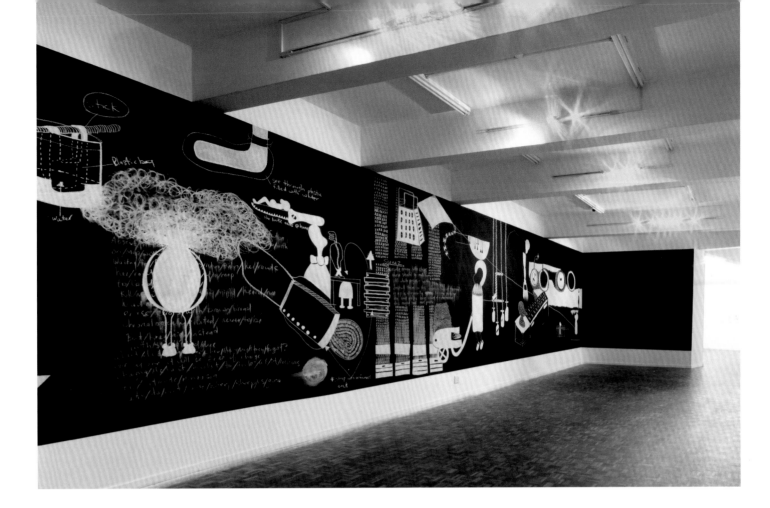

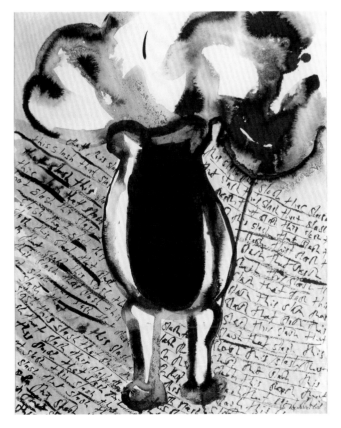

Lagos
by Antawan I. Byrd

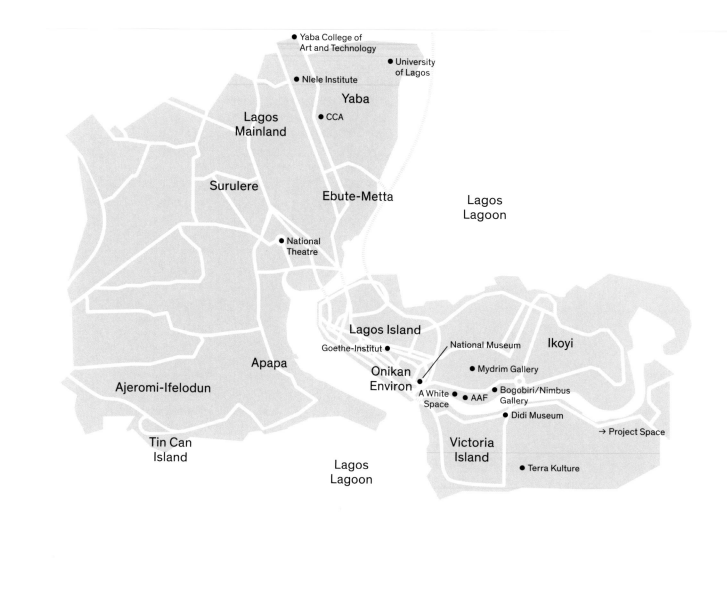

N

Yaba College of
Art and Technology

University
of Lagos

Nlele Institute

Yaba

Lagos
Mainland

● CCA

Surulere

Ebute-Metta

Lagos
Lagoon

● National
Theatre

Apapa

Lagos Island

Goethe-Institut ●

National Museum

Ikoyi

Onikan
Environ

● Mydrim Gallery

Ajeromi-Ifelodun

A White ● ● AAF
Space

● Bogobiri/Nimbus
Gallery

● Didi Museum

Tin Can
Island

Victoria
Island

→ Project Space

Lagos
Lagoon

● Terra Kulture

0 1 km

● African Artists' Foundation (AAF)
54 Raymond Njoku Road

● A White Space
58 Raymond Njoku Road

● Bogobiri/Nimbus Gallery
9 Maitama Sule Street

● CCA
9 McEwen Street

● Didi Museum
175 Akin Adesola Street

● Goethe-Institut
Lagos City Hall
Catholic Mission Street

● Mydrim Gallery
74B Norman Williams Street

● National Museum
Awolowo Road, Onikan

● National Theatre
Iganmu-Surulere

● Nlele Institute
3 Thorborn Avenue

● Project Space
2 Ekanem Close

● Terra Kulture
1376 Tiamiyu Savage

● University of Lagos
University Road

● Yaba College of Art and Technology
Herbert Macaulay Road

Attempts to convey the character of Lagos frequently draw on terms such as 'dynamic' 'energetic' or 'fast-paced'. While these words are often embraced to address the city's unique urban rhythms, its social temperament and spatial design, they also convey the logic underpinning its current artistic and cultural climate. Perhaps unsurprising given its population of more than fifteen million, today Lagos has the largest local art scene in West Africa, bolstered by more than twenty art and cultural institutions, a sizable local collector base, a strong art market and a profusion of artists working across a range of media. Like the ever-evolving city itself, the art scene is at times difficult to grasp, not simply because of its density, but also due to its multi-directionality.

Throughout its history Lagos has played a number of significant roles: a major hub of the nineteenth-century slave trade, an administrative base of the British colonial government in Nigeria until 1960, and the capital of the country's federal government until the shift to Abuja in 1991. Although the Yoruba make up the city's largest ethnic population, since the late nineteenth century Lagos has become the most vibrant and cosmopolitan city in West Africa, host to a rapid and ceaseless flow of people, cultures and identities. As writer and cultural critic Odia Ofeimun has observed, 'Lagos always was and is Nigeria's closest example to the idea of a melting pot … a culture of inclusiveness that fuses the best and the worst in ways that have promised if not quite delivered on a grand ethic of nation-building'.[1] By the mid-twentieth century the city had become a locus of creative and intellectual ingenuity, pan-African dialogue and nationalist activity.[2] During this period, and especially in the years bracketing the country's emergence from colonialism, Lagos wielded a heavy influence on the imagination of political leaders, writers, musicians and visual artists across West Africa and beyond. Beginning in 1966, however, the country suffered bouts of civil and political unrest including sustained military regimes, which adversely affected social and infrastructural development.

Although the art sector also experienced setbacks, under the dictatorship of Olusegun Obasanjo, Lagos State hosted the mammoth Second World Black and African Festival of Arts and Culture (FESTAC '77), which suggests that the country's political upheavals did not completely deter local culture. In 1983, Dr. (Chief) Newton Chuka Jibonoh established the Didi Museum, the country's first private non-profit art institution. With the imperative to preserve and display Nigeria's artistic heritage, the museum became notable for exhibiting vanguard Nigerian Modernist painters such as Yusuf Grillo, Bruce Onobrakpeya and Ben Enwonwu as well as traditional bronze works from Benin and Ile-Ife.[3] Its collection intends to represent classical and modern art practices throughout the country, and Africa more broadly. The museum also organized seminal contemporary art exhibitions such as '…Unbind Me' (1988), the first solo show of mixed-media artist Olu Oguibe. After a period of sporadic activity, in 2012 Jibonoh renovated the one-storey building on Akin Adesola Street in Victoria Island, reopening the museum with a photography exhibition by Kelechi Amadi-Obi.

As a non-profit endeavour, the Didi Museum highlights the ways in which the city's cultural infrastructure – especially after democracy was restored in 1999 – has depended on individual or collective private efforts. This is particularly so given the limited resources of the country's national museums. While most commercial galleries, clustered in the affluent neighbourhoods of Victoria Island and Ikoyi, tend to focus on conventional painting and sculpture, some commercial institutions like Mydrim Gallery (established 1992), the Nimbus Art Centre (established 1997), the now defunct Pendulum Art Gallery (founded by the late Peter Areh in 2000) and Terra Kulture (founded 2003) have played an important role in cultivating collectors and providing support and visibility to local practitioners and those from other regions of the country. In 2001, for example, Mydrim and Nimbus co-hosted the groundbreaking exhibition 'New Energies' organized by the Ghanaian, Nigerian-based sculptor El Anatsui. Featuring the work of artists from the

University of Nigeria in Nsukka, the show boldly transgressed local conventions through its emphasis on installation and, for the first time, video art.[4]

Over the past two decades, alternative spaces have proliferated in regional cities such as Accra, Cotonou, Dakar and Douala, so it comes as no surprise that such institutions have led the way for cultural and artistic expression in Lagos. In this regard, 2007 was a watershed year for the city's contemporary art scene, when independent curator Bisi Silva founded the Centre for Contemporary Art, Lagos (CCA), which currently consists of a gallery, a residency and the largest art library in West Africa.[5] Situated in Sabo, Yaba, a neighbourhood on the mainland, CCA's strategic location shifted the geography of the city's contemporary art scene. Beyond signalling an alternative spirit, this location also facilitates collaborations with students from the nearby University of Lagos, as well as the city's foremost art academy, Yaba College of Art and Technology. CCA's own informal training programmes, run by a changing roster of local and international artists and curators, have begun to explore alternative pedagogical models for art in Lagos.

With its strong focus on research and archival documentation, CCA was initially conceived as an autonomous library, but soon opened a laboratory-like gallery space for exhibitions, workshops and other projects of public discourse. Beginning with 'Democrazy' (2007–08), a trilogy of politically-charged exhibitions chronicling Nigeria's recent history and the subsequent impact on art and culture, CCA has continued to show challenging and experimental artwork by Nigerian and international artists. The controversial exhibition 'Like A Virgin' (2009), featuring work by Nigerian artist Lucy Azubuike and South African artist Zanele Muholi, broached issues surrounding gender, sexuality and lesbianism in ways previously unexplored locally, eliciting heated debate in the city's often-conservative art community.[6] 'Identity: An Imagined State' (2009) was the first international video art exhibition organized in Lagos.[7] Co-curated by Jude Anogwih and Oyinda Fakeye of CCA, it led to the formation of the Video Art Network (VAN) in 2011, a Lagos-based independent platform Anogwih and Fakeye established with artist Emeka Ogboh.

The Omooba Yemisi Adedoyin Shyllon Art Foundation (OYASAF) also emerged in 2007 as a vital resource for scholars of Nigerian art. Founded by Lagosian collector Yemisi Shyllon, it boasts one of the most important collections of classical, modern and contemporary Nigerian art in the world, with substantial holdings of work by pioneering painters such as Aina Onabolu and Akinola Lasekan, and early sculpture by El Anatsui. Recalling the ambitions of the Didi Museum, OYASAF aims to promote cultural heritage. The non-profit African Artists' Foundation (AAF), directed by Azu Nwagbogu, also opened in 2007 in the Ikoyi neighbourhood. In addition to its focus on painting and sculpture, the foundation gradually began to support video and photography, launching the international festival Lagos Photo in 2010. A stone's throw from AAF, the city's first conceptual pop-up, A White Space, was initiated in 2010. And artist Emeka Udemba established Project Space in 2012 to support artist-led curatorial interventions and installation, video and performance practices. Located in semi-remote Badore, about ten kilometres from Victoria Island off the Lekki-Epe expressway, Project Space adds to the spatial dispersion of the local art scene.

Because of the dearth of state funding for art in Nigeria, many small-scale organizations adopt multi-layered strategies for sustainability, relying on support from international cultural institutions and, increasingly, local corporations. Since 1962 the Goethe-Institut has impacted the city's art scene, and under the tutelage of directors Renate Albertsen-Marton, Arne Schneider and Marc-André Schmachtel it provided a forum for serious debate on media and other experimental art making, as well as early support for artists such as Dilomprizulike and Emeka Udemba.[8] Formerly located in Victoria Island, the Goethe-Institut moved into a smaller space on Catholic Mission Street in Lagos Island in 2011, where it has increased collaborations with other art organizations; for example, co-organizing the city's inaugural performance art festival, Lagos_Live, in 2012. Beyond institutions, a surge of artist initiatives have promoted

↑ Ojuelegba Transportation
Terminal

↓ LagosPhoto 2010, large
format public installation on
bamboo frames

↘ Dancers at the New Effect
Network building in Computer
Village, Ikeja, Lagos

↓ A library project for the
History/Matter International Art
Programme at CCA, 2012

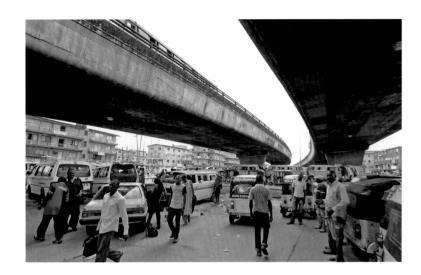

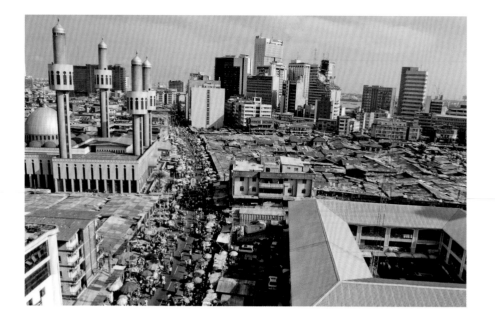

↑ Eko, Lagos Island

↓ Members of the Invisible
Borders Collective at Millennium
Monument, Goha Bridge,
Ethiopia, 2011

↙ Jide Alakija, 'Owambe,
Aso-Ebi and the Politics of Dress',
insallation view at CCA

↓ 1004 Housing Estate, Victoria
Island, seen from Lagos Lagoon

ideas of civic exchange among the city's diverse population. In 2011, artists Richardson Ovbiebo, Victoria Udondian and six others collaborated on *A Kilo of Hope*, a five-day residency at a landfill in the Lagos suburb Oke-Afa, Isola, which engaged the community in re-commodifying refuse materials. Although this emphasis on environment and materiality is not new – precedents can be found in the work of prominent Lagos artists Ndidi Dike and Olu Amoda – *A Kilo of Hope* demonstrated how the younger generation is responding locally and creatively to persistent issues of globalization and environmentalism. Such projects disclose a key reality of the city's art scene: though greatly diverging in concept, style and media, a strong sense of fellowship and a mutual interest in contemporary art's critical possibilities are points of cohesion for Lagosian artists.[9]

This fellowship is most pronounced in recent artist collectives, especially in photography, which has gained prominence due to its critical potential and portability. In 2001, the Depth of Field collective (DOF) began to elaborate on the work of pioneering photographers J. D. 'Okhai Ojeikere, Don Barber and Sunmi Smart-Cole by examining the cultural life and social realities of the city. During the intense political period following Nigeria's reinstated democracy, the six members of DOF met weekly to exchange ideas and devise means of documenting city transformations.[10] Formed in 2006, the Black Box collective differed from DOF in its elastic approach to collaboration, allowing for varying styles and independent modes of engagement.[11] Although both collectives were mostly inactive by the late 2000s, many members have since organized independent civic-oriented projects. Black Box's Uche Okpa-Iroha inaugurated the Nlele Institute (an academy-style enterprise), while his cousin, Uche-James Iroha of DOF, kickstarted the community-building initiative Photo.Garage which promotes photography as a tool for socially conscious art.

In 2009, artists from both collectives joined Invisible Borders, a Trans-African project started by Emeka Okereke of DOF.[12] Using photography to convey the practical and political challenges of transnational travel within Africa, the project provides an international discursive platform for artists, writers and cultural institutions, and is the most ambitious collaborative endeavour on the part of Nigerian artists in recent years. Painters Uthman Wahab, Cyril Oma, Soji Adesina and others established the Bunguru Collective in 2012. Producing large-scale, often satirical figurative work, the group attempts to reinvigorate the genre of painting; examining the cosmopolitan culture of Lagos from vantage points of globalization, urbanism and sovereignty.[13]

There are many other independent projects and artist-led initiatives that have emerged in recent decades, which still demand rigorous examination. However, the aforementioned developments are noteworthy for the ways in which they foreground the city as a living entity, entertain the complexities of contemporary life and exemplify the enterprising and resourceful spirit characteristic of Lagos and its inhabitants. Though local in their impact and orientation, these developments in the art scene are influenced by, or link to, broader global networks, reinforcing the cosmopolitanism that is key to the city's identity. While this account seeks to convey the current temperature of the art climate in Lagos, there are still many hurdles for the city to overcome, particularly in the way of publishing initiatives, curatorial practice, art criticism and education. Notably absent is a biennial system to mediate and present new forms of practice emerging globally, and provide valuable links between artists and institutions in other parts of the world. However the growing international buzz surrounding ambitious local institutional and artist-led projects suggest that this port city will be a vital capital for contemporary art and culture through the twenty-first century.

Jelili Atiku

An activist whose practice is premised on the advocacy of human rights and the promotion of social justice, over the years Jelili Atiku has dedicated his art to raising social consciousness. Although working in sculpture, drawing and video, it is primarily his performance art – a medium underrepresented locally – that has positioned him at the forefront of contemporary art in Lagos. While precedents can be found in the work of Dilomprizulike and Uche Edochie, who began to integrate performance into their mixed-media practices in the early 2000s, it is Atiku's serious disciplinary engagement and spectacular theatrics that distinguish him from his peers.

Among his most ambitious endeavours is *In the Red* (2008–present). Taking place on the streets or within institutional contexts in cities such as Lagos, Cotonou, Lomé, Kampala, Harare, Tokyo and London, this project derives its title from Atiku's attire: a head-to-toe bodysuit wrapped with dangling red bandages. While, for the artist, the colour alludes to life and death, vitality and mummification, the costume and the spontaneity of his performances are generally inspired by both the political activism of an artist like Joseph Beuys and Yoruba *Egungun* masquerade traditions which commemorate the dead through ancestral worship. Atiku typically presents himself as a spectacle – suspended by rope from the side of a building, disrupting the flow of overcrowded streets or posing as a public monument – in order to stimulate awareness of global or place-specific political issues.

The 2009 performance *Agbo Rago* marked a significant turning point in his practice. 'Agbo', a Yoruba word for market or community, and 'Rago', meaning ram in Hausa, name the setting for the work: a privately owned ram market in the artist's hometown of Ejigbo, outside Lagos. Wrapped in cellophane plastic with meat secured around his neck, Atiku allowed himself to be dragged around the market, shrieking alongside onlooking rams. Described by the artist as a form of installation theatre, *Agbo Rago* attempted to realize the metaphor of 'being treated like an animal' as a means of calling attention to social and political injustices suffered by marginalized subjects. The hour-long performance was witnessed by a sizable crowd of locals and a number of critics and writers who were participants in the project. In 2011 he published his first fully illustrated catalogue, *Agbo Rago: Jelili Atiku in Performance*, through the independent press Atekchu Forms Limited, with editorial contributions by select audience members. A component of his practice specifically intended to document exhibitions and performances, Atekchu Forms Limited is a response to the lack of critical contemporary art publishing initiatives in Lagos, as well as a facet of the artist's engagement with topical discussions of the ephemerality of performance practice. For Atiku, a publication is not simply an inert record of a live event, but rather a continuation of the performance; its physical circulation should highlight many of the same issues as the work itself.

Recent performances still bear the political traces of his earlier works, such as *Cain's Feast* and *Abel's Feast* (both 2012), in which the slaughter of animals for food is used to explore the question of human sacrifice in the name of religion, particularly in the context of Nigeria's recent history of jihadism. But Atiku has also begun to shift his focus to more intimate concerns, exploring ways to imbue the performing body with elements of personal memory and family history.

← *Cain's Feast*, 2012, performance in Yaoundé, Cameroon

↗ *Red Light* from *In The Red Series #06*, 2009, performance at Community Market, Ahmadu Bello University, Zaria, Nigeria

↑ *Reddendum* from *In The Red Series #05*, 2009, performance at the Fine Arts Department, Ahmadu Bello University, Zaria, Nigeria

↓ *Agbo Rago*, 2009, performance in collaboration with The Crown Troupe, Ejigbo Ram Market, Lagos

Andrew Esiebo

Andrew Esiebo looks at how local cultural concerns operate within broader terrains of inquiry. This approach has resulted in several complex projects, the most compelling of which reflect an ethical engagement and social consciousness. With a background in journalism, Esiebo began his training in photography in 2006, participating in a string of local and international workshops through which he cultivated comparative and heterogeneous modes of working. These experiences informed a practice that broaches issues of sexuality and masculinity in ways that few of his Lagos contemporaries have attempted.

In *Alter Gogo* (2010), the artist expanded his interest in African football culture by engaging the Gogo Getters, a team of grandmothers living in Orange Farm, a town outside Johannesburg. Wanting to complicate perceptions of football as a quintessentially male sport, the project unfolds as a series of diptych portraits capturing the elderly women within domestic settings and as uniformed athletes on the pitch. The dual portrait seeks to represent each woman as empowered, complicating generational identity and deep-rooted notions of the African female body as a site of oppression.

Due to the practical difficulties of working on LGBTQ issues in Nigeria, where homosexuality is strictly illegal, Esiebo began to explore this subject while in France. His earliest foray into film, the documentary *Living Queer African* (2007), is a compelling portrait of a young Cameroonian student, Rene, who struggles with the gay and African dimensions of his identity. The experience of producing this film, and its subsequent critical support, confirmed for Esiebo the need to investigate these issues amid recent cultural and political upheavals at home. Since 2008, he has cultivated relationships with underground LGBTQ alliances in Lagos, resulting in the 2010 expansion of *Living Queer African* through an ongoing series of deeply affecting portraits. Recalling the formal character

of Zwelethu Mthethwa's portraiture, Esiebo's photographs are typically shot within domestic interiors. In works such as *Untitled VI* (2010), and others from the series *Who We Are*, he portrays the confidence of his sitters in defiance of the conservative social forces that attempt to circumscribe their experiences. The bifurcated pictorial structure of *Untitled (Jide Macaulay)* (2011), in which a priest stands adjacent to a gay pride flag, alludes to the perceived incompatibility of homosexuality and religion in societies the world over. It portrays the openly gay Nigerian Reverend Rowland Jide Macaulay in London, after years of self-imposed exile prompted by violent reaction to his gay rights advocacy in Nigeria. The question of faith which features in many of Esiebo's portraits is also echoed in *God is Alive* (2007–present), a body of work that examines the influence of Pentecostal and Evangelical religion on Ghanaian and Nigerian culture.

Touching on masculinity, *Pride* (2012) conveys how respect and honour condition transactions between barbers and their clients. Inspired by male hair culture in Lagos, the work is a comparative photographic ethnography unfurling across the West African cities of Lagos, Cotonou, Accra, Abidjan, Monrovia, Dakar, Nouakchott and Bamako, that consists of approximately three hundred images taken over the course of five months. Documenting both interiors and exteriors of barber shops, as well as before-and-after shots of particular haircuts, Esiebo's atlas reveals at once the mutation of particular hairstyles in the region, the influence of international popular culture and self-fashioning trends and expressions of masculinity and spiritual faith. If *Pride* is an elaboration of Nigerian photographer J. D. 'Okhai Ojeikere's seminal *Hairstyles* project (begun in 1968), it is perhaps because Esiebo too acknowledges the constantly evolving and continued relevance of hair as a signifier of cultural identity.

← *Untitled*, from the series *Pride*, 2012, digital photograph printed 200 × 80 cm, dimensions variable

↑ *Untitled*, from the series *Pride*, 2012, digital photograph printed 120 × 80 cm, dimensions variable

↓ *Untitled*, from the series *Alter Gogo*, 2010, digital photographs each printed 136 × 100 cm, dimensions variable

↳ *Untitled*, from the series *Who We Are*, 2010, digital photograph printed 120 × 80 cm, dimensions variable

Peju Layiwola

Peju Layiwola's practice spans that of studio artist, art historian, cultural activist and university professor, yet without assigning hierarchies to the presumed responsibilities of each role. Instead she deploys an array of methodologies, from creative to academic, on long-term interdisciplinary projects. She has been much influenced by her mother, Princess Elizabeth Olowu, also a cultural activist and among the first female bronze-casters in Nigeria, where this particular mode of production has historically been dominated by men. Because art played a major role in her early childhood development, Layiwola maintains a sense of civic responsibility with regard to the cultural sector, especially in advocating the work of female artists and arts education among youth, which led her to establish the Women and Youth Art Foundation in 2004. An independent community arts initiative, the Foundation seeks new paradigms for civic engagement in Lagos and throughout Nigeria.

As an artist, she works predominately in metal, specifically bronze, in addition to some printmaking and mixed media installations. Regardless of the medium, however, the recurring themes in her work include history, memory and cultural expropriation – particularly from the vantage point of the West African Kingdom of Benin, from which Layiwola is descendant. Among her most ambitious projects to date is *Benin 1897.com: Art and the Restitution Question* (2010–11), a comprehensive meditation on the infamous 1897 punitive expedition. When British troops invaded the city of Benin (today the capital of Edo State, in southern Nigeria), they captured and destroyed the city, looting as many as four thousand artefacts including the acclaimed Benin Bronzes, which had constituted the kingdom's cultural archive for more than 500 years. The artefacts were subsequently dispersed throughout Europe and America where the bulk of them can be found today, in the public collections of the British Museum in London and the Ethnologisches Museum in Berlin, among others.

Years in the making, the complex collaborative project featured a travelling solo exhibition of installations and sculptural works by Layiwola; a series of workshops and symposia at several Nigerian universities; and a publication (co-edited by writer Sola Olorunyomi) engaging questions of expropriation and restitution, which featured contributions by international scholars. Bridging theory and practice, Layiwola elaborated on her extensive knowledge of Benin art production and the history of the 1897 expedition to create a range of potent works that, both technically and formally, index the objects looted from the royal palace. Produced over the course of a year, *Benin 1897.com* consists of approximately one thousand meticulously executed mold-cast and fired terracotta sculptures of various heads and plaques. Some were partially wrapped in copper foil and glazed with pigment while others were intentionally broken and dismembered – gestures that amplified the visual correspondence to their ancient referents. The series of newly produced sculptures were then piled onto gallery floors to evoke the placement of the stockpiled artefacts as depicted in archival photographs of the expedition.

Neither an attempt to restage the events of 1897, nor produce surrogates for long-gone objects, Layiwola's intervention more explicitly explores strategies for registering memories of the past in the present through material form. By creating works linked to Nigerian history, Layiwola's sculptures, and the larger projects in which they are situated, aim to combat cultural amnesia. Her installations provide a space of reflection in which viewers can both return to significant pre-colonial historic moments and also confront the injurious effects of those moments and their impact on contemporary culture locally.

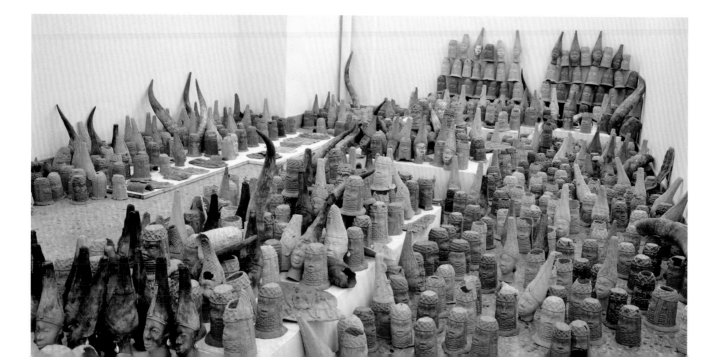

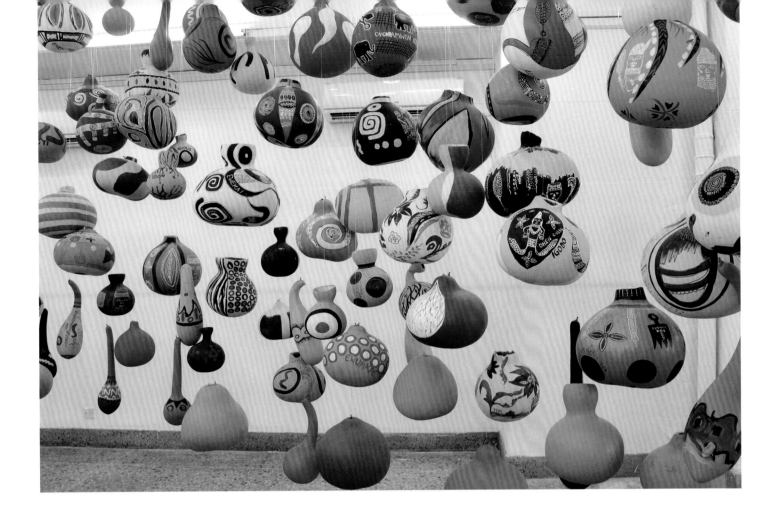

← *1897.com*, 2009, installation with terracotta, inlaid copper, twine, cowrie shells, cow horns, wood, acrylic paint and brass foil, dimensions variable

↑ *Oba Ghato Okper (Long Live the King)*, 2009, installation with gourds, fishing line and acrylic paint, dimensions variable

→ *Theatre of War* (detail), 2009, terracotta and copper wire, 200 × 210 cm

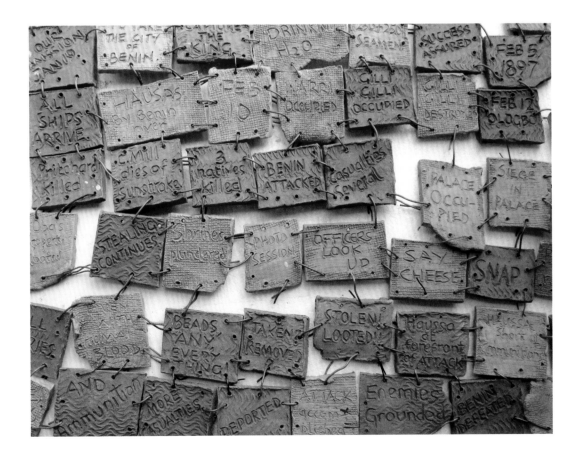

Emeka Ogboh

Among an emerging generation of contemporary Lagosian artists embracing digital and mobile technology, Emeka Ogboh is one of few whose practice consistently and rigorously engages sound, audio technologies and social media, in addition to his work in video. Following his 2008 participation in the Fayoum Winter Art Academy in Egypt, he began to engage the sonic dimensions of Lagos through a series of local and international collaborations, ultimately resulting in the seminal sound-mapping project www.lagossoundscapes.com. Using sound to convey the infrastructural changes and shifting cartographies of Lagos, Ogboh's art foregrounds how the city's recent transformations have contributed to new modes of social interaction. Though this focus on the local marks a significant departure point, his work is as compelling when it participates in international arenas.

Based on movement and dialogue, the formal and theoretical structures of Ogboh's work seem to follow the 'back and forth' logic of the prefix re-, found in the key terms of his artistic vocabulary: record, remix, repetition, reflexivity and return. While 'recording' is often used to describe his work, it better articulates the method by which he captures his basic material. Ogboh typically relies on microphones to create sonic representations of areas in Lagos that suggest its status as a megacity: booming marketplaces, busy transportation terminals and the boisterous interiors of public buses known as danfos with their characteristic sounds of shouting conductors, loud music, and multilingual conversations. After archiving these unedited recordings, Ogboh manipulates and engineers them into complex compositions for integration into site-specific installations, videos or internet-based artworks. His video works are also largely concerned with the urbanism of Lagos; and as a co-founder of VAN (Video Art Network), he has organized training workshops and exhibition projects at the Centre for Contemporary Art, Lagos, as well as universities throughout Nigeria and internationally.

Through headphones or loudspeakers, listeners typically encounter Ogboh's work by way of indoor or outdoor installations, or both. For Lagos By Bus (2010), exhibited at the Rautenstrauch-Joest-Museum in Cologne, the artist erected a three-dimensional cadmium-yellow enclosure within the exhibition space; it was adorned with black stripes and stickers bearing local expressions that referenced the distinct aesthetic of the danfos. In another installation at the Museum for Contemporary Art Kiasma in Helsinki, Ogboh presented two unique compositions of varying length in the form of the two-part installation This is Lagos (2011). Near the museum entrance a series of loudspeakers projected a repetitive loop of sounds onto the streets of Helsinki, resulting in a sonic mélange of two urban spaces. Inside, listeners intimately engaged another of the artist's compositions through headphones tethered to a signpost with its directional elements spelling out: LAGOS.

Like the Cologne installation – and others in Madrid, Roskilde and Manchester – the components of the Helsinki work strategically implicate the institution and the listener in a sensory experience that establishes a dialogue between two geographically distant places. If the clamour operates as exotic noise or a kind of unintelligible speech, it also rings familiar. Replete with references that embed the sounds within the specific spaces and tempos of Lagos, the discordant structures also resonate with the rhythm of major urban cities globally. In this way, Ogboh's installations create auditory experiences that complicate binaries between here and there, native and alien; compelling listeners to acknowledge the capability of sound to alter perceptions of time, space and cultural proximity.

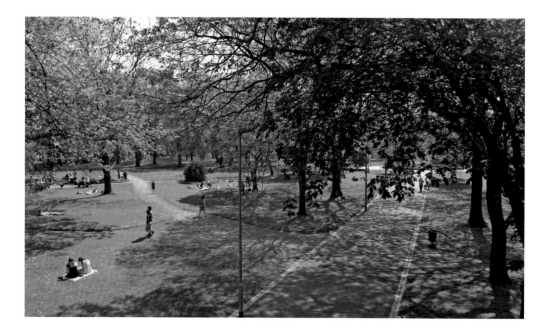

← *LOS-MAN: Whitworth Park*, 2012, site-specific sound installation on loudspeakers for 'We Face Forward', Manchester

↑ *Lagos Soundscapes*, 2010, sound installation with loudspeakers, painted wall, stickers and text

↓ *This Is Lagos: Part III*, 2011, signpost, approximately 304 cm

↘ *Mic and the City 6*, 2010, digital photograph, 40 × 26 cm

Abraham Oghobase

Abraham Oghobase's photographic practice engages notions of human emotion, absence and animation by exploring the visual character of cities. A graduate of the Yaba College of Technology in Lagos, his early art training was supplemented by formal apprenticeships with acclaimed Nigerian photographers Deji Ajose and Uche James-Iroha, followed by participation in several international workshops and artist residencies. By now photography is commonplace on the Nigerian contemporary art scene, but Oghobase's work stands out for its highly personal approach – often deploying his own body as a conceptual device – which differs from the largely documentary work of his local counterparts.

During a 2007 residency in Berlin he created the seminal body of work *Lost In Transit*, a series of black-and-white portraits shot on film. In this series, Oghobase constructs a visual narrative chronicling his experiences of ambivalence and solitude resulting from personal attempts to bridge cultural differences. This exploration of emotional and physical space developed into a key theme in his subsequent work.

In 2009 Oghobase elaborated on the Berlin pictures, examining distance by way of proximity, but focusing this time on his relationship to the city he calls home. In *Ecstatics* (2009), we encounter the artist's suspended body jockeying against gravity in an upward flight from an abandoned bus, his extended arms at once suggesting catharsis, euphoria and freedom. Conceived in response to the contentious dynamic of Lagos – resulting from its notorious congestion and overpopulation – the series operates as a performative meditation on the connection between individual subjectivity and locality. The pictorial structure of these images positions the city as a space of becoming, strategically emphasized by the way in which a narrative develops across individual photographs in succession. Oghobase's interest in transitional space is apparent in *Are We Humans?* (2010), which poetically captures, in black and white, the interiors of domestic spaces in the artist's neighbourhood, abandoned by their residents due to financial difficulties or other extenuating circumstances. The uninhabited photographs reveal only slight references to human presence by way of discarded possessions – clothing, posters, dishes – marking an investigation into the nature of traces and photography's evidential character.

Oghobase has extended the concerns of *Ecstatics* into an untitled body of photographs which register the economic and aesthetic potentiality of Lagos. *Untitled (Piano Lesson)* (2012) depicts the artist playing an imaginary piano, taking cues from the advertising copy scrawled on the wall before which his body is suspended, in a manner reminiscent of performance-based photography by South African artist Robin Rhode. This series documents the informal marketing strategies entrepreneurs and others devise to secure visibility in the city by means of graffiti or pasted-up street signs. In a culture where scamming and other illicit activities are pervasive, such advertisements are quickly overlooked; their use-value ultimately reduced to an aesthetic. Oghobase's satirical performance partially obstructs the legibility of the advertisements, and their function, instead amplifying their formal potential. In this way, his photographs propose a method for visualizing the city based on strategies of interactivity and animation.

← From the series *Ecstactic*,
2009–10, colour photograph,
each 90 × 60 cm, overall
90 × 240 cm

↑ From the series *Are We Humans?*,
2010, black and white digital
photograph printed 34 × 52 cm,
dimensions variable

↓ *Untitled*, 2012, black and white
digital photograph printed
152 × 101 cm, dimensions
variable

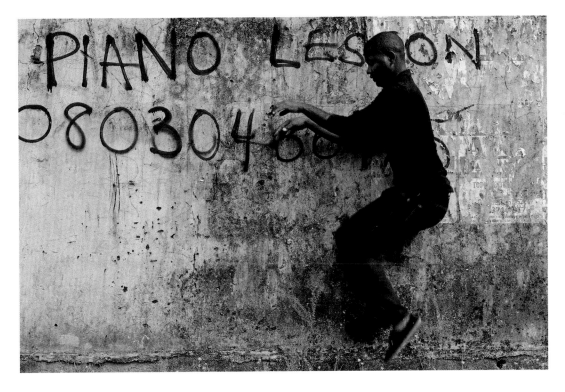

Temitayo Ogunbiyi

By means of art production, critical writing and exhibition making, Temitayo Ogunbiyi is part of a new generation of artists exploring the influence of social media on everyday life. Born in the United States to Nigerian and Jamaican parents, she lived in New York City and Yallahs, Jamaica, before relocating to Lagos in 2011. The sense of becoming in her transformative works, which emph size ideasof chance and openness, is frequently at odds with local expectations for artworks that articulate formal resolution, perhaps especially on the part of traditional or conservative Lagosian collectors. Her exhibitions occasionally mutate during their public presentation, as she modifies elements of works or installation configurationsin response to her interactions with viewers. It is this sense of reflexivity and dialogue that characterizes her expanding oeuvre as she investigates aspects of the environment, fashion, textile production and social media.

Ogunbiyi's early collages suggest an interest in biological processes through acts of suture, repetition and regeneration. In *Topographic Keloids* (2010), collages on large grounds of torn and misshapen white paper, the artist grafts printed transparencies of landforms onto graphite renderings of keloid lesions to produce composite visuals of disfigured topographies. The artist's partial structural geologies put forward a surface view of the world as fragmented and supported by nodular forms of excess growth, effecting a subtle visualization of the traumatic realities of ecological transformation and geopolitical upheaval that have become part and parcel of contemporary life.

Ogunbiyi's preoccupation with repetition and fragmentation is most pronounced in her digitally printed canvas textiles. In her Ikeja studio located in Lagos's 'Computer Village' – reputedly the largest market in West Africa for technological goods – the artist digitally reconfigures screenshots, tweets, e-mails and text messages mined from websites and mobile phones. She subverts the instantaneously communicative logic of these materials by digitally amalgamating them into all-over compositions that evoke the repetitiveness of Ankara wax designs or the bilateral symmetry of snakeskin patterns. These procedures are embodied in works such as *Wahala Means Trouble* (2011), a compendium of textiles of variable dimensions. The elements of the work are typically hung loosely against gallery walls in overlapping spatial configurations. Allowing the canvas textiles to scroll onto the floor, these installations highlight the site-specificity of their presentation as well as notions of surplus – the works are manufactured by printers in large production runs that result in an excess of fabric. Ogunbiyi's nontraditional use of canvas flouts conventional genre hierarchies that favour painting and sculpture.

Dissonant, elusive and at times even illegible, her textiles effectively represent in microcosm the unquantifiable impact of social media on present modes of communication, especially in the rapidly transforming cities of Nigeria, which has the fastest growing telecommunications market in Africa. The artist's use of industrial methods and cyber material has also prompted her to engage discourses on authorship and ownership. Such concerns were represented in her first solo exhibition in Europe, 'Am I A Thief?' (2012), at the Freies Museum in Berlin, where her textile patterns were both hung on the walls and used to construct garments. Ogunbiyi has recently channelled her ethnography of social media into projects exploring the effect of technology on expressions of love in Nigeria. Drawing on the local history and popularity of 'love text message books', commercial manuals replete with pithy expressions of romantic love, she has continued developing ways to address social relations and digital interactivity in her textile works.

← *Topographic Keloids (Dipped)*,
2010, print on transparency,
pastel, ink and pencil on paper,
48 × 38 cm framed (left)

← *Topographic Keloids (I Think
That's a Bit of the Sahara)*, 2010,
print on transparency, pastel,
ink and pencil on paper,
48 × 38 cm framed (right)

↑ *Accomplice (Zebra)*, 2012, collage
on planks of wood and digital
textile print assembled
by Ugoma Adegoke of Zebra
Living, womens' dress size 8 (US)

↓ *Wahala Means Trouble*, 2011,
digital textile print and acrylic,
dimensions variable

Charles Okereke

An early member of the civic-minded Black Box collective, Charles Okereke is also a founding member of the more recent Trans-African photography initiative Invisible Borders. His lens-based practice embodies a highly evocative and uncanny relationship to Lagos, transcending both traditional representations of the port city and associations with the commonplace. Often dwelling on easily overlooked dimensions of the urban, his images capture seemingly mundane objects in order to release new associations and forms of meaning.

Canal People (2009–present) is an ongoing project resulting from the artist's long-term work with an informal settlement community in Festac, a town on the outskirts of Lagos. Although consisting of several bodies of photographs that document the domestic life and working conditions of community members, Okereke's approach to visualizing the pollution in the surrounding environments is the most distinctive feature of these works. It distinguishes him from other local photographers who engage environmental crisis from a purely journalistic perspective. Recalling the confluence of abstraction and environment at play in photographs by his American counterparts J. Henry Fair or David Hanson, Okereke's *Mirrors* series (2009–10) is an imaginative and critical response to local waste problems. For this series the artist photographs discarded paper bags, milk containers and other detritus that he finds floating in the neighbourhood's dark canals. Framed from close perspectives and oblique angles, the photographs are typically presented in large-scale formats

that de-familiarize the objects, endowing the images with a sublime and meditative allure. Furthermore, the deliberate composition, which avoids overt references to land, lends the work a universal relevance despite its response to particular local realities. Interested in the luxurious associations inspired by surface, light and reflection, Okereke's camera transforms the by-products of consumption into enticing still-lifes, forcing viewers to reconcile the work's ambivalent positioning of ecological subtext within a realm of aesthetic contemplation.

Motivated by an introspective desire to interrogate the surface of things, Okereke's *Resurrection* series (2010–present) provides visibility to the neglected objects populating the grounds of urban street corners and alleyways. 'Moving around Lagos', Okereke has said, 'I frequently stumble across strange forms on the ground – typically abstract fragments of things completely familiar, or entirely foreign and mysterious. Though I usually bypass these objects, they always seem to linger with me. So I gradually began photographing them as a means of collecting, capturing them as records of experience.'[14] Shot digitally from above, the black-and-white images evoke aerial or archaeological photography, associations that heighten the sense of affect and archaic sentiment. Providing viewers with an uncommon perspective on the shifting sands of Lagos, Okereke's work elicits pointed questions concerning the subject matter of photography from Africa; and how we come to see, know and represent immediate moments in our surroundings.

← *Mirrors: Reflection 1*, from the series *The Canal People*, 2011, colour digital photograph, 96 × 128 cm (left)

← *Mirrors: Reflection 3*, from the series *The Canal People*, 2011, colour digital photograph, 96 × 128 cm (right)

↑ *Mirrors: Reflection 2*, from the series *The Canal People*, 2011, colour digital photograph, 96 × 128 cm

↓ *Resurrection: Bared Shoulder*, from the series *Unseen Worlds*, 2012, black and white digital photograph, 82 ×123 cm

↓ *Resurrection: Exhumed*, from the series *Unseen Worlds*, 2012, black and white digital photograph, 82 × 123 cm

Kainebi Osahenye

Since training at Auchi Polytechnic Institute in southern Nigeria and Yaba College of Art and Technology in Lagos in the 1980s, Kainebi Osahenye has become well known for his painting practice, despite forays into sculpture and, more recently, installation. His art can be characterized by an experimental interplay of the figurative and the abstract and a spontaneous means of response to a range of concerns, from existentialism to environmentalism.

Although painting has been a dominant force in Nigerian art history, during the last decade it has been relatively dormant – a situation that Osahenye seeks to reverse. Abstracted or barely legible bodies recur as motifs across canvas supports or panels of aluminium and wood. Though meticulously executed, these paintings are far from idyllic and often crude in appearance, conveying the urgency of their making. Both *Pleasure and Pain* (2003) and *Moment of Repose* (2011) depict idle bodies in various configurations, flattened against a monochrome ground within a tightly cropped pictorial frame. Any sense of intimacy is undermined by the mysterious contortions of the figures, which instead articulate the anxiety and existential ambivalence of the human condition in moments of crisis. These works also exemplify the artist's interest in the historically fraught African body within both sociopolitical discourse and systems of visual representation.

A major shift occurred in 'Trash-ing', Osahenye's 2009 solo exhibition at the Centre for Contemporary Art in Lagos. Consisting of six large-scale works deploying urban detritus – discarded plastic bottles, aluminium cans, empty paint tubes and newspaper – as material supports for a range of painterly interventions, the show sparked heated local debate as to the nature and value of painting when extended into the realm of installation art. For example, plastic bottles saturated with dried pigment in vibrant hues formed two large installations that compelled viewers to engage the notion of painting through the lens of consumption and environmental degradation. That the plastic vessels resemble those found in the artist's studio (they are used for mixing paint) draws a parallel between the critique of environmental waste and some of the technical processes that underpin the production of art.

Though still exploring many of the material and aesthetic ideas operative in 'Trash-ing', Osahenye has since channelled his painterly concerns into larger installations that grapple more conceptually with urbanism, ecology and humanity. *Echoes of a City* (2011) is a shingle-like site-specific floor piece composed of individually overlapping plywood squares painted in cadmium yellow and supported by a stack of concrete blocks; the references to building and design evoke the informal character of urbanism in overcrowded megacities like Lagos.

Also emblematic of his recent preoccupation with site-specificity are *Redemption I (Version I)* (2012) and *Redemption I (Version II)* (2012), which incorporate photographic cut-outs of eyes, burnt and disfigured aluminium cans and dull pigments in engrossing, room-sized installations. The depressive sentiment evoked by these gloomy installations conveys Osahenye's attempt to spotlight the darker realities of the past, from holy wars to natural disasters. By configuring these works in altar-like spaces, he conflates the spiritual and the sinister, encouraging viewers to meditate on historical realities they might otherwise prefer to forget.

← *Pleasure and Pain*, 2003, acrylic
 on canvas, 71 × 71 cm (left)

← *Moment of Repose*, 2011, oil,
 enamel, spray paint on canvas,
 183 × 152 cm (right)

↑ *Echoes of a City*, 2011, installation
 of plywood, breeze blocks and
 pigment, dimensions variable

→ *Redemption II* (Version II), 2012,
 installation of flattened cans,
 cut photographs and pigment,
 dimensions variable

San Juan
by Pablo Léon de la Barra

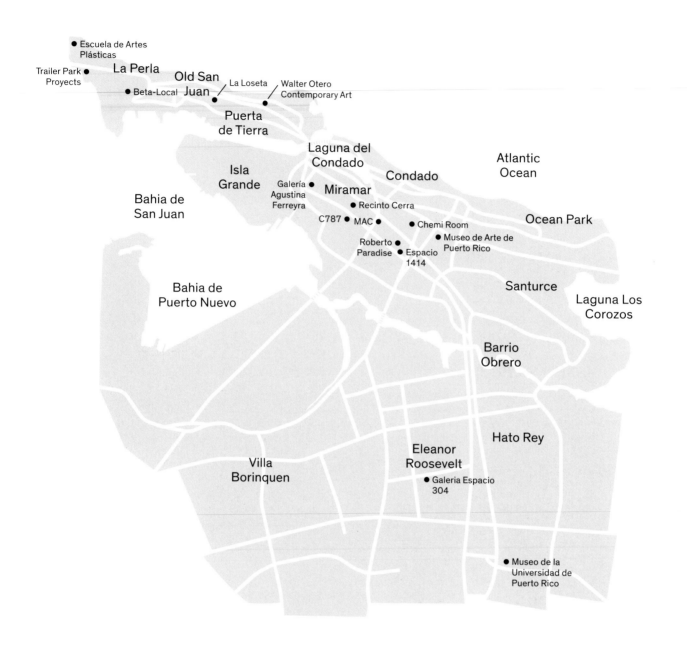

N

Escuela de Artes Plásticas
Trailer Park Proyects
La Perla
Old San Juan
Beta-Local
La Loseta
Walter Otero Contemporary Art
Puerta de Tierra
Laguna del Condado
Isla Grande
Condado
Atlantic Ocean
Bahia de San Juan
Galería Agustina Ferreyra
Miramar
Recinto Cerra
Ocean Park
C787 ● MAC ●
Chemi Room
Roberto Paradise
Museo de Arte de Puerto Rico
Espacio 1414
Bahia de Puerto Nuevo
Santurce
Laguna Los Corozos
Barrio Obrero
Hato Rey
Villa Borinquen
Eleanor Roosevelt
Galeria Espacio 304
Museo de la Universidad de Puerto Rico

0 1 km

● C787 Studios
734 Calle Cerra

● Beta-Local
208 Calle Luna

● Chemi Room
1707 Calle Latimer

● Escuela de Artes Plásticas
Campo del Morro, Barrio Ballajá

● Espacio 1414
1414 Avenue Fernández Juncos

● Galería Agustina Ferreyra
750 Avenue Fernández Juncos

● Galeria Espacio 304
304 Eleanor Roosevelt

● La Loseta
200 Calle San Agustin
Puerta de Tierra

● Museo Arte Contemporáneo
de Puerto Rico (MAC)
Avenue Juan Ponce de León
and Avenue R. H. Todd

● Museo de Arte de Puerto Rico
299 Avenue De Diego

● Recinto Cerra and La Productora
619.5 Calle Cerra

● Roberto Paradise
610 Calle Hipódromo

● Trailer Park Proyects
65 Calle Balseiros, Rio Piedras

● Museo de la Universidad de
Puerto Rico
Avenue Juan Ponce De León

● Walter Otero Contemporary Art
402 Avenue Juan Ponce De León

When Jennifer Allora and Guillermo Calzadilla represented the United States at the 54th Venice Biennale, it seemed that the USA had finally recognized the contribution of Puerto Ricans to its artistic discourse. Collaborators since 1995, Allora (born in Philadelphia) and Calzadilla (born in Havana but raised in Puerto Rico) live and work in San Juan. Their 2011 pavilion presentation cast a critical eye on national art representation, which they compared to Olympic participation. Among the works shown was an American decathlon medallist running on a treadmill atop a fifty-two-ton US military tank flipped upside down. The artists' intelligent appraisal of foreign affairs and internal US politics is a clear result of their everyday context, which also allows them a certain critical distance. Yet only one piece in Venice directly acknowledged the Puerto Rican situation: the video projection *Half Mast\Full Mast* (2010) which depicted a series of acrobatic exercises on a pole to evoke the image of a human flag, suggesting both the situation of occupation and the desire for independence on the island. Despite its high profile, Allora and Calzadilla's intelligent exhibition did little to spark international interest in the wider Puerto Rican art scene.

Puerto Rico lives in a state of indeterminacy. Neither incorporated to the United States nor an independent country, the island was ceded by Spain in the 1898 Treaty of Paris that ended the Spanish-American War, thus shifting from Spanish to US colonization. Ever since, Puerto Rico has enjoyed a double status, with its inhabitants living as second-class citizens (unable to vote in presidential elections) yet granted US passports and US dollars in exchange for the use of a strategic Caribbean location that also serves as a laboratory for the broader global expansion of American imperialism.

Old San Juan, the historical centre of Puerto Rico's capital, has been beautifully renovated, almost into a caricature of itself. Its picturesque landscape of colonial houses, complete with tourist shops selling souvenirs and T-shirts, is constantly photographed by US vacationers arriving via cruise ship; the island satisfies their desire for exoticism while being both safer and easier to visit than a foreign country. Tourism, Puerto Rico's main industry, attracts around three and a half million visitors each year, a significant figure considering the two million inhabitants of the San Juan metropolitan area (roughly half the population of the island). Meanwhile there are approximately four million residents of Puerto Rican origin in the mainland United States, mostly due to lack of opportunity at home. Although English is one of the island's two official languages, many residents do not speak it. In real terms, Puerto Rico is subject to an unofficial cultural embargo; annexed to the United States, it consumes American products and is cut off from the rest of the Caribbean and Latin America with which it shares a history, a language and a culture. This cultural in-between state has produced an identity crisis.

At the same time, the complex context has produced a stimulating art scene in San Juan, which is both responsive to and aware of its reality. If Puerto Rico's insularity and dependence on the United States induces a situation of isolation, this isolation does not produce the anxiety for mainstream recognition found in other 'peripheral' art scenes. Limited institutions and a fragile market have obligated artists and curators to develop their own means to support cultural life, with proposals that are often contextually driven, allowing the possibility to work at a rhythm that is not dictated by market demands. The combination of creative leisure with a social agenda and 'tropical-povera' aesthetic is particular to the Puerto Rican art scene, and also what keeps it alive.

Most of the island's artists passed through the Escuela de Artes Plásticas de Puerto Rico (School of Plastic Arts of Puerto Rico), where professors like Marimar Benítez, Charles Juhasz-Alvarado, Marxz Rosado, Julio Suárez, and the late Haydee Venegas shaped several generations. But because island life produces a desire for escape, many artists and art professionals emigrate as soon as they finish their studies. Among others, Javier Bosques and Monica Rodriguez left Puerto Rico for Los Angeles; Esteban

Gabriel for San Francisco; Josué Pellot and Edra Soto for Chicago; Jason Mena for Mexico City; Marina Reyes Franco and Guillermo E. Rodríguez Rivera for Buenos Aires; Hector Arce-Espasas, Ignacio Lang and Glorimarta Linares for New York; and Carolina Caycedo and Chaveli Sifre for Berlin. A few have successfully integrated themselves into the commercial mainstream, including Enoc Pérez, who is represented by Acquavella Galleries in New York, Ángel Otero, who shows with Lehmann Maupin, and José Lerma, who teaches at the School of the Art Institute of Chicago and shows with Andrea Rosen. Nevertheless, all these artists continue to identify as Puerto Ricans, and continue an artistic relationship with Puerto Rico. Others, like Gamaliel Rodríguez, have left San Juan only to move to the calmer interior of the island.

Recently, there has been a re-evaluation of Puerto Rican artists active in the second half of the twentieth century. Seminal figures include Rafael Ferrer, a pioneer of Conceptual art who participated in the historic exhibitions 'Anti-Illusion: Procedures/Materials' at the Whitney Museum of American Art (1969), 'Live In Your Head: When Attitudes Become Form' at Kunsthalle Bern (1969) and 'Information' at the Museum of Modern Art (1970). 'Retro/Active: The Work of Rafael Ferrer', curated by Deborah Cullen at El Museo del Barrio[1] in New York in 2010, was the artist's first major museum retrospective, presenting his influential and eclectic production from the past fifty-five years. When he left Cuba, Félix González Torres lived in Puerto Rico (1976–88) where he also studied art at the University of Puerto Rico. Afterwards he moved to New York, but maintained close ties to the island. The influence of these formative years on González Torres's later work was examined by another El Museo del Barrio exhibition in 2006, organized by New York-based Cuban curator Elvis Fuentes. Interest in other overlooked Puerto Rican art figures has also meant the 'rediscovery' of the abstract topographies of Zilia Sánchez, the geometric abstractions of Julio Suárez, the political conceptual work of Carlos Irizarry and the concrete poetry of Esteban Valdés Arzate.

San Juan has everything a burgeoning art scene needs: talented artists, an art school, museums, collectors, a few commercial galleries and, until recently, an art fair (CIRCA, 2005–10). But these different players remain somewhat disconnected, which translates into inconsistent support for the artistic community. San Juan counts two art museums: the Museo de Arte de Puerto Rico, which opened in 1995 in the former Municipal Hospital, houses a representative collection of Puerto Rican art dating from the seventeenth century through the contemporary period; and the Museo de Arte Contemporáneo de Puerto Rico, founded by artists in 1984, and located in a former school in Santurce. Both are somewhat detached from the context, without a strong commitment to exhibiting local artists or producing public exhibitions that investigate the culture of the island. The Museo de Arte de Ponce gets a much higher mark for its programming, but is located on the south coast in Ponce (an hour and a half by car from San Juan). The Trienal Poli/gráfica de San Juan, dedicated to art from Latin America and the Caribbean, makes up for these institutional oversights and continues the legacy of the Bienal de San Juan del Grabado Latinoamericano y del Caribe, initiated in 1970. The first edition of the Trienal, in 2004, was organized by Houston-based Puerto Rican curator Mari Carmen Ramírez, followed by Brazilian Adriano Pedrosa in 2009 and American Deborah Cullen in 2012.

A new generation of independent Puerto Rican curators has also been very active where the island's institutions are lagging. Carla Acevedo Yates, through her website, DaWire, gives visibility to young Puerto Rican artists in addition to organizing thematic exhibitions such as 'The Dialectic City' (2011), which took place in an unused warehouse in the district of Santurce (2011). Celina Nogueras Cuevas, who was part of the Puerto Rico Public Art Project team and artistic director of CIRCA, recently published the anthology *Frescos* (2011), featuring work by fifty Puerto Rican artists under the age of thirty-five. Meanwhile, at the Banco Popular Centre, Io Carrión staged 'The Way In' (2012), an overview of Puerto Rican contemporary art from the last forty-five years. A series of artists' initiatives also build support for the San Juan art scene, including the exhibition project La Loseta, established by Radames 'Juni' Figueroa in his apartment; Chemi Room, run by Chemi Rosado-Seijo from his house and patio; the art studios and

↑ Overlooking Condado, Santurce

↓ Museo de Arte de Puerto Rico

→ The outdoor hallway leading to
the patio at Chemi Room

↓ From Allora & Calzadilla,
Half Mast\Full Mast, 2010,
HD 2-channel video, colour,
silent, 21 min. 11 sec.

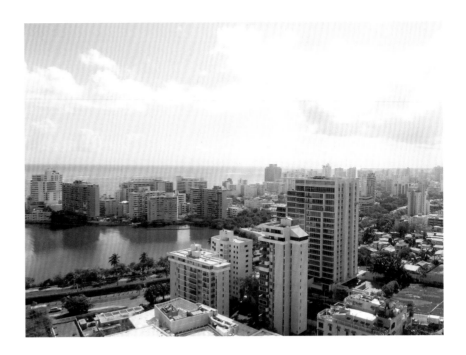

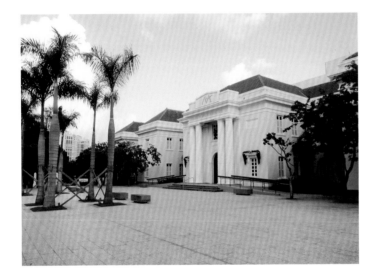

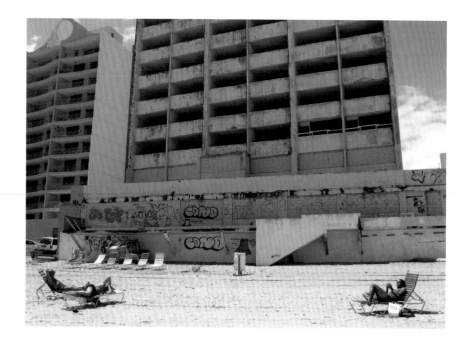

↑ Sunbathers on Condado Beach

↓ The daily routine at Beta-Local

→ Exhibition view, Third Poly/
 Graphic Triennial, 2009,
 directed by Adriano Pedrosa

↓ Roberto Paradise exterior

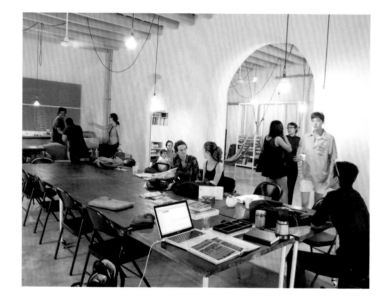

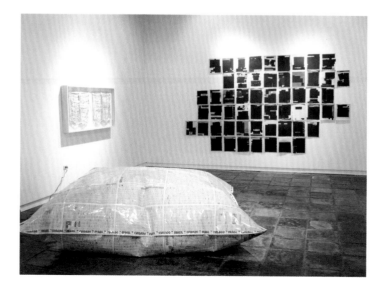

exhibition room Recinto Cerra, directed by Jaime Crespo with Jesús 'Bubu' Negrón; and Conboca, a print and web publication edited by Abdiel Segarra.

While Puerto Rico might have more collectors per artist than any other nation in the region, many tend towards investment paintings sold by New York galleries rather than work produced by local artists on the local scene. Some exceptions to this are César and Mima Reyes, who have developed close relations with Puerto Rican and international artists (including Jorge Pardo, who designed their weekend home), and the Berezdivin Collection's Espacio 1414, which had a brilliant period of exhibitions and artist projects curated by Julieta González (2005–09). With commercial galleries appearing and disappearing, Francisco 'Tito' Rovira has been crucial for the new generation of artists, first through Galería Comercial (2003–08) and afterwards through his latest gallery, Roberto Paradise. Post-recession, things are slowly changing. Alexis Figueroa runs the gallery on wheels Trailer Park Proyects; and both Agustina Ferreyra and dealer Walter Otero opened gallery spaces in San Juan.

It is impossible to write about Puerto Rico's contemporary art scene without recognizing the immense contribution of Michy Marxuach, who has been the driving force behind the island's avant-garde, especially in rethinking real possibilities for art's impact. In the early 2000s Marxuach created and directed M&M Proyectos, artist studios and residences in a former department store in Old San Juan. As part of M&M Proyectos, she developed the Puerto Rico 00, Puerto Rico 02 and Puerto Rico 04 biennials (2000–04), which sought new ways for artists to engage with the local context. PR00 took place in Old San Juan, while PR02 expanded to the neighbouring towns of Bayamón, Naranjito and Loíza, and PR04 took place in Rincón, a beach town on the west coast. The biennials were breeding grounds for many artists active today, who share a concern for creating community and building social relations as part of their practice. By establishing a network among participating artists, the PR biennials helped to break down local artistic isolation, not only through international exposure, but also by making the younger generation aware of its potential to develop projects despite infrastructural limitations. After the biennials, Marxuach briefly retired from the scene, returning in 2009 to launch the nonprofit organization Beta-Local with artists Beatriz Santiago Muñoz and Tony Cruz Pabón. Beta-Local has become a hands-on, critical alternative for Puerto Rico's art community. While the PR biennials focused on the project and exhibition format, Beta-Local emphasizes the development and exchange of knowledge through a series of initiatives: a study and production programme that functions as a postgraduate alternative to emigration abroad; a residency program for international artists, curators and other cultural practitioners; an experimental school open to the general public; and a reference library of art and design resources. As part of its study programme, Beta-Local has already been instrumental in supporting the development of the island's next generation of artists, including Alana Iturralde, Michelle Gratacós-Arill and Joel 'Yoyo' Rodriguez. The increasing community-driven efforts by multiple generations within San Juan indicates a strong future for cultural discourse on the island; leaving local galleries, collectors and the city's museums much work to do.

Tony Cruz Pabón

Tony Cruz Pabón draws measurements and distances. Generally, these drawings do not happen on paper, but on walls and other surfaces. His *Distance Drawings* (2003–present) are unfinished wall drawings made with pencil, carbon or chalk that try to trace the miles or kilometres separating one place from another, most often the distance travelled from his home in San Juan, Puerto Rico, to the place where he is exhibiting. The attempt to draw these distances almost always ends in failure, due to the impossibility of visualizing such a journey in its totality; the traces of the artist's unattainable endeavour remain on the wall as the work of art. To date, Cruz Pabón has completed eight of these drawings, including attempts to record the distances between San Juan and Vilnius (8,433 km) (2003), San Juan and Cuenca (2,762 km) (2004), San Juan and his parents' house in Vega Alta (87 km, completed) (2004), the distance between Sao Paulo and Rio de Janeiro (420 km) (2008), and the distances from San Juan to London (6,751 km) (2011) and San Juan to Bogotá (1,763 km) (2012).

If *Distance Drawings* document a distance travelled, then *Top View of My House and the Objects that Occupy 1574.02 Square Metres, 0.355:30* (2008) does not represent a journey but rather the space that the artist occupies every day. Here the furniture and other items in his house are described by lines, with the sum of lines comprising each object in the drawing equivalent to the number of square metres of the apartment that it fills. By contrast, *Baseball Drawings* do not happen on walls, but in ballparks. For these Cruz Pabón collaborates with baseball players, asking them to trace from memory the most important ball trajectories of a recent game with coloured chalk. In this way the playing field becomes a giant board temporarily containing a drawing of the game. *Baseball Drawings* have been executed in Santo Domingo, Dominican Republic (2003), Rincón, Puerto Rico (2004), and in Corozal and Vega Alta, Puerto Rico (both 2005).

Living on an island makes one acutely aware of territorial limits; the horizon line is both the edge of the surrounding physical world and a possible place for mental escape. Cruz Pabón's *Horizon* series (2009) is another means by which the artist approximates his everyday landscape. These pencil drawings on paper show the view from the balcony of his house in San Juan and the daily changing position of boats at sea. Thus the drawings are another attempt to trace something impermanent or ungraspable. In *Horizon* (2011), a perspective wall drawing of the sea's horizon, the measurement of lines is not as important as in the carefully precise *Distance Drawings*. With quick blue chalk lines, Cruz Pabón produces an image that can be thought of as landscape, but also functions as optical illusion. For *Andamios* (Scaffolding, 2011), he creates wooden structures that support a selection of books from his own library, held open to passages describing what the artist refers to as the 'unstable landscapes' of the island.[2] The miniature scaffolding gives structure to this instability, while also serving as a poetic metaphor for the individual perception of this changeable landscape.

← *Scaffolding*, 2011, installation of
15 structures made with books
and wood

↑ *Drawing on Ball Park*, 2003,
Santo Domingo

↓ *Distance Drawing: San Juan/
London*, an attempt to draw the
distance from San Juan, Puerto
Rico to London, England (6,751
km), realized only 0.0031890
percent (2,153 m), 2011

Radames 'Juni' Figueroa

Central to Radames 'Juni' Figueroa's work is the development of an artistic language that responds to the everyday reality of Puerto Rico and celebrates the local way of life in the tropics. Painted in 2009, *Untitled (Tiger, Zebra & Leopard Roof)* consists of three rooftop murals, each with a different animal pattern. Located in the rough neighbourhood of La Perla along the tourist trail to Fort San Felipe del Morro (Old San Juan's main historical attraction), the murals question the perception of this area as a savage territory without law, and transform a fierce landscape into a work of art.

During the past few years Figueroa has produced a series of *Tropical Readymades* (2007–present), found objects that he subtly transforms. For example, he plants mother-in-law's tongue (*Sansevieria trifasciata*) in sport trainers or discarded basketballs, converting these objects into useful pots but also sculptures that can be scattered across the gallery floor, which then becomes a garden. *Tropical Readymade (Clothes Drying System)* (2008) is inspired by the way people dry laundry at housing estates outside San Juan, trapping clothes between the slats of louvre windows to expose them to the elements. He installs these louvres within gallery walls, using them to hang his own T-shirts, swimming trunks and socks so that the work becomes a self-portrait of the artist as well as a reflection on everyday Puerto Rican aesthetics. In 2009, together with organic food entrepreneur Tara Rodriguez and industrial designer Esteban Gabriel, he collected wild plants and transferred them to buckets, which were then arranged into a garden around a bus shelter for the readymade *Parada 'Phantom' (Tropical Bus Stop)*; thus integrating urban infrastructure with domesticated nature in the social realm.

Figueroa's works challenge the idea of the tropics as a paradise, an idealized place of leisure where one need not work, where exuberant vegetation extends ripe fruit directly to the hand. *Untitled (Rainbow)* (2010) is constructed from cheap plastic gas pipes, spray-painted with fluorescent colour; its bent form is anchored by two large planters. *Rainbow* has existed in exhibition spaces, as a public sculpture visible atop the artist's house, as well as emerging from the jungle during San Juan's first Bienal Tropical (2011) – its material presence invokes the sense of hopefulness produced by a real rainbow.

Created for exhibition openings, Figueroa's *Tropical Fountains* (2010–present) consist of a glass or plastic bowl with a fountain pump inserted into a column of fruit, which is then filled with a combination of hard liquor and tropical juices – whisky and coconut water, or fruit punch and Caribbean rum – creating the fantasy of a never-ending supply of happiness but also really producing a next-day tropical hangover, both part of everyday island living. The notion of a tropical hangover also featured in his solo show 'Bar Escandalo' (2010) at Preteen Gallery in Mexico City, which the artist transformed into a bar decorated with replicas of the posters and kitsch found in his favourite local San Juan bars. 'Bar Escandalo' also dealt with the personal history of the artist, whose father and grandfather kept bars.

In 2011 Figueroa developed the project La Loseta, an artist-run space located in his home, as a response to the lack of exhibition spaces in Puerto Rico. For twelve months he invited twelve artists to produce work for the apartment, which quickly became a local arts centre known for showing work by young Puerto Rican and international artists.

← *Escandalo Bar*, 2010, tables, chairs, red lights, alcohol, ecstasy, smoke machine and wall installation of artwork gathered from bars in Puerta de Tierra, 460 × 460 cm

↑ *Untitled (Zebra, Tiger and Leopard Roof)*, 2009, industrial paint and residential rooftops in La Perla, Old San Juan

→ *Tropical Readymade (Shoe Planters)*, 2008–present, plants, soil, sport trainers, dimensions variable

↓ *Untitled (Rainbow)*, 2011, PVC pipes, spray paint, buckets and plants, 366 × 244 cm

Karlo Andrei Ibarra

Karlo Andrei Ibarra's work refers directly to Puerto Rico's subordinate position as an unincorporated territory of the United States, and aesthetically examines the implications of this association. In the video *Crossover* (2009), he uses a term normally applied to Latin pop singers and actors who perform in English in order to access US and other English-speaking audiences. Ibarra asks average Puerto Rican citizens he approaches on the street to become readymade crossover artists by singing the US national anthem. The lack of knowledge of the song lyrics and their pronunciation amplifies the social and cultural distance between Puerto Rican citizens and the United States, presenting both an uncomfortable tension between those who desire statehood but often do not know (and are not taught) the language of the country they wish to join, and the failure of the dominating country to assimilate its desired subjects. A similar critique is found in *Continental* (2007–10), a neon work powered by solar energy that illuminates the phrase *Vivo en America* (I live in America). Exhibited in Havana (2007) and at the Biennial of the Americas in Denver (2010), it refers to the hijacking of the name of the continent by the United States, thus becoming a geopolitical sign of appropriation for Spanish speakers who also live on the American continent.

In other works Ibarra uses bananas – the most important harvested product of Central America and the Caribbean, and the main reason for US economic and political interest in many of these countries, which are sometimes derogatively called Banana Republics (a synonym for tropical nations governed by US-backed dictators or politicians). *Remnants* (2011) is an ephemeral piece for which a green plantain bunch is tattooed with texts describing the effect of the economic policies outlined by the North American Free Trade Agreement (NAFTA), which perpetuates US domination in the region. The decay of the bananas suggests that these policies may not be as beneficial as they seem.

In *Speeches* (2009) bananas refer to local politics. A microphone stands on a barrel covered in banana peels, while speeches recorded during the political campaigns for Puerto Rico's 2008 gubernatorial elections play from speakers positioned on the floor nearby. The banana peels allude to the slipperiness of political promises, which are mostly forgotten when the campaign ends. Meanwhile, for *Slippery Government* (2011), yellow plastic floor signs that normally warn of wet floors are instead silkscreened with the title of the work. These signs are intended for installation in government offices during periods of political instability, corruption or at any other time that authorities fail or neglect those whom they are elected to represent. In a similar way, the video work *Aspirations* (2009) follows the action of a Puerto Rican citizen with a vacuum cleaner in the stairway of the Capitol Building, signifying the aspiration for a clean and transparent local government, which in Puerto Rico (as in many other places) is not always the case. With his thematically charged works, Ibarra might be the most political artist of his generation, joining together island aesthetics with ever-present political realities.

← *Continental*, 2007–10, neon
powered by solar light,
15 × 91 cm

← *Slippery Government*, 2011,
silkscreen on plastic floor sign,
30 × 30 × 66 cm

↑ *Crossover*, 2009, single-channel
video projection, 3 min. 11 sec.

→ *Remnants*, 2011, green plantain,
tattoo machine, wood table made
with wood filler used to export
and import products

Michael Linares

The conceptual artist Michael Linares works in a variety of mediums, although the relationship between artwork and spectator, and particularly the aspect of duration, lies at the core of his practice. The series *Wait Till It Grows* requires the passage of time to fully germinate. *Wait Till It Grows (Hammock)* (2011–present) consists of two baby palms just sprouting from a coconut. A white hammock tied to each lies on the floor, relying on the trees to grow so that it hangs and someone can swing or rest in it. The still ongoing works *Tree House* (2006), *Hanging Bridge* (2007) and *Swing* (2007) from this series all require care and patience to develop, and for the embedded elements of play to become usable; in the meantime they produce an image of hope for the future.

For *Oasis (Mexico)* and *Oasis (New York)* (both 2006) a square plywood bench is positioned in the exhibition space to seem like ordinary seating for observing artwork, apart from the square hole cut into the centre of each, which holds a bucket of ice and beer. *Oasis* is activated when the public discovers it can interact with the bench, and subsequently perform as normal at an opening; socializing, drinking and participating in the work's creation. A reference to Tom Marioni's *The Act of Drinking Beer with Friends is the Highest Form of Art* (1970), and a work of post-relational aesthetics, the remaining bottles rest on top of the bench for the exhibition's lifespan. *Oasis/Inclusive Structure* (2010), reminiscent of Sol LeWitt's *Four-Sided Pyramid* (1997), uses white foam coolers as a basic construction unit. Stocked with cold beer, the pyramid quickly becomes a support for empty bottles, growing more chaotic in form as the last few beers are drunk

and the public desperately scavenges for more. The permanent installation *Light Spectre* (2011), commissioned by Espacio 1414, reflects the bands of colour that result when white light is broken down into its component parts. This work alludes to the horizontal inclusiveness of the island's everyday heterotopia and the natural resource of its social and cultural diversity. By highlighting unseen optical properties of the atmosphere, Linares finds in the fleeting promise of the rainbow a more enduring presence.

He also established the online library La Sonora (www.lasonora.org) with the support of Beta-Local in 2010. It contains audio files of translated texts relevant to contemporary art and culture; many which did not previously exist in Spanish. La Sonora is a response to the lack of Spanish-language publications circulating in Puerto Rico. But it can be accessed online from other Spanish-speaking regions, and the audio format also makes texts typically perceived to be academic more accessible. The first three albums were compiled by Linares; on the history of Conceptual art, the readymade and Situationism. He has invited others to create further albums: Beatriz Santiago Muñoz translated an excerpt from Claude Lévi-Strauss's passage through Puerto Rico published in *Tristes Tropiques* (1955), as well as little-known Afro-Antillano poems by Luis Palés Matos (which were suppressed by white Puerto Ricans during the 1920s for dealing with issues of blackness); Carla Zaccagnini, from São Paulo, translated Brazilian songs and art-historical texts; and Guatemalans Stefan Benchoam and Rodrigo Fuentes recorded Latin American literature by an emerging generation of authors.

← *Wait Till It Grows (Hanging Bridge)*, 2007–present, wood, rope, trees, variable dimensions

↑ *Light Spectre*, 2011, spray paint on metal, 370 × 850 cm

↓ *Oasis/Inclusive Structure*, 2010, foam coolers, mounting tape, beer, 254 × 508 × 508 cm

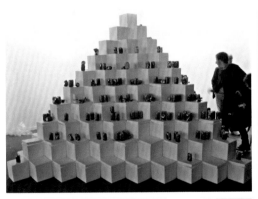

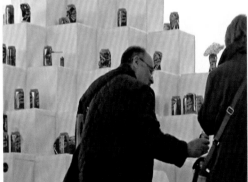

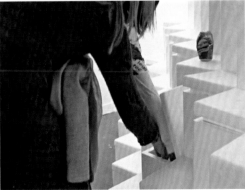

Melvin Martínez

Melvin Martínez's canvases are dense accumulations of oil and acrylic paint and glitter that explore the surface of the painting to find meaning within its texture. His seductive layers of paint sometimes resemble an extravagant icing, perhaps made by an abstractionist cake decorator, or the gaudy fluorescent and pastel plaster and cement textures found on the facades of some Puerto Rican homes. As such, they are an investigation and a vindication of what some on the island might consider an aesthetics of bad taste. In addition to celebrating the popular local penchant for the decorative, the ornamental and the kitsch, Martínez is also deeply committed to life on the island; while other successful painters of his generation have chosen to live abroad, he remains faithful to San Juan and the inspiration he finds there.

Although best known for his canvases, Martínez's works sometimes escape their fabric supports to reflect on the act of painting. *Paintings And/Or Books Tied Up* (2004–09) are piles of painted books and canvas that appear gift-wrapped. Continuing the artist's festive studies, they also symbolize a means of tying up the past, and, through their wrapping, signal the end of an artistic period after which painting can begin again. In other works, paint covers the surfaces of objects that become sculptures, or formless sculptural objects are derived from painting materials. Titled after the romantic salsa hit, *Devorame otra vez* (Devour Me Again, 2006) is a humorous work that completes the transition from painting to sculpture to cake: paint and glitter serve as frosting and decoration for a giant four-tier cake sculpture. The painted cake rotates on an axis while the salsa song plays in a loop, stimulating the viewer's desire to literally eat the cake. With its celebratory aspect, the work evokes memories of village parties for a saint's feast day or a coming-of-age Quinceañera celebration.

On other occasions, collateral materials used in the production of paintings are repurposed as artworks. *Paintbrushes* (2009) is an installation made from the used brushes that accumulate in Martínez's studio over time, each one inserted into plaster inside an empty paint can. The resulting garden of more than five hundred brushes becomes a colour field of remainders from previous paintings, translating a trace of the memory of those works into a new form. *El Material* (2011) isolates the raw glitter often used in his paintings. For this work the artist exhibits plastic bags full of glitter that are sold at the market rate of his canvases during art fairs. He has produced one-gram bags as well as one-kilo sacks, and even suitcases filled with kilo sacks for those collectors with voracious appetites. *El Material* is presented within a performance for which two men are charged with filling the plastic bags, thus drawing an analogy between the art market, cocaine sales, production and addiction while commenting on Puerto Rico's strategic location along South American drug routes to the United States.

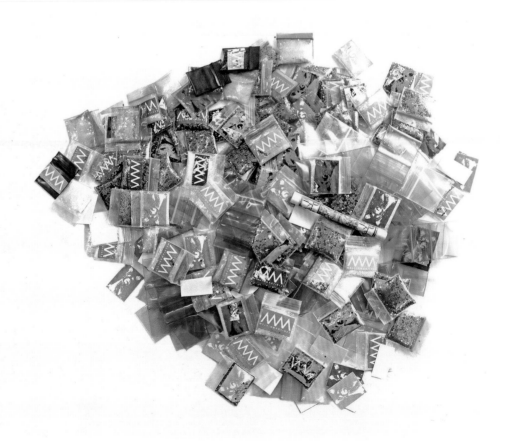

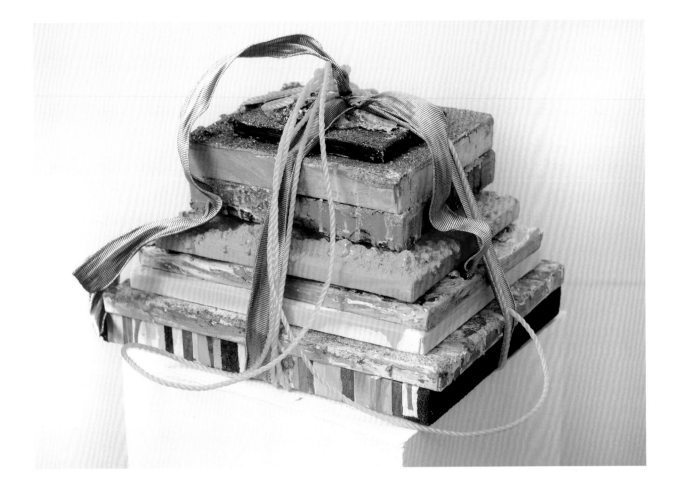

← *El Material*, 2011, performance and 1 gram bags of glitter

↑ *Books*, 2004–09, acrylic, oil, polystyrene, textile, wood and canvas, dimensions variable

→ *The Bitch*, 2012, acrylic, modelling paste, urethane and textile over polystyrene foam, 279 × 838 cm

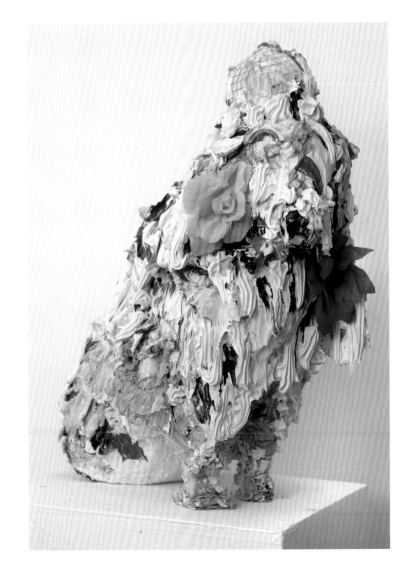

Jesús 'Bubu' Negrón

For his early work *Primeros Auxilios* (First Aid, 2001–02), Jesús 'Bubu' Negrón created a cast for the broken left leg of the deteriorated public sculpture of Puerto Rico's first boxing champion, Sixto Escobar, which stands in front of the stadium bearing his name. The artist's application of first aid to the monument commented on the lack of historical memory on the island, and paid tribute to one of Puerto Rico's forgotten popular heroes. His act ultimately obliged city authorities to restore the statue to its former glory.

In another early piece, *Cigarette Path (Homage to Angito)* (2002), he collected cigarette butts found on the street during a month-long period, using them one by one to fill gaps in between the cobblestones of an alley in Old San Juan. The work and its ritual did homage to Angito, the much-loved late bartender at El Corosaleño, the alley's neighbourhood bar. Discarded cigarette butts soon became a preferred artistic material, which the artist collects for his *Cigarette Butt Sculptures* (2003–present) – replicas that are at least twenty times the normal size. For the eighth Sharjah Biennial (2007), the artist, together with Indian street sweepers, collected enough cigarette butts to unravel and piece together (aided by Pakistani immigrant workers) a carpet inspired by the traditional weaving of the region; the delicate *Cigarette Butts/Street Rug* (2007) which resulted was then installed on the floor of Souk Al Arsa, the emirate's carpet bazaar.

Negrón has used handicraft techniques in other works such as *Rosa Tecata (Junky's Rose)* (2005), a giant flower made of folded palm leaves after the manner of those sold by drug addicts on the streets of San Juan. Commissioned for the first Turin Triennial, the rose was exhibited next to Michelangelo Pistoletto's *Rosa Bruciata* (1965), thus linking San Juan craft to the history of Italian Arte Povera. For San Juan's first Bienal Tropical, which took place in the seaside jungle of nearby Loíza, the artist exhibited *Palma Vejigantes (Original Traditional Masks)* (2011), a series of coconut masks he copied from the traditional designs made by descendants of African slaves living in the village. After hand carving and painting the masks, he installed them with the help of coconut pickers over coconuts still hanging in area palm trees. Thus he returned nature (the coconut), which had been transformed into culture (the mask), back to its origin; paradoxically using the coconut mask to mask another coconut.

This interest in folklore, and in keeping alive traditions in danger of disappearing, is also evident in *Banco Marímbula* (2012), a long, customized bench containing three updated versions of the marímbula (a traditional musical instrument) that allows three musicians (or members of the public) to sit and play the instrument together. After it was shown in the exhibition 'The Way In' (2012), *Banco Marímbula* was donated to the Museo Taller Africano, where Negrón had met the folk musicians he collaborated with for the work's creation, in this way directly inserting a means of rethinking tradition into the museum. Similarly, for *Honoris Causa* (2006) Negrón introduced a hot dog vendor and a stall peddling African masks outside the museum into the lobby for the duration of the Whitney Biennial. By using the daily activity of New York street merchants to question the institution and what is typically excluded from it, Negrón highlighted these external happenings in such a way as to blur distinctions between high art and everyday life and culture.

← *Banco Marímbula*, 2012, wood, gramophone disc and paint, 43 × 183 × 43 cm

↑ *Palma Vejigantes (Original Traditional Masks)*, 2011, acrylic on coconuts, installed on palm tree, dimensions variable

↗ *First Aid*, 2001–02, plaster, dimensions variable

↓ *Cigarette Butts (Street Rug)*, 2007, cigarette butts and glue, 183 × 152 cm

Chemi Rosado-Seijo

The large-scale intervention *El Cerro Project* (2002–present) marked a turning point in Chemi Rosado-Seijo's practice, when he began to engage with Puerto Rico's social and urban fabric. Part land art, part mural painting and part community project, it consisted of painting, alongside local residents, the facades of houses in the small village of El Cerro in different shades of green. *El Cerro* (which means hill or small mountain) is a slum in the town of Naranjito, an hour southwest of San Juan. Rosado-Seijo's project pays tribute to the spontaneous informal architecture created by the community and its harmonious co-existence with the regional topography and landscape. *El Cerro Project* changed the perception that outsiders and inhabitants of El Cerro had of themselves, their community and the place where they live; the artist's involvement with the residents through this work still continues.

Parallel to *El Cerro*, for most of the past decade Rosado-Seijo has explored the relationship between skateboarding and artistic practice by constructing interior and exterior skateboarding ramps within gallery or public spaces to bring the skating world into the art world and vice versa. These works have appeared in exhibitions and biennials including at Ex Teresa Art Centre in Mexico City (2003), where the ramp's slope was an inverted copy of the church vault in the former convent; and more recently at the Bienal de Pontevedra in Spain (2010), where he constructed an outdoor ramp. In *Untitled (To Pollock)* (2004), realized at the Cuenca Biennale in Ecuador, and *To Pollock (Personal Version)* (2005–06), the plywood surfaces of Rosado-Seijo's ramps, with their random marks and skated traces, were recycled as wall paintings and hung inside the exhibition space. During a residency at Art in General in New York, the artist mapped the use of public space by skaters in Manhattan; the resulting *Manhattan Skateboard Map* (2005) was then grafted to a skateboard with the aim of mass-producing a useable object.

Rosado-Seijo's large-scale sculptural project History On Wheels (2004–present) turns art history books into skateboards by attaching wheels to them, thus denying their readability and dissolving skateboarding history into the history of contemporary art. The first book he transformed was Edward Lucie-Smith's *Movements in Art Since 1945* (2001). Rosado-Seijo's own *History on Wheels (Concrete Movements, Skateboard Wave in Art, Roadmap Since 1960(45), Space and the City, Issues and Concepts)* (2009), an artist's book produced for the San Juan Poly/Graphic Triennial, is an assemblage mixing together pages from skateboarding magazines and art books; the holes pre-punctured in its cover allow the reader to insert wheels and transform the book.

El Bowl (2006) is a permanent concrete construction located on the Atlantic coast in San Juan's La Perla neighbourhood. A public artwork where locals can skate (or swim, when the bowl fills with water), it has also become an international destination on the skateboarding circuit. *El Bowl* was designed with veteran skateboarder Roberto 'Boly' Cortez and built in collaboration with residents and skaters from the island. Yet another skateboarding project exists only as a model; set adrift on the ocean, *Floating Bowl* (2010–present) will be built from Styrofoam junk collected along the coast. For Rosado-Seijo, skateboarding is a critically performative practice that connects art, architecture and urbanism through the individual and collective occupation of space.

The artist also runs Chemi Room from the lounge and patio of his home in San Juan, which has become a vital gathering place for the artistic community; regularly playing host to skate performances and other impromptu projects and exhibitions.

← *Spring Rhythm (Number 30)*
 from *History on Wheels*,
 2012, skateboarding marks
 and scratches on wood,
 268 × 526 cm

↑ *The Villagarcia Ramp (Inverted
 Arc)*, 2010, reclaimed pallets,
 wood, plastic, metal, pipes and
 white paint, 3 × 6 × 11 m

↑ *The Gesture: On Pollock and
 Post American Art* from *History
 on Wheels*, 2007, skateboard
 trucks and wheels on book,
 11 × 17 × 24 cm

↓ *Inverted Exteresa Copula* from
 History on Wheels, 2003,
 wood and white paint,
 400 × 550 × 850 cm

↳ *El Cerro Project*, 2002–present,
 Naranjito, Puerto Rico

Beatriz Santiago Muñoz

Beatriz Santiago Muñoz's films evolve from long periods of observation and documentation in which the camera frames political and aesthetic thought. For *Fábrica Inútil* (Useless Factory, 2002) she spent two months in a packaging plant outside San Juan, speaking extensively to employees about the factory's production logic. She then asked the workers to perform a series of actions during their shifts based on these discussions. Factory production was stopped so everyone could watch the sunrise (shifts typically began before dawn); lunch was cooked on burners usually used to melt glue; a bed of leftover materials provided space to nap on the factory floor; a wrestling match was staged in a purpose-built arena; and a curtain of plastic threads was hung to mark off a dance floor. In the final performance, the managers acted out a fictional scene in which they announce it is the last day of work due to the factory's impending closure. (It shut down some years later.) Introducing dreams and leisure into structured production, Santiago Muñoz subverts traditional capitalist logic through a study of the human desires negated by mechanized work.

Folc-Industrial (2011), filmed in Porto Alegre, Brazil for the eighth Mercosul Biennial, continues this research into industrial labour. The setting is a mega-factory which employs a workforce of 4,000 and runs twenty-four hours per day, non-stop. Santiago Muñoz filmed workers leaving the factory after their shifts ended, at the moment when each again becomes an individual subject in public space among other men and women. At the same time, new workers enter the factory to keep the machine in constant motion. The scene is an actualized version of the first-ever film image, produced by the Lumière brothers, of workers leaving a Lyon factory in 1895. An archetypal image of modernity, this rarely exists in Puerto Rico anymore, where there are few factory entrances to frame, fewer factory workers and little factory work, due to the impact of US economic policies.

The artist's other films seek out alternatives to capitalist structures. *Flowers of Antimony* (2008) portrays the banal everyday activities of anarchist groups in San Francisco and Oakland; while *Pyotr* (2007) shows the retired Puerto Rican labour union leader Esteban Valdés Arzate (also a concrete poet and master gardener) talking about anarchist aesthetics and the 'errors of youth' while trimming his plants. *Esto es un mensaje explosivo* (This is an Explosive Message, 2010) is a portrait of the artist Carlos Irizarry, who in 1979 threatened to blow up an American Airlines plane if Puerto Rican political prisoners held in the United States were not liberated. Sometimes referred to as a work of conceptual art, sometimes an act of terrorism, the event exists as unverified rumour in Puerto Rican art history. On film Irizarry insists on the political aspect of his action to the exclusion of aesthetic considerations, yet imbues it with symbolic meaning by regarding it as a 'work'. More recent films shift their focus to the landscape of Puerto Rico and its relationship to the island's history and infrastructure. *La Cueva Negra* (The Black Cave, 2013) features the indigenous burial site Paso del Indio, discovered only two decades ago during the construction of a highway. Through interviews with archaeologists, the excavation crew and locals living nearby, Santiago Muñoz examines the geological layers and material history of this previously overlooked area; as in all of her films, the work ultimately reflects on conditions that inform ideas of place, community and culture today, in a society increasingly affected by flows of global capital.

← *Useless Factory*, 2002, video, 30 min.

↑ *This is an Explosive Message*, 2010, HD video, 16 min. 36 sec.

↓ *Folc-Industrial*, 2011, HD Video accompanied by a live score, 8 min. loop

↓ *The Black Cave*, 2013, HD Video, 20 min.

São Paulo
by Kiki Mazzucchelli

N

SESC Pompeia

Pinacoteca
do Estado

Perdizes

Higienópolis

República

Centro

Alto De
Pinheiros

Consolação

Vila
Madalena

Galeria Fortes
Vilaça

Galeria Vermelho

Galeria Luisa
Strina

Mendes
Wood

Bela Vista

MASP

Liberdade

Pinheiros
River

CCSP

Jardins

Pinheiros

Parque do
Ibirapuera

Itaim Bibi

Vila Mariana

MAM-SP

MAC USP

0 1 km

- Centro Cultural Sao Paulo (CCSP)
 Rua Vergueiro, 1000

- Galeria Fortes Vilaça
 Rua Fradique Coutinho, 1500

- Galeria Luisa Strina
 Rua Padre João Manuel, 755

- Galeria Vermelho
 Rua Minas Gerais, 350

- Museu de Arte Contemporânea
 da Universidade de São Paulo
 (MAC USP)
 Parque do Ibirapuera
 Ciccillo Matarazzo Pavilion

- Mendes Wood
 Rua da Consolação, 3358

- Museu de Arte Moderna (MAM-SP)
 Parque do Ibirapuera, Portão 3

- Pinacoteca do Estado
 Praça da Luz, 2

- Museu de Arte de São Paulo (MASP)
 Avenida Paulista, 1578

- SESC Pompeia
 Rua Clélia, 93

São Paulo
by Kiki Mazzucchelli

When Le Corbusier visited São Paulo in 1929, the city was already showing its ambition to become a large metropolis with an international profile. Having undergone dramatic changes in the first decades of the new century, it had been quickly transformed from a nineteenth-century colonial village into a modern urban centre fostered by the economic growth of a thriving coffee industry. In this short period many streets were paved, and houses and buildings in different architectural styles were built, among them some landmarks such as the Municipal Theatre, the São Bento church and the Luz Rail Station. In fact, the constant process of building and rebuilding would become, until more recently, one of the city's most enduring features. So would the problem of traffic – which Le Corbusier attempted to address in the fanciful project he proposed during his visit, placing expressways on top of cross-shaped skyscrapers in order to bridge São Paulo's deep valleys.

The prosperity of the rural elites did not only bring material progress. At this point, São Paulo had already seen the emergence of its first wave of modernity, famously epitomized in Oswald de Andrade's 1928 *Anthropophagous Manifesto*, in which the Paulista poet proposed a model for resisting cultural colonialism, tropicalizing Hamlet's dilemma: 'Tupi or not Tupi, that is the question'. But 1929 was also the year of the Wall Street crash that marked the end of the coffee era and the dawn of an authoritarian central government that would implement a series of structural changes to modernize the country within the next two decades. For the city of São Paulo, this meant an accelerated process of urbanization, guided by Mayor Prestes Maia's 'Avenues Plan', which resulted in the construction of large expressways that cut through the city to connect the centre with residential areas, thus prioritizing the circulation of cars over public transport and drastically changing the urban fabric once more.

In 1930, Russian-Brazilian architect Gregori Ilitch Warchavchik inaugurated the 'Modernist House Exhibition' in a newly built project in the region of Pacaembú. Featuring a tropical garden designed by his wife, Mina Klabin Segall; works by modern artists such as Tarsila do Amaral, Di Cavalcanti and Anita Malfatti; Bauhaus carpets and Sonia Delaunay cushions; and bespoke modernist furniture and lighting designed by the architect himself, Warchavchik seemed to anticipate the centrality that architecture would achieve in the country's second wave of modernity, boosted by increasing industrialization in the 1930s and 1940s. Another key moment in the São Paulo context of the 1930s was the creation of the University of São Paulo (USP) in 1934. Conceived by the local elites who had lost much of their political influence after the 1930 coup that brought southern president Getulio Vargas to power, the university sought to prepare new elites to regain the state's prominence nationally. Among the many European professors invited to form its faculty was Claude Lévi-Strauss, who moved to São Paulo in 1935 to teach sociology, and ended up joining his wife Dina – a trained ethnologist who also taught at USP – on her expeditions to the Brazilian backcountry, later becoming one of the world's most renowned anthropologists. In the field of visual arts, these decades saw the emergence of organized groups of working-class artists – many of whom had arrived with recent waves of immigration – as well as the creation of the first modern art salons.

At this point, São Paulo's only art museum was the Pinacoteca do Estado, inaugurated in 1905, but it was not until the end of the 1940s that São Paulo would see the creation of new art institutions open to the artistic experiments of the twentieth century. In 1947, invited by communications tycoon Assis Chateaubriand, the Italian dealer Pietro Maria Bardi and his wife, the architect Lina Bo, created the Museo de Arte de São Paulo (MASP). The collection formed by Bardi in the subsequent years is impressive, and Bo's innovative approach to architecture culminated in the construction of an extraordinary purpose-built venue for MASP in 1968. This radical project featured an innovative glass easel display system for the permanent collection that made the artworks appear to float

in the air. Occupying the open-plan second floor of the museum, entirely surrounded by glass windows, the works contaminated each other, breaking chronological and geographical hierarchies, and were also contaminated by the city. Bo died in 1992, and Bardi, already debilitated, left the museum in 1996. In keeping with the city's typical disregard for public heritage, Bo's display system was taken down by the new directors, despite strong protests from the artistic community.

In 1948, São Paulo gained another museum: the Museu de Arte Moderna (MAM-SP), also created by a private initiative. Its founder, the industrialist Francisco 'Ciccillo' Matarazzo Sobrinho, advised by Nelson Rockefeller, then president of the board at MoMA in New York, decided to follow the MoMA institutional model. His ambition to modernize the local circuit went further, and in 1951 he created the São Paulo Biennial, this time based on the Venice Biennale. The emergence of these new institutions marked a period of great creative coalescence, which saw the emergence of the Concrete movement in art and poetry and the systematic presentation of international art by the Biennial – including significant works from the European avant-gardes of the first half of the century as well as global contemporary production – all of which had a great impact on the local São Paulo scene.

In 1963, Ciccillo donated the MAM-SP collection to the University of São Paulo and created yet another institution: the Museum of Contemporary Art (MAC-USP). However, this optimistic period of expansion would soon be cut short by the military coup, which installed a dictatorship that lasted for the next thirty years. Still, experimental artistic practices would continue to flourish until the late 1960s and early 1970s, when intensified repression forced many artists into exile. For those who stayed in São Paulo, the MAC-USP, under the directorship of renowned historian and curator Walter Zanini, became a hub for new conceptual art practices, managing to elude censorship and maintain a dialogue with the international art community.

In the early 1980s, with the dictatorship already in crisis, Zanini would curate two editions of the São Paulo Biennial. This was a time of great political agitation, with major strikes in the metropolitan region and the 1980 creation of the Workers' Party (Partido dos Trabalhadores or PT), which rose to power twenty years later. In 1982, São Paulo would gain two more important multidisciplinary institutions: the SESC Pompéia, Lina Bo Bardi's groundbreaking project in a former factory complex, which brought together visual art, music, theatre and community oriented activities and services; and the Centro Cultural São Paulo (CCSP), which also engaged various areas of culture, hosting a permanent art collection, historical archives and an emerging artists' programme of exhibitions.

The expansion of the São Paulo gallery circuit in the late 1980s and 1990s was one of the driving forces behind the internationalization of Brazilian art in the following decades. While galleries began to participate in art fairs around the globe, established artists such as Hélio Oiticica and Lygia Clark had their first retrospective exhibitions abroad and would be gradually incorporated into Western art historiography over the next decades. Young artists such as the Paulistana Jac Leirner – daughter of Adolpho Leirner, one of Brazil's most important art collectors, and relative of key São Paulo conceptual artist Nelson Leirner – also achieved critical acclaim globally, an unprecedented feat for emerging Brazilian artists.

After the turn of the century, the country's newfound economic stability created a more suitable environment for the proliferation of commercial galleries, independent art schools, artist residencies, artist-run spaces and even an art fair, giving rise to a more complex, multilayered circuit. Traditional art schools such as ECA-USP or FAAP (Fundação Armando Alvares Penteado), with such noted artists on their faculties as Carmela Gross and Regina Silveira, were still producing many young São Paulo artists. But as this circuit expanded, so did the need for more varied and critical approaches to artistic training. Prominent São Paulo curators such as Lisette Lagnado and Adriano Pedrosa became course leaders at Faculdade Santa Marcelina and PIESP-Escola São Paulo, respectively, recruiting high-profile artists and curators as faculty and thus creating

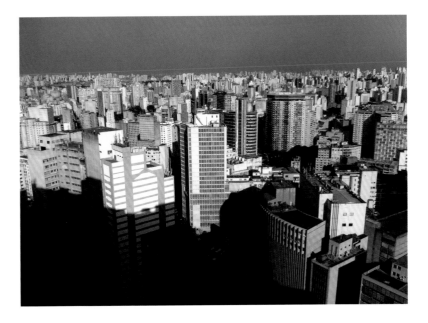

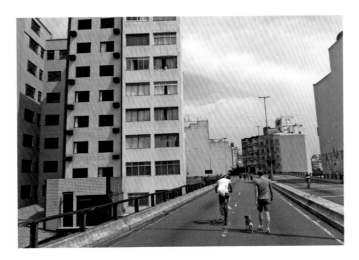

↑ Street view of SESC Pompéia, designed by Lina Bo Bardi

↗ Aerial view of São Paulo from the top of the Copan Building

↑ Minhocão, an elevated highway in the city centre closed to vehicles every Sunday

→ Marcelo Cidade, *Esquina da X coma Y*, 2008, photograph, 100 × 100 cm

→ Escola São Paulo

← Ciccillo Matarazzo Pavilion in the Parque do Ibirapuera, ca. 1957

↓ 30th Bienal de São Paulo, 2012, Ciccillo Matarazzo Pavilion

↙ *Marcelina #6*, biannual academic review published by the Master of Visual Arts programme, Faculdade Santa Marcelina

↓ Paulo Monteiro's studio at Casa 7, 1986

marcelina | artista-arquiteta
publicação semestral ano 3 n°6 2011

a platform for more diversified forms of debate. Established commercial galleries such as Galeria Luisa Strina (1974) and Fortes Vilaça (1992),[1] and new ones such as Vermelho (2002) and Mendes Wood (2010), began to systematically present more experimental exhibitions, festivals and other projects organized by guest curators – a role that public institutions, for financial or bureaucratic reasons, were not fulfilling.

The early 2000s also saw the creation or reactivation of existing cultural institutions across Brazil, such as Museu de Arte Moderna Aloisio Magalhães (MAMAM) in the north-eastern city of Recife, which presented a series of solo exhibitions by contemporary artists from across the country; and the Museu de Arte da Pampulha located in Belo Horizonte, the capital of Minas Gerais, which in 2002 created the country's first museum-based artist-in-residence programme. These endeavours helped initiate a decentralization of the internal art circuit, which previously revolved mainly around the Rio de Janeiro-São Paulo axis.

However, the legacy of the São Paulo Concrete artists, with their cerebral and rigorous approach to geometric abstraction, and the rise of the more sensuous and more open Rio de Janeiro Neo-Concrete movement, would still occupy a central place in local artistic debate in the following years. The strong revisionist stance towards Concrete and Neo-Concrete principles in the work of some young artists today is perhaps as much the result of Brazilian art's increased international visibility as it is part of a global movement to reassess Modernism in general. As the second decade of the twenty-first century approached, Brazilian art had already reached a significant international audience and was now being 'cannibalized' by foreign artists – this was precisely the theme of the 31st Panorama da Arte Brasileira, curated by Adriano Pedrosa and presented at MAM-SP in 2009. More recently, a new form of revisionism has taken place in São Paulo; an even younger generation of artists has chosen to work exclusively in the traditional medium of painting, looking back at the legacy of São Paulo painters from the 1980s including Rodrigo Andrade, Paulo Monteiro and Nuno Ramos, all members of the Casa 7 group and all still very active.

In the current scenario, some local institutions seem to have reached their maturity. The Pinacoteca do Estado has consistently organized contemporary and historical exhibitions of a high standard over the last decade and has recently inaugurated an impeccable rehang of their permanent collection, in which historical pieces are punctuated by contemporary works. CCSP continues to promote emerging art but has begun to focus on mid-career exhibitions by Brazilian artists, providing an important platform for producing and disseminating knowledge about the country's recent artistic production.

It is in this more intricate and multi-layered context that the São Paulo artists of different generations are working today. Although it is impossible to speak of a heterogeneous group, many of their practices are informed by one or more of the avant-garde iterations of modernity that have taken root in the city over the past century. At the same time, they seem to be equally driven by the city's impermanent character; things are constantly being demolished and constructed, and distinct architectural styles and periods coexist without any kind of harmony. The rhythm of these seemingly contradictory forces of memory and destruction seems to give rise to a production that, at its best, is fully aware of its cultural legacy without having too much reverence for the past. In this sense, such production does not intend to simply replicate previous artistic endeavours, but rather incorporate them into its critical vocabulary so as to reflect on the present and open new possibilities for the future.

Marcelo Cidade

The uneasy relationship between marginality and art has permeated Marcelo Cidade's work since the very beginning. Before attending art school, he was assiduously involved in skateboarding and graffiti, practices that often overstep the limits of legality and order. In a city where middle-class citizens live mostly indoors or inside their cars due to the fear of daily violence and lack of an effective public transport network, he spent his teenage years freely exploring the harsh reality of the São Paulo streets. With its unkempt pavements abundantly inhabited by homeless families, its precociously-aged concrete towers with facades darkened by pollution and the city's characteristic all-black graffiti, or *pichação*, and lack of regular maintenance by public authorities, this immediate urban environment would become one of Cidade's main subjects, playing a fundamental role in his practice.

Later, at university, he would become aware of the experimental production of Brazilian artists during the late 1960s and 1970s under military dictatorship. Either as an allegory for resistance or as a means to foreground social inequality in the country, many of these works made direct reference to marginalized figures, as epitomized by Hélio Oiticica's banner showing a photograph of the dead body of Rio de Janeiro outlaw slum-dweller Cara de Cavalo – who was violently murdered by the police – alongside the inscription 'Be marginal. Be a hero.' The artistic legacy of this generation would also become a recurrent theme for Cidade, who appropriates and repositions it in order to problematize the subversive potential of art in the post-utopian era of today's over-commodified art circuit.

His *Metaesquema Punk* (2010) features four pieces of felt arranged over a black background in a composition that replicates the homonymous series of abstract geometric works produced by Oiticica in the late 1950s. But while Oiticica's pictures show elegant grid-like structures formed by squares and rectangles, in primary colours against a pale background, Cidade's piece is dark and clumsy, incorporating the symbolic weight of the material to evoke both the blankets of city street dwellers and the experiments of Joseph Beuys. Other key figures of Brazilian modernity appear in Cidade's works. *Amor e ódio a Lygia Clark* (Love and Hate for Lygia Clark, 2006) consists of a pair of brass knuckles that, welded together, lose their functionality as weapons, instead bringing together gang culture and participatory art. A similar operation happens in *Desapropriação* (Disappropriation, 2010), for which Cidade rebuilt Lina Bo Bardi's famous Frei Egidio chair using plywood. In this new form, it is no longer able to support a person's weight, becoming a sort of participatory trap. Without a doubt, these pieces are partly homage, but they also show a certain cynicism in relation to the unfiltered and fetishistic appropriation of the artists' legacies. If, in the 1960s, art was supposed to change the world, does art in today's post-totalitarian, post-Berlin-Wall market-driven context still have the potential to change the order of things? This unresolved conflict is at the heart of his work.

← *Espaço Entre* (Space Between),
2008, iron and aluminium
sculpture, 320 × 320 × 320 cm

↑ *Disappropriation*, 2010,
pink plywood, metal clamps,
screws and 9 cement bricks,
120 × 57 cm

↓ *Metaesquema Punk*, 2010,
acrylic on felt blanket,
170 × 190 cm

↘ *Love and Hate for Lygia
Clark*, 2006, bronze sculpture,
15 × 13 × 1 cm

Adriano Costa

In his paintings, sculptures and installations, Adriano Costa often references art-historical genres or movements. However rather than merely quoting, he combines these references with other symbolically charged objects which he finds in his immediate environment and in everyday situations. In this way, he invests them with renewed meaning. The materials he employs are often chosen for their affective value: stained letters and notes kept by the artist for years or a torn and worn-out piece of patterned fabric. Costa's works are assembled in a calculated manner, with special concern for composition and form, to explore different styles and genres. Sometimes he seems to evoke the pale still lifes of Morandi; in other moments we can glimpse a floor work by Carl Andre or a Russian Constructivist sculpture. However, in spite of his careful attention to form, there is no attempt to disguise the fragility of the materials, and the resulting constructions often seem to be on the verge of collapse.

For the *Tapetes* (Rugs, 2011) and *Tapeçarias* (Tapestries, 2009–12), Costa composes floor and wall-based works by juxtaposing different fabrics taken from cloth scraps, T-shirts, flags, doormats and rugs that he has accumulated since 2008. These are arranged in what the artist calls a 'pre-sculptural' manner, which he describes as 'a moment in the process of constructing a sculpture in which the final form still has not been defined.'[2] Despite the soft quality of the materials, each assemblage is constructed in a rigorous manner, combining elementary geometric shapes of different colours and textures, sometimes displaying existing inscriptions or images. In contrast to the solidity of traditional sculptural forms, these pieces, which are simply placed on the ground without any fixing mechanism, or pinned lightly to the wall, are innately unstable and transitory. Mixing great geometric rigour with a

tactile appeal and a performative character, these works are also suggestive of the erudite Brazilian Neo-Concrete legacy without rejecting the symbolic value inherent in the tasteless old rags from which they are built.

'Plantation', the title of his 2012 solo exhibition at Mendes Wood, refers to the European economic model that predominated in Brazil during colonial times, in which the biological diversity of nature was subjected to a rationalist, profit-driven use of land. In some of the works presented, Costa used everyday objects such as bath towels, umbrellas and curtains. He juxtaposed traditional knitting techniques and the antagonistic formal concerns of modern art to trace an allegorical commentary on Brazil's aesthetic position: between the European model of modernity that characterizes its main urban centres and the spontaneous, artisanal production of its backlands. In many of the forms found in this exhibition, there is also an idea of germination, as if the tiniest beings or simplest organic forms emerged in the midst of a dense geometry, thus suggesting a certain animism of things; in the small embroidered black spots on a translucent piece of fabric, which seem like mosquitoes on a net, or the bronze-cast sugarcane leaning in the corner of the room.

In the oscillating gesture that refers simultaneously to consecrated art history and to the symbolic character of worthless detritus and organic fragments, Costa's practice finds its expression. However, his work is not about a purely formal contrast between chaos and order, marginality and officialdom, transition and permanence. Nor is it about precariousness or an attempt to mobilize a Third World narrative. With improvisation and urgency, Costa articulates the contradictory character of Brazil's cultural make-up – a country 'condemned to modernity', in the words of the late critic Mario Pedrosa.[3]

← *Landscape*, from the series
Tapestries, 2009–12,
acrylic on fabric, 30 × 14 cm

↑ 'Plantation', 2012, exhibition
view at Mendes Wood,
São Paulo

→ *Pintura* (Painting), 2012, iron,
fabric and acrylic on linen,
112 × 85 × 50 cm

↓ *A Place Built to Be Destroyed*,
2012, pigment on linen crochet,
83 × 75 cm

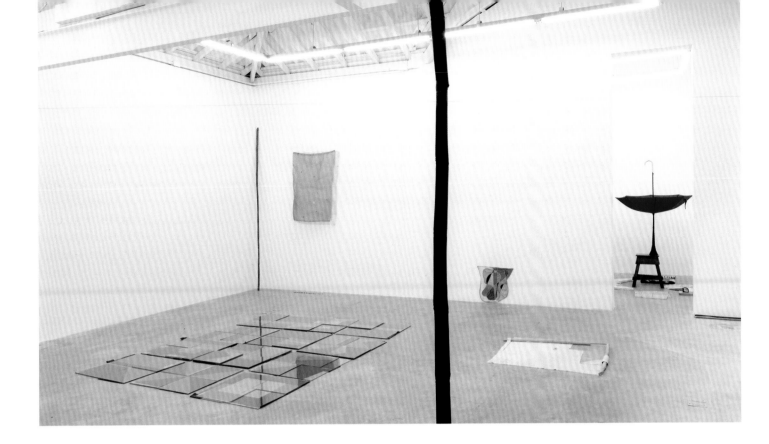

Valdirlei Dias Nunes

Having emerged in the São Paulo art scene in the early 1990s, Valdirlei Dias Nunes has developed a very unique and consistent body of work over the past two decades. Working primarily with painting and drawing, his distinctive production escapes any ready-made historical categories. Indeed, painting was never the preferred medium of his generation; which saw the rise and fall of dominant neo-expressionist trends in the 1980s. His peers often chose a more detached, conceptual approach to art-making, in which artistic self-expression was less evident. And although Dias Nunes seems to share this same ethos, he also brilliantly translates it into the medium of painting, opening it up to new dimensions beyond the formal concerns of his predecessors.

His early paintings, always executed with great precision, often followed the same rule of composition: a small everyday object, placed on a plinth or table in the lower central section of the canvas, set against a solid background. Employing a muted and economical palette to pursue a finite range of forms, these paintings, although undeniably figurative, already suggested the irresolvable vacillation between figuration and abstraction that would characterize his later works. In the late 1990s, this economy of form and colour became gradually more prominent. In his series of untitled paintings from 1998, Dias Nunes eliminated the single object, retaining only the plinth-like wooden structures depicted in light browns and yellows against an off-white ground. The purity of abstraction, with its permanent forms and rigorous geometry, seems to be infected by the materiality and transience of worldly objects; we can almost feel the grainy touch and warm surface of the wood, conveyed with deft illusionism.

Dias Nunes's experiments always maintain a close dialogue with his historical antecedents, particularly the Brazilian legacy of geometric abstraction. In his recent series of relief works from 2011, he takes his pictorial research further into the three-dimensional plane, marking the passage from planar to spatial geometry. *Sem título (Relevos)* (Untitled [Reliefs]) consists of a series of bulky plywood boards featuring one or two thin golden brass bars that cut through and beyond the surface, protruding from a pristine white background as if emerging from a bowl of milk. These works unmistakably reference the late Swiss-born São Paulo-based artist Mira Schendel's last series of works, *Sarrafos* (Slats, 1987). These large chalky and sleek surfaces, meticulously treated with gesso and tempera, are crossed with a dark wooden slat which seems to rise from the border and advance towards, and sometimes beyond, the work's centre. Schendel was never officially a member of the Brazilian avant-garde Concrete and Neo-Concrete movements, although her name is often mentioned in relation to them. Her spontaneous approach to geometry was distinctive, and her later works simultaneous experiments in drawing, painting and sculpture. Dias Nunes's recent reliefs, in turn, are his first in which the figurative is completely absent. Significantly, the preciousness with which he painted his earlier figures is replaced by the symbolic preciousness of actual material.

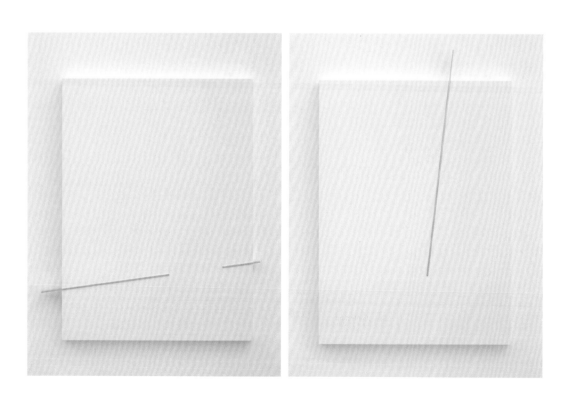

← *Untitled (Relief 8)*, 2011, matte lacquer on MDF and polished brass, 130 × 110 × 5 cm (left)

← *Untitled (Relief 6)*, 2011 matte lacquer on MDF and polished brass, 146 × 95 × 5 cm (right)

↑ *Untitled (Wooden Box)*, 2010, oil on canvas, 70 × 80 cm

↓ *Untitled (Wooden Structure)*, 2008, acrylic gesso and oil on MDF, 58 × 90 × 55 cm

→ *Untitled (Longitudinal Golden Bars II)*, 2010, oil on canvas, 70 × 50 cm

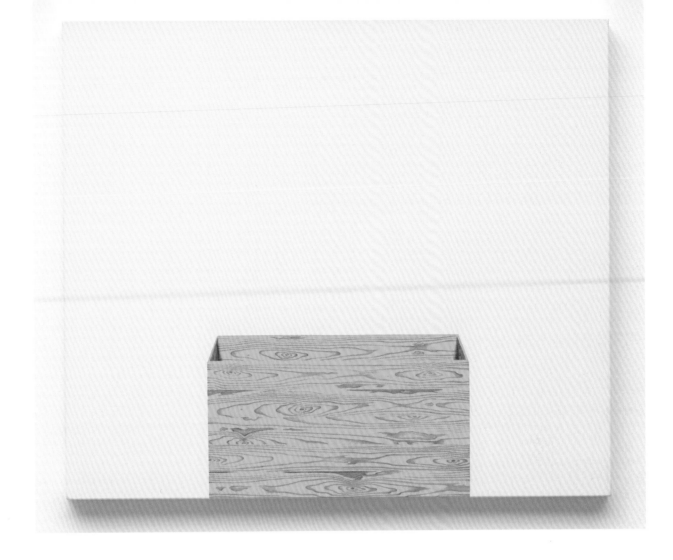

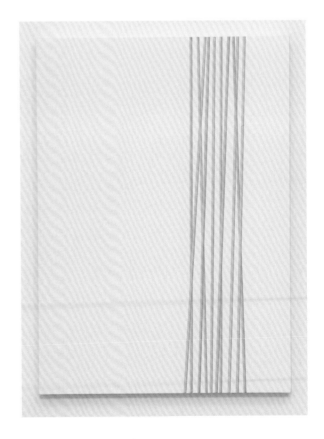

Marcius Galan

Marcius Galan belongs to a specific lineage of Brazilian conceptual artists whose work is characterized by precise, minimalist forms and a particular interest in geometry. In many of his pieces, he carefully reconstructs objects while subjecting them to suppressions, additions and material misuse, thus redefining their functionality and form. By intentionally undermining their use-value, Galan addresses the relationships of these objects to social organizations, bureaucratic processes or economic systems. In *Extensão* (Extension, 2004), he employed 5,000 metres of electrical cord, piled up on the floor, to power a single light bulb hanging from the ceiling. The faint, flickering quality of the resulting light was due to the energy expended by the unnecessarily long cable. The piece deals with the squandering common to bureaucratic processes that use a lot of energy to accomplish a simple task. The installation *Imóvel/Instável* (Immobile/Unstable, 2011) comprises a seemingly complex system of concrete weights interconnected by tightly stretched steel cables and slanted wooden bars in a delicate balance under imminent threat of collapse. This whole apparatus has a single function: to vertically stabilize a small black coin on the ground with extreme precision, thus providing a material metaphor for the tortuous financial schemes behind today's tenuous notions of economic stability.

In another body of work, Galan emphasizes the phenomenological. Playing with the elusiveness of perception, these works make us aware of the gap between how we perceive objects and their actual physical existence, pointing to the indefiniteness of objects and space. In the series *Isolante* (Insulating, 2008), small areas of the room are cordoned off or defined by apparently pliable, bright yellow ribbon, often wrapped around mundane objects like bottle crates, bricks and chairs, or hung floppily from one or more nails on the gallery wall. These evoke the makeshift arrangements used on the unkempt streets and pavements of São Paulo to insulate potentially hazardous holes and cracks. Yet as we approach these works in the gallery, we realize the ribbon is in fact made of iron. Mobility is rendered stiff and static; expansion and flexibility are impossible.

Dealing with ideas of deceptiveness and frustration, this approach is quite distinct from the renowned participative production of the Brazilian Neo-Concrete artists who proposed an approximation between art and life in the 1960s and beyond. Even on an environmental scale, Galan pursues phenomenology as a tool to destabilize our certainties about spatial representation and the bodily experience of space. His work *Seção Diagonal* (Diagonal Section, 2008), for instance, consists of an architectural intervention in the exhibition space for which walls, ceiling and floor are coated with a layer of wax, slightly altering the colour and texture of their surfaces to give the impression that we are looking through a glass window. Here, as the work takes on an architectural scale, it becomes increasingly dematerialized. Indeed, it exists only on the verge of illusion, as a mental process that unmakes itself as we step closer to it. And it is precisely in this indefinite zone between supposedly stable, accepted systems of representation and the lived experience of objects and space that Galan's work can be located.

← *Área Comum* (Common Area), 2008, concrete and paint, 13 × 150 × 150 cm

↑ *Immobile/Unstable*, 2011, cement, wood, iron, steel cables and coin, dimensions variable

↓ *Diagonal Section*, 2008, wood, wax, light filters and painting on wall, dimensions variable

↘ *Extension*, 2004, light bulb, energy and 5,000 m electric cable, dimensions variable

↪ *Inclination to the Left*, 2008, painting on wall, wood and screws, 140 × 230 × 8 cm

Runo Lagomarsino

The consequences of the colonialist past that reverberate through the imperialist present – particularly the connections between Portuguese and Spanish conquests of American territories and the current notions of exporting democracy and diaspora – recur thematically in Runo Lagomarsino's work. He is interested in challenging discursive and historical mechanisms, representational systems that are traditionally used as tools to convey meanings, truths or political ideologies. Employing a variety of media such as video, drawing, sculpture and photography, his projects often encompass intricate arrangements of different symbolic fragments and historical facts, prompting us to critically reassess the ways in which we read history.

Contratiempos (Against Times, 2009–10) is a product of the artist's perambulations around the marquee of Ibirapuera Park, designed by architect Oscar Niemeyer in 1954 on the occasion of the fourth centenary celebrating the founding of São Paulo. With an area of 28,000 square metres, this covered structure – whose primary function is to connect several buildings located in the park, including important art venues such as the Biennial Pavilion and the Museum of Modern Art – provides shelter from both the tropical rainstorms and the sizzling heat of the city's summer months. The marquee is also a gathering place for different groups of park users: skateboarders, street vendors and passersby. On the concrete floor of this marquee, intensely used but lacking regular maintenance, Lagomarsino identified a series of images that suggested the outline of the South American continent. Using this elegant example of the modern architecture of the tropics, the artist focused on the most prosaic of its features: the random designs formed by the cracks permeating its entire foundation,

through which he was able to identify a kind of order corresponding to his mental idea of the territory. This quasi-performative exploration of space results in images of a continent whose tentative outline is sometimes sharpened, sometimes absolutely shattered. The work is presented as a slide show, a technology reminiscent of Brazil's golden era of economic growth when the marquee was built.

In *Trans Atlantic* (2010–11), Lagomarsino entrusted forty-nine sheets of paper to a sailor who was about to cross the Atlantic alone in his boat following the same maritime route used by the Portuguese merchants who travelled to Brazil in the sixteenth century. Protected by plastic bags, these sheets were individually tied to the boat with ropes and exposed to sunlight for different periods of time. Burned by the sun's rays, their surface became stained with brownish patches and crossed by white streaks where the ropes protected them. Each sheet was then diligently catalogued by the sailor, who recorded the dates and number of days of exposure, as well as information regarding relative latitude and longitude during these periods. In this manner, Lagomarsino simultaneously employs two distinct epistemological models for recording the Atlantic crossing: the empirical evidence by which the paper bears the physical marks of the crossing, and cartography, the traditional European science which developed a system for geographically charting the globe through the establishment of fixed points, thus creating the possibility to conquer the world. With a dual Argentinean and Swedish heritage, Lagomarsino has been based in São Paulo since 2009, after having lived in Malmö. His Italian ancestors possibly followed a similar maritime route as that delineated in *Trans Atlantic* on their way to Argentina.

← *Trans Atlantic (Under Process)*, 2010–11

↑ *Against Times*, 2010, Dia projection loop of 27 original images in Kodak slide projection carousel with timer

↓ *Trans Atlantic*, 2010–11, 32 sun drawings and 17 unrealized sun drawings on newsprint, each 33 × 48 cm

Marina Rheingantz

Born in Araraquara, in the countryside of the state of São Paulo, Marina Rheingantz has retained an interest in her homeland's rural landscape and colour. After completing her BA in Fine Arts in São Paulo in 2006, her work was featured in the group show '2000e8' (2000and8, SESC Pinheiros, 2008), which brought together a new generation of painters working predominantly with figuration. Despite not having directly experienced the 1980s boom of gestural painting in São Paulo – most were actually born in the 1980s – these young painters often consider the artists from the so-called *Geração 80* (eighties generation), such as Rodrigo Andrade or Nuno Ramos, to be their main influence. Unlike the generation that emerged in the late 1990s and early 2000s, who tend to work with photography, sculpture, installation and video – perhaps as a natural reaction to the mannerism and omnipresence of painting among their predecessors – this new group embraces painting as a medium still rife with possibilities for experimentation.

Rheingantz's early paintings often employ a subdued palette of pastels to geometrically reduce scenes into solid areas of colour. Since the beginning, her themes have been mainly suburban or rural, picturing the domestic environments of a kitchen table and chairs in *La Cocina* (The Kitchen, 2009) or a swimming pool (*The Pool*, 2009), an aerial view of a tractor in *Colheita* (Harvest, 2008), the pathway leading to a house surrounded by cypress trees in *Cipreste* (Cypress, 2008) or a barren landscape (*Seven Sisters*, 2008). There is a certain mystery to all of these scenes, as if we can never be sure whether the places or situations exist in reality or if they were simply imagined by the artist. First of all, the human figure is never present, which makes the paintings seem abandoned or unreal. Then there are no evident clues as to where these places may be – they are clearly not in the city of São Paulo, but the muted palette also suggests a more temperate or colder region than anywhere in Brazil.

Recently, Rheingantz's brushstrokes have become more visible and expressive, and her colours slightly more bright and vivid. These subtle but significant formal changes seem to have shifted her work in different directions, as her freer hand is able to concentrate on details. In *Pelada Caipira* (Rural Football, 2011), for instance, the level of detail allows us to identify what appears to be an improvised football field amid the growing vegetation that surrounds it. In spite of the predominant grey tones, this is an unmistakably local scene, depicting a visual element widely found in the Brazilian landscape. In *Jardim Botânico* (Botanic Garden, 2011), nature – often represented by flat green areas of canvas in earlier works – here becomes more intricate and detailed, conveying the lushness and diversity typical of the tropical and subtropical regions. In the background we can distinguish a simple house, painted in the light pink and green tones of the Brazilian southern countryside famously epitomized in the work of modernist painter Tarsila do Amaral. Approximately eighty years later, Do Amaral's investigations around *cor caipira*, or 'rural colour', seem to find renewed relevance in Rheingantz's palette.

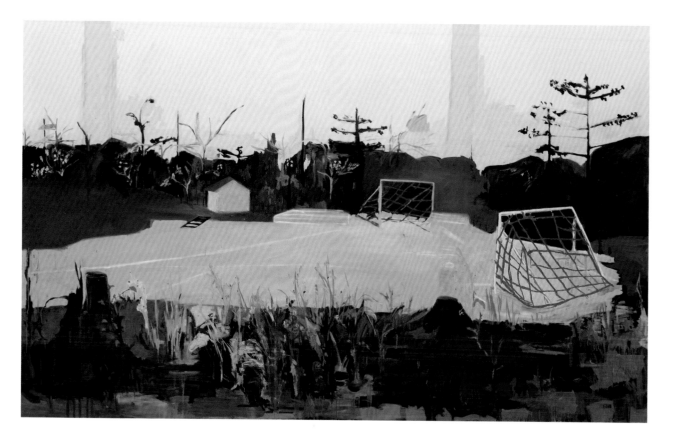

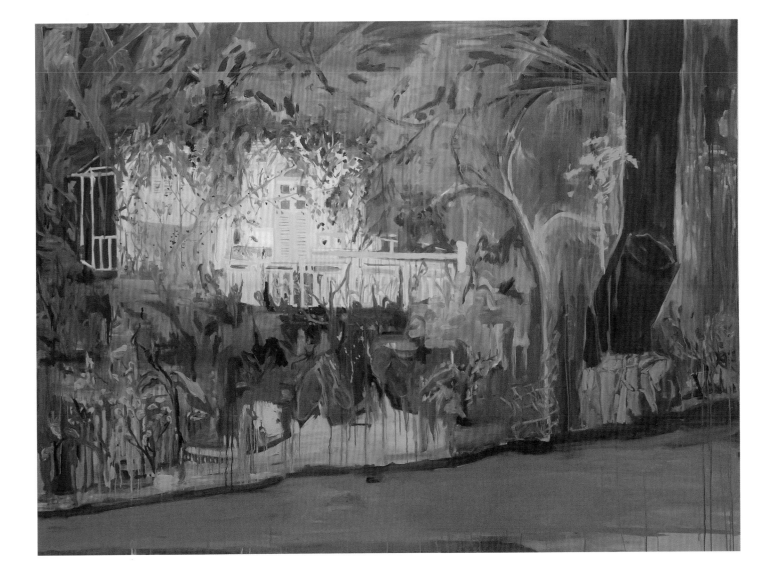

← *Rural Football*, 2011, oil on
canvas, 210 × 330 cm

↑ *Botanic Garden*, 2011, oil on
canvas, 160 × 210 cm

↑ *The Kitchen*, 2009, oil on
canvas, 24 × 30 cm

→ *Seven Sisters*, 2008, oil
on canvas, 160 × 180 cm

Erika Verzutti

Erika Verzutti works with seemingly incompatible materials or themes to create sculptures that make reference to modern art, ordinary life and the natural world. A pineapple, a jackfruit and a squash are only a few of the many fruits and vegetables that the artist has cast in bronze and incorporated into her assemblages. These elements are sometimes distorted, serialized or combined with other materials in compositions that are often formally reminiscent of a Brancusi column, a Maria Martins sculpture or a painting by Tarsila do Amaral, among other art-historical sources. Importantly, within the context of Verzutti's work, the articulation of disparate elements breaks with hierarchical conventions; a papaya, for instance, is as aesthetically valuable as a Henry Moore sculpture.

Another distinctive aspect of Verzutti's practice is the lack of interest in the kind of formal rigour that usually marks modern artistic production. Distinguished by a certain imprecision typical of handmade objects, her sculptures often bear traces of the artist's gesture or imperfections such as splashes of paint or formless accumulations of Plasticine. Furthermore, they are distinct from much of the work of her Brazilian generation, which is largely characterized by a strongly conceptual lexicon, a minimalist approach to form and a meticulous sensibility. Verzutti does recuperate, however, some distinctive features from the generation of São Paulo artists that immediately preceded her: the neo-expressionist painters who dominated the local art scene in the 1980s.

Quoting their emphasis on gestural and material expression, Verzutti demonstrates an affiliation with this generation in various instances. During her formative years in the early 1990s, artists such as Leda Catunda, Paulo Monteiro and Sergio Romagnolo, who were at the epicentre of the art circuit at the time, were her first references. Later, as part of her investigation of art-historical quotation, she initiated collaborative projects with artists whose work she admires and with whom she maintains an ongoing dialogue. In her solo exhibition 'Pet Cemetery' (2008), there were collaborations with artists Alexandre da Cunha, Efrain de Almeida, Tiago Carneiro da Cunha and Tonico Lemos Auad. Her outdoor sculpture *Bicho de 7 Cabecas* (Seven Headed Monster, 2010) features several 'guest heads' by other artists. Some saw this as a liberating opportunity to create something completely unconnected to their own practice; others preferred to retain their own style. Ultimately, Verzutti created a situation in which works from fairly renowned artists – such as Adriana Varejão, Ernesto Neto and Damian Ortega – are collected in a very compact space, from which they must literally stretch their necks out to gain some visibility.

These collaborative works, like her own sculptures, are a kind of collage of various external contributions. They underscore the organic manner in which the variety of pieces feed into one another, extending her practice of generating meaning through unpredictable approximations. Verzutti's intention, however, is not to historicize the forms and references she appropriates, or to view them in a nostalgic way, but to activate certain unsuspected or unfashionable connections between works of art that may be high or low, contemporary or historical, renowned or inconspicuous. In this way she challenges our understanding of Brazilian art beyond the usual clichés.

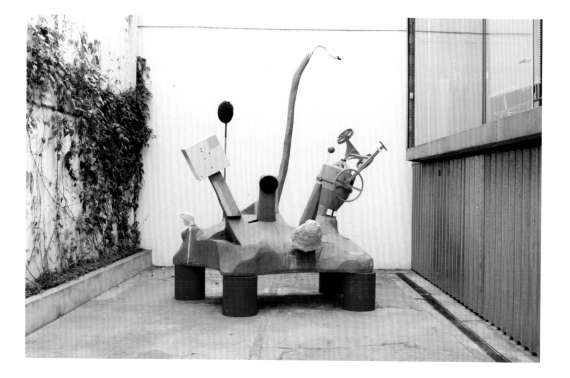

← Seven Headed Monster, 2010, mixed media, 406 × 220 × 310 cm

↑ Henry, 2008, bronze, 32 × 37 × 40 cm

↗ Dino, 2012, concrete, pigment and bronze, 80 × 12 × 20 cm

↓ Dino Tropical, 2012, bronze, concrete and wax, 240 × 15 × 30 cm

→ Escala Carmelo (Caramel Scale), 2011, bronze, acrylic and graphite, 2 pieces, 20 × 14 × 8 cm overall

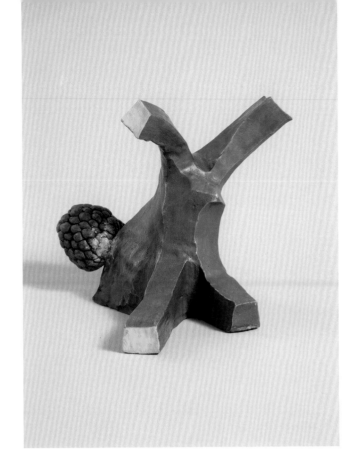

Carla Zaccagnini

Born in Buenos Aires, Argentina, Carla Zaccagnini moved to São Paulo in 1981. Relocating to a Portuguese-speaking country with different cultural traits may have sparked her ongoing interest in processes of translation, which she understands as relatively open systems with fissures and cracks that produce slight shifts in meaning. She often plays with the impossibility of exactitude by deviating from traditional representational systems and conventional ways of viewing. Often she creates a set of rules that must be followed by the public, who completes or activates the work, thus producing a collective and unpredictable construction of knowledge. With an emphasis on mental or conceptual processes over material or formal concerns, her works cannot be attached to a particular style or medium. Her multifaceted production moves freely across different media, relying on temporary sets of circumstances for material.

This is precisely the case in her project *Museu das vistas* (Museum of Views, 2004–present), an ongoing collection of drawings mediated by discourse. For this work, Zaccagnini mobilizes a police artist, who is based in and around the exhibition space for a certain period of time. He or she is then instructed to make drawings of the specific views described by members of the public who volunteer to take part. Each drawing is made on self-copying paper; the original is given to the describer, while the copy is retained and integrated into the museum's collection. Besides reworking the tradition of landscape painting, *Museum of Views* is also an experiment in how landscape becomes a mental image and how this mental image can be translated into a visual representation.

Zaccagnini has developed many works during artistic residencies in other countries, and these projects refer specifically to their cultural, political and social contexts. *Sobre la igualdad y las diferencias: Casas gemelas* (On Equality and Difference: Twin Houses, 2005), is a photographic series showing originally identical house facades in the streets of Havana that have been gradually modified by their inhabitants over the years. The images of formerly identical facades are presented side by side, revealing both the sameness of the buildings' structures and the differentiation that emerged from changes in taste, habit or the specific needs of each dweller. Within the political context of Cuba, the work becomes a sort of architectural metaphor for the authoritarian character of socialist regimes and their inability to contain subjectivity amid forced standardization.

Another concern in her work is the possibility to convey content through lived experience rather than intellectual means. *Reação em cadeia com efeito variável* (Chain Reaction with Variable Effect, 2008) is an installation that was commissioned for the 28th São Paulo Biennial. Located outside the Biennial pavilion, in the Ibirapuera Park, it consisted of a fully functioning playground with a set of swings, a roundabout and a seesaw. These were connected to a sophisticated hydraulic system specifically engineered to supply water to a fountain, which had to be collaboratively activated. More than one user was required to play in order to set the water pump in motion, thus evoking the idea of socially shared responsibility. The fact that the artist often involves other people in her works – either through collaborations with other artists or by relying on the participation of the viewing public – is somehow a symptom of her gregarious nature. In the São Paulo art scene, Zaccagnini is a prolific thinker who also develops parallel activities as a curator, lecturer and writer.

← *On Equality and Difference: Twin Houses*, 2005, series of colour photographs, dimensions variable

↑ *Alfabeto Fonético Aplicado II: They paved a Panamericana and all I can see is the Darien Gap*, 2010, anodized aluminium, 56 plaques, each 20 × 60 cm

↘ *Chain Reaction With Variable Effect*, with Alexandre Canônico, 2008, mechanical hydraulic system activated by the simultaneous use of seesaws, swings, merry-go-round and chaise-longues

↓ *Museum Views*, 2004−present, collection of drawings mediated by discourse

Seoul
by Hyun Jung

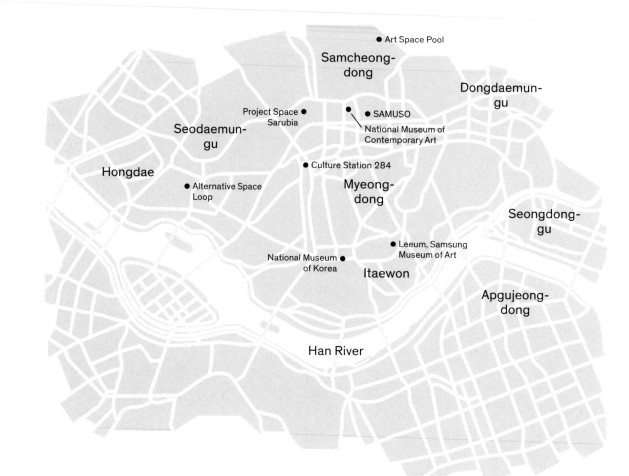

N

Art Space Pool

Samcheong-
dong

Dongdaemun-
gu

Project Space
Sarubia

SAMUSO

Seodaemun-
gu

National Museum of
Contemporary Art

Hongdae

Culture Station 284

Alternative Space
Loop

Myeong-
dong

Seongdong-
gu

Leeum, Samsung
Museum of Art

National Museum
of Korea

Itaewon

Apgujeong-
dong

Han River

↓ Nam June Paik Art Center

0 1 km

● Alternative Space Loop
 335-11 Seokyo-dong, Mapo-gu

● Art Space Pool
 56-13 Gugi-dong, Jongno-gu

● Culture Station 284
 1 Tongil-ro, Jung-gu

● Leeum, Samsung Museum of Art
 747-18, Hannam-dong,
 Yongsan-gu

● Project Space Sarubia
 158-2 Changseong-dong,
 Jongno-gu

● Nam June Paik Art Center
 Paiknamjune-ro 10
 Sanggal-dong Giheung-gu
 Yongin-si Gyeonggi-do

● National Museum of
 Contemporary Art
 97, 1-gil, Yulgok-ro, Jongno-gu

● National Museum of Korea
 168-6, 6-ga, Yongsan-dong,
 Yongsan-gu

● SAMUSO
 137-5 Hwa-dong, Jongno-gu

Seoul is a metropolis with a population of over ten million, or roughly one-fifth of the population of South Korea. The political, economic, cultural and educational hub of Korea and the country's capital for over six hundred years, Seoul is as dramatic and complex as its history is long. In the twentieth century, that history was distinctly melancholy. After opening its ports, the country was devastated in the aftermath of Japanese colonialism and the Korean War. In the ruins, short-term rapid growth took hold under a military dictatorship's stringent economic development plans, driven by desperation for a higher quality of life and a stronger nation. Such mass psychology and compressed development largely contributed to Seoul becoming a city that is much more dynamic and radical than many others today. The demolition of cultural artefacts to make way for new buildings was carried out in the name of progress without any moral hesitation during this period of recklessness. On the other hand, cultural policy after the war emphasized pre-colonial traditions, in an effort to exalt national independence. The struggle for cultural purity was enforced to the point of censoring the Western influence of Pop and various left-leaning counter-cultures.

The Minjung Misul (People's Art) movement of the 1980s transformed the possibility for an indigenous Korean contemporary art into a political, anti-authoritarian art for the people. As an outcry against a dictatorial government that suppressed freedom of expression, Minjung Misul endorsed activist art that avoided formalism, intentionally promoting amateurism through genres like mural painting, printmaking and performance art. However the movement's ideology, which intervened in individual creativity to an excessive degree, became a subject of dispute later on, and the influence of Minjung Misul gradually weakened with the Korean shift to democracy. Art in Seoul in the aftermath of the war vacillated between modernity and tradition, Korean art and Western art, and the tedious dispute over the legitimacy of art continued. The fact that a history of twentieth-century Korean art has only recently been written by Kim Young-na, the director of the National Museum of Korea, suggests the degree of confusion and divisiveness that existed in the art world at that time. Reflecting such circumstances, the exhibition 'Korean Rhapsody', held at the Leeum, Samsung Museum of Art in 2011, traced the history of twentieth-century art in Korea through periods of political upheaval, from the end of the nineteenth century and the rise of modernity to post-war economic development and the onset of the contemporary in the twenty-first century. 'Korean Rhapsody' sought to bridge the gap between the past and the present day, when economic dynamism favours the image of a highly developed global city and nation. While portraying the realities of modernization, the exhibition also presented Korea as a country that has matured enough to be able to piece together the fragments of its history and face the traumas of its past.

The art world in Seoul met with radical change at the turn of the millennium, due primarily to the proliferation of alternative art spaces. Founded in 1999 with funding from a large company, Ssamzie Space was one of Korea's first nonprofit spaces. Not only did Ssamzie Space play a leading role in producing cultural trends, promoting international exchange and underground culture, it ultimately gave birth to a group of artists known for their association with it. (Ssamzie closed in 2010.) Alternative Space Loop, Project Space Sarubia and Art Space Pool followed, functioning as gateways for emerging artists by supporting alternative practices and presenting groundbreaking exhibitions at the vanguard of contemporary art in Korea. Many well-known artists today who work across a wide range of media, including Park Chan-Kyong, Oh Inhwan, Ham Jin, Minouk Lim, Yeondoo Jung and Bae Young-whan were introduced to the Seoul art scene by showing at alternative spaces.

The millennial paradigm shift was also influenced by the prevalence of Korean artists studying abroad in the 1990s, who returned to Seoul from Europe and America in

the early 2000s, bringing with them new attitudes and approaches to art making. Many were more interested in exploring their own distinctive cultural and social outlooks than dealing with the legacy of Korean art from the past. The third and final factor affecting the Seoul art scene in the last decade was the atomization of the art subject. While the art system began to encourage individuality and creativity, the establishment of a social-democratic environment meant the broaching of subject matter once considered taboo. For example, Oh Inhwan presented his work on homosexuality and Seoul's gay community in his solo exhibition 'Meeting Place, Meeting Language' at Alternative Space LOOP in 2001. It was the first attempt to present a discourse on homosexuality in the context of art rather than sociology. The solo exhibition of artist, critic and former director of Alternative Space Pool, Park Chan-Kyong, held at Ssamzie Space in 2005, shed light on the ambiguous relationship between North and South Korea and the period of division between them. Focused on the historical event of opening the air route between North and South Korea for the first time in fifty years, Park's ten-minute video *Flying* captured features of both the one-hour flight time between Seoul and Pyongyang and the irreversible five decades of severance. Division is no longer a story of outdated ideologies; rather, it now yields the untold accounts of individuals. With over 20,000 North Korean defectors living in South Korea, new narratives for recent history are also entering the artistic realm.

In the first decade of the twenty-first century, the structure of the art institution was somewhat established; built on national, public and private art museums, commercial galleries, alternative spaces, art educational institutions and the Arts Council Korea. Artistic discourse strayed from conventional art practice and the arguments over modernism and traditionalism which had persisted since the mid-twentieth century. Contemporary art trends rapidly shifted to ideas of subjectivity, the subversion of conventionality, everyday life, and anthropological excavations or explorations of the city. This movement in visual culture compensates for the lack of cultural diversity within the city's existing institutional structures, and is in an ongoing process of forming more substantial foundations. Significantly, the Nam June Paik Art Center, established in 2008, is dedicated to organizing Asia-focused exhibitions that reflect the international ideas of the eponymous late artist. Founded in 2005, SAMUSO is a cultural production agency that presents exhibitions, publishes artists' books and catalogues, and holds forums and workshops. It hosted the annual exhibition Platform Seoul from 2006 to 2010, and has supported great diversity in media and expression with surveys of performance art, political art and political video. Many of these shows were mounted in exhibition spaces spanning the old quarter of Seoul. In particular, the old Seoul Station and the former Defense Security Command building, both former venues of Platform Seoul, have respectively been transformed into Culture Station 284 (an art, architecture, design and performance space) and the recently completed National Museum of Contemporary Art.

The realm of discourse in Seoul is expanding its influence in step with changes to the institutional system, while discussions between artists and critics are being supported by the increasing circulation of art journals and the expansion of the commercial art world. Although the importance of criticism is growing through the influence of cultural and post-colonial studies, what seems to be necessary is a gestation period for Western theories to be adapted and absorbed into the Korean context. The territory of discourse is wider than ever; this is in contrast to the crisis in the humanities at the university level, which is slowly giving way to vocational education due to economic pressures. University students have begun to self-organize alternative systems for humanities studies — much like the contemporary artists who develop their own rules and communities — which is indicative of the current aspiration for collective intelligence in society and art, through a non-institutional and autonomous cultural infrastructure. Reflected directly in current avant-garde practice in Seoul are changes to society's structural base with the influx of North Korean defectors and migrant workers from East Asia, especially surrounding issues of urban gentrification, population ageing, generational conflict, ecology, local culture and globalism. Such dynamic shifts enrich the art world, but also reveal the

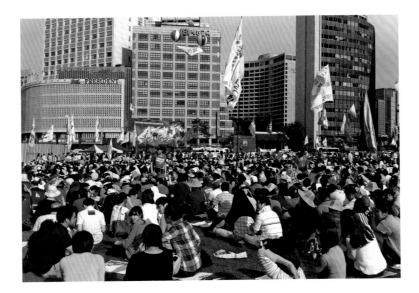

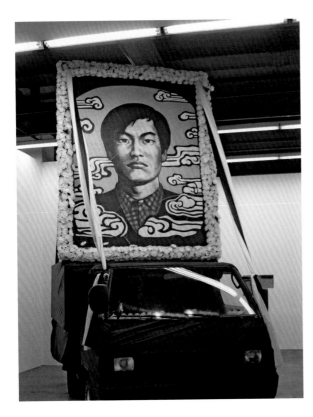

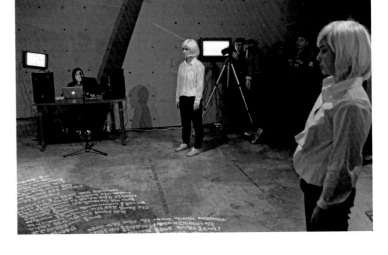

↑ Peoples' strikes in the Seoul City
 Hall Plaza

↗ A performance by Hong Sung Min
 at Alternative Space Loop

↑ Replica of Byungsoo Choi's 1987
 Portrait of Han-yeol Lee in the
 style of Minjung Misul, at
 the 2010 Gwangju Biennial

↓ Exterior of Art Space Pool, 2010

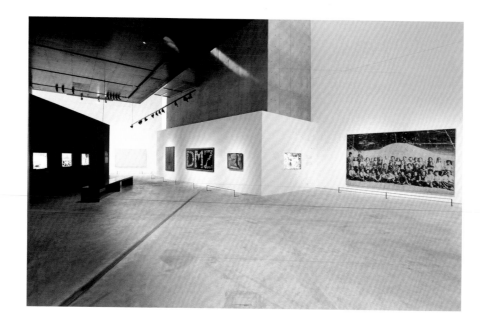

↖ Exhibition view of 'Korean Rhapsody' at Leeum, Samsung Museum of Art, 2011

← Sunwonjeon, near Gyeongbokgung Palace, during a performance of *Let's Walk and Chat Together: Jeongdong Chapter* by Jooyoung Lee, 2011

↑ Nam June Paik Art Center

← Park Chang-Kyong, *Flying*, 2005, video, 12 min.

fragility of the cultural ecology as artists, small galleries and alternative spaces die out due to results-oriented administrative systems and a lack of continuous funding sources. Radical social change manifests in forms of anxiety for the future among the younger generation, causing artists to reject the mainstream and form collectives – including Part-time Suite, Okin Collective, Listen to the City and many more – to deal with real world problems. There seems to be an element of *Nouveau Réalisme* in Seoul's avant-garde, in its tendency to examine the identity, social function and raison d'être of the artist amid political, economic and social insecurities. Furthermore, artist collectives propose a model of self-development that reflects the enterprising nature of capitalism. They overcome the limitations of the individual by working outside of the collective if need be, and by voluntarily collaborating with specialists from various fields. Without regard for convention, these artists build autonomous systems of production that defy fixed structures, exploring forms such as rock bands, graphic design companies, independent publishing houses, radio stations, blogs and other urban initiatives.

Seoul has two faces: one marked by the high aspirations of the modern myth of progress, and the other filled with melancholy for fragmented twentieth-century ideologies. Naturally, there are countless iterations of the city between them, leaving its visual and cultural identity in a state of ambiguity. Intentionally or not, innovative artists will try to find ways to connect the gap between the faces of Seoul in ways that are personal and diverse, rather than assuming any unilateral historical perspective. The challenge for Seoul's avant-garde today is to explore, rather than define, the identity of the city.

Hyun A Cho

Hyun A Cho's photographs capture the lives of wanderers who are unable to settle down. Having lived abroad for more than a decade – studying in the United States after high school and then receiving her master's degree in photography at the Royal College of Art in London – her images imbue common scenes of daily life with a rich and almost magical cultural sensibility that reveals the vulnerable psychological state of city dwellers. Her pictures of Seoul unfold like the atemporal heterotopias proposed by Michel Foucault, while those of England betray an anthropological pers-pective, as in the series *Melancholic Mélange* (2007), which focuses on plants in a botanical garden. The tropical plants in the garden suggest exotic fantasies within the rarified space of cultural imperialism. In these photographs the plants undergo numerous levels of printing to acquire an exaggerated sense of darkness, artificial colour and depth, their leaves twisting to the point of a grotesque which might indicate a poisonous species. Working through ideas of place, phenomena and life forms both indigenous and displaced, Cho discovers the presence of the other. Her explorations of Seoul's post-apocalyptic identity have led her to discover street cats, the currents of the Han River and the dispossessed urban poor who live along its banks.

Des Grands Sphinx (2011–12), which comes from Baudelaire's poem *Les Chats* (1847), begins by drawing an analogy between lowly cats and the magnificent Sphinx. The project was inspired by the cats displayed in the storefront window of an animal hospital that Cho happened across in a decaying Seoul neighbourhood. A multiple-family housing complex and nearby roads identify the area as a humble district, yet the street cats roaming its alleyways late at night, as photo-graphed by the artist, suggest a place with a mysterious secret. The cats become a poetic metaphor for the discarded in these haunted, marginal areas; while the luminous game machines glowing from the depths of dark corners cast the dynamic city in elegiac shadow.

False as Water (2012) consists of fifteen photographs and three drawings of the Han River, which divides Seoul into north and south. The surface of water, in symbolic philosophical terms, represents the circulation of life and death, Eros and Thanatos, and moves ontologically like the ripples (*le pli*) suggested by Deleuze. Cho photographs the water from the subway as it crosses over the river. The resulting images, which are uncontrollable due to the technical limitations of the camera and the motion of the train, reveal the surface of the river, boats and other floating bodies in an unfamiliar and ambiguous way, appearing as something unreal. By giving visibility to that which fails to keep pace with Seoul's abrupt economic development, Cho depicts time segmented by the dash of contemporary civilization, producing images that manifest the difference in speed between the waters of the river and the train.

In *Han River Melancholia* (2012–present), which documents the people who haunt the banks of the Han River, she further develops her philosophical relationship with water. A significant symbol of the city, the river has dual attributes: as a subject of contemporary myths of urban economic development, and as a no-man's-land that is separated from reality. Paradoxically, the Han River is geo-morphologically a centre of Seoul, but also a social periphery. In the form of a photo-roman, the work in this series betrays symptoms of human anxiety typically concealed by the drive for civic success.

← From *Melancholic Mélange*,
2007, C-print, 130 × 150 cm

↑ From *Des Grands Sphinx*,
2011–12, 35 mm slide projection

→ From *Des Grands Sphinx*,
2011–12, 35mm slide projection

↓ From *False as Water*, 2012,
digital print, 23 × 31 cm

Hodeuk Kim

Hodeuk Kim's black paintings trace the movement of *Qi* (energy) from the dot to the line and the plane, eclipsing the Western postmodernist notion of the death of painting. Rendered in calligraphy, his meditative painterly world also rejects the typical formality of Eastern pen-and-ink landscape paintings. The connection between creativity and the mind is most pronounced through his use of simple materials; the harmony of black ink radiating with abundance and boundless possibility across the lightweight *dak* paper creates a surface of pure dynamism. In particular, the installation work *Wave of Mind, Awakening Moment Between* (2011) induces a synaesthetic experience almost exclusively through the use of material, as black and white planes diagonally cross the gallery's architectural interior. A tank full of ink forms a black mirror underneath these planes, filling the space with its scent and becoming the site of a poetic performance on the final day of the exhibition, when it becomes a well into which the paintings are dropped. When the material expression of the artist's mind falls into the ink and is extinguished, mind and material reach a state of unity – suggesting ideas of Yin and Yang, birth and death, and inviting the audience to consider the unstable boundaries of consciousness when emotion escapes human control.

Traditional Korean painting prioritizes discipline in the handling of paper, pen and ink; thought always precedes process. Training with materials accompanies the training of the body. The artist's attitude towards the material and method of creation is considered more important than the final outcome, because the mind infiltrates the material as it is worked. Intelligent material is thus charged with the potential to form relationships to other materials, generating an alchemy between them. Kim has said, 'The most fundamental element in painting a picture is making the first stroke, according to the theory of Chinese artist Shi Tao, who teaches that everything else in the painting is set, and a world formed, with that first stroke.'[1]

The brushstrokes of *Midday Mountain Ridge* (2010) allude to the mountains, wind, sun and time of day. Eastern painting is characterized by the harmony of image and text, where the simplified poetry of a title serves to complete the painting with a refined energy. Kim's work fundamentally originates from pen-and-ink landscape painting. Only he treats the landscape as a representation of nature, as well as a psychological subject reflective of a Taoist worldview; a synthesis perhaps alluded to in the more abstract play of light, shadow and grey intermediary tones of *Early Morning* (2011) and *Night* (2008). The installation *Between Layers* (2011) proposes the simplest state of pigmented and unpigmented black and white, as a meditation on the boundless possibility of paper and ink rather than a rejection of representation.

In an art world that tends to deny the past, Kim is praised for persistently pursuing values of Korean-ness. Bog-gi Kim, editor of the magazine *Art in Culture*, has commented, 'If Hodeuk Kim's persistence remains a virtue in the Korean art world, it's probably because he holds fast to the mentality that defines Korea and its traditions'.[2]

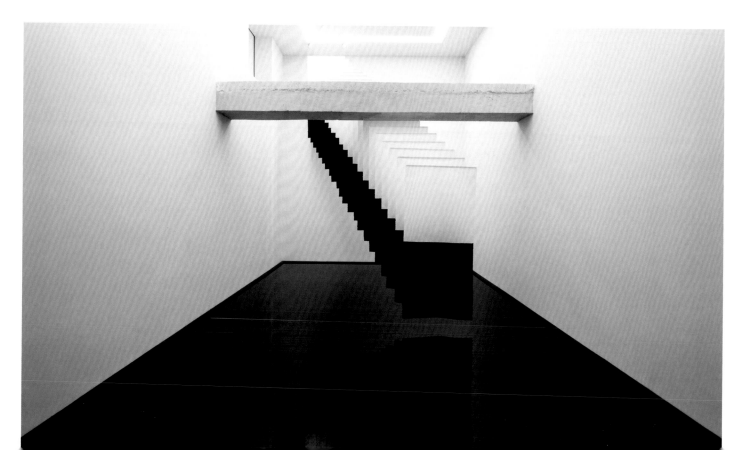

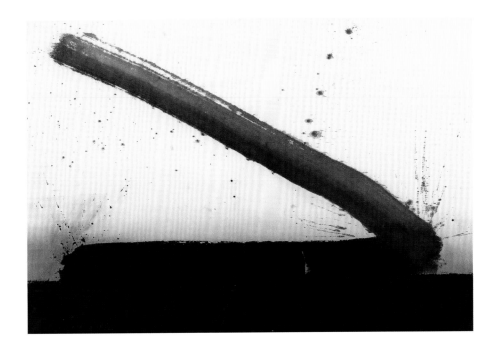

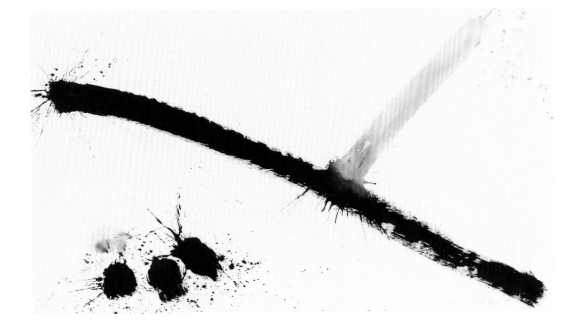

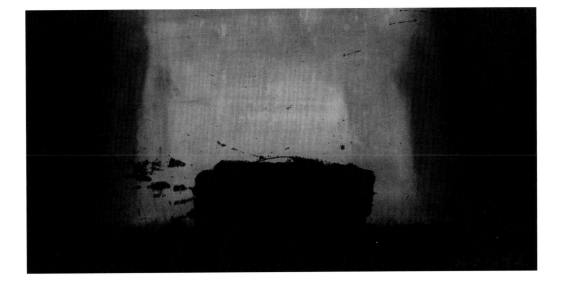

Jooyoung Lee

Jooyoung Lee explores the territory between place and memory. Having lived abroad in her childhood, Seoul is more of a subject of exploration and curiosity than a city she knows intuitively. Her walking projects are documented in photographs, videos, texts, posts on her website and blog, and eventually published in book format. They are mostly carried out in areas associated with modernization and division, which are scattered all over the city. For Lee, the process of piecing together the fragmented timeline of Korea's disastrous twentieth century is less of a cultural or anthropological excavation than it is an opportunity to meet the countless individuals associated with such places and to shed light on their heretofore private lives.

Lee's interest in dislocated time began with the project *Sincere Apologies for the Inconvenience Caused* (2009). For this work she convinced the owner of a twenty-four-hour convenience store near her house, a branch of the Family Mart conglomerate, to turn off the store's lights and signage from 3:00–4:00 am on 8 September 2009. The piece confronted a serious social problem in Seoul, where even small neighbourhoods are dominated by large corporations. The unlit hour symbolized a momentary interruption of Korea's frenzied postindustrial society.

Lee explores cities that hold traces of other civilizations and hybrid cultures. The series of performances *Let's Walk & Chat Together* began in Incheon in 2009, continued on to Berlin in 2010, the Jeong-dong neighbourhood in Seoul in 2011, and ventured to both Yokohama and the Demilitarized Zone in 2012. The port cities of Incheon and Yokohama have welcomed foreign cultures from early on, Jeong-dong is the seat of modern Korea where numerous international political projects were implemented, and Berlin and the DMZ share a past of militarized division. In the walking project *Fantasy Residency* (2010), Lee pursued remnants of the Berlin's partition while seeking traces of totalitarian North Korea. Although the North Korean intellectuals, restaurants and embassy she encountered in Berlin exist in reality, they appeared more like apparitions to Lee, a South Korean with little first-hand knowledge of the North. This process culminated in the photographic essay *Fantasy Residency in North Korea: Please Don't Take Off the Lids, the Pots are Empty* (2011), which was subsequently adapted into a theatrical performance in Seoul.

Lee's fascination with North Korea led her to the Demilitarized Zone, a consecrated site where the ruins of the Korean War remain intact. Now a tourist destination, the DMZ freezes the scars of division in time. She took a tour bus into this absurd reality and later developed the performance documentary *Being Together 10 Li from the DMZ* (2012). In this project, scenes of people walking through the DMZ and behaving in a theatrical manner are paired with the tour guide's explanations. The stylized actions of the performers heighten the already surreal atmosphere.

Recently Lee has begun work on a book that documents a walking project in Yokohama. Through the life of Kaneko Fumiko, the lover of a Japanese resistance fighter and a supporter of Korean independence during the Japanese Imperial Period, the artist pursues a history beyond what has been written. By emphasizing individuals as the subjects of her performative walking projects, she has developed her art practice into what could be described as a contemporary ethnographic land art.

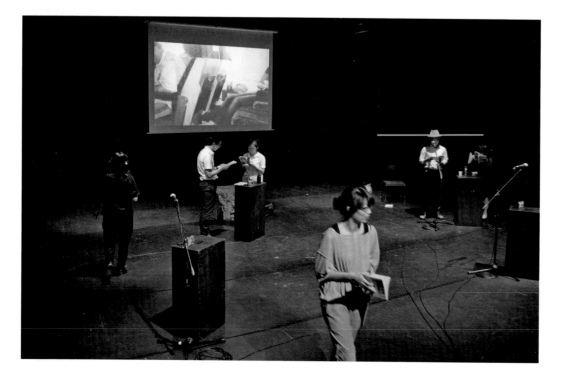

← *Fantasy Residency in North Korea*, 2011, performance

↑ *Waiting Together 10 Li from the DMZ*, 2012, video with sound, 17 min. 48 sec.

↓ *Sincere Apologies for the Inconvenience Caused (On)*, 2011, light-jet print, 70 × 47 cm

↓ *Sincere Apologies for the Inconvenience Caused (Off)*, 2011, light-jet print, 70 × 47 cm

To monitor North Koreans attempting to cross the DMZ
as well as attempts to cross from the South.

Jungho Oak

Jungho Oak explores absurdities in contemporary Korean society through photography and video works derived from his performances in public spaces. He previously executed public art and community-based urban geography projects as a member of the artist collective Flying City through the mid-2000s. Their work, which looked at the social problems caused by urban gentrification, mapped out the socio-psychological topography of the city environment and presented art projects intentionally connected to actual sites. This element of site-specificity later became crucial for Oak's individual practice.

Oak attended university when the political art movement of Minjung Misul was winding down. Yet a spark of influence remained, bestowing a psychological weight on artists of subsequent generations. The so-called post-Minjung Misul wave during the 2000s, rather than posing art as revolution, extended artistic practice to observing, diagnosing and critiquing the political and ideological influences then dominating Korean society. While the self-regulating nature of public art in Seoul is somewhat related to the prominence of Minjung Misul, the growing intimacy between art and society is also reflective of a democratic value system. Oak's early performance works, which he produced after leaving Flying City, are a reaction to the oppression of Minjung Misul. Among these, *Made in Korea: English Village* and *Made in Korea: Chinatown* (both 2006) parody the concept of the English Village, emblematic of the zeal for English education in Korea, and that of Chinatown, which has been constructed through clichés about China. Both the English Village and Chinatown are fake cities within Seoul; ornamented with facade displays that are bereft of any actual cultural content, they reflect trends of globalization that have devastated regionality. Designed out of context, such mini-cities reveal Korea's vulnerability; a vanity that relies on the logic of external cultural authority.

In the recent performance works *Supported Headstand Pose: Salamba Shirshasana* and *One-Legged King Pigeon Pose: Eka Pada Rajakapotasana* (both 2011), Oak holds yoga poses on a mud flat. Yoga is a meditative practice of self-discipline through breathing, and using the inner eye to observe the body and mind. But the artist's efforts to maintain his balance on the muddy and unstable ground are both amusing and pathetic, alluding to the futile efforts of people today who try to remain balanced in order to survive an unstable reality. His video work *The Sun Salutation: Surya Namaskar* (2012) is set in four different locations; the front of a building, the city centre, the artist's house and a village in Laos. Oak assumes the yoga pose in each place – alongside street cleaners and on the riverbank – except at home, where he instead cries like a rooster in the stairwell. In Korea the early morning crowing of roosters symbolizes diligence and sincerity; but the rooster crow the artist heard while travelling in Laos had no special relevance, not even to time. The work thus caricatures Korean society's excessive obsession with success, which even ascribes moral lessons to the cries of fowl.

Oak's site-specific satires take, as points of departure, the ideological narratives of past Korean art. His performative interventions in public space propose the possibility for a post-realism that overcomes the boundaries between public and private.

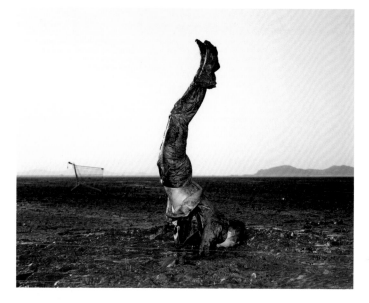

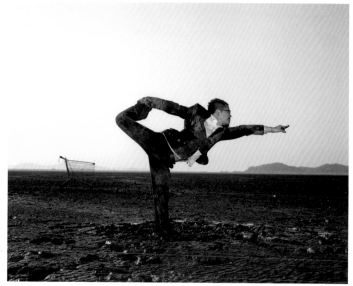

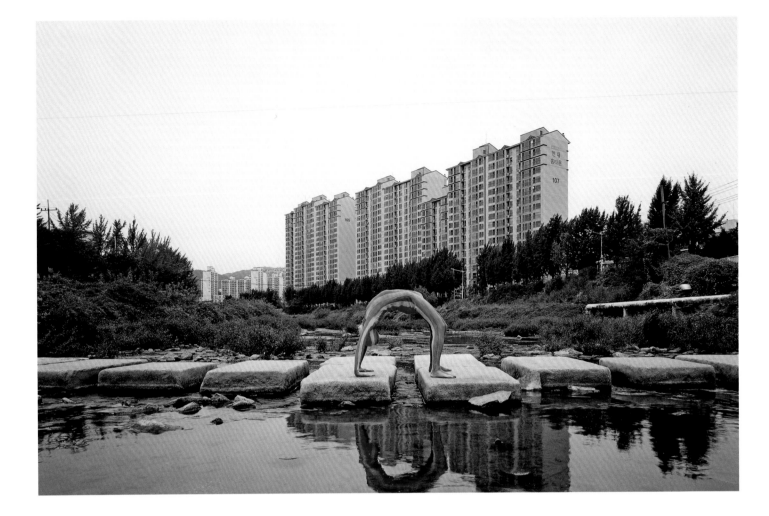

← *Supported Armstand Pose:*
 Shirshasana, 2011, archival
 pigment print, 127 × 152 cm

← *Standing Bow Pulling Pose:*
 Dandayamana Dhanurasana,
 2011, archival pigment print,
 127 × 152 cm

↑ *Anyang City Rainbow: Anyang*
 Stream, 2007, digital C-print,
 70 × 47 cm

→ *Made in Korea: Chinatown*, 2006,
 digital C-print, 102 × 127 cm

Okin Collective

Urban gentrification is a major problem in Seoul today. Pushing the limits of both land and capital, massive redevelopment projects are being carried out in order to transform the metropolitan area into a global city. Through formal experimentation carried out in performances and workshops, and explorations of distributional channels ranging from internet to radio, books and pamphlets, the artist group Okin Collective poses social questions about urban redevelopment, as well as the essence and value of everyday life. Formerly known as the Okin Apartments Project, the collective has firmly established its identity in recent years and evolved into a community-based endeavour.

Okin Collective was founded in 2009 by members Hwayong Kim, Joungmin Yi and Shiu Jin. Its name was taken from Okin Apartments, located in the old Okin-dong neighbourhood of Seoul. The apartment block is a microcosm for Seoul today, where structures from the near past are being eradicated due to standardized urban planning regulations. Constructed as a modern communal housing complex in 1971, less than forty years later, in 2009, it was bulldozed for redevelopment and the inhabitants displaced. The collective was born when its members began to work with the space of their friend's demolished unit in the block. They invited artists and curators to meet in Okin Apartments, transforming a place stripped of its everyday function into a playful space. Through events such as 'Vacation in Okin-dong', 'Mt. Inwang Sketching Contest', and 'Acoustic Rap Tour', the artists and participants share ideas and concerns about the city's identity and its disappearing spaces.

Okin OPEN SITE was launched in 2010 to collect and share memories of Okin Apartments. Focusing on the situation of at-risk urban communities, the project soon developed into a public statement through the workshop and performance piece *Okin Manifesto: 5-Minute Revolution* (2010). The first exhibition by the collective, 'Concrete Island' (2010), explored spaces of the man-made city in a sporadic and appropriational way, using nomadism as a means to criticize contemporary society and the excessive accumulation associated with capitalism. Conducted in cooperation with residents of Itaewon, a district of Seoul with a high concentration of foreigners locally employed in a range of occupations from hairdresser to architect, critic to human rights activist. The project encouraged communication between these diverse groups of neighbours through Okin's internet radio station, Studio +82.

Operation: For Something White and Cold (2010) was an autonomous performance in the city with the exhibition space functioning as operational headquarters for shovelling snow; participants used modified picket signs as symbolic tools for their labour. A satire on urban gentrification, the project employs the fickleness of the weather to demonstrate the gap between an insecure future and the illusion of stability. The installation project *Hear the Ground Sing* (2012) consists of a variable structure that can be used as a radio broadcasting studio. For the period of exhibition, Okin Collective clean the floor of the exhibition space and varnish it with wax, in order to 'welcome' the neighbours who come to visit.

Okin Apartments no longer exist. But Okin Collective continuously strive to engage local residents living with uncertainty. 'We are urbanites who lack any real wealth, people defined by the dubious job category of "artist". For us, countless similar cases of demolition that continue to this day are the reason we remain Okin Collective even after we have left Okin Apartments.'[3]

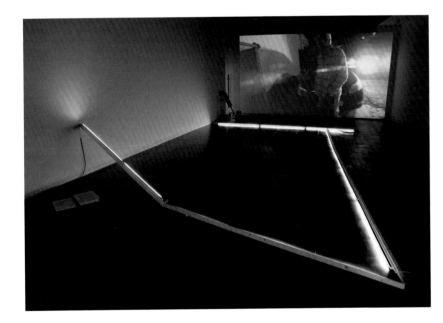

← *Okin Manifesto: 5-Minute Revolution*, 2010, workshop and performance

↑ 'Vacation in Okin-Dong', 2009, two-day public programme held in the half-demolished Okin Apartment complex in Seoul

↗ *Hear the Ground Sing*, 2012, installation with floor polisher, polished floor, fluorescent lighting

→ *Operation: For Something White and Cold*, 2010, installation and performance, dimensions variable

Part-time Suite

Formed in 2009 by members Jaeyoung Park, Miyeon Lee and Byungjae Lee, the collective Part-time Suite carries out site-specific projects in Seoul; which provides subject matter and raw material, as well as stage and playground. This approach, like that of the Situationists, allows for a variable and spontaneous process which emphasizes interactions with place rather than visual results.

The generation that experienced the 1997 Korean financial crisis has become sensitive to economic fluctuation, and following the 2007 world financial crisis, the concept of the future has become something unstable for many young Koreans. Based on the hypothesis that the average monthly income for people in their twenties in Korea is 880,000 *won* (less than $800), the now common term '880,000 Won Generation' was originally coined for the title of a book co-written by economist Sukhoon Woo and activist Kwonil Park in 2007. Part-time Suite addresses the insecure realities of this new generation through projects dealing with issues of community, transience and nomadism.

Under Interior (2009) took place in a building rented by the collective, where the basement was flooded with water up to knee-height. A poem on insecurity, written on a fabric banner, hung against the wall; its letters smudged as the water vapour in the air increased, eventually rendering the text unreadable. The damp air, the smell of mould and the psychological resonance of the basement all reflect the anxieties of the present. Similarly, *Loop the Loop* (2009) is a video work that documents a performance of repeatedly walking the rooftop perimeter of a building, illustrating both the coldness of the city and the perils of everyday life.

Set in the basement of Seoul Art Space Mullae, *Multi Purpose Base Camp* (2011) presented a twist on the ambiguity of the hospitable 'multi-purpose' room. Inviting young underground artists to help discover a collective function for the space, the project yielded a book documenting their conversations. This post-Dada approach – asking what value *is* as opposed to producing value – deviates from the strict standard of accomplishment in Korea. During their stay at Mullae, the collective also travelled to the nearby DMZ for *Drop By Then* (2010). Part-time Suite's video captures the reality of division and the scars of extreme ideologies that remain in this remarkably preserved bastion of the Cold War era. In close proximity to Seoul yet remote from contemporary life, the unreal space of the DMZ is theatrically foregrounded against the trauma of war which lingers in the national psyche.

The collective's 2011 exhibition 'Post-Untitled', nominated for the Hermes Foundation Art Award, explored the joy of physical labour in works such as *Wave*, an unfinished piece of hand embroidery. For *The 42m² Club*, a small dance floor was built into the gallery space to house the video *March Dance*, which shows the three members as they stomp upon and mix rapidly hardening cement, trying to delay the natural solidification process – a seemingly futile act that also conveys a sense of pleasure. By inserting into the video documentation words and phrases such as 'market', 'richer become richer, poor become poorer', 'recession tunnel' and 'new trend' (taken from lyrics by the underground musician Yamagata Twixter) the work expresses a complex mixture of emotions, from bliss to weariness.

Part-time Suite places greater emphasis on physical process than completed works of art. While this can lead to radically open-ended projects, such as the impromptu night-time activities that comprise *Off-Off-Stage* (2009), it is also considered a necessary aspect of collaboration. Their collective projects shed light on contradictory social structures and the everyday predicaments of contemporary life.

← *Under Interior*, 2009, installation of black waterproof cloth and floor filled with water, 811 × 717 cm

↑ *Loop the Loop*, 2009, documentation of performance

→ *Waves*, 2011, ceiling installation of yarn handicraft on PVC mesh, 800 × 175 cm

↓ *Waves*, work in progress

Jae Oon Rho

Jae Oon Rho's world is constructed of videos composed of data (images, news reports, film clips) extracted from the web. When the internet came to Korea in the mid-1990s, there had been limited cultural exchange with the outside world, and it quickly became a utopian space for intellectuals and artists to transcend physical distance and other constraints. But the online environment soon mutated from a channel of communication between individuals to a dystopic sea flooded with information. In 2004 the artist mounted the exhibition 'Skin of Korea', which analyzed the facades of buildings, city blocks and towns throughout the country by extracting shared images filtered in real-time from online media.

The art critic and artist Park Chan-Kyong has described Rho's work as an open form of anti-capitalist post-author itarianism that contests the originality of art, the authorship of the artist and the art system at large. A firm believer in the democratic capabilities of the internet, Rho established a film production company, based entirely online and publicly accessible, as an alternative means for producing film and video works presented in the white cube. All of the sound and images in his works are found materials taken from the internet and methodically edited together, without need of a camera or an auteur.

His solo show 'Mulian, Mulian' at Atelier Hermes Seoul in 2011 not only featured an homage to classic film, but also materialized forms that expanded into drawing, painting, sculpture and installation, relying on film mainly as a template for seeing the world. The exhibition included *Jataka Mirror* (2011), which is a sutra dealing with Buddha's past life. Starting from the idea of standing in the present and looking at one's previous life, the work constructed a space in which the audience sees its reflection through mirrors installed in the aspect ratio of film screens. Visualizing the world through various screen ratios in Western and Eastern films from the last century has become a fascinating subject of study for Rho. Presented at the old Seoul Station, the installation *Strangers On A Train* (2011) fuses history and modern transportation technology to show the continuous evolution in the properties of machine, speed and medium.

Rho collects film and video material from diverse sources. But of central interest to the artist is the depiction of Taoism and Buddhism in mid-twentieth-century films from Korea and Hong Kong. This theme is evident in the series of landscape drawings *Braindead-Scape* (2009), which present a metaphor for nature and civilization. These sketches of mountains with holes at their peaks suggest the decay of a diseased brain – and by extension the destruction of both man and environment. Fusing the Eastern concept of landscape with a meditation on the technological medium of film, the work proposes a natural disaster via filmic elements. Similarly, the musical composition *Score of Aspect Ratios* (2011) condenses the four phases of human life by means of twelve different aspect ratios and symbols such as the spiral, ladder, skull, diamond, dot and cross. For the work *Rusty Network* (2011), a sculptural rendering of the Chinese characters that denote 'The End' in the end credits of Hong Kong films is suspended from the ceiling with metal chain. Through the filmic interpretation of the end as another beginning, and the notion of human karma as a cycle, Rho presents ontological issues of past and present, man, nature and civilization, life and death.

← *Jataka Mirrors (Mirrors of Previous Birth)*, 2011, colour acrylic mirrors, aluminium frames and joints, dimensions variable

↑ *Braindead-Scape*, 2009, Korean ink on canvas, 91 × 117 cm

↗ *Rusty Network*, 2011, steel and chain, 32 × 27 × 1 cm

→ *Strangers On A Train*, 2011, colour acrylic sheets, aluminium frames and joints, 100 × 400 × 100 cm

Dongchun Yoon

Dongchun Yoon's work satirizes Korean cultural absurdities from a perspective that is both universal and regionally specific; making use of painting, sculpture, installation, readymades and photography. He has been active in Seoul since 1988, after studying art locally at Seoul National University (where he is currently a professor of fine art) and abroad, at the Cranbrook Academy of Art in the United States.

Despite tangible infrastructural developments in Seoul, a strong cultural desire to become a first-class global metropolis grips the city with collective anxiety. In a society that strives for the elusiveness of 'the best', there is also a strong tendency in art to rely on status rather than subjectivity or personal taste. In reaction to this, Yoon pursues art that can be read through experience rather than exclusive knowledge. His visual lexicon is intentionally commonplace; for Yoon, art and life share the same territory. The work focuses on language and sentimentality beyond anything defined by a globalized artistic language; where regionality doesn't signify the opposite of globality, but rather an independent world.

The items that appear in *Meaningful Objects: Tools for the Politician* (2011) are trivial: detergent, insecticide, fly swatter, rat trap and dung dipper. In the context of contemporary art, such objects immediately recall Duchamp's readymades or the sculpturally elevated industrial products of Jeff Koons. However in Yoon's work these items expand their original function to attain a social meaning. The fly swatter, insecticide and detergent become sanitation tools to purge corrupted politics. His advertising balloon installation *Politician: Campaign Pledge* (2011) suggests that the democratic society advocated by politicians is nothing more than an exaggerated pledge inflated with colourless, odourless helium gas.

Yoon's interest in expanding the social meaning of products began with *Meaningful Object: Kaleidoscope* (1995). When industrial objects enter an exhibition context, they are usually granted an artistic position that eradicates their utility. Yet the artist's treatment of language, through a work's title, often suggests a new function for the objects; thus also proposing the role of the artist as a designer of new systems for thinking.

Social criticism can often result in the emergence of yet another ideology, and certain ideologies that have driven Korean modernization also continue to frustrate the Korean contemporary art world. Yoon attempts to both avoid ideology and eradicate the sanctity bestowed on artworks by inviting the audience to address those problems suggested by the relationship between a visual object and its title. While the work alone might, for example, seem to belong to a genealogy of ordinary art history such as Abstract Expressionism or Minimalism, each title reveals something else the abstract image or form indicates. While *Woolhwa* (Enraged, 2011) and *Booah* (Rage, 2011) evoke a similar meaning of anger in their English language translations, the sense of each is very distinct in Korean. *Woolhwa* describes a pathological symptom of anger in which the metabolism is upset, while *Booah*, which also means 'lungs', expresses an emotional state of being angry.

Understanding Yoon's work requires a sharp sensibility for language and an awareness of Korea's changing social conditions and conventions. That he persists in using the Korean language, even though some meanings cannot be translated, is also a gesture that denounces the homogenization of global culture. Furthermore, he aspires to a social function of art that directly engages public understanding.

← *Tools for the Politician: Fly Swatter*, 2011, fly swatters and fly papers, dimensions variable

↑ Installation view of *Politician: Campaign Pledge*, 2011, 3 advertising balloons, each 3 m diameter, and *Politician: Growing Nose*, 2011, branch, stain and iron pole, 180 × 180 cm

→ *Woolhwa* (Enraged), 2011, hammered synthetic material, 90 × 90 cm

↓ *Booah* (Rage), 2011, hammered synthetic material, 90 × 90 cm

Singapore
by Eugene Tan

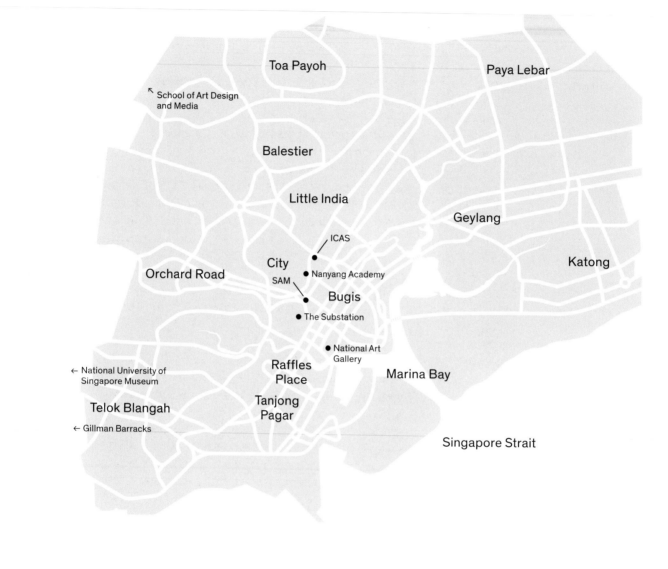

N

Toa Payoh

Paya Lebar

↖ School of Art Design
and Media

Balestier

Little India

Geylang

ICAS

City

Katong

SAM

● Nanyang Academy

Bugis

● The Substation

● National Art
Gallery

← National University of
Singapore Museum

Raffles
Place

Marina Bay

Orchard Road

Telok Blangah

Tanjong
Pagar

← Gillman Barracks

Singapore Strait

0 0.5 km

● Gillman Barracks
 9 Lock Road

● Institute of Contemporary Arts
 Singapore (ICAS)
 LASALLE College of the Arts
 1 McNally Street

● Nanyang Academy of Fine Arts
 151 Bencoolen Street

● National Art Gallery, Singapore
 St. Andrew's Road

● National University of
 Singapore Museum
 50 Kent Ridge Crescent

● School of Art Design and Media,
 Nanyang Technological University
 81 Nanyang Drive

● Singapore Art Museum
 71 Bras Basah Road

● The Substation
 45 Armenian Street

Singapore
by Eugene Tan

The external perception of Singapore is often one of contradictions. It has been called a city of 'pure intention', of 'authored chaos' and 'willed absurdity', even 'dangerously peaceful' and perhaps most memorably, 'Disneyland with the death penalty'.[1] It is known, on the one hand, for its cultural and racial diversity and the tolerance that this engenders, and on the other, for the heavy-handedness of state censorship of the media and the arts. The spectre of the National Art Council's de facto ban on performance art for an entire decade – a reaction to a series of performances staged in 1993 – still haunts the local scene.[2] A similar response was also evident as late as 2011, when the Singapore Art Museum, which organizes the Singapore Biennale, censored an installation by Simon Fujiwara.[3] Given this degree of censorship, there has been much scepticism about the feasibility of a vibrant and dynamic artistic community developing in Singapore.

Nevertheless, in recent years a burgeoning art scene has transpired, made possible by several factors. The first is Singapore's growing position within the region, not only as a hub of Southeast Asia, but also as an important economic centre. Asia's identity has always been determined by economic realities. While an underlying premise of neo-liberal capitalism is that of continuous economic growth, this notion is even more critical here, where the development of art and economic modernization are intimately linked. Current Western understandings of Asia generally derive from the region's growth as an economic power: led by Japan in the post-war period; followed by the rapid growth of the so-called 'Tiger' economies of Hong Kong, Singapore, South Korea and Taiwan; the currency crisis faced by Southeast Asian economies at the end of the 1990s; and, more recently, the resurgence of China, India and Southeast Asia and the perceived potential of their expanding consumer markets. This economic potential has been further highlighted in recent years by the contrasting woes of the United States and the European Union. With Hong Kong now a part of China and increasingly dominated both culturally and economically by the mainland, Singapore has emerged as a more neutral centre from which to reach out to other Asian markets, thereby strengthening its strategic position.

Today, the economic power a country wields has a strong correlation to broader market interest in the art which its artists produce. This is evident in the focus on art from China and India during the past decade, supported by large, relatively untapped and increasingly affluent populations. Contemporary Chinese and Indian artworks have financially appreciated to record levels at an unprecedented pace, driving the growth of art auctions, among other indicators, which point to China as perhaps the most important globally emerging art market. The reverberating effect on Southeast Asia has been profound. With art now more widely accepted as an alternative form of investment that has also achieved the status of an international asset class, speculation has been widespread. Governments in the region have also begun to recognize the benefits that arts and culture can bring, both in terms of direct economic gain as well as branding, which is seen as enhancing the wider economy. Singapore has embraced this type of branding in a significant way. Published in 2000 by the Ministry of Information Communication and the Arts (MICA), *Renaissance City Report: Culture and the Arts in Renaissance Singapore* sought to develop the local art scene through an ambitious programme of internationalization. It began with participation in the 2001 Venice Biennale, with the state's first pavilion, followed by the Singapore Biennale in 2006, and the subsequent announcement of the formation of a national art institution, the National Art Gallery, due to open in 2015.

The new National Art Gallery will occupy some sixty thousand square metres, making it rival in size museums such as the Musée d'Orsay in Paris and Tate Modern in London. It will house one of the most comprehensive collections of Southeast Asian art, and has stated ambitions to become the main authority on Southeast Asian art through its holdings and exhibition programme. Such an infrastructural development will have

a profound effect on Singapore's relationship to the rest of Asia. The current market domination of art, which is perhaps more pronounced in the region due to a less developed cultural ecosystem, is, in effect, a conflation of economic globalization and cultural globalization. This has endowed art buyers with a disproportionate level of power relative to the gallerists, curators, art critics and historians who are traditional gatekeepers to the art world, resulting in a situation in which art's commodity status also dictates its social, art-historical and aesthetic values. Thus Singapore may be able to establish a significant role in the region by providing symbolic or cultural validation through institutions such as the National Art Gallery. Given the lack of credible public museums and nonprofit structures throughout Southeast Asia, institutions such as the Singapore Art Museum, with its impressive regional collections and international programme of contemporary exhibitions, have become key non-market players. The Singapore Biennale, which the museum also organizes, has developed into an important platform for producing new work by regional artists. The artistic director for the first two editions, in 2006 and 2008, was Fumio Nanjo of Tokyo's Mori Art Museum, followed by the Singaporean artist Matthew Ngui in 2011. These efforts are reinforced by other independent initiatives such as the Institute of Contemporary Arts Singapore (ICAS), currently headed by Charles Merewether; the National University of Singapore Museum; and The Substation, Singapore's original artist-run space founded by the late playwright and activist Kuo Pao Kun in 1990.[4]

A few state-sponsored projects complement the nonprofit infrastructure in the city, including Art Stage Singapore, an international art fair established in 2011 that has former Art Basel director Lorenzo Rudolf at the helm. With a strong focus on Asia, the fair also gives international exposure to regional galleries. A new arts district at Gillman Barracks, a former British military camp, was inaugurated in September 2012. Envisioned as a site for the production and distribution of contemporary art, it will comprise more than fifteen mostly international commercial galleries, and a new Centre for Contemporary Art (CCA) that will house an artist residency, a research centre and an exhibition programme. Galleries such as ShanghART and Pearl Lam from Shanghai; Tomio Koyama, Mizuma, and Ota Fine Arts from Tokyo; and The Drawing Room and Silverlens from the Philippines have opened spaces at Gillman Barracks, with additional dealers from Europe and America forming part of the eventual mix. The absorption of these prominent Asian and international galleries into the art system will further Singapore's influence in the region.

The unique position that Singapore occupies as a cultural crossroads has also contributed to the art produced here. Drawing upon the city's unique character, Singaporean artists have developed new modes of expression which engage dialectically with established practices in the West and emergent practices in Asia, some of which counter or mediate the dominance of the market. While contemporary art surfaced in Singapore in the 1980s – largely through performance works by Tang Da Wu, Vincent Leow, Amanda Heng, Lee Wen and others associated with The Artists Village collective who sought outright confrontations of authority – artists today are finding their own ways to navigate the sociopolitical landscape of the city and with more productive means.[5] Singapore-based artists are not merely finding the appropriate mode of translation for the context governing their lives and experiences, but rather problematizing the translation process and making space for its contradictions and limitations. By so doing, they are projecting a new vision of and potential for Asia – one that is premised upon cultural exchange and diversity rather than economic progress.

Without an existing arts infrastructure, earlier generations of artists including Da Wu, Cheo Chai Hiang and The Artists Village worked in relative isolation, which mitigated the impact that their practices might otherwise have had. Today a stronger and more complete ecosystem in Singapore nurtures artists from the region, many of whom attend one of three art schools in the country: the Nanyang Academy of Fine Arts, the LASALLE College of the Arts and the School of Art Design and Media. This is a significant departure from the previous era when many artists trained abroad in Australia, the

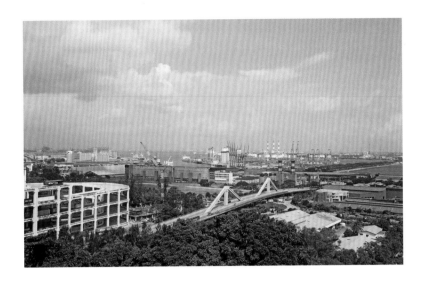

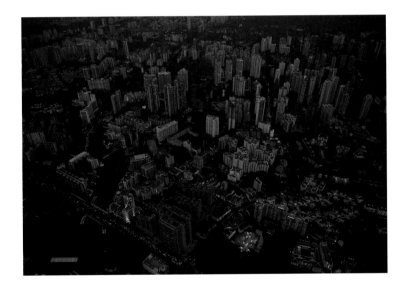

↑ View from Jurong Hill overlooking
Jurong Port

↗ Singapore Art Museum

↑ LASALLE College of the Arts

→ Aerial view of Singapore

↓ Exhibition view, 'Ian Woo:
A Review, 1995–2011', at
ICAS, 2012

United Kingdom and the USA. (This shift in arts education within a generation points to Singapore's rapid growth as a site for cultural exchange and production, and subsequent impact on the development of the local scene.) The significance and depth of work produced in Singapore is evident in projects by artists such as Ming Wong and Ho Tzu Nyen, who represented Singapore at the Venice Biennale in 2009 and 2011 respectively, to international critical acclaim. The eight artists featured in the following pages are a further testament to the growing importance of Singapore as a nexus for art in Asia. Although diverse in modes of expression, their work engages aspects of the local and the regional within a much wider context, reflecting Singapore's growing cultural position globally.

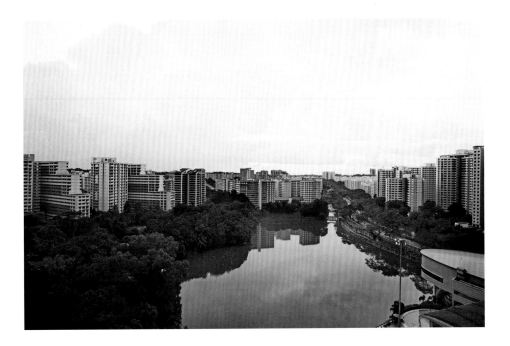

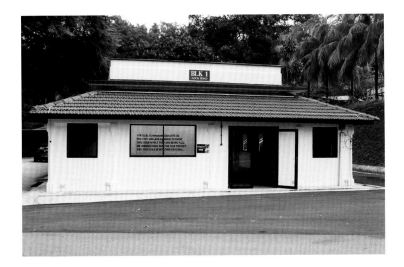

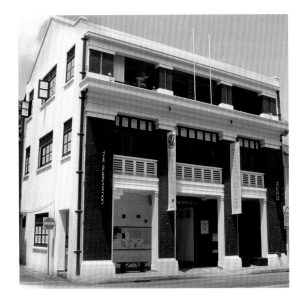

↑ View of Bukit Panjang Reservoir Park, one of many urbanized rainwater catchments in Singapore

↑ The newly renovated art district at Gillman Barracks

→ The Substation

↓ Local band Zozi performing for Night Festival 2012 at The Substation

Song-Ming Ang

Song-Ming Ang explores the role of music in society. At the heart of his practice is a process of creating temporary communities through music and sound, which are later examined for their social implications. His work in this manner began through his involvement in Singapore's burgeoning sound art scene of the mid-2000s, when he collaborated with sound artists such as Chong Li-Chuan and Cyril Wong. He has also participated in the local music scene; composing and releasing recordings, organizing concerts and writing about audio culture, activities that can be seen as extensions of his art practice. For the work *Guilty Pleasures* (2007–present), Ang invites members of the public to a listening party, instructing them to bring a piece of music they secretly like but are embarrassed to let others know about, for whatever reason. Everyone shares what they like about a particular song as well as the reasons they are ashamed to admit it, after which the piece of music is played aloud, in a collective confessional experience which creates communal intimacy among participants. As Ang states in his invitation, 'ABBA is ok, Bananarama is cool, Celine Dion is hot, and Kenny G is God. We all stand accused, but will you confess to your sins?' First presented as part of the Singapore Fringe Festival in 2007, *Guilty Pleasures* has since been staged in Berlin, London, Melbourne and Hong Kong.

Ang further explores the relationship between music and community by highlighting how the former is today commonly used to incite a public response rather than express unity. This is evident in *Be True to Your School* (2010), which he developed during a residency at ARCUS Project in Japan. Ang asked former students of an elementary school, now middle-aged, to sing their school song from memory. As each performer struggled to recall the lyrics and melody, the artist recorded the process on video. He then organized an informal school reunion, gathering more past students to join together to perform the song as a group. At a certain point, Ang joined them on glockenspiel, having finally determined the melody from his work on the individual videos. The resulting piece reunites a community and explores the depths of collective memory. Like the former schoolmates brought together for the occasion, the song was made complete only by putting together the remembered fragments of each participant; the whole exemplified by the artist's rendition of the melody through the collection of its parts.

In his more recent work *Parts and Labour* (2012), Ang's practice has shifted to examining the instruments of music-making as an artistic intervention and a learning process. During a residency in Berlin, he found a piano workshop that agreed to take him on as an apprentice for four months, a process which culminated in the complete dissembling and reassembling of an entire piano. The resulting video documenting the artist's activities not only shows the fastidious unhinging, unwiring, unscrewing and unbolting of hundreds of pins, wires, keys and hammers, followed by their reassembly; but is also a musical composition in its own right that employs the unexpected or incidental sounds that the piano makes at various stages of its construction.

← *Be True to Your School*, 2010,
 5-channel video, each 2–3 min.

→ *Parts and Labour*, 2012,
 HD video, 26 min.

↓ *Parts and Labour*, 2012

↓ *Parts and Labour*, 2012

Heman Chong

Heman Chong's work investigates the philosophies, motivations and methods behind individual and collective imaginings of the future. Central to his practice is the circulation of ideas, objects and images through collaborations and other constructed situations, characterized by his fascination with science fiction; a literature of ideas that imagines alternative possible worlds in an attempt to understand our own. This is evident in works such as *LEM1* (2012), created for his first solo exhibition in London. Chong set up a bookshop consisting of second-hand science fiction and fantasy books that visitors could purchase for one pound each. Shown alongside the books were his paintings of self-designed book covers for sci-fi novels *Cover (Versions)* (2009–present). Intended as conversation pieces, the paintings reference the content of the books and function as 'recommendations', a mode of communication Chong often uses to transfer ideas. The display of second-hand books takes the artist's recommendation a step further, from mere suggestion to active exchange. The nominal cost of each indicates that the transaction is essentially social rather than economic, while the act of making second-hand materials available reinforces the notion of the social life of ideas as constantly recycled, reused and reinvented. This transmission of ideas is further explored in *Advanced Studies in... (Ten Lessons for Life)*. Commissioned for the Singapore Arts Festival in 2012, *Advanced Studies* is a performance comprising a set of ten one-on-one lessons taught by fifteen- and sixteen-year-old students from the School of the Arts (SOTA) Singapore. Based on the idea of storytelling, for each lesson participants engage in discussion with one student-teacher on a theme associated with a novel or a play written by one of ten writers who have been influential for Chong (including Kazuo Ishiguro and Fyodor Dostoyevsky).

Underlying the conceptual framework of Chong's practice is a strong formalist approach, seen in the grid-like presentation of books for *LEM1* as well as the geometrical patterns of his accompanying *Cover (Versions)*. This approach is also apparent in *Calendars (2020–2096)* (2004–10), first shown at the National University of Singapore Museum in 2012. It comprises a collection of 1,001 paper calendar sheets, each representing one month between the years 2020 and 2096, and featuring a different public space in Singapore which the artist photographed in the complete absence of people and passers-by. The work reads like a picture essay of an imagined future that is at once reassuring in its familiarity yet eerily vacant. Arranged edge-to-edge in a horizontal grid, the installation resembles a columbaria where the once-vibrant spaces depicted, having lost their vitality, are laid to rest. The post-apocalyptic imagery invites viewers to speculate about the circumstances that could lead to such futures.

Chong is among Singapore's more established artists and one of the most internationally exhibited. He was the first artist from Singapore selected for the Künstlerhaus Bethanian International Studio Programme in Berlin (2003), he represented Singapore at the 2003 Venice Biennale, and has participated in numerous exhibitions and biennials since. Apart from his art practice, Chong is also an influential curator and writer who has introduced the work of emerging Singaporean artists to international audiences through his curatorial projects. In 2009, he founded PLURAL, a loosely organized network of local artists who meet regularly to exchange ideas.

← *LEM1 (A Science Fiction and Fantasy Book Store)*, 2012, shelves, 3,000 second-hand books, store counter and performance by sales assistant

↑ *Advanced Studies in… (Ten Lessons for Life)*, 2012, durational performance with eight 15 year-old teenagers

↓ *Calendars (2020–2096)*, 2011, 1,001 offset prints with matte lamination, each 30 × 30 cm

Ho Tzu Nyen

Upon returning from his studies at the University of Melbourne in Australia, Ho Tzu Nyen was among the first artists in Singapore to explore the use of video. Employing a range of media from painting to film, sound and performance, his practice is characterized by investigations of key cultural moments, which serve as points of departure. An engagement with historiography is evident in *Utama: Every Name in History is I* (2003), first exhibited at The Substation. An installation that combines video and painting to explore the mythology of Sang Nila Utama, the pre-colonial founder of Singapore, Ho highlights the mythmaking inherent to the construction of history and collective memory. Other types of histories, for example art history, are explored in works such as *4 × 4: Episodes of Singapore Art* (2004), a four-part video piece on the controversies surrounding four works that have significantly influenced the development of contemporary art in Singapore, including Tang Da Wu's performance *Don't Give Money to the Arts* (1995) and Cheo Chai Hiang's *5' × 5' The Singapore River* (1972). The notion of re-interpretation is also crucial for the artist, specifically the re-examination of historical objects ranging from philosophical texts, as in *Zarathustra: A Film for Everyone and No One* (2009); history painting, as in *EARTH* (2009); and popular music, as in *The Bohemian Rhapsody Project* (2006). Through the analysis and deconstruction of visual and acoustic devices in *Newton* (2009) and *EARTH*, Ho highlights repetition, duration and other sensory elements that constitute the experience of art.

These various strategies occasionally overlap, as they did recently for *The Cloud of Unknowing* (2011). Commissioned for the Singapore Pavilion at the 54th Venice Biennale then later exhibited at the Mori Art Museum in Tokyo and screened at the 2012 Sundance Film Festival, the work references French philosopher Hubert Damisch's text *A Theory of /Cloud/: Toward a History of Painting*, first published in 1972. Ho's *Cloud of Unknowing* explores an art-historical concept of the cloud, from its fleeting meteorological inspirations, to the transcendental allusions of Constable's cloud studies, to a device that distinguishes between the sacred and the earthly in the work of Tintoretto and Correggio, to a signifier of transience that resists representation in Chinese landscape painting. Fusing these references with perspectives on Singapore's peculiar socioeconomic conditions, Ho highlights the city-state's complexities. Set in a deserted, low-income public housing block in Singapore, the work presents eight scenes of solitary, idiosyncratic characters in their individual apartments, each encountering a cloud-like form that alternates between figural or spectral embodiment and vapour. At the moment of meeting with this mist, a transformation occurs via direct experience of the senses rather than an insight of the mind. In the same way the cloud brings the work's eight characters together, it also links the viewing audience to the film through theatrical effects of installation. (A fog machine releases a cloud into the exhibition space at climactic moments.) The result is a merging of the imaginary and the real. Finally enveloped in a cloud that remains ephemeral and mysterious, much like the amorphous forms in the sky, rouses the viewer's imagination.

Ho's collaboration with residents of a public housing estate for *The Cloud of Unknowing* highlights his engagement with the political realities of Singapore, where racial and cultural demographics are orchestrated by the authorities. This is also evident in the feature-length film *Here* (2010). Set in a mental asylum, it has been interpreted as a commentary on the current state of Singaporean society, and in particular, its regulation.

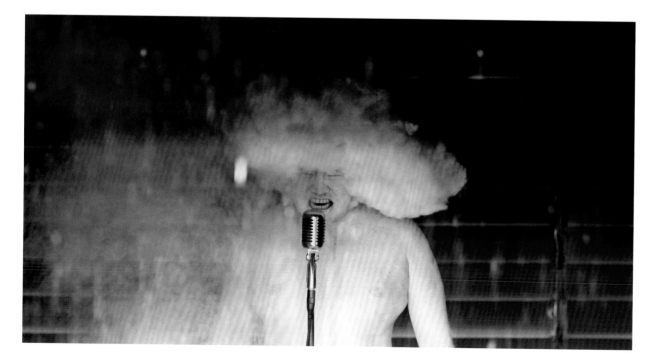

← *The Cloud of Unknowing*, 2011, HD video, 17 min.

→ *Utama: Every Name in History is I*, 2003, acrylic and ink jet on canvas, 39 × 49 cm

↓ *Zarathustra: A Film for Everyone and No One*, 2009, HD video, 24 min.

↳ *EARTH*, 2009, HD video, 42 min.

Charles Lim

Charles Lim was one of the first artists in Singapore to incorporate new media and the internet into his work. In 2001, with fellow artist Woon Tien Wei and scientist Melvin Phua he co-founded tsunamii.net, a collective that explored the impact of connectivity on society. Responding to the advent of information technology and widespread use of the internet, tsunamii.net developed a series of projects examining the relationship between virtual and physical systems. For example the *alpha* series (2001–04), a part of which was exhibited at Documenta 11, used specially created 'webwalker' software that required a user to surf the virtual world of the internet through the physical movement of her body. The webwalks challenge our notions of speed and reality when online, translating virtual time into real time. This act of decompressing time in cyberspace also highlights issues of traversing borders and territories – the negotiations between the webwalker and various authorities encountered on the journey mirror the extensive negotiations between multiple nations that made the creation of submarine cables such as SEA ME WE3 (the longest telecommunications cable in the world linking Southeast Asia, the Middle East and Western Europe) possible – betraying the false notion of a depoliticized virtual space of speed, mobility and global connectivity.

When tsunamii.net disbanded in 2005, Lim's interest in manmade systems led him to further investigations of SEA ME WE3. His physical search for the cable in the sea revealed the complex regulatory systems and networks that are not unlike those designed for carefully planned urban environments on land. Lim's *SEASTATE* series (2005–present) encapsulates his fascination with the sea as urbanized space, through a series of photographs, an installation, sculptures and a performance which complicate our perceived notions of fluidity and movement across both sea and land. For *SEASTATE 1: Inside Outside* (2005), Lim photographed the actual physical markers or buoys that denote the sea limits around Singapore, both from an external perspective looking in and from inside the boundary looking out. *SEASTATE* highlights the geo-politicized and territorial nature of the sea; tamed by manmade networks with lines that can be drawn and regulated, it is no longer a negative space that functions merely to demarcate continents.

The significance of the sea in Lim's work can also be attributed to his personal relationship to it. Having grown up in a fishing village, he was formerly a competitive sailor. Yet his affinity to water is in contrast to the typical Singaporean's estrangement from it; most residents feel no connection to the once-important lifeline that, after all, played a significant role in the development of the city. Singapore's strategic location along major sea trade routes was the primary reason for its colonization by Britain in the nineteenth century and its later economic success as an independent state. But the general feeling of indifference towards the sea among the local population led Lim to examine the inseparable relationship between water and city by way of the 'veins' (drains or *longkangs*) that form part of a complex underground network of water passages. *All Lines Flow Out* (2011) is a video and sculptural installation that features a migrant worker navigating the hidden waterways of hypermodern Singapore, revealing its unseen underbelly. Unruly passageways, at times filled with debris, contrast sharply with the state's image of cleanliness and order. Lim's striking cinematography in the cavernous canals is both forbidding and alluring, presenting a radically different and little known perspective on the metropolis.

← *All Lines Flow Out*, 2011,
single-channel video installation

↑ *SEA STATE 1: Inside Outside*,
2005, C-print from series,
each 61 × 46 cm

→ *SEA STATE 3: Line On Chart*,
2008, installation of photographs,
scanned MPA nautical chart and
marine VHF radio from boat trip

Donna Ong

Donna Ong creates installations that evoke surprise, delight, amazement and nostalgia. Experiencing her work can be both enchanting and bewildering; the viewer cannot help but be drawn into the intimate environments she creates. But beyond these initial sensations and responses is a sense that all is not as it seems. Her environments and situations are constructed around familiar or reassuring elements that simultaneously gesture towards the sinister, or even macabre, to unsettle the viewer. The intriguing partial narratives that emerge from these works raise more questions about the artist's intentions than they answer. This compelling ambiguity has been a distinctive characteristic of her practice since graduating from Goldsmiths College in London, at which time she returned to Singapore. It was evident, for example, in the series of installations she produced for the 2006 Singapore Biennale, entitled *Secrets, Interiors: Chrysalis (19–22)*. Modelled after four private chambers of former judges on the Singaporean Supreme Court, she created four installations that imagine the secret lives and private fantasies of the past occupants. Realized using everyday materials and found objects, the work is at times sinister and disturbing; juxtaposing hidden desires and urges with official and implacable civic roles to reveal the tensions that exist between our private selves and public personas.

In recent works such as *In Xanadu Did Kubla Khan* (2011), Ong continues to employ seemingly mundane objects. Inspired by Samuel Taylor Coleridge's opium-fuelled dream of Kublai Khan's summer palace, she uses ornately decorated teacups and vessels of local Peranakan origin, as well as antique Chinese porcelain, to create a 'garden' complete with a menagerie of tiny ceramic animals. The installation contrasts a fading local culture and heritage in the decorative arts with the grand visions of empires past, which in turn highlights the impossibility that anything can last forever in a contemporary society obsessed with the new. What remain are the relics of each era, discrete objects that embody the memories, hopes and dreams of individuals.

Cocoon (2012) is the latest in a series of works using found images on paper and in paintings. Set inside a small and dark wallpapered room, an antique wardrobe opens to reveal several lightboxes featuring landscapes composed of images and motifs cut out from reproductions of paintings from textbooks. Upon closer inspection, the viewer realizes these lush, fantastical landscapes feature minute, hauntingly familiar figures of women. Images of the Virgin Mary, as depicted throughout Western art history, in various expressions, ages and demeanours, play against re-composed traditional imagery within this unexpected setting, which allows for new visual narratives to emerge.

Alongside her individual practice, Ong has worked with sound artists such as George Chua, Chong Li-Chuan and Song-Ming Ang on various performances. This aspect of collaboration lends another dimension to her installation work that further complicates the relationship between private and public. She also plays an important role in the development of Singapore's young art scene, through teaching at LASALLE College of the Arts and through managing the website Artvark (www.artvark.com.sg), an online directory for the local arts community that also organizes a monthly programme of public talks by specialists and arts professionals.

← *Cocoon (The Garden of Waiting Virgins)*, 2012, found images, acrylic, LED lightboxes, wardrobe, carpet, lights, table and plywood painted walls, 311 × 421 × 220 cm

↑ *Landscape Portraits (In a Beautiful Place Nearby)*, 2009, single channel video projection and shelves with 188 embedded objects, dimensions variable

↓ *In Xanadu Did Kubla Khan*, 2010, installation of 323 ceramic and cloisonné vessels, ceramic animals, glass top, wooden table and ceiling light, 150 × 90 × 90 cm

↓ *In Xanadu Did Kubla Khan* (detail), 2010

Vertical Submarine

Members of the Vertical Submarine collective Fiona Koh, Justin Loke and Joshua Yang met as students at the Nanyang Academy of Fine Arts. Their name was inspired by an episode involving a Singaporean artist who received a prize from the French deconstructionist philosopher Jacques Derrida. While congratulating the artist, Derrida kept repeating the word 'subvert' as a commendable quality of the work, from which Koh, Loke and Yang later playfully derived 'Vertical Submarine'.

This purported incident goes a long way in explaining the project of the collective, who have made their mark on Singapore as iconoclasts. With humour and irony, they subvert received knowledge and popular perceptions. This is evident in *Foreign Talents* (2007), two temporary sculptures of migrant workers; one erected opposite a monument to Sir Stamford Raffles (the founder of Singapore) and another in 'Little India', the district where Indian labourers congregate. The work highlights the loss of collective cultural memory: numerous migrant workers have contributed to the region's contemporary development, while Singapore as a society reveres its colonial past. For the Singapore Art Museum's Night Festival in 2010 the group staged the interactive event *Abusement Park*, which merged collective nostalgia for the carnivalesque with a semblance of the everyday public violence of the post-war period, allowing viewers to experience instruments of pain as entertainment, and tortured souls as amusement, ultimately complicating notions of repression and societal excess.

The Garden of Forking Paths (2010) is based on the Jorge Luis Borges short story of the same title; specifically the description of such a path as 'a labyrinth that folds back upon itself in infinite regression', which has also inspired new media theories and hypertextual fiction. For this project Vertical Submarine show new possibilities for the construction of meaning, which stems from their interest in poststructuralism and the subversion of text. Conceived as a labyrinth into which the viewer enters, the installation is based on the artists' interpretation of the parts of the house inhabited by Borges's protagonist Stephen Albert. The work explores the analogous relationship between the physical experience of the labyrinth and the mental experience of reading and writing. Walls create passages filled with objects and images referenced in the text, which lead the viewer, depending on his or her choices, to different interpretations of the work via different pathways.

To produce the play *Dust: A Recollection* (2011), Vertical Submarine collaborated with TheatreWorks company. Based on Singaporean writer Chien Swee-Teng's short story *Bak Teng* (Diced Meat), written in 1979, the work continues the collective's engagement with sociopolitical themes. Its setting is a flat within a 1970s public housing block which is covered in layers of dust that have built up since the demise of the first occupants. The term 'ghosts' takes on a wider meaning in this context, to indicate not only spectral figures but also marginalized, neglected and otherwise forgotten groups such as the old, the unemployed and the newly immigrated. Beginning with a newlywed couple moving into their new home in the 1970s, the play sees the husband wake up one morning to find lying next to him, not his young bride, but a wrinkled old woman. After encountering the reflection of his older self in a mirror, he eventually realizes that much time has passed since their first night together. *Dust: A Recollection* reflects upon the rapid pace of contemporary life, based on the economic progress and development that govern society today, and the resulting loss of memory and experience.

Ian Woo

Apart from his individual practice, which has greatly contributed to the development of a critical discourse on painting in Singapore, Ian Woo's role as an educator at the LASALLE College of the Arts, where he oversees the Master of Fine Arts programme, has made him a significant figure for maturing generations of young painters in Southeast Asia.

Engaged with abstraction, he maintains a special position within Singapore's art scene. Painting in contemporary Asian practice has largely been dominated by figuration. Abstract painting, when explored by artists, is typically overshadowed by Abstract Expressionist-inspired gestural modes. Woo is one of very few artists to explore the fundamental language and syntax of painting. Because contemporary art emerged in Singapore primarily through performance and post-conceptual practices, painting did not receive the same emphasis as other novel forms of expression. Only due in large part to artists like Woo, who trained abroad and returned to Singapore with new ways of thinking about painting, did this more traditional medium gain ground here. Inspired by geometric abstraction and monochrome, his canvases take the tension between abstraction and figuration as their point of departure. Addressing the relationship between figure and ground through monochrome and colour-field painting, his works have begun to approach and question other painterly constructs. Through

a reflexive process, he deconstructs painting's symbolic and representational language, to allow for the emergence of a new paradigm of representation and signification. Although seemingly expressionistic, Woo's paintings begin with mark making as a form of communication that at the same time expresses its limitations. The result is a complex layering and juxtaposition of form, gesture and colour that simultaneously hint to and disrupt narrative elements.

This is evident in recent works such as *Fire at Gigabyte Mountain* (2011) and *White Sun* (2012), which reveal a complexity unfolding gradually over time. Vibrant colour and the vivid but ambiguous imagery in these paintings, which oscillate between abstracted and recognizable forms, at various scales and uncertain depths, linger steadily with the observer. The nuanced, durational experience of viewing which Woo's dense layering and careful construction require is akin to perceiving an intricate musical composition. This relationship to music is not incidental; the lyrical nature of his canvases is informed by the artist's personal engagement in music through his activity as a bass guitar player in a local rock band. Woo has often described the process of his paintings, both their making and receiving, as similar to the experience of music, which develops, surprises and perhaps even unsettles.

← *Transmissions from the History of
Folk Music*, 2012, acrylic on linen,
152 × 122 cm

← *White Sun*, 2012, acrylic on
canvas, 46 × 36 cm

↑ *Fire at Gigabyte Mountain*, 2011,
acrylic on linen, 250 × 200 cm

↓ *Two Flags*, 2011, acrylic on linen,
200 × 180 cm

Zhao Renhui

Zhao Renhui employs photography to explore the nature and construction of meaning in contemporary society. Parodying scientific research and working primarily under the auspices of *The Institute of Critical Zoologists* (ICZ), his work explores the fluid boundaries between the real and the imaginary. The pseudo-scientific name of the institute is reinforced by the projects it undertakes, which serve to further the goals of an 'interdisciplinary centre dedicated to promoting critical zoological dialogue and research'. Among these, *A Heartwarming Feeling* (2011) explores the natural phenomenon of birds migrating north instead of south due to effects of global warming on the earth's magnetic field. The project consists of a series of documentary photographs of birds that froze to death after embarking on confused migratory journeys to the Arctic Circle. These are accompanied by images created with pinhole cameras that the artist and his purported ornithologist collaborator had attached to the birds, and which captured a composite image of their final voyages. Such is the degree to which Zhao skilfully attends to detail, manipulating visual elements and narratives until it is difficult to distinguish the real from the fictional.

There is an inherent humour in his work that strategically challenges meaning and signification. This is evident in *The Great Pretenders* (2010–12), which centres around the '26th Phylliidae Convention', an annual gathering of scientists who study the phenomenon of camouflage in insects. The images comprising the work are portraits of the winning breeders of Phylliidae (leaf insects), pictured next to their exceptional breed; but it is often difficult to spot the insects due to their adept biomimicry of the leaves and stems of the plants upon which they are photographed. Scientific notes that classify each winning species serve as captions, which further parody the unquestioned faith in science and empiricism still prevalent in contemporary culture. Other projects of the ICZ have examined the incident of sighting a rare species of whale (*Whiteness of a Whale*, 2010) and the discovery of a new animal species on a previously unknown island (*Pulau Pejantan*, 2009).

Zhao's clever means of undermining meaning and signification also extend to works that do not fall under the auspices of the ICZ. For example, *The Land Archive* (2011) takes on history and its relationship to local collective memory. This archive purportedly documents Singapore's landscape before its rapid development into one of the major urban centres in Asia today, and contains images of desert landscapes and whale watchers at sea, long since disappeared.

Zhao's engagement with image making and its potential for constructing meaning have impacted theoretical discourses on photography in Singapore and have made him one of the most significant artists of his generation. His body of work continues to influence younger artists who play with similar concepts to challenge aspects of the production of history and contemporary reality. Together with fellow artist Genevieve Chua, Zhao also conceptualized and directed *Landing Space* (2012), a series of guerrilla-style projects for which artists were invited to present site and occasion specific works that could be installed in a public space in a period of less than one hour.

← *The Author* from the series *The Great Pretenders*, 2011, archival pigment print, 121 × 84 cm

↑ *Blind Long-tailed Owl* from the series *A Heartwarming Feeling*, 2011, archival pigment print, 121 × 84 cm

↗ *Changi, Singapore, Possibly 1970s* from the series *As We Walked On Water*, 2012, archival pigment print, 152 × 110 cm

↓ *The Institute of Critical Zoologists* from the series *The Blind*, 2009–11, archival pigment print, 121 × 84 cm

Vancouver
by Reid Shier

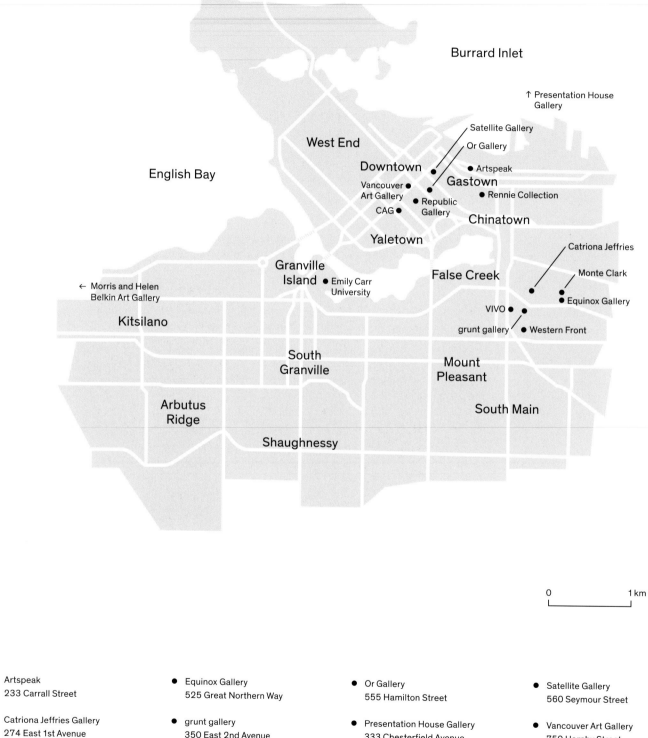

N

Burrard Inlet

↑ Presentation House
Gallery

West End

Satellite Gallery

Or Gallery

English Bay

Downtown

● Artspeak

Gastown

Vancouver
Art Gallery ●

● ● Rennie Collection

CAG ●

● Republic
Gallery

Chinatown

Yaletown

Granville
Island

● Emily Carr
University

False Creek

Catriona Jeffries

Monte Clark

← Morris and Helen
Belkin Art Gallery

VIVO ●

● Equinox Gallery

Kitsilano

grunt gallery ● ● Western Front

South
Granville

Mount
Pleasant

Arbutus
Ridge

South Main

Shaughnessy

0 1 km

● Artspeak
233 Carrall Street

● Catriona Jeffries Gallery
274 East 1st Avenue

● Contemporary Art Gallery (CAG)
555 Nelson Street

● Emily Carr University
1399 Johnston Street

● Equinox Gallery
525 Great Northern Way

● grunt gallery
350 East 2nd Avenue

● Monte Clark Gallery
525 Great Northern Way

● Morris and Helen Belkin Art Gallery
1825 Main Mall
University of British Columbia

● Or Gallery
555 Hamilton Street

● Presentation House Gallery
333 Chesterfield Avenue,
North Vancouver

● Rennie Collection
51 East Pender Street

● Republic Gallery
732 Richards Street

● Satellite Gallery
560 Seymour Street

● Vancouver Art Gallery
750 Hornby Street

● VIVO Media Arts Centre
1965 Main Street

● Western Front
303 East 8th Avenue

Geographically isolated at the continent's western edge, Vancouver is circumscribed by mountains, ocean and the United States border, and is hours by plane from any city of comparable size. Its cage is gilded by the immense natural splendour of the coastal rainforest, and the city is consistently ranked as one of the world's 'most beautiful' and 'most livable' places.[1] Productively, this insulation has allowed iconoclasm and independence to flourish. Artists have matured without the comparative anxieties found in many North American communities outside New York, and the city has bred successive generations with the confidence to look outwards while maintaining self-reflexivity and a defining sense of locality that is closely attentive to the particularities of the region. An early example is the region's first major modernist artist, Emily Carr, whose rhythmic post-impressionist paintings of the 1920s and 1930s document the coastal forest and her fascination with indigenous West Coast art. Carr's Victorian identification with themes of abandonment and dispossession found fertile subject matter in a natural landscape scoured by the early lumber industry and the deteriorating situation of Northwest Coast First Nations,[2] whose populations had been decimated by disease and whose culture was under attack by the Canadian government. Carr's work is often framed as a progenitor of an ongoing nature/culture thematic in Vancouver art, but this is a mischaracterization. In *Scorned as Timber, Beloved of the Sky* (1935), for example, sentinel-like trees left from clear-cut logging stand not in proto-environmental derision, but as emblems of what was deemed useless at the time. This articulation of society's margins would grow and expand as a subject in the hands of regional artists, including post-war painters such as Jack Shadbolt, and culminate pronouncedly in the 1980s and 1990s when artists focused cameras on the suburban and exurban spaces of the city. Carr's accomplishment, and legacy, was to avoid an ideologically driven idealization of the landscape (then in fashion among her eastern Canada counterparts) in favour of a pictorialism that sought to bear witness to the specifics of place.

In Vancouver, this dialectic has provided a rich, ongoing subject of representation partly because of the close, indexical link between the visual grandeur of the coastal landscape and the immense scars left by the orchestrated dismantling of its (immensely profitable) constituent parts. An orgy of exploitation began soon after European contact in the late eighteenth century when sea otter pelts and monstrous coniferous trees lured the first in a long succession of profit seekers. Today, natural resources remain the backbone of the regional economy and continue to mark Vancouver's psyche with the assumption that wealth is to be found lying on the ground or in the waters of the Pacific Northwest; one need only stop and pick it up. Within this ecology, property values have exploded, with double-digit annual increases fuelled by North America's most comprehensively planned urban regeneration scheme. 'Vancouverism' is now a global buzzword for planning guidelines that proscribe architectural conformity to preserve the city's true resource: mountain vistas and an ocean backdrop. One effect is a growing exodus of younger artists to cheaper cities, some to Toronto, many to Berlin. It is a common centre/periphery narrative, but one that arrived untypically late to Vancouver, which throughout the 1980s and 1990s was defined with legitimate pride by artists who remained resident.

Generatively, one of Vancouver's important early instigators was artist Ian Wallace, who began teaching at the University of British Columbia in 1967, moving to Emily Carr University (then Vancouver College of Art) in 1972. His students included Jeff Wall, Rodney Graham, and later Stan Douglas. Wallace's interest in the history of popular film and media helped crystallize a conversation that would lead toward cinematically scaled image production. At the time, Vancouver was deeply informed by conceptual art practices circulating up and down the West Coast, and played host to repeat visits from Lawrence Weiner, Yvonne Rainer, Robert Smithson and Dan Graham, all of whom were invited to town by local artists. Ingrid and Iain Baxter, whose N.E. Thing Co. was at the

epicentre of an active international dialogue, were included in a local exhibition staged by Seth Siegelaub in 1969 and, along with other local artists, Lucy Lippard's landmark '955,000' exhibition at Vancouver Art Gallery in 1970.

Wallace first coined 'photoconceptualism' to reference large wall-mounted images marrying contextually specific conceptual art with filmic staging, *mise en scène* and serialism. The content and scale of his work foreshadow that of later artists of the so-called Vancouver School: Wall, Graham and Douglas as well as Chris Dikeakos, Ken Lum, Roy Arden, Vikky Alexander and Arni Haraldsson, among others. While they chafe at the 'school' label, each has – at least episodically – used photography to produce ambitious representational images that employ, or directly picture, the city as a condition and subject of the flow of capital. While the strength and fame of their individual practices has led to a finite local following, a pictorial legacy has been polemically taken up by First Nations artists, notably painter Lawrence Paul Yuxweluptun, whose Surrealism-tinged landscapes are inhabited by modern variants of the coast's early colonial profiteers.

Another discourse emerged from the counter-culture ethos around the dematerialization of the artwork. It included abstract painters and object makers whose work began to shift with growing exposure to Fluxus and performance. Roy Kiyooka, Glenn Lewis, Michael Morris, bill bissett, Judith Copithorne, Gerry Gilbert, Helen Goodwin and Al Neil were instigators of a fluid and energized community in the late 1960s and early 1970s, and their collaborations, happenings and events informed an intense, multi-dimensional attempt to embody 'life as art'. Projects such as Morris, Vincent Trasov and Gary Lee Nova's 'Image Bank', a repository of correspondence and ideas collected through the post, were conceived as endlessly expanding through an invitational and transnational artist network – a kind of proto internet. Invested in ideas of hybridity, stagecraft and theatricality, they invented numerous alter egos, the most notorious example of which was Trasov's 1974 Vancouver mayoral campaign as Mr. Peanut. For a brief moment, collective energies enjoyed socially transformative possibilities, the most concrete legacy of which was the Artist Run Centre (ARC) movement that spawned first Intermedia in 1967 and then the Western Front in 1973.

The 'Front' would, in turn, facilitate government funding programs allowing other ARCs to rapidly expand in the late 1970s and 1980s, when critical conversations were particularly vibrant. Satellite Video Exchange, now VIVO (1973–present), Pumps (1975–80), Helen Pitt Gallery (1976–present), Or Gallery (1983–present), grunt gallery (1984–present), Artspeak Gallery (1986–present), and issue-based organizations like Women in Focus (1974–84) and Association for Non Commercial Culture (1986–98) would play a pivotal role both hosting and generating complex discussions on feminism, cultural theory and the nature of representation.

The 1980s also saw the success of the photoconceptual generation, when many key works by Wall, Graham, Lum and Douglas were produced, unleashing a wave of international attention upon the city. Careers bifurcated and collective spirits began to wane. The resulting rupture saw the emergence of Geoffrey Farmer, Brian Jungen, Myfanwy MacLeod, Damian Moppett, Ron Terada and Steven Shearer. Many of these artists showed early in the city's ARCs, but by the mid-1990s notions of collective artistic self-determination were viewed with a more jaundiced eye, particularly as university-trained curators began to take over management of the ARCs. This trend has increased in the past decade as Canadian public funding has (mercifully) stabilized and most ARCs have moulted into small, vital public galleries. Concurrently, the city's larger public spaces, including the Morris and Helen Belkin Gallery, the Contemporary Art Gallery and the Vancouver Art Gallery are staging exhibitions that draw attention to local histories while continuing to legitimate the city's emerging talent. Commercial spaces have also begun to play a more active role as a small collector base slowly grows; and while the ambition of collector Bob Rennie or philanthropist Michael Audain are still the exception in Vancouver, gallerists such as Catriona Jeffries and Monte Clark have begun to cultivate interest in critical work (both locally and nationally) in a manner not seen since Nova Gallery or Doug Chrismas' Ace Gallery closed their doors in the early 1980s.[3]

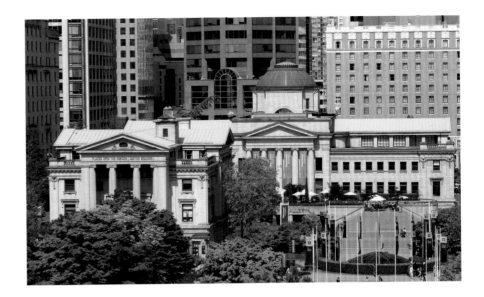

→ Vancouver Art Gallery

↓ Emily Carr, *Scorned as Timber, Beloved of the Sky*, 1935, oil on canvas, 112 × 69 cm

↘ Canadian Pacific Railway, East Vancouver

↓ VIVO Signal & Noise Media Art Festival, 2008: Women With Kitchen Appliances

← The Rennie Collection,
 Wing Sang Building, Chinatown

← Intangible Economies
 Conference, presented by Fillip
 and Artspeak, 2011

↓ Vincent Trasov, *Mr. Peanut in
 front of City Hall*, 1974

↓ Morris and Helen Belkin Art
 Gallery, University of British
 Columbia

Although the city itself has diminished as a subject of representation, for conceptually inclined artists such as Tim Lee, Althea Thauberger, Elizabeth Zvonar and Mark Soo, as well as photographers like Steven Waddell and Scott McFarland, this doesn't necessarily imply a disregard for place. Jungen's alchemical reconfigurations of transnational commodities into cultural insignia – Nike shoes transformed into First Nations masks, or plastic garden chairs re-imagined as whale skeletons – build on notions of cultural interaction, visual appropriation and the contest between local idioms and the flow of global goods.

A DIY material aesthetic has, perhaps not coincidentally, resurfaced in work by today's emerging artists, in contrast to the large economies and expanding studio practices of the successful older generations. This ethos could be viewed in relationship to an investigation of personal subject matter, and there is a distinct autobiographical bent in much recent practice. The following pages expand on some of these trajectories, but it bears mentioning that the interests of Ron Tran, Isabelle Pauwels and others in the founding figures of the Western Front are part of a growing local fascination, tainted with some irony, for the collective experiments of the early 1970s. For artists carving out space in an extremely prohibitive city today, their once utopian ideals resonate practically and economically. Experimental practices can now be found hosted in hybrid spaces that erode distinctions between nonprofit and commercial such as CSA and 221A, which are financed through the ancillary business of their founders; while the project spaces Exercise and Hardscrabble, each open only one day per week, exhibit a level of curatorial energy reminiscent of early ARCs.

Artists continue to drive critical and visual discourse in Vancouver, and the same self-reflexivity can be seen in its emerging generations, who now draw from more established local models. Rapacious civic erasure and renewal still provoke an acute historical attentiveness, but the city's heretofore mutable environment might also be understood as a resource for creative invention. As Geoffrey Farmer has recently described, 'Ian Wallace, Jeff Wall and Stan Douglas opened up a door to theatricality and to the construction of history … The West Coast kind of promises the possibility of reinvention, to re-examine certain traditions and mix them up.'[4] How this relative freedom might be nurtured and sustained is a question that will test Vancouver's coming generations, particularly as growing wealth pressures the city into a more adamantine form. For now, younger artists have learned to carry the experimental ethos that has driven the city's energized art scene on their backs as they shuttle from place to place and even city to city, while continuing to produce ambitious, contextually specific artworks inscribed by histories of place and claims of ownership.

Raymond Boisjoly

Unlike practicioners who are invested in (re)interpreting tradi-
tional West Coast forms and idioms, and whose work argues
a priori for historical identification, most First Nations artists
active in Vancouver's contemporary art scene are burdened
by biography. Writing on Brian Jungen's work, for example,
typically mentions his mixed Swiss/Dunne-za heritage, thus
reiterating a cultural frame through which he and other First
Nations artists are uniquely perceived. Raymond Boisjoly,
whose Haida and Québécois parentage has led to similar
positioning, has made this spatializing language a particular
area of interest. Like Jungen, Boisjoly draws on the ways
in which identification is tied to cultural, and therefore (in
Vancouver and Canada) visual signification; his practice is
grounded in literary frames that suggest links to earlier gen-
erations of Vancouver artists, and especially to Ken Lum. In
one (unfinished) work made in art school in 2006, for instance,
Boisjoly digitally altered pages from Guy Debord's *Society of
the Spectacle* (1967) to produce a red/blue colour separation
that could then be viewed through 3D glasses, tying the text's
(mythic) status as a work of Marxist critical theory to that of a
hallucinatory visual object.

Like Lum, Ian Wallace and Jeff Wall, Boisjoly has (almost
alone among his generation) taken on the disappearing role
of critical respondent – not only in writing, but also through
teaching Critical Studies at Emily Carr University. Boisjoly
moves fluidly between mediums, producing photographic
prints, installations, collage, murals, video and sculpture.
However, this eclecticism is conceptual at heart, as his choice
of material centres on the particular adaptability of mediums
to marry distinct cultural associations with formal or visual
effects. Nylon tarps, for example, have appeared in works as
a ground, as in *The Writing Lesson: Spuzzum* (2011), where
black vinyl-cut letters applied to the back of a white tarp show
through faintly when viewed from the front; and as a lighting
scrim, as in *The Ever-Changing Light* (2010), where a video
projection shines onto a gallery wall through block letters of
a phrase cut from tarp. In both cases, the material recalls –
in addition to flags and commercial signage – its practical
value in rural settings (like Spuzzum[5]), in providing shelter or
securing a truck's contents.

A new, ongoing work follows the artist's attempt to compile
an image inventory of all the petrol stations on First Nations
reserves in British Columbia, picturing each through the most
rudimentary photographic means: by laying a crudely pro-
duced negative (a photocopy on acetate) over black construc-
tion paper, then bleaching the paper under bright sunlight.
The process provides an indexical link to the locale in which
the photograph is made, emphasizing the complex relation-
ship between Aboriginality and place. The titles of these
photographs – rural British Columbia addresses – refer to
the station listings on rezgas.com, a website that names the
locations where a First Nations status card can be used for
a discount fill-up. While the series references Ed Ruscha's
photographs of American gasoline stations, Boisjoly's pro-
visional methodology also resonates with the fieldwork of early
frontier photographers, which often featured First Nations
subjects. In constructing this 'ethnographic' portrait, Boisjoly
strategically returns, through the lens of conceptual seriality,
a cultural specificity rendered largely invisible by western
stereotyping.

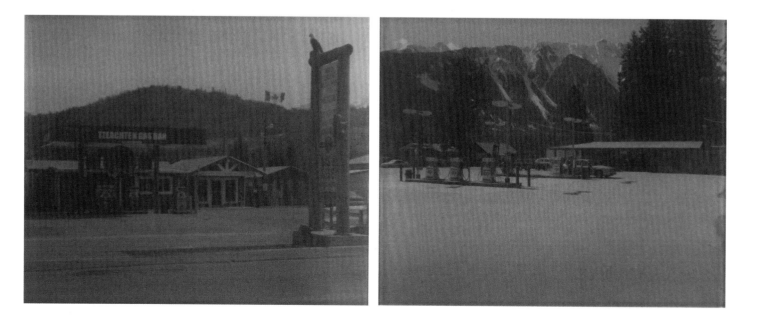

← *6336 Vedder Rd, Chilliwack, BC V2R 1C8*, 2012, sunlight, construction paper, acrylic glass, 61 × 51 cm (left)

← *Ir 10 Rd, Squamish-Lillooet C, BC V0N 2KO*, 2012, sunlight, construction paper, acrylic glass, 61 × 51 cm (right)

↑ *The Writing Lesson: Spuzzum*, 2011, tarpaulin and vinyl text 274 × 366 cm

↓ *The Ever-Changing Light*, with Julia Marshburn, 2010, broken television, tarp screen, video projector, camera and stools, dimensions variable

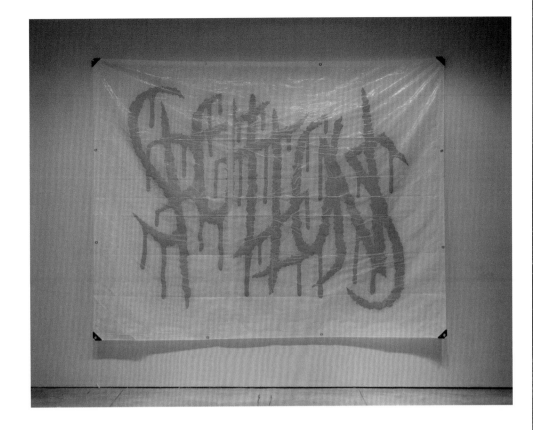

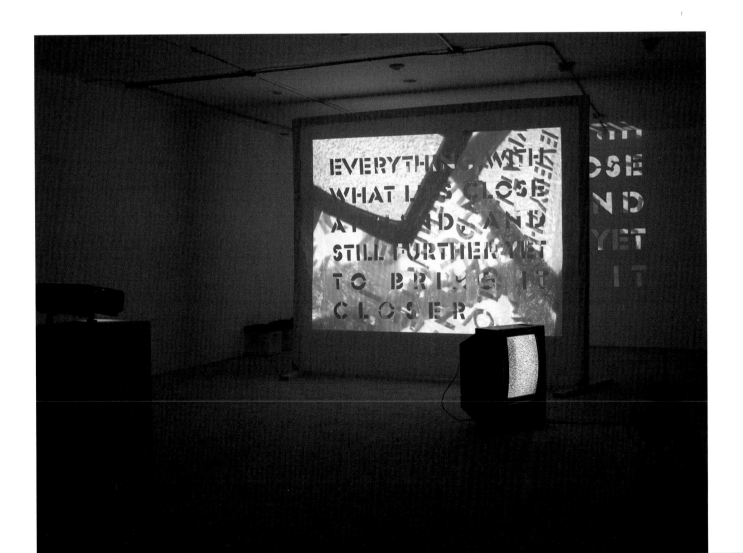

Rebecca Brewer

One of several young Vancouver painters to come to prominence during the past decade, Rebecca Brewer has contributed to the medium's resurgence in the city after decades in the shadows of photo-conceptualism. Since 2007, Brewer has developed a unique language, part abstraction and part figuration, inspired as much by local practices as international influences. Her attention to some of the city's long-term histories, and the largely unbroken trajectory of abstract painting on the West Coast, beginning with Emily Carr, have provided fertile ground for her practice.

Brewer develops her compositions intuitively, working primarily in oil and often beginning with an initial set of arbitrary marks. Her recent paintings often feature a single, partially defined figure against an abstract or loosely patterned background; an earth-tone palette; and a gestural, skittering mark-making that together call up a range of art-historical precedents from the fragmentation and tonality of analytic cubism to the cartoonish figures of Philip Guston. In *Beuys Painting* (2010) for example – a work that won her a major national painting award – formal ambiguity is underscored by the specificity of the figure's pose, seeming to recall a capped and cloaked Beuys during his 1974 New York City performance with a coyote. In fact, much of Brewer's work mines the depths of the twentieth-century Western canon, merrily and voraciously pinballing allusions to Mary Heilmann, Milton Avery, Matisse and Silke-Otto Knapp.

Brewer belongs to a loose group of painters (including Nicole Ondre, Eli Bornowsky and Monique Mouton, among others) who studied at Emily Carr University principally under Elizabeth McIntosh and Neil Campbell, both abstractionists from under whose tutelage much of Vancouver's new painting talent has emerged. McIntosh and Campbell have themselves built on the history of abstraction on the West Coast, which begins with Carr's fauvist landscapes and moves successively through a series of local artists who bridge the abstract and figurative divide, including Jack Shadbolt during the 1950s, Roy Kiyooka and Michael Morris in the 1960s and early 1970s, and the likes of Mina Totino, Lawrence Paul Yuxweluptun, Derek Root and Attila Richard Lukacs through the 1980s and into the 1990s.

Brewer's latest works narrow their focus on figure/ground relationships even further. Her Beuys painting prefigures a cycle of works shown together in her solo exhibition 'Nine Paintings of Ayn Rand' (2012) that employ a stylized, art-deco figure reminiscent of the famous covers of Atlas Shrugged (designed by Rand's husband) as a kind of leitmotif. The titles of these works – *The Improviser*, *The Economist*, *The Luddite* – seem to convey Randian archetypes, yet any strong affinity (or argument) with the controversial objectivist philosopher is left for the viewer to speculate. Perhaps due to the vagueness of her theme, Brewer's genuine talent emerges quite clearly, and the tension between ambiguity and historical specificity is, at least in this case, allowed to fade into the background as a simple armature for an astonishing compositional and paint-handling capability, and the desire to push an image to the edge of recognition.

← *Beuys Painting*, 2010, oil on panel, 107 × 119 cm

↑ *The Improviser*, 2012, oil on panel, 91 × 107 cm

↗ *The Economist*, 2012, oil on panel, 91 × 107 cm

→ *The Luddite*, 2012, wool felt, gesso, acrylic, powdered tempera, 130 × 160 cm

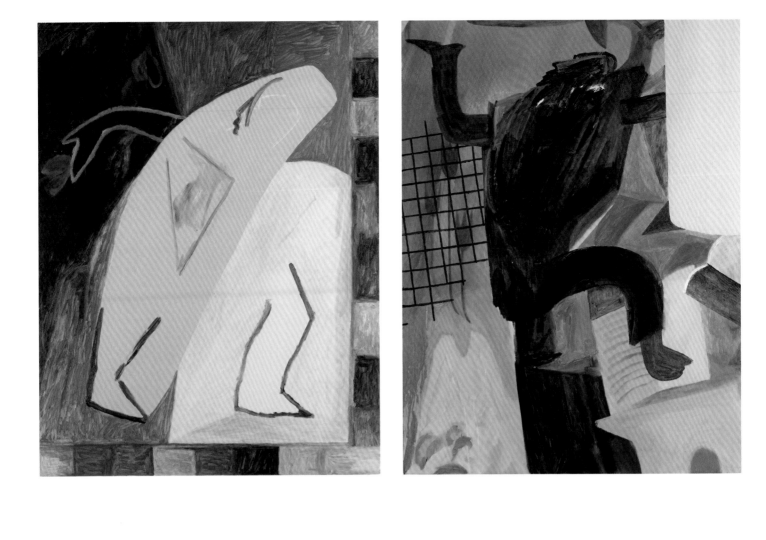

Andrew Dadson

The seven-part photograph *Neighbour's Trailer* (2003) documents an argument with the next-door neighbour who once parked a camping trailer in front of Andrew Dadson's house. Over the course of a week, the artist surreptitiously moved the trailer a few feet further along each night. In this way he won the minor battle, and importantly, he initiated an ongoing exploration of edge spaces and the fraught social codes that define boundaries. For example, in *Roofgap* (2005), the artist asked a homeowner for permission to climb onto the roof of her house. He then jumped the gap separating her house from two neighbouring houses, breaching the legal, though invisible, line between properties and the space between permission and intrusion.

Dadson's conceptual documentary approach – largely filmic and photographic – has since moved towards more formal object making, chiefly painting. A critical turning point came with *Visible Heavens from 1850–2008* (2008), an artist book based on a found star map dating from 1850. He photocopied the original map and then re-photocopied each subsequent copy (a total of 158 times, once for each year) so that the final page displays only a black smear. The work's Smithson-esque meditation on entropy turns on the very real disappearance of stars from our optical vision over the past century and a half, alongside the waning of their allegorical import, as conveyed by the monochromatic image wrought by the slow accretion of mechanically reproduced errors. For Dadson, the monochrome has become a formal means to bind his curiosity for social compacts and edge spaces through the co-optation of traditional avant-garde experiments. While these works manifest as simple black or white compositions, usually employing rectangles, they are achieved in a wide range of mediums including paint, fabric dye and documented landscape interventions. *Black Yard* (2007) is a striking colour photograph of a lawn physically painted black (with vegetable dye colour) that hovers at the interstice of a Mark Rothko and delinquent suburban graffito. It also betrays the acute influence of local artist Ian Wallace's combination of hard-edge painting and socially descriptive photography by means of an almost physicalized marriage.

His latest paintings employ repetition and accumulation to create quasi-sculptural forms. In the *Re-Stretched* series (2009–present), numerous alternating layers of black and white paint are squeegeed over the edges of a stretched canvas and allowed to dry. The canvas is then re-stretched on a larger frame, which brings the gloopy edges into relief and creates a raised rectangle of paint on the linen surface. Similarly, for the *Leaner* works (2010–present) he squeegees hundreds of layers of colour across a canvas propped at a slight angle to a wall, over time allowing the paint to build up into an architectonic buttress joining the canvas to its support. A final coat of paint in either black or white reinscribes a simple monochrome, accentuating the work's uncomfortable position, and negotiation, of wall, floor and the social space of the gallery.

← *Black Yard*, 2007, C-Print,
137 × 203 cm

↑ *Black/White Re-stretched*,
2012, oil on canvas, 61 × 50 cm

↓ *Black Painted Lawn with
White Fence*, 2006, C-Print,
152 × 183 cm

← *Black Yard*, 2007, C-Print,
137 × 203 cm

↓ *Black Painted Lawn with
White Fence*, 2006, C-Print,
152 × 183 cm

Julia Feyrer

Julia Feyrer initially conceived *The Poodle Dog Ornamental Bar* (2010) as a 16mm narrative film, but its set (a replica of the little-known, turn-of-the-century Vancouver logger bar, The Poodle Dog Saloon) in fact became the centrepiece of this distinctive work. The artist reconstructed the bar as a stage in the backyard of a rented Vancouver house, using a nineteenth-century photograph (accidentally discovered in a civic archive) as her sole referent. Picturing an interior adorned from top to bottom with rough wooden filigree and backwoods parquetry, a handwritten inscription over the image explains how a man named Bert Burton 're-ornamented' the bar using 'every kind of bush, limbs of trees, moss, fungus and vine maple…'

Over the summer of 2010, she opened the saloon/set to friends and guests, serving homemade, dollar-a-glass apple spritz at what became a late-night speakeasy, a venue for talks, poetry readings and performances, and vitally, a bar of last resort. The unscripted events held in the space guided the focus for her film, which shifts from a narrative approach to a documentary and improvisational one. Throughout the production, Feyrer allowed her camera to drift at the voyeuristic edge of her set, reflexively employing mirrors and shooting peek-a-boo scenes through holes. Coupled with an overdubbed, unsynced soundtrack recorded live within the bar, the finished work is astonishingly atmospheric, ephemerally blurring past with present.

Time is at the heart of Feyrer's projects, and this is perhaps why photography and film are such central, structural mediums for her. She was one of the first of a number of Vancouver artists to study at Frankfurt's Städelschule during the past decade, and the looping, narrative mechanisms of Simon Starling (one of her professors) suggest influential methods of re-enactment and restaging. *The Artist's Studio* (2010), for example, is a short 16mm colour film loop that also draws inspiration from a photograph, in this case the 1837 daguerreotype *L'Atelier de l'artiste* – by Daguerre himself – considered the first successful example of the photographic process. She arrays paraphernalia and found garbage in her studio into a crude facsimile tabletop still life; shooting from a viewpoint that hovers between sincere homage and slapstick.

Her most successful recent works sidestep a tendency towards arcane material fetishism to create alchemical, experiential ruptures. *In Little Pitchers Have Big Ears* (2012), a sculpture and audio work recorded in Victoria's omnibus Royal BC Museum, Feyrer used a binaural microphone set within a sculptural recreation of her own head to record herself walking through the Museum's galleries. We listen through a museum audio guide to her footsteps and to the rising and falling voice of a museum guide as he relates, taxonomically, the stories of individual natural history dioramas. Like *Poodle Bar* – and unlike Janet Cardiff's audio walks, to which the work directly relates – *Little Pitchers* gradually builds its temporal and spatial rifts. As centuries and story lines bleed into one another, real and artificial time seem to accordion, schismatically folding upon themselves.

← *Little Pitchers Have Big Ears*, 2012, plaster head, mugwort, mugwort oil, binaural microphones, silicone ears, cotton, felt, wood, compass, museum audio guides with headphones, Royal BC Museum binaural recording and binaural recording device, dimensions variable

↑ *The Poodle Dog Ornamental Bar*, 2010, C-print, 61 × 91 cm

→ *The Artist's Studio*, 2010, colour 16mm film loop with non-synchronized sound, 5 min. 50 sec.

Gareth Moore

In the summer of 2005, Gareth Moore and then-collaborator Jacob Gleason began a fifteen-month project running a small Vancouver corner shop they dubbed *St. George's Marsh*. In a storefront room they stocked an assortment of canned goods, candies and soft drinks for sale, a 'pick one, leave one' library of videos and second-hand books, a gallery of folk art, as well as a vast display of found objects – including a beaver pelt, an old saw, boxes of postcards, used toys, board games, mountaineering equipment and a terrarium – all displayed with quasi-museological diligence in vitrines and on the walls. Over the course of its short lifespan, the Marsh was the site for performances, screenings, talks and events, thus operating as a de facto artist-run centre. But its distinguishing feature was the unfettered confusion of its purpose: whether a commercial store, public museum, private gallery or backwoods flea market.

This perplexity was compounded by the Marsh's vaguely arcane atmosphere, as if one had stepped sideways and slightly backward in time into a suburban cabinet of curiosities. It's a sensibility that runs through many of Moore's projects: a relational interest in the contemporary Gesamtkunstwerk, with an aesthetic derived from that of a nineteenth-century colonial explorer whose journalistic activities are fuelled by the re-use and re-display of found objects. He is particularly influenced by artists whose assemblage or collage practices serve a larger vision, including Kurt Schwitters, American artist Noah Purifoy and Vancouver artist Geoffrey Farmer.

Following the Marsh, Moore began the two-year project *Uncertain Pilgrimage* (2006–07), travelling extensively across North America and Europe with 'the aim of collecting and fabricating en route a kind of sculptural narrative, along the way visiting Henri de Toulouse-Lautrec's old cane, entering the false caves of Lascaux, placing my arm in the Mississippi River and asking Richard Long for a pair of his shoes.'[6] In a subsequent exhibition he showed a reliquary of objects from this trip, including a faux cave carved into the gallery wall and photographic documentation alongside an assortment of curious mementos (a little man fashioned from cigarette butts) and a number of crude tools and sculptures jerry-rigged from wood scraps. Long's shoes were exhibited in the plastic bag with which Moore presumably carried them away.

The auratic effect of *Uncertain Pilgrimage*'s artefacts barely hints at the breadth of the artist's labour, a level of investment that was more on display in *A Place: Near the Buried Canal*, produced for Documenta 13, where he homesteaded in Karlsaue Park for over a year. Arriving in Kassel in early 2011, and using only found, salvaged and scavenged materials, Moore built a small shack as an 'artist's residence', where he lived with no running water and only a small hearth during the cold winter and through the end of the exhibition in September 2012. During this period, the shack became the axis for a growing compound of outbuildings and gardens interconnected by roped-in pathways, including guest quarters (with functional shower), souvenir kiosk, workshop and theatre, as well as a temple to Vulcan, complete with a nineteenth-century statue seconded from the Fridericianum. After relinquishing their cameras and mobile phones, visitors to the remarkable little village, confined to a designated walking path, were left to ponder the vexing question of who in fact was on display.

← *St. George's Marsh*, with Jacob Gleeson, June 2005–August 2006, temporary store

↑ *Tarring Wheels* from *Uncertain Pilgrimage*, 2006–09 LightJet print, cardboard, rock 53 × 41 × 19 cm

→ *A Place: Near the Buried Canal*, 2011–12, site-specific installation, various materials, dimensions variable

↓ *A Place: Near the Buried Canal*, 2011–12, site-specific installation, various materials, dimensions variable

Isabelle Pauwels

For her 2003 solo exhibition 'Unfurnished Apartment for Rent', Isabelle Pauwels showed scale models of six low-rent apartment buildings. Each detailed an individual apartment floor – much like a real-estate office display – but where solid walls would normally have appeared, lattices of gaps, cuts and large holes partitioned the space between each residence. The narrative conceit, detailed in an accompanying artist book, had the building's tenants manufacturing their own furniture (presumably due to poverty) by cannibalizing, à la Gordon Matta-Clark, the walls of their apartments. Thus for each creature comfort, such as a bed or desk, tenants were forced to sacrifice a measure of personal privacy. The book's subtitle, *AN IMAGINARY FILM*, grounds its script-like dialogue, which stages fractious scenes between apartment tenants and visitors that play out like the forced interactions of rats caught in the maze of a mad scientist.

'Unfinished Apartment for Rent' generated many themes that Pauwels continues to explore, including an acute, almost microscopic interest in class and economic stratification as it is marshalled across architectural and narrative spaces. Dan Graham and, locally, Stan Douglas are models, and like Douglas, Pauwels has pursued video – in distinction to her cross-disciplinary peers – as a primary medium. The capacity of video installation as both a dimensional form and a story-telling vehicle was a critical discovery for her: '…I realized if I was going to stress the narrative aspects of installation, I was going to have to find another delivery system for text…'[7] Samuel Beckett provides inspiration (as he also does for Douglas), particularly in terms of the deployment of acid pessimism in prosaic and slightly surreal scenarios.

A reflection of structuralist concern can also be seen in a work like *B-----+----+----+-----E* (2008), a video principally shot within a Vancouver porn theatre, where the camera's POV apes that of a back-seat patron. Onscreen, a montage of scenes from a stock 'nurse/patient' flick is constantly interrupted by the opening (and closing) of a theatre door at stage left, which bathes the dark room in sunlight, bleaching out the action at intervals. Pauwels screened the video in a room that was itself outfitted with a steel crash door, so as to gleefully puncture the aura of the exhibition space with the help of the viewers' noisy, routine intrusions.

Pauwels's most recent work, *LIKE…/AND, LIKE/YOU KNOW /TOTALLY/RIGHT.* (2012), a single-channel video projection made during a residency at Western Front, uses the idiosyncratic personalities of the initiative's founding members as fodder for an essay on Vancouver art-world dynamics. Between homages to seminal video and performance works by Eric Metcalfe, Glenn Lewis and Hank Bull (*Crime Time Comix: Steel and Flesh*, 1980; *Sax Island*, 1984; *Hitler*, 1974), Pauwels interlaces a parallel exploration of a childhood club whose members count the artist and her twin sister, an actress who moonlights as a dominatrix. The dizzying jump cuts and bold intertitles splashed with enigmatic phrases ('BLIND-SIDED by the whole SHOW!') take viewers back and forth between present-day voiceover narrations by the Front's founders and scenes of Pauwels and her sister (wearing plastic monkey masks) rehearsing the rules of their club. The work plays at the borderline of tribute and biting critique; as the particularities of a local history are stitched together, the mechanisms that made that history so fertile are as quickly frayed. Pauwels thus draws a complex historical portrait that utilizes autobiographical detail not as expository material, but as a filter through which larger power dynamics are microscopically and obsessively dissected and displayed.

→ *June 30*, 2009, HDV projection with sound, 7 min. 55 sec.

↑ *LIKE…/ AND, LIKE/ YOU KNOW/ TOTALLY/ RIGHT.*, 2012, 720p HD video projection with sound, 63 min. 23 sec.

← *B-----+----+----+-----E*, 2008, VHS projection, 13 min. 31 sec., installation view at Presentation House Gallery

Kevin Schmidt

In his 2002 video *Long Beach Led Zep*, Kevin Schmidt stands on a beach on the west coast of Vancouver Island, his back to the Pacific Ocean and the setting sun. He plays Led Zeppelin's 'Stairway to Heaven' on electric guitar, the live sound coming from two Marshall amps (powered by portable generator) that bracket him. Judging from his rain gear, the setting is wet and frigid, which might explain the tentative, amateurish guitar work at the song's start. But as the ten-minute video plays out, he finds confidence and begins to tap the song's slow, anticipatory rhythm as it rises towards Jimmy Page's solo and Robert Plant's screeching vocal climax. By the end, Schmidt's playing is spine-tingling.

The structural balance created by *Long Beach Led Zep* is astonishingly measured given its mix of two fatigued, sterile tropes: the iconic bombast of Zeppelin's stadium-rock staple and a stereotypically picturesque West Coast sunset. But it is only through this surprising combination that any latent utopian frisson, in either song or landscape, can be resuscitated.

A number of Schmidt's subsequent works seek a similar transcendental arc through the coupling of prosaic pop-cultural idioms and spectacular natural settings. In the video installation *Wild Signals* (2007), for example, he erects a small concert light stage, complete with fog machines, in the middle of a frozen Yukon lakebed. The light performance is cued to a musical score the artist composed in unabashed homage to the infamous five-note tonal sequence from Steven Spielberg's 1977 movie *Close Encounters of the Third Kind*. Like *Long Beach Led Zep*, the sequence's cloying oversaturation is deployed in such an unexpected environment that the

recuperative gesture does not invite our cynicism, but rather poses a provocation.

Schmidt's debt to Rodney Graham is apparent in the way he frames an idea of the sublime through the lens of pop culture. But where Graham foregrounds the technical (and therefore social) means by which we construct ideas of the natural, Schmidt uses nature as a stage where, à la Caspar David Friedrich, narratives of redemption and loss are played out. Also, like other artists of his generation, particularly Brian Jungen and Gareth Moore, Schmidt's themes are increasingly explored through extended, often expeditionary projects.

In the ongoing work *A Sign in the Northwest Passage* (2010–present), he crafted a wooden sign upon which he routed (apocalyptically) phrases from the Book of Revelations. He then took the work to the outer reaches of the Canadian Arctic's seasonal ice shelf, on the Beaufort Sea, and moored it on drum-barrel pontoons. Theoretically, when the ice melted the sign would float into (newly formed) shipping lanes and find its way east or west, like a message in a bottle. Schmidt attempted to locate the sign the following summer, having been instructed by an oceanographer that it would likely drift towards Russia. The artist documents his unsuccessful hunt on video, but his purposefully Franklin-esque[8] over-tones are complicated by a surprising cache of accompanying photographs; taken by a young Inuit who discovered the moored sign on a seal hunt before the thaw. Schmidt had heard about the digital images posted to the teenager's Facebook page, but only saw them after returning from his travels north, when he was 'friended' by the hunter.

← *Wild Signals*, 2007, HD video, 9 min, 42 sec.

↑ *Prospect Point*, 2007, LightJet print, 188 × 221 cm

↓ *A Sign in the NW Passage*, 2010–present, digital photograph taken where the sign was moored

↪ *A Sign in the NW Passage*, 2010–present, wood, concrete, and wine barrels, approximately 609 × 609 × 609 cm above the ice

Ron Tran

For *The Peckers* (2004), Ron Tran sprinkled birdseed over amplified instruments in a public courtyard, then recorded the incidental sound produced by the pigeons as they ambled over and across the instruments. In *Walking Strangers Home* (2004–05), he offered to accompany unsuspecting passers-by back to their places of residence, and photographed those who accepted. More aggressively, in *Dinner with a Stranger* (2004), he sat for evenings in a fast-food restaurant and mimicked, for the duration of a meal, every action of the diner sitting next to him.

The performative quality of these early works, particularly those involving Tran's personal investment and occasional voyeuristic cruelty, signal his ongoing interest in social inter-actions both as subject and medium. This interest has grown in tandem with his deployment, as in *Peckers*, of readymade props around which unscripted situations may unfold – as allegories for the artist and the creative act.

For example, his work *Apartment #201*, included in the 2008 exhibition 'Everything Should Be Made as Simple as Possible, But Not Simpler' at Vancouver's Western Front, Tran removed the front door of his apartment and re-hung it on one of the gallery's walls. He then lived for the duration of the exhibition without any barrier between himself and the other tenants of his East Vancouver apartment block. Reflecting either the city's relative safety or its citizens' temerity, no thefts or incidents resulted in the several weeks without a door.

Similarly, in a work for the sixth Berlin Biennale (:::::: ::::::, 2010), Tran moved a number of park benches normally situated on opposite sides of Oranienplatz into closer proximity across the square's main path. Used most commonly (and with strict gender division) by the area's large Turkish population, the newly conversational distance incited a range of new uses,

if not social formations. Here again Tran's repositioning (or decommissioning) transforms bench (or door) into an auratic object of its prior use while simultaneously instigating new, albeit temporary, situations.

This relational approach reached something of an apotheo-sis in the exhibition 'It Knows Not What It Is' at Vancouver's Charles H. Scott Gallery in 2011, where he invited eleven fellow artists to create an homage or replica (all framed in installation as quasi-religious icons) of a simple wooden stick bought from a homeless person on the street in Toronto. At some future point Tran intends to return the stick to its owner, bringing the Duchampian gesture full circle: from junk to sculptural relic and back to junk again. Until then, the exhibition's most cogent provocation is the questioning of authorship in terms of art-world hagiography, set in stark relief by the unacknowledged collaboration of his peers (who were referenced only in the press release).

Tran cheekily skewered authorship and authenticity in *Peanut, Leopard and Sharks* (2011), for which legendary per-formance artists Vincent Trasov, Kate Craig and Glenn Lewis, associated with the Western Front, were remade quite literally as child-sized costumes modelled on their iconic alter egos Mr. Peanut, Lady Brute and Flakey Rosehips, respectively. The frenetic energy of the children who donned the costumes recalled the spontaneity and impish good humour of the original performances. At the same time, any commemorative or recuperative aspect of the work was bracketed by Tran's acerbic interpretation of the Front artists as unreflective pranksters. A backhanded compliment perhaps, but one that signals a reappraisal, if not re-affirmation, of the Front's Robert Filliou-inspired philosophy of 'art as life' for the socially embedded, relational art of Tran's generation.

← *Peanut, Leopard and Sharks (re-creating Mr. Peanut, Lady Brute and Flakey Rosehips for kids to perform)*, 2011, papier-mâché, fabrics, carpet, paint, neoprene and wire, dimensions variable

↑ *:::::: ::::::*, 2010, relocated public wooden and metal benches, dimensions variable

↓ *It Knows Not What It Is*, 2011, C-print, 66 × 102 cm

→ *Apartment #201*, 2008, door of the artist's apartment made of wood, metal hinges, door handles and keys, 203 × 81 × 20 cm

■ Beirut 08–33

1 Conversation with the author, August 2004.
2 Ibid.
3 Samir Kassir, Beirut, trans. M. B. DeBevoise, University of California Press, Berkeley and Los Angeles, 2010, p. 30.
4 Conversation with the author, September 2007.
5 Cherri's video installation gained another layer of relevance in the summer of 2012, when Fares, by then a general, defected from the regime of Bashar al-Assad, fled across the border to Turkey and pledged his allegiance to the opposition.
6 From the wall text accompanying Zaatari's installation of this work at Documenta 13.

�’ Bogotá 34–59

1 By contrast, emigrants from abroad are a minority, since the country has been traditionally unreceptive to immigration. This might account for a distinct trait in our collective psyche, which I like to call xenophilia, the opposite of xenophobia: in Colombia we adore foreigners.
2 So high that it's become a sign of local pride. The city's promotional slogan is: 'Bogotá, 2,600 metres closer to the stars.'
3 The US Department of State recently had a travel warning on its webpage that discouraged American nationals from visiting Colombia, doing so at their own risk.
4 A well-run art fair, several alternative fairs, a government-funded programme to host international curators and of course decades of work by local curators and institutions also helped raise awareness of Bogotá's flourishing art scene.
5 It might have been Tarzan the Terrible from the Sunday comic strips.
6 In Colombia we say that you never cease to be an emerging artist, at least in regards to the international circuit. Maybe the only artist to have fully emerged is Doris Salcedo.
7 ¿Dónde está la franja amarilla?, Grupo Editorial Norma, Bogotá, 2003.
8 Charles Saffray, Journey to Nueva Granada (1869–70), quoted in José Alejandro Restrepo, Musa Paradisiaca, Colcultura, Bogotá, 1997, p. 15.
9 The arts department of the Banco de la República was previously part of the cultural centre Biblioteca Luis Angel Arango. I was arts director there for more than a decade, and left in 2008 after the new building was finished and the museum created.
10 Such as María Inés Rodríguez, chief curator of Museo Universitario Arte Contemporáneo (MUAC) in Mexico City; Inti Guerrero, chief curator of

TEOR/éTica in San José, Costa Rica; and independent curator Juan Andrés Gaitán, formerly at Witte de With in Rotterdam. Curators like Carmen Maria Jaramillo, Santiago Rueda, María Iovino, Mariángela Méndez, Carlos Betancourt and Ana María Lozano are working locally and internationally from Bogotá.
11 Remedios para el Imperio: Historia natural y apropiación del Nuevo Mundo, ICANH, Bogotá, 2000, p. 9.
12 'U.S. Anti-Drug Official Calls Colombia a "Narco-Democracy"', Houston Chronicle, 1 October 1994, section A, p. 21. See also: Antonio Caballero, 'Quotes of the Week', Semana International, 9 January 1995.
13 I have written several articles and curated exhibitions on the subject: 'Flora Necrológica', Lápiz-Revista Internacional de Arte, Madrid, 2001; 'Botánica Política', Sala Montcada, la Caixa, Barcelona, 2004; and 'Outras Floras', Galeria Nara Roesler, São Paulo, 2008.
14 Juan Manuel Echavarría's contemporary versions of the plates for the Royal Botanical expedition made with human bones; the cultural elaboration of nature by Milena Bonilla; Juan Fernando Herrán's decade-long investigation of the cultural implications of Papaver somniferum, or common poppy, which is the basic ingredient of opium and heroin; Maria Fernanda Cardoso's use of plastic flowers in wall installations that evoke the vertical cemeteries common in Colombia; Graciela Duarte and Manuel Santana's urban botanical expeditions; Wilson Díaz, who has transported coca seeds in his body across frontiers; Doris Salcedo's breathtaking shroud of rose petals; Miguel Ángel Rojas's use of coca leaves and dollars as primary materials; and many more.
15 Conversation with the author, 2001.

◪ Cluj 60–85

1 Unless otherwise stated, all quotes on pp. 63–67 are from e-mail correspondence with the author in December 2011.
2 The evolution of the Paintbrush Factory initiative is as follows: Daria D. Pervain wanted to open Sabot and found a room in a half-empty building. In parallel, Plan B had to leave their Einstein Street space. While Mihai Pop and Rarita Zbranca were having a coffee together, they realized they were both searching for new locations. Knowing about Sabot moving to the Paintbrush Factory, Mihai came up with the idea of joining the building. Zbranca arrived at the idea of not only moving there, but creating an art centre. Together with Pop she proposed the Paintbrush Factory

initiative, which Pervain and Sabot agreed to join.
3 Plan B Gallery was started by Adrian Ghenie and Mihai Pop in September 2005. The two artists met through Pop's friend, artist Victor Man, who was a colleague of Ghenie's in the University's painting department. Man proposed Ghenie and Pop join forces in a gallery project. The colleagues were determined to bring a focus to Cluj and its artists through the establishment of an independently funded, artist-run space. Plan B functions as a production and exhibition space for contemporary art; at the same time it is a research centre focusing on Romanian art of the last fifty years. The name of the gallery is a reference to the general situation of art spaces in Romania; as most are reliant on insufficient public resources, Plan B is a fall-back plan predicated on individual involvement, a different understanding of the institution and a coherent managerial policy.
4 The Bucharest galleries Andreiana Mihail and Ivan have both achieved international success with a number of Cluj-based artists in their programs.
5 Peles Empire is a collaborative work by Katharina Stoever and Barbara Wolff. The project borrows its name from the Romanian castle Peleş, built between 1893 and 1913. Since 2005 Stoever and Wolff have reproduced ten rooms of the castle in Frankfurt, Los Angeles and London, as well as in Cluj, and have organized over thirty exhibitions within these spaces. Bazis Gallery is a project of Association Bazis, which produces an art journal in addition to holding exhibitions. It focuses on art and artists from Transylvania while also promoting international work. Its three co-founders are ethnically Hungarian: Zsolt Berszan, István Betuker and Szabolcs Veres. Sabot Gallery's mission statement declares that it was brought into being 'for the purpose of checking the raison d'être of a gallery today … and promoting new avant-garde tendencies'.
6 Mihai Pop was invited to assume the role of Commissioner of the Romanian Pavilion at the 2007 Venice Biennale, and Attila Tordai-S curated the Periferic 7 International Biennial for Contemporary Art in Iaşi in 2006.
7 Co-founder of Studio Protokoll and the Protokoll Association (established to promote the education of cultural theory and conceptual thinking), Tordai-S also co-founded tranzit.ro of the Erste Foundation, dedicated to supporting artistic and cultural activities with a critical approach from local and global perspectives.
8 Tordai-S's recent involvement in the educational side of contemporary art through the People's School of Contemporary Art (PSCA) in Cluj is intended to promote the development of critical analysis and cultural theory in the Cluj context on a long-term

basis. Though now no longer running, another significant outreach that helped to shape Cluj's international perspective was the Sindan Cultural Center (SCC)(1999–2003), which hosted and produced forty-three contemporary art exhibitions. Established in 1999 by Sindan Pharma under the directorship of curator Maria Rus Bojan, in addition to hosting exhibitions it offered support for an impressive number of artistic projects by Romanian artists abroad.
9 In Autumn 2011 he was awarded the coveted Marcel Duchamp Prize, which earns the recipient an exhibition at the Centre Pompidou in Paris. Cantor participated in the Venice Biennale as far back as 2001.
10 Christy Lange, 'Focus: Mircea Cantor', Frieze, no. 95, November–December 2005. Lange recounts how the young artist hitchhiked his way from his home in Romania to France. He went on to make a film about the journey. Cantor's artistic forebear Brancusi had, of course, already paved the way to France.
11 Coline Milliard, 'Haunch of Venison tries to come back to life with a show of Transylvanian artist Adrian Ghenie', ARTINFO.UK, 26 August 2011. Georgina Adam, 'The Art Market: Recovery Position', Financial Times, 9 September 2011. The idea of grouping the painters in this manner was first presented in a formal international context by the organizers of the Prague Biennial in 2007.
12 E-mail correspondence with the author, March 2012.
13 Oliver Basciano, 'Fair Report: Liste, Basel', Artreview.com, 13 June 2012.
14 Filip-Lucian Iorga, 'Totul este poezie, dacă te pricepi să vezi', Romania Literara, no. 23, 2004.

◧ Delhi 86–111

1 A highly sophisticated Mughal culture defined Delhi from the sixteenth through the nineteenth century; in 1911, it became the capital of the British Empire.
2 At two subsequent moments Delhi was witness to state coercion and communal carnage: in 1975, Prime Minister Indira Gandhi declared a state emergency (lasting until 1977) and repressed dissent through draconian laws; in 1984, thousands of Sikhs were massacred by Hindu mobs after Sikh militants killed Indira Gandhi.
3 Roughly analogous to the Arts Council of Great Britain, the 'Akademis', Lalit Kala, Sangeet Natak and Sahitya, support fine arts, performing arts and literature, respectively.
4 Officially named the National Handicrafts and Handlooms Museum.
5 Comprising the Lekha and Anupam Poddar Collection.
6 Supported by Shiv Nadar, founder-chairman, Hindustan Computers

Footnotes

Footnotes A–B 320–321 Limited (HCL) and the Shiv Nadar Foundation.

7 Among the many overseas centres active in Delhi as part of cultural diplomacy, Goethe-Institut/Max Müller Bhavan (named for the German Indologist) supports experimental arts including photography and video, dance, theatre and music.

8 Through the Triennale-India, Delhi has hosted artists including Roberto Matta, Sarkis and Carl Andre; and critics such as Octavio Paz and Harold Rosenberg.

9 In Indian political life, 'communal' implies discrimination and strife between ethnic and religious (especially Hindu and Muslim) communities.

10 Some of these travelling performance platforms include 'Artists Against Communalism' (1991), 'Anhad Garje' and 'Muktanaad' (1993); and noteworthy exhibitions: 'Hum Sub Ayodhya' (1993), 'Postcards for Gandhi' (1995) and 'Ways of Resisting' (2002). In early 2013, The University of Chicago's Smart Museum hosted an exhibition on Sahmat's twenty-five-year history.

11 India's renowned modernist painter M. F. Husain, facing criminal charges by right-wing Hindu nationalists for degrading Hindu gods, chose self-exile in Dubai and Qatar during his final years. He died in London in 2011.

12 'Khoj' means 'search'. See Khoj, Harper Collins, New Delhi, 2010.

13 Staged for Khoj's tenth anniversary celebrations, international participants included: Steven Cohen, DA MOTUS, Doug Fishbone, Mwangi Hutter, Mehr Javed, Hassan Khan, Fred Koenig, Ray Langenbach, Boris Nieslony.

14 In December 1989, K. P. Krisnakumar, her partner and the charismatic leader of an artist collective (Radical Painters and Sculptors Association, Baroda-Kerala, 1987–89), committed suicide in despair at the collective's 'failure' to change the conditions for art and politics in India.

15 See Rosalind Krauss, The Optical Unconscious, October Books/MIT Press, Cambridge, Massachusetts, 1994.

16 See Georges Bataille, Story of the Eye (1928), Urizen Books, New York, 1977. The word 'eye' is common to lewd phrases and sexual profanity in Indian languages.

17 See Utsa Patnaik, The Republic of Hunger and Other Essays, Three Essays Collective, Delhi, 2007. Orissa/Odisha is the eastern end of a swathe of land across India where extreme exploitation by (global) corporations and the state has activated tribal, peasant and labour uprisings and left-wing movements. Installed at Samadrusti in Bhubaneswar, Odisha, The Sovereign Forest is an exhibition, a library, a memorial, a public trial, a call for 'evidence' and a collaboration between

art and activist politics.

18 See Jameson, 'The Utopian Enclave' in Archaeologies of the Future, Verso, London and New York, 2004.

19 With face and ear to the ground, her 'lying down' has an acoustic aspect, emphasized, for example, in the Somnambulist's Song.

20 The flâneur is a cosmopolitan vagrant, a bourgeois dropout; whereas the working class tramp survives in a state of tolerant disregard, as city detritus.

21 This diary, sourced by Cybermohalla Ensemble (proletarian urbanists in dialogue with Raqs), was re-composed in response to The Nights of Labour, read in Hindi translation.

22 Carolee Schneemann's performance Interior Scroll (1975), in which she extracted a scroll from her vagina, like entrails, and read out a feminist text, relates to the character of Sen's work.

23 It is illuminating to consider Sen in relation to two remarkable painters from India: Bhupen Khakhar (1934–2003) whose morbid yet resplendent portrayal of gay sexuality forever changed Indian painting; and Nalini Malani (b. 1946), whose misshapen creatures (crossed between amoeba, humans and accursed figures from mythology) produce an apocalyptic theatrics.

24 Kali, stepping naked on the prone body of her consort, the great god Shiva, embodies and enacts the cycle of life and death, producing among her devotees maddened forms of ritual worship.

Istanbul 112–137

1 There were artists who established and maintained their practices outside the system of the Fine Arts Academy in Istanbul, such as Fahrelnisa Zeid and her son Nejad Devrim, both abstractionists educated in Paris. Zeid held her first exhibition in 1944 at her home in Istanbul, followed by exhibitions in Europe. Both mother and son's paintings were highly original, and it would be unfair to categorize their work alongside the cosmetic Western style of state-sponsored painters.

2 Vasıf Kortun, 'Modern Essays' SALT, Istanbul, 2011, saltonline.org/en/#!/en/40/modern-essays_break/

3 Nilgün Özayten, 'Batı'da Obje Sanatı / Kavramsal Sanat / Post-Kavramsal Sanat ve Türkiye'de 1965–92 Yılları Arasındaki Benzer Eğilimleri' in Mütevazı Bir Miras: Nilgün Özayten Kitabı (A Modest Inheritance: The Nilgün Özayten Book), ed. Sezin Romi, SALT, Istanbul, 2013, e-book.

4 STT translated the writings of Marcel Duchamp and texts by Joseph Kosuth and Jan Dibbets into Turkish. Published in their artist books, the translations represented the direct participation of the authors of the texts, who were named on exhibitors lists. STT also invited guest artists

such as İsmail Saray and Alpaslan Baloğlu to publish in their books.

5 Contact with the global art world was limited to those who could travel (for example, Gülsün Karamustafa did not obtain a passport until 1986 due to her political activism, while İsmail Saray fled the country and sent works to Istanbul from London after the coup). Magazines brought back from trips abroad became treasured items for keeping up with the international zeitgeist.

6 While some editions of this series were criticized for direct appropriation of Conceptual and object-based art movements from the West without the addition of any new material or content, the catalogue text for the final exhibition championed the experimental nature and originality of the works presented in the series, defending the 'new' of the title.

7 Large-scale solo exhibitions of Kutluğ Ataman, including 'The Enemy Inside' (2011), at Istanbul Modern and 'Mesapotamia Dramaturgies' (2012) at ARTER, featured works never shown in Turkey before.

8 Statistics compiled by the editors of 'Almanac 2012', ArtAsiaPacific, vol. 7, January–February 2012, p. 192.

9 Erden Kosova, neresi? burası?, The Museum of Modern Art, Saitama, Japan, 2003, p. 52.

Johannesburg 138–163

1 Ivan Vladislavić, Portrait with Keys: Joburg & What-What, Umuzi, Johannesburg, 2006.

2 Part of the influx during this period resulted from a damningly exploitative system that ultimately saw blacks, stripped of their rural land, become migrant labourers. Initially populated by whites from Europe and North America, black men from the countryside and neighbouring states were soon forced into unskilled work in the mines. They were housed in compounds in the cities, while women and children were left behind to work the land. The scars of this violent and deliberately racialized dispossession are evident still today. Many labourers from southern China, later recruited into the mine workforce, settled permanently in Johannesburg and have since created a strong Chinese community. Rural women who found work in the developing city brewing beer for black migrant workers coexisted alongside European prostitutes, gangsters, impoverished Afrikaners, tradesmen and the Zulu men, or AmaWasha, who offered laundry services.

3 Sarah Nuttall and Achille Mbembe, ed., Johannesburg: The Elusive Metropolis, Wits University Press, Johannesburg, 2008.

4 The boycott was officially lifted in 1993 when the promise of democratic elections in South Africa was assured.

5 Including Peter Magubane, Alf Khumalo, Bob Gosani, Jürgen Schadeberg, Ernest Cole and numerous photojournalists such as Kevin Carter, Greg Marinovich, Ken Oosterbroek and João Silva. These images fed an international awareness campaign to monitor conditions in South Africa, and some were featured in local publications including Drum magazine. More recently, photographers Jo Ractliffe, Guy Tillim, Mikhael Subotzky, Sabelo Mlangeni and Terry Kurgan have photographed unseen or unspoken aspects of the city, while Zanele Muholi's powerful photography voices her activism for the right to safety, dignity and social acceptance for LGBT individuals.

6 For example, Alexander's sculpture Butcher Boys (1985–86) provides a surreal critique of the dark potential of human nature.

7 Terry Kurgan's collaborative project Hotel Yeoville (2010) considers the changing demographics of a historically immigrant Johannesburg suburb, not as an anthropological act, but as a reconsideration of human intimacy and the public realm.

8 Although currently based in France, Cohen remains intimately involved with Johannesburg.

9 Now dividing her time between Johannesburg and Berlin, Orlin still refers to Johannesburg as the source of her inspiration and creative drive.

10 Due to the cultural boycott, international modernism was received in South Africa mostly via academic textbooks, leading to a great deal of misinterpretation in some instances, especially in relation to scale and intent. Among others, artist Zander Blom explores this phenomenon in his work.

11 The Market Theatre Gallery, the Market Photo Workshop (founded by David Goldblatt), Newtown Galleries (Ricky Burnett) and Artist Proof Studio (founded by Kim Berman and Nhlanhla Xaba), all in Newtown, and the Goodman Gallery under the direction of Linda Givon showed work by Johannesburg-based artists David Koloane, Pat Mautloa, Santu Mofokeng, Nhlanhla Xaba and Mmakgabo Helen Sebidi, among others.

12 Other such initiatives include the Joubert Park Project (JPP), founded by Dorothee Kreutzfeldt, Jo Ractliffe and Joseph Gaylard in 2001, which invited artists to respond to the culture and economy of the Joubert Park precinct, an informal commercial hub and home to the Johannesburg Art Gallery. Still continuing to diversify its programme, active JPP members include Kreutzfeldt, Gaylard, Lawrence Lemaoana, Bie Venter and Rangoato Hlasane. Established in 2008, the Keleketla! Media Arts Project, an independent interdisciplinary library, began as a one-off collaboration

with Bettina Malcomess, Rangoato Hlasane, Malose Malahlela and JPP.

13 E-mail correspondence with the author, January 2013.

14 From Zander Blom's introduction to *The Drain of Progress: A Catalogue Raisonné 2004–2007*, Rooke Gallery, Johannesburg, 2007.

15 *Ibid.*

16 From the press release for 'lešobana!! lešobana! lešobana!!! (le bulegile); lešobana! lešobana! lešobana!!! (go phunyegile)', Bopape's 2011 solo show at Stevenson, Johannesburg.

17 While queer identity is far less marginalized in South Africa than it once was, this is not always the case in broader communities beyond the art world.

18 From a statement by the artist, October 2012.

19 E-mail correspondence with the author, February 2008.

20 As part of Colin Richards's noteworthy exhibition 'Graft', held in Cape Town.

21 For Hedwig Barry and Rory Bester's six-part television series *Right Through the Arts*, screened by South African Broadcasting Corporation (SABC), the national broadcaster.

22 'Ukuguqula iBatyi' translates to 'the pencil test', a demeaning racial identity test employed during apartheid, whereby a pencil or pen would be inserted into the hair of a person whose racial group was deemed uncertain.

23 Berni Searle, Penny Siopis, Sue Williamson, Tracey Rose and William Kentridge, among many others.

Lagos 164–189

1 Odia Ofeimun, ed., 'Preface', *Lagos of the Poets*, Hornbill House of the Arts, Ikeja, Lagos, 2010, p. xxiii.

2 For an introduction to the modern cultural history of Lagos, see Okwui Enwezor, 'Lagos in the Culture of Twentieth- Century Modernity' in Iwona Blazwick, ed., *Century City: Art and Culture in the Modern Metropolis*, Tate Gallery, London, 2001; and Olu Oguibe's essay 'Twin Capitals of Nascent Africa' in the same volume. For more in-depth history, see Weyinmi Atigbi and Olakunle Tejuoso, ed., *Lagos: A City at Work*, Glendora Books, Lagos, 2005; and John Godwin and Gillian Hopwood, *Sandback City: Lagos at 150*, Kachifo Limited, Lagos, 2012.

3 On the history of modern Nigerian art, see Chika Okeke-Agulu, 'The Quest for a Nigerian Art: Or a Story of Art from Zaria and Nsukka' in Olu Oguibe and Okwui Enwezor, ed., *Reading the Contemporary: African Art from Theory to the Marketplace*, Institute of International Visual Arts, London, 1999, pp. 144–165. See also Sylvester Ogbechie, *Ben Enwonwu: The Making of an African Modernist*, University of Rochester Press, Rochester, NY, 2008.

4 The ten participating artists in 'New Energies' (16–26 May 2001) were Joseph Eze, Chika Aneke, Chiamaka Ezeani, Chikaogwu Kanu, Martin Loriliam, Chidi Nnadi, Eramus Oniyishi, Nnenna Okore, Ozioma Onuzulike and Uchechukwu Onyishi. See El Anatsui, *New Energies: An Exhibition of Concepts, Media Processes and Gestures of Ten Young Artists*, Mydrim Gallery and Nimbus Art Centre, Lagos, 2001.

5 From 2009–11, the author was based in Lagos at the Centre for Contemporary Art.

6 For more on the exhibition, see Bisi Silva and Christine Eyene, *Like a Virgin: Lucy Azubuike & Zanele Muholi*, Centre for Contemporary Art, Lagos, 2009.

7 Featuring six local and six inter- national artists, it was accompanied by a seminal history of video art practice in Nigeria and West Africa, including a contribution by the late pioneering video and mixed media artist Goddy Leye. See Bisi Silva, ed., *Identity: An Imagined State*, Centre for Contemporary Art, Lagos, 2009.

8 See *Thirty Years of Exhibitions at the Goethe-Institut, Lagos, 1962–92*, Goethe-Institut, Lagos, Nigeria, 1992.

9 Devised by Emeka Udemba, the dynamic art projects *Lagos Open* (2005) and *In God We Trust* (2008) mobilized artists and art students to collaborate with members of the Ajengunle and Mushin communities to revamp neighbourhoods and churches. Engaging art beyond formal sites of creation and display, the projects elicited considerable dialogue concerning the civic responsibility of artists.

10 The founding members of Depth of Field were Kelechi Amadi Obi, Ty Bello, Uche James-Iroha and Amaize Ojeikere; later including Zaynab Toyosi Odunsi and Emeka Okereke. See Erin Haney, *Photography and Africa*, Reaktion Books, London, 2010, pp. 160–61. See also Brian Dillon, 'Depth of Field – South London Gallery', *Frieze*, issue 91, May 2005, p. 125.

11 The Black Box photo collective formed after the Goethe Institut workshop 'Soccer Worlds', led by Berlin-based Nigerian photographer Akinbode Akinyibi. Its members include Chiemela Azurunwa, Andrew Esiebo, Mary Kassim, Uche Okpa- Iroha, Adeniyi Odeleye, Abraham Oghobase, Charles Okereke, Charles Ologeh and Chidinma Nnorom.

12 Core group members include Nike Adesuyi-Ojeikere, Kemi Akin-Nibosun, Lucy Azubuike, Emmanuel Iduma, Uche James-Iroha, Ala Khier, Chidinma Nnorom, Nana Oforiatta-Ayim, Amaize Ojeikere, Emeka Okereke, Charles Okereke, Ray-Daniels Okeugo, Uche Okpa-Iroha, Tom Saater and Jumoke Sanwo.

13 Work by the Bunguru Collective was shown in the exhibition 'Fresh Vernacular' (2012), curated by artist Mudi Yahaya at Signature Gallery, Lagos.

14 E-mail correspondence with the author, October 2012.

San Juan 190–215

1 Coincidentally, El Museo del Barrio founder Raphael Montañez Ortiz is a first-generation American of Puerto Rican heritage.

2 E-mail correspondence with the author, July 2012.

São Paulo 216–241

1 The gallery, founded in 1992 by dealer Marcantonio Vilaça and his business partner Karla Meneghel, was formerly known as Camargo Vilaça. Vilaça died in 2000, and in 2002, under the direction of Alessandra D'Aloia and Márcia Fortes, the name was changed to Fortes Vilaça.

2 From the artist's statement for the travelling exhibition 'Videobrasil On Tour 2012–13'.

3 *Folha da Manhã – São Paulo*, 26 December 1953.

Seoul 242–267

1 From an interview with the Korean cultural webzine *Culppy*, 2004

2 Hodeuk Kim interviewed by Bog-gi Kim, *Art in Culture*, July 2008, pp. 134–43.

3 Okin Collective, 'The Manifesto Has Been Delayed: What Makes Us Stay Together?' in *Okin Collective*, Workroom Press, Seoul, 2012, p. 14.

Singapore 268–293

1 See William Gibson, 'Disneyland with the Death Penalty', *Wired*, no. 1.04, September–October 1993; and Rem Koolhaas, 'Singapore, Portrait of a Potemkin Metropolis, Songlines… or Thirty Years of Tabula Rasa', in Rem Koolhaas and Bruce Mau, *S, M, L, XL*, Monacelli Press, New York, 1995, p. 1011.

2 Controversy surrounded performances that took place during the Artists' General Assembly at the end of 1993, an event jointly organized by two collectives: 5th Passage and The Artists Village. As a result, the National Arts Council condemned the works and suspended funding for performance art. Legislation was passed requiring a license for all performances to be presented in public, which also stipulated that a script be pre- approved by police authorities. These restrictions were only eased at the end of 2003.

3 See Susie Lingham, 'Art and Censorship in Singapore: Catch 22?', *ArtAsiaPacific*, November– December 2011.

4 The Substation provided critical and developmental space for interdisciplinary art practice, fostering much of the experimental and collaborative work between visual artists, musicians and per-forming artists, that was characteristic of the art scene at the time.

5 Educated in London and influenced by the work of Joseph Beuys, Tang Da Wu established The Artists Village in Singapore in 1988 with other like-minded artists such as Vincent Leow, Lee Wen and Amanda Heng, who had trained in Europe and the United States. Their performance- and installation-based practices, which were inspired to some extent by European and American conceptual and performance art of the 1970s, are widely acknowledged as the roots of contemporary art practice in Singapore. See *The Artists Village: 20 Years On*, Singapore Art Museum, 2009.

Vancouver 294–319

1 Vancouver is third on *The Economist*'s 2012 Livability Ranking and Overview.

2 Canada's Aboriginal populations who are neither Inuit nor Métis.

3 While in a taxi to the airport after his 1976 exhibition at Ace Gallery, Andy Warhol wrote: 'Nobody in Vancouver buys art … they're not interested in painting.' Andy Warhol and Pat Hackett, *The Andy Warhol Diaries*, Warner Books, New York, 1989.

4 BLOUIN ARTINFO Canada, 10 December 2012, ca.blouinartinfo. com.

5 Spuzzum, a small British Columbia town north of Vancouver, was recently vilified for its 'ugly native-sounding' name, during a public debate on the proposed renaming of Stanley Park to Xwayxway. In contrast, the 2010 rechristening of the Queen Charlotte Islands as Haida Gwaii was deemed 'beautiful' in local news reports.

6 E-mail exchange with the author, August 2010.

7 See 'Correspondence: an interview with Paul Kajandar' in *Isabelle Pauwels*, Jonah Gray and Helga Pakasaar (ed.), Presentation House Gallery, Vancouver, 2013, p. 36.

8 Royal Navy Officer John Franklin's expedition departed for the Northwest Passage in 1845, never to return. His vessels have yet to be recovered.

Halil Altındere
born 1971 in Mardin, Turkey

Solo Exhibitions: 2013 'Halil Altındere', CA2M, Madrid, ES • 2012 'Infinity has no Accent', Tanas, Berlin, DE • 2011 'If I Can't Dance it's Not My Revolution', Pilot Galeri, Istanbul, TR • 2008 'I am Not Sure if This is an Exhibition', Yapı Kredi Kazım Taşkent Gallery, Istanbul, TR

Group Exhibitions: 2013 'Signs Taken in Wonder', MAK, Vienna, AT • 2012 'Dear Art', Museum of Contemporary Art Metelkova, Ljubljana, SI • 2011 'The Global Contemporary: Art Worlds After 1989', ZKM, Karlsruhe, DE; 'Streetwise', Chelsea Art Museum, New York, USA; 'Miragens', Centro Cultural Banco do Brasil, Rio de Janeiro, BR • 2010 'Second Exhibition', Arter, Istanbul, TR; 'Not Easy to Save the World in 90 Days', Tanas, Berlin, DE and 44 Moen, Askeby, DK • 2009 Sharjah Biennial 9, Sharjah, UAE; 'Dream and Reality', Zentrum Paul Klee, Bern, CH; 'Socially Disorganized', Experimental Art Foundation, Adelaide, AU • 2007 Documenta 12, Kassel, DE

Song-Ming Ang
born 1980 in Singapore

Solo Exhibitions: 2012 'Cover Versions', Future Perfect, Singapore and Künstlerhaus Bethanien, Berlin, DE; 'Guilty Pleasures', Spring Workshop, Hong Kong, CN • 2011 'Sonic Visions', The Substation, Singapore • 2010 'You and I', SoundFjord, London, UK

Group Exhibitions: 2013 'Singapore Platform', Art Stage Singapore • 2012 'We Notice No Disturbances', Kunstverein Göttingen, Göttingen, DE; 'Panorama: Recent Art from Contemporary Asia', Singapore Art Museum, Singapore • 2011 'Spectator', In Transit Festival, Haus der Kulturen der Welt, Berlin, DE; 3rd Singapore Biennial, Singapore; 'I Want to Remember', Singapore Arts Festival, Singapore • 2010 'John Cage', SCHUNCK, Heerlen, NL; Sovereign Asian Art Prize, Artspace@HeluTrans, Singapore

Don J. Cohn, 'Where I Work: Song-Ming Ang', ArtAsia Pacific, no. 79, July 2012.
Deepika Shetty, 'In Tune with Art', The Straits Times, 26 April 2012.

Ziad Antar
born 1978 in Saida, Lebanon

Group Exhibitions: 2012 'Portrait of Territory', Sharjah Art Foundation, Sharjah, UAE; 'Intense Proximity', Paris Triennial, Palais de Tokyo, Paris, FR • 2011 'Blockbuster: Cinema for Exhibitions', MARCO, Monterrey, MX; 54th Venice Biennale, Venice, IT; 'Live Cinema/In the Round', Philadelphia Museum of Art, Philadelphia, USA • 2010 'Morality: Act V', Witte de With, Rotterdam, NL; Trust: Media City Seoul, Seoul, KR • 2009 Prospectif Cinéma, Centre Pompidou, Paris, FR; 'Younger Than Jesus', 1st New Museum Triennial, New Museum, New York, USA; Sharjah Biennial 9, Sharjah, UAE • 2008 6th Taipei Biennial, Taipei, ROC

Andrew Pulver, 'Photographer Ziad Antar's Best Shot' The Guardian, March 2011.
Jim Quilty, 'Pictures From the Anti-archive', The Daily Star, March 2011 .
Kaelen Wilson-Goldie, 'Goal', Bidoun, #13, December 2010.

Marwa Arsanios
born 1978 in Washington, DC, USA

Group Exhibitions: 2013 Home Works VI, Beirut, Lebanon; Rotterdam Film Festival, Rotterdam, NL; 'Angels of History', ENSBA, Paris, FR; 'Selling Snails in the Muslim Neighborhood', Westfälischer Kunstverein, Münster, DE • 2012

'Future Generation Art Prize 2012', Pinchuk Art Centre, Kiev, UA; 'Paper Scissors Feet', Wild West, Maastricht, NL; 'Three Artists Walk Into a Bar', De Appel, Amsterdam, NL; 'Subversion', Cornerhouse, Manchester, UK; 'In Other Words', NGBK, Berlin, DE • 2011 12th Istanbul Biennial, Istanbul, TR; 'Bidoun Art Park', Art Dubai, Dubai, UAE; 'There Are No Ruins Here' Villa Romana, Florence, IT • 2010 Rio de Janeiro Short Film Festival, Rio de Janeiro, BR

Jelili Atiku
born 1968 in Lagos, Nigeria

Performances: 2012 Where is Jelili Atiku?, with Lan Hungh, Lagos, NG and Berlin, DE; +++=+ (In The Red Series #14), with Grace Morgan Pardo, Tate Modern, London, UK; Cain's Feast and Abel's Feast (The Feast Series), Yaoundé, CM • 2011 RED uctio AD AB surdum (In The Red Series #11), Lome, TG • 2009 Agbo Rago, Ejigbo Ram Market, Lagos, NG; Red Entangle (In The Red Series #08), Big Sight, Ariake, Tokyo, JP • 2008 Red Mummy in Sabo (In The Red Series #02), Sabo Bus Stop, Lagos, NG • 2004 Shadows in the Dark, National Museum, Onikan, Lagos, NG

Group Exhibitions: 2011 'Do Not Resuscitate', Freedom Park, Lagos, NG; 'A Kilo of Hope', Yusuf Grillo Gallery, Lagos, NG • 2010 'On Independence and the Ambivalence of Promise', CCA, Lagos, NG • 2009 'Old News #6', Den Frie, Copenhagen, DK, CCA, Lagos, NG and Malmö Konsthall, SE; 2nd African Regional Summit and Exhibition on Visual Arts, Abuja, NG; 19th International Video Art Festival, Casablanca, MA

Sally O'Reilly, 'Actions Speak Louder', Tate Etc., no. 25, Summer 2012, p. 67.
McPhillips Nwachukwu, 'Protest Art and Removal of Fuel Subsidy', Vanguard, 19 January 2012, p. 38.

Alberto Baraya
born 1968 in Bogotá, Colombia

Solo Exhibitions: 2013 'Border Plantings', Australian Experimental Art Foundation, Adelaide, AU • 2010 'Expedition Nova Brasiliensis', Nara Roesler Gallery, São Paulo, BR • 2009 'Expedition to N. Z.', Grovett-Brewster Contemporary Art Museum, NZ • 2003 'Herbario de plantas artificiales', MAMBO, Bogotá, CO • 2001 'Expedition Europeen, une tokyoram, Palais de Tokyo, Paris, FR

Group Exhibitions: 2013 'The Hunter and the Factory', Fundación Colección Jumex, Ecatepec, MX • 2009 53rd Venice Biennale, Venice, IT • 2007 'Displaced: Contemporary Art From Colombia', Glynn Vivian Art Gallery, Swansea, UK • 2006 27th São Paulo Biennial, São Paulo, BR • 2005 'Global Tour' W139, Amsterdam, NL

Ivón Pini, 'Reflexiones en torno a la ficción', ArtNexus, no. 112, September 2007.
José Roca, 'Alberto Baraya', Frieze, no. 108, June 2007.

Marius Bercea
born 1979 in Cluj, Romania

Solo Exhibitions: 2012 'Concrete Gardens', François Ghebaly Gallery, Los Angeles, USA • 2011 'Remains of Tomorrow', Blain Southern, London, UK • 2010 'Qui Vivra Verra', François Ghebaly Gallery, Los Angeles, USA • 2008 'Shorn Lambs Fall Behind', Mie Lefever Gallery, Ghent, BE

Group Exhibitions: 2012 'European Travellers', Kunsthalle Budapest, Budapest, HU • 2011 'Selektionseffekte', Blain Southern, Berlin, DE • 2010 'No New Thing Under the Sun', Royal Academy, London, UK • 2009 4th Prague Biennial, Prague, CZ • 2008 '15 Hungarian and Romanian Painters', Plan B Gallery, Cluj, RO

Rebecca Wright, 'Marius Bercea', Studio International, 10 October 2011.
Martha Schwendener, '18 Journeys Forged in Communism', The New York Times, 14 January 2010.
Marie Maertens, 'L'ecole de Cluj', Artpress, no. 365, March 2010, p. 58–64.

Zander Blom
born 1982 in Pretoria, South Africa

Solo Exhibitions: 2011 'Place and Space', Pinnacle Gallery, Savannah, USA; 'New Paintings', Stevenson, Johannesburg and Stevenson, Cape Town, ZA • 2010 'The Black Hole Universe', Galerie van der Mieden, Antwerp, BE; 'Paintings, Drawings, Photos', Stevenson, Cape Town, ZA

Group Exhibitions: 2011 'The Global Contemporary: Art Worlds After 1989', ZKM, Karlsruhe, DE; 'Geography of Somewhere', Stevenson, Johannesburg, ZA • 2010 'Ampersand', Daimler Contemporary, Berlin, DE • 2009 'Black', Blank Projects, Cape Town, ZA; 'Why Not?', Kuckei + Kuckei, Berlin, DE • 2008 'ZA: Young Art From South Africa, Palazzo Delle Papesse, Siena, IT

Sean O'Toole, 'The Scavenger Artist', Financial Mail, 19 November 2010.
Mary Corrigall, 'Zander Blom at Gavin Rooke', Sunday Independent, 15 March 2009.

Raymond Boisjoly
born 1981 in Langley, Canada

Solo Exhibitions: 2012 'The Work That Work Leaves Undone', Forest City Gallery, London, CA; 'The Spirit of Inconstancy', Lawrimore Project, Seattle, USA • 2011 'Indirect Angles of Encounter with Textual Events', Fourteen30 Contemporary, Portland, USA; 'The Writing Lesson', Republic Gallery, Vancouver, CA • 2010 'The Ever-Changing Light', Access Gallery, Vancouver, CA

Group Exhibitions: 2012 'Tools for Conviviality', The Power Plant, Toronto, CA; 'Phantasmagoria', Presentation House Gallery, North Vancouver, CA; 'Beat Nation', Vancouver Art Gallery, Vancouver, CA; 'Devouring Time', Western Bridge, Seattle, USA • 2011 'Studies in Decay', Or Gallery, Vancouver, CA • 2009 'The Secret of the Ninth Planet', Photo Epicenter, San Francisco, USA • 2008 'The Sooner The Better Late Than Never', Morris and Helen Belkin Art Gallery, Vancouver, CA; 'Being There and Elsewhere', Organ Gallery, Chongqing, CN

Henry Adam Svec, 'To Haunt All That Might Yet Come To Be', The Work That Work Leaves Undone, Forest City Gallery, Vancouver, 2012.
Jonah Gray, Raymond Boisjoly, Jordy Hamilton, Laura Piasta: Studies in Decay, Or Gallery, Vancouver, 2011.

Dineo Seshee Bopape
born 1981 in Polokwane, South Africa

Solo Exhibitions: 2011 'lešobana!! lešobana! lešobana!! (le bulegile); lešobana! lešobana! lešobana!! (go phunyegile)', Stevenson, Johannesburg, ZA • 2010 'long live the immaterial...effect no.55', Mart House Gallery, Amsterdam, NL; 'the eclipse will not be visible to the naked eye', Stevenson, Cape Town, ZA • 2008 'love strung', KZNSA Gallery, Durban, ZA

Group Exhibitions: 2013 'The Beautyful Ones', Nolan Judin, Berlin, DE • 2012 'The Progress of Love', The Menil Collection, Houston, USA; 'De Menocchio, nous savons beaucoup de choses', Betonsalon, Paris, FR • 2010 'Morality: Act IV', Witte De With, Rotterdam, NL; 'Derangement', CCS Bard, Annandale-on-Hudson, USA • 2009 'Rebelle', Museum Voor Moderne Kunst, Arnhem, NL; 'Younger Than Jesus', 1st New Museum Triennial, New Museum, New York, USA

Sandra Spijkerman, 'Identity Questioned, Story Rewritten', *Kunstbeeld*, no. 09, 2010.
Kathleen Massara, 'Detritus and Drawings', *The Brooklyn Rail*, April 2009.
Lauren Cornell, Massimiliano Gioni and Laura Hoptman, ed., *Younger Than Jesus: Artist Directory*, New Museum and Phaidon Press, New York and London, 2009.

Mihuţ Boşcu Kafchin
born 1986 in Cluj, Romania

Solo Exhibitions: 2013 'Il Clouds', Gaudel de Stampa Gallery, Paris, FR • 2011 'A Prologue to Vanity and Self-Adoration', Sabot Gallery, Cluj, RO • 2010 'How It's Made', Laika, Cluj, RO • 2009 'Long Gone Future', National Museum of Art, Cluj, RO

Group Exhibitions: 2012 'Intense Proximity', Paris Triennial, Palais de Tokyo, Paris, FR; 'European Travellers', Kunsthalle Budapest, Budapest, HU; 'New Nomenclature', Pies Gallery, Poznań, PL • 2011 Walter Koschatzky Exhibition, MuMoK, Vienna, AT; 'BERLIN SHOW #3: Glimpse', Plan B gallery, Berlin, DE

Ciprian Mureşan, 'The Paintbrush Factory: Snapshot (Diapositives from One Year of Existence)', *IDEA arts + society*, no. 35, 2010, pp. 36–7.
Bogdan Iacob, 'Offline', *Critical Texts*, LIMES, Cluj, 2010.

Răzvan Botiş
born 1984 in Brasov, Romania

Solo Exhibitions: 2011 'Diamonds for Everybody', Andreiana Mihail Gallery, Bucharest, RO; 'Trying to Purchase What I Once Wanted to Forget', Krinzinger Projekte, Vienna, AT • 2010 'The Idiot', Center for Visual Introspection, Bucharest, RO • 2009 'The Hill Was a Mountain', Andreiana Mihail Galley, Bucharest, RO

Group Exhibitions: 2012 'European Travellers', Kunsthalle Budapest, Budapest, HU • 2011 'Eight Works and a Half', Salonul de Proiecte, Bucharest, RO; 'Here and Then', Club Electroputere, Craiova, RO; 'Art from Bosnia and Herzegovina, Georgia and Romania', ArtPoint Gallery, Vienna, AT 2010 • 'Crossing Limits', Lust Gallery, Vienna, AT • 2009 'Invisible Body Conspicuous Mind', Luckman Gallery, Los Angeles, USA; 'Young Romanian Art', Romanian Cultural Institute, Venice, IT • 2008 'A Starting Point', Zendai Museum of Modern Art, Shanghai, CN

Raluca Voinea, *When Absence is Breathing*, Krinzinger Projekte, Vienna, 2011.
Ciprian Muresan, 'One Way', *IDEA arts + society*, no. 39, 2011.

Rebecca Brewer
born 1983 in Tokyo, Japan

Solo Exhibitions: 2012 'Nine Paintings of Ayn Rand', Exercise, Vancouver, CA • 2009 'Path to the Oracle', Galerie Werner Whitman, Montreal, CA • 2007 'Over and Over the Hills', Helen Pitt Artist Run Centre, Vancouver, CA

Group Exhibitions: 2012 'Through a Glass Darkly', Vancouver Art Gallery, Vancouver, CA • 2011 RBC Canadian Painting Competition, The Power Plant, Toronto, CA; 'Some Paintings', Equinox Gallery, Vancouver, CA • 2010 'Reoccurence: Serial Motifs', Helen Pitt Artist Run Centre, Vancouver, CA • 2009 'Take Your Time', Simon Fraser University Gallery, Burnaby, CA; 'The Unreal', Gallery Atsui, Vancouver, CA • 2008 'Works of Art With the Minimum of Steel', GAM, Mexico City, MX

Marshe Lederman, 'Vancouver's Rebecca Brewer Wins RBC Painting Prize', *Globe and Mail*, 28 September 2010.

Emmy Lee and Stephanie Rebick, *Reoccurence: Serial Motifs*, Helen Pitt Gallery, Vancouver, 2010.

Johanna Calle
born 1965 in Bogotá, Colombia

Solo Exhibitions: 2012 'Irregular Hexagon: Colombian Art in Residence', Sàn Art, Ho Chi Minh City, VN; 'Perimeters', Marilia Radzuk Gallery, São Paulo, BR • 2011 'Submergentes', Museum of Latin American Art Project Room, Long Beach USA; 'Signs', Casas Riegner, Bogotá, CO • 2008 'Political Variations of The Line', Teorética, San Jose, CR

Group Exhibitions: 2013 'Drawing and Language', Drawing Room, London, UK • 2012 'When Attitudes Became Form Become Attitudes', CCA Wattis Institute, San Francisco, USA • 2011 12th Istanbul Biennial, Istanbul, TR • 2009 7th Mercosul Biennial, Porto Alegre, BR; 'Artists and War II', North Dakota Museum of Art, USA

Marta Rodríguez, 'Johanna Calle', *ArtNexus*, Issue 84, March–May 2012.
Guido Hoyos, 'The Woman of Pandora's Box', *Cromos Magazine*, no. 4804, 2011, pp. 106–109.
Cecilia Fajardo-Hill, *La abstracción significativa de Johanna Calle*, Editorial D'Ivini, Bogotá, 2010.
Natalia Gutiérrez, 'Johanna Calle: no, no, no que no y que no', *Arte al Día*, no. 127, 2009.

Antonio Caro
born 1950 in Bogotá, Colombia

Solo Exhibitions: 2012 'En Maco todo esta muy caro', Zona Maco Sur, Mexico City, MX • 2010 'Antes de Cuiabá', Galería Casas Riegner, Bogotá, CO • 2008 'Antonio Caro', Museo Antropológico y de Arte Contemporáneo, Guayaquil, EC • 2007 'CARO: es de todos', Alianza Francesa, Cali, CO • 2002 'Todo está muy Caro: Retrospective 1970–2002', Museo de La Ciudad, Quito, EC and Museo de Arte Moderno La Tertulia, Cali, CO

Group Exhibitions: 2012 'El Reverso del Pedestal', R & M Galería, Cali, CO • 2011 'Crisisss: Ameríca Latina, arte y confrontación 1910–2010', Museo de Palacio de Bellas Artes, Mexico City, MX • 2007 Encuentro Internacional Medellín, Medellín, CO • 2004 Trienal de Puerto Rico, San Juan, PR • 2000 'Define "Context"', apexart, New York, USA

Aslı Çavuşoğlu
born 1982 in Istanbul, Turkey

Solo Exhibitions: 2010 'How I Travelled Around the World', Galeri Non, Istanbul, TR • 2006 'The Magnificent Seven', Kargart, Istanbul, TR

Group Exhibitions: 2012 Frieze Projects, London, UK; 'Turkish Art Nice and Superb', Tanas, Berlin, DE; 11th Baltic Triennial of International Art, Vilnius, LT; 'Soundworks', ICA, London, UK • 2011 Performa 11, New York, USA; 'Seven New Works', Borusan Contemporary, Istanbul, TR • 2010 'December the 13th', DKM, Diyarbakr, TR; 'When Ideas Become Crime', Depo, Istanbul, TR; 'The Tourist Syndrome', NGBK and Kunstraum Bethanien, Berlin, DE; 'Fantasy & Island', Frac Corse, Corsica, FR • 2009 'This Place You See Has No Size At All', Kadist Art Foundation, Paris, FR; 'Interferencia', Museum of Health Sciences, Bogotá, CO; 'End-game', Alternative Space Loop, Seoul, KR

Ali Cherri
born 1976 in Beirut, Lebanon

Solo Exhibitions: 2012 'Bad Bad Images', Galerie Imane Farès, Paris, FR • 2011 'A fleur de peau', Galerie Regard Sud, Lyon, FR

Group Exhibitions: 2012 'Dégagements: La Tunisie un an après', Institut du Monde Arabe, Paris, FR; 41st Rotterdam International Film Festival, Rotterdam, NL • 2011 17th SESC VideoBrasil, São Paolo, BR; Beyrouth ô Beyrouth', Centre Pompidou, Paris, FR; 'Exposure', Beirut Art Center, Beirut, LB; 'Beirut', Kunsthalle Wien, Vienna, AT • 2010 'Workspaces', The Delfina Foundation, London, UK • 2009 'A Fantasy For Allan Kaprow', Contemporary Image Collective, Cairo, EG • 2008 Home Works IV, Beirut, LB • 2007 Lebanese Pavilion, 52nd Venice Biennale, Venice, IT • 2006 'Out of Beirut', Modern Art Oxford, Oxford, UK

Hyun A Cho
born 1974 in Seoul, Korea

Solo Exhibitions: 2009 'Melancholic Mélange', Gallery Ssamzie, Seoul, KR • 2007 'Collecting In-between Spaces', Asia House, London, UK

Group Exhibitions: 2012 'Fiction Walk', National Museum of Contemporary Art, Seoul, KR • 2011 'RCA Secret', Royal College of Art, London, UK • 2010 'The Soul Travels at the Pace of a Camel', IMART Gallery, Seoul, KR • 2007 'The Man Group Photography Award', Royal College of Art, London, UK

Heman Chong
born 1977 in Muar, Malaysia

Solo Exhibitions: 2012 'Advanced Studies in… (Ten Lessons for Life)', SOTA Gallery, Singapore; 'Interview(s)', with Anthony Marcellini, Wilkinson Gallery, London, UK; 'LEM1', Rossi & Rossi, London, UK • 2011 'Calendars (2020–2096)', NUS Museum, Singapore • 2007 'Common People and Other Stories', Art In General, New York, USA; 'The Sole Proprietor and Other Stories', Vitamin Creative Space, Guangzhou, CN

Group Exhibitions: 2012 7th Asia Pacific Triennial, Queensland Art Gallery, Brisbane, AU • 2011 6th Nordic Biennial of Contemporary Art, Moss, NO; Performa 11, New York, USA • 2010 Manifesta 8, Murcia, ES • 2008 Singapore Biennial, Singapore; 'A Question of Evidence', Thyssen-Bornemisza Art Contemporary, Vienna, AT • 2003 Singapore Pavilion, 50th Venice Biennale, Venice, IT

Vivian Rehberg, 'Heman Chong', *Frieze*, no. 145, February 2012.
Rike Frank, 'Like an Attali Report, but Different', *Art-forum*, vol. 47, no. 3, November 2008.
Claudia La Rocco, 'People Who Mistook Life for a Museum and Vice Versa', *The New York Times*, 8 Nov-ember 2011.

Marcelo Cidade
born 1979 in São Paulo, Brazil

Solo Exhibitions: 2012 'Quase Nada', Galeria Vermelho, São Paulo, BR • 2010 'Avant-Garde is Not Dead', Galeria Vermelho, São Paulo, BR • 2009 'Vamos falar senhor fantasma', Fundação Serralves, Porto, PT; 'Norms, Patterns, Systems', Galerie Motte et Rouart, Paris, FR

Group Exhibitions: 2012 'O retorno da coleção Tamagni', MAM-SP, São Paulo, BR • 2011 8th Mercosul Biennal, Porto Alegre, BR; 'The Natural Order of Things', Max Wigram Gallery, London, UK • 2010 'Paraser Construídos', MUSAC, Léon, ES; XIV Sculpture Biennial of Carrara, Carrara, IT • 2009 'After Utopia', Museo Centro Pecci, Prato, IT • 2008 'An Unruly History of the Readymade', Jumex Collection, Mexico City, MX • 2007 'Whenever It Starts It Is The Right Time', Frankfurter Kunstverein, Frankfurt, DE

Santiago B. Olmo, 'A Kit Model', *ARTECONTEXTO*, November 2010.

Jessica Morgan, 'Marcelo Cidade', *ArtReview*, no. 20, March 2008, p. 88.

Adriano Costa
born 1975 in São Paulo, Brazil

Solo Exhibitions: 2012 'Crisis Doesn't Matter If You Love Me', Galeria Nuno Centeno, Porto, PR; 'Plantation', Mendes Wood, São Paulo, BR • 2010 CCSP, São Paulo, BR • 2009 'Black Barroco', Galeria Polinésia, São Paulo, BR

Group Exhibitions: 2013 'April', Sadie Coles HQ, London, UK • 2012 'Abre Alas 8', Galeria A Gentil Carioca, Rio de Janeiro, BR; 'Rumos Artes Visuais', Itaú Cultural, São Paulo, BR; '23°33'42"_46°40'09"', Galerie TORRI, Paris, FR • 2011 'Estou aqui', Galeria Marília Razuk, São Paulo, BR • 2011 'Mythologies', Cité Internationale des Arts, Paris, FR; 'Meditação, Transe', Mendes Wood, São Paulo, BR; 17th SESC VideoBrasil, São Paolo, BR • 2009 'Lo-Fi Kibbutz', Galeria Polinésia, São Paulo, BR • 2007 'Tropical Punk', Whitechapel Art Gallery, London, UK

Tony Cruz Pabón
born 1977 in Vega Alta, Puerto Rico

Solo Exhibitions: 2011 'Andamios', Casas Riegner, Bogotá, CO • 2008 'Tony Cruz', Luisa Strina Gallery, São Paulo, BR • 2005 'Diálogos', Espacio 1414, San Juan, PR

Group Exhibitions: 2012 3rd Poly/Graphic Triennial, San Juan, PR • 2011 'The Peripatetic School', Drawing Room, London, UK • 2010 'To Draw is to Write, to Write is to Draw', Casas Riegner, Bogotá, CO • 2009 'Acciones Disolventes', Centro de Cultural Chacao, Caracas, VE • 2008 'Hecho a mano, el oficio en el arte', Casas Riegner, Bogotá, CO

Micah Malone, 'Future Anterior', *Art Papers*, vol. 35, no. 6, November–December 2011, p. 44. Holland Cotter, 'Caribbean Visions of Tropical Pardise and Protest', *The New York Times*, 31 August 2007.

Andrew Dadson
born 1980 in White Rock, Canada

Solo Exhibitions: 2013 'Waited', David Kordansky Gallery, Los Angeles, USA • 2012 'The Brink', Henry Art Gallery, Seattle, USA • 2010 'New Paintings', Lawrimore Project, Seattle, USA • 2009 Galleria Franco Noero, Turin, IT • 2007 'Evening All Afternoon', Charles H. Scott Gallery, Vancouver, CA and Galleria Franco Noero, Turin, IT

Group Exhibitions: 2012 'Phantasmagoria', Presentation House Gallery, North Vancouver, CA; 'Again, Again and Again', The Vancouver Art Gallery, Vancouver, CA • 2011 'Everything You can Imagine is Real', Xavier Hufkens, Brussels, BE; 'Che cosa sono le nuvole?' Museion Bolzano, Bolzano, IT; 'Without You I'm Nothing', Museum of Contemporary Art Chicago, Chicago, USA • 2009 'Nothing to say and I am Saying it', Kunstverein Freiburg, Freiburg, DE

Monika Szewczyk, 'There is Something to Nothing Here', *Mousse Magazine*, no. 20, September 2009.

Valdirlei Dias Nunes
born 1969 in Bom Sucesso, Brazil

Solo Exhibitions: 2011 'Relevos', Casa Triângulo, São Paulo, BR • 2008 Casa Triângulo, São Paulo, BR • 2006 Galeria Luisa Strina, São Paulo, BR • 2005 'Pinturas Negras', Galeria Luisa Strina, São Paulo, BR

Group Exhibitions: 2012 'Cabinet of Curiosities', Espaço Coleção Particular, São Paulo, BR • 2011 'En Obras', Tenerife Esp-acio de las Artes, Tenerife, ES • 2009 31st Panorama of Brazilian Art, MAM-SP, São Paulo, BR;

'Nuevas Miradas', Galeria Fernando Pradilla, Madrid, ES • 2008 'MAM 60', OCA, São Paulo, BR • 2007 'Cabinet of Drawings', MAM-SP, São Paulo, BR

Agnaldo Farias, *80, 90: Modernos, Pós-modernos Etc...*, Instituto Tomie Ohtake, São Paulo, 2009, pp. 498–9.
Rodrigo Moura, 'Valdirlei Dias Nunes', *Flash Art International*, no. 250, October 2006, pp.125–6.

Anita Dube
born 1958 in Lucknow, India

Solo Exhibitions: 2013 'Offering', Lakeeren Gallery, Mumbai, IN • 2012 Galleria Marabini, Bologna, Italy • 2011 'Babel', Galerie Dominique Fiat, Paris, FR • 2008 'Recent Works', Bose Pacia Gallery, New York, USA • 2007 'Inside Out', Bombay Art Gallery, Mumbai, IN; 'Phantoms of Liberty', Almine Rech Gallery, Paris, FR

Group Exhibitions: 2013 'Difficult Loves', Kiran Nadar Museum of Art, Delhi, IN; 'Labyrinths', Dr. Bhau Daji Lad Museum and Lakeeren Gallery, Mumbai, IN • 2011 'Paris-Delhi-Bombay', Pompidou Centre, Paris, FR; 5th Prague Biennial, Prague, CZ; XI Jogja Biennial, Yogyakarta, ID • 2010 'Spiral Jetty', Nature Morte, Delhi, IN • 2009 'Beyond Globalization', Beyond Art Space, Beijing, CN; 3rd Moscow Biennial, Moscow, RU • 2003 'How Latitudes Become Forms', Walker Art Center, Minneapolis, USA

Cevdet Erek
born 1974 in Istanbul, Turkey

Solo Exhibitions: 2012 'Week', Kunsthalle Basel, Basel, CH • 2011 'Update', AKINCI, Amsterdam, NL

Group Exhibitions: 2012 Documenta 13, Kassel, DE; 'Ungovernables', 2nd New Museum Triennial', New Museum, New York, USA • 2011 12th Istanbul Biennial, Istanbul, TR; '…' with Ahmet Öğüt, Overgaden, Copenhagen, DK • 2010 'Tactics of Invisibility', TBA21, Vienna, AT, Arter, Istanbul, TR and Tanas, Berlin, DE • 2009 'El Ele', with Anna Boghiguian, Rodeo Gallery, Istanbul, TR • 2006 'Just In Time', Stedelijk Museum CS, Amsterdam, NL

Duygu Demir and Cevdet Erek, *Cevdet Erek: Room of Rhythms 1*, Verlag der Buchhandlung Walther König, Cologne, 2012.
Monika Szewczyk, 'The Changing Times: Cevdet Erek and Hannah Weinberger', *Afterall*, 21 March 2012.

Köken Ergun
born 1976 in Istanbul, Turkey

Solo Exhibitions: 2011 Kunsthalle Winterthur, Winterthur, CH • 2007 'Nightworkers', YAMA, Istanbul, TR

Group Exhibitions: 2013 'Former West', Haus der Kulturen der Welt, Berlin, DE • 2012 'Intense Proximity', Paris Triennial, Palais de Tokyo, Paris, FR; 'About Stupidity', Petach Tikva Museum of Art, Petach Tikva, IL; 'Asymmetric Europe', MoCAV, Novi Sad, CS • 2011 'Based in Berlin', Atelierhaus Monbijoupark, Berlin, DE; 'Labor & Leisure', Wyspa Institute of Art, Gdansk, PL • 2010 'Politics of Art', National Museum of Contemporary Art, Athens, GR • 2009 'Not Easy to Save the World in 90 Days', Tanas, Berlin, DE; 'Istanbul Traverseé', Palais des Beaux Arts, Lille, FR • 2008 'Soft Manipulation', Casino Luxembourg, LU

Oliver Kielmayer, We are All Beautiful, *Flash Art International*, no. 284, May–June 2012.

Esra Ersen
born 1970 in Ankara, Turkey

Solo Exhibitions: 2013 Richmond Art Gallery, Richmond, CA • 2009 'Passengers', Tanas, Berlin, DE and Kâzım

Taşkent Gallery, Istanbul, TR • 2008 'Perfect: Growing Older (Dis)Gracefully', Rahn Contemporary, Zürich, CH • 2007 'Elsewhere', Kunsthaus Baselland, Basel, CH • 2006 'Ist das Leben nicht schön?', Frankfurter Kunstverein, Frankfurt, DE

Group Exhibitions: 2011 'Seven New Works', Borusan Contemporary, Istanbul, TR • 2010 'Tactics of Invisibility', TBA21, Vienna, AT, Arter, Istanbul, TR and Tanas, Berlin, DE • 2009 'Tarjama/Translation', Queens Museum of Art, New York, USA • 2008 'Personal Protocols and Other Preferences', CCS Bard, Annandale-on-Hudson, USA • 2006 27th São Paulo Biennial, São Paulo, BR; 4th Liverpool Biennial, Liverpool, UK

H. G. Masters, 'Esra Ersen: Empathy Machine', *ArtAsiaPacific*, September–October 2012, vol. 80, pp. 110–21.
Jörg Heiser, 'The Most Important Thing is to Make Decisions Together', *Esra Ersen*, Yapi Kredi Publications, Istanbul, 2011.

María Elvira Escallón
born 1954 in London, United Kingdom

Solo Exhibitions: 2012 'Urgencias', Museo de Arte Universidad Nacional, Bogotá, CO • 2007 'En estado de coma', Museo de Bogotá, Bogotá, CO • 2004 'Desde adentro', Galería Alcuadrado, Bogotá, CO • 2003 'Nuevas Floras', Planetario Distrital, Bogotá, CO

Group Exhibitions: 2012 'Click or Clash: Strategies of Collaboration', Galeria Bianconni, Milan, IT • 2011 8th Mercosul Biennial, Porto Alegre, BR • 2010 'Ciudadanas', Centenario Museo del Chopo, Mexico City, MX; 'Crónica, 1995–2005', Museo de Arte Moderno de Medellín, CO • 2009 10th Havana Biennial, Havana, CU • 2008 'Once More With Feeling', The Photographer's Gallery, London, UK; 'Sin remedio', Galería Alcuadrado, Bogotá, CO

Diego Garzón, *De lo que somos: 110 obras para acercarse al arte contemporáneo colombiano*, Lunwerg Editores, Barcelona, 2011.
Carmen María Jaramillo, *En estado de coma*, Instituto Distrital de Patrimonio Cultural, Bogotá, 2009.

Andrew Esiebo
born 1978 in Lagos, Nigeria

Solo Exhibitions: 2012 'Na God', Palazzo Moroni, Padova, IT • 2008 'For the Love of It', Thought Pyramid Gallery, Abuja, NG

Group Exhibitions: 2012 11th Havana Biennial, Havana, CU; 'Moving into Space', National Football Musem, Manchester, UK • 2011 Photoqaui Biennial, Musée du Quai Branly, Paris, FR; 'Beyond Football', Goethe Institut, Lagos, NG; 'Sharon Stone in Abuja', Location One Gallery, New York, USA • 2010 29th São Paulo Biennial, São Paulo, BR • 2009 8th African Photography Encounters Biennial, Bamako, ML; Chobi Mela V Photography Festival, Dhaka, BD • 2007 14th Noorderlicht Photofestival, Groningen, NL

Jane Weeks, 'We Face Forward', *Museums Journal*, no. 112/09, September 2012, pp. 46–9.
Nana Ocran, 'A Cut Above', *Wings Magazine*, July–August 2012.

Julia Feyrer
born 1982 in Victoria, Canada

Solo Exhibitions: 2013 Walter Philips Gallery, Banff, CA; Johan Berggren Gallery, Malmö, SE • 2012 Catriona Jeffries, Vancouver, CA • 2011 'Irregular Time Signatures', Johan Berggren Gallery, Malmö, SE • 2010 'The Poodle Dog Ornamental Bar', Artspeak, Vancouver, CA

Group Exhibitions: 2012 'The Rotting Husk', Leonhardi Kultur Projekte, Frankfurt, DE; 'Phantasmagoria', Presentation House Gallery, North Vancouver, CA • 2011 'Children's Films', Bielefelder Kunstverein, Bielefeld, DE, Contemporary Art Gallery, Vancouver, CA and International Project Space, Birmingham, UK; 'The Problem of Nothing', Hayaka ARTI, Istanbul, TR • 2010 'Geschmacksverstärker', MMK Zollamt, Frankfurt, DE; Chilliwack Biennial, Or Gallery, Vancouver, CA; 'Happy Accidents', 381 Projects, Toronto, CA • 2008 'The Composition Kids', Access Artist Run Centre, Vancouver, CA

Radames 'Juni' Figueroa
born 1982 in San Juan, Puerto Rico

Solo Exhibitions: 2012 'Sal Si Puedes', Roberto Paradise, San Juan, PR • 2011 'Me tuviste enfrente y jamas me viste', Galeria Revolver, Lima, PE • 2010 'Escandalo Bar', Preteen Gallery, Mexico City, MX • 2006 'Chochi Bichi Loves la Rue', Galeria Comercial, San Juan, PR

Group Exhibitions: 2012 'Roberto Paradise', Josh Lilley Gallery, London, UK; 'Rat Piss Virus Give it to Me', Preteen Gallery, Mexico City, MX; 'Cave-In', Ramiken Crucible, New York, USA • 2011 1st Tropical Biennial, San Juan, PR; 'Paraiso', Roberto Paradise, San Juan, PR and ltd los angeles, Los Angeles, USA; 'Mayami son machine', Gallery Diet, Miami, USA • 2009 'It Ain't Fair', O.H.W.O.W. Gallery, Miami, USA

Carla Acevedo Yates, 'On la Loseta and la Bienal Tropical', *South Magazine*, no. 1, Summer 2012.
Pazmaker No. 10: By Means of Issue, June 2012.

Marcius Galan
born 1972 in Indianapolis, Indiana, USA

Solo Exhibitions: 2011 'Imóvel/Instável', Galeria Luisa Strina, São Paulo, BR • 2010 'Área Útil = Área Comum', Galeria Silvia Cintra + Box 4, Rio de Janeiro, BR • 2009 'Seção Diagonal', Galeria Box 4, Rio de Janeiro, BR • 2008 'Área Comum', Galeria Luisa Strina, São Paulo, BR; 'Geometria Informal', Galeria Pedro Cera, Lisbon, PT

Group Exhibitions: 2013 'Crossed Circuits' MAM-SP, São Paulo, BR; 'Blind Field', Krannert Art Museum, University of Illinois at Urbana-Champaign, Champaign, USA • 2012 'Repeat to Fade', Mendes Wood, São Paulo, BR; 'Planos de fuga', Centro Cultural Banco do Brasil, São Paulo, BR • 2011 'Mythologies', Cité Internationale des Arts, Paris, FR; 'En Obras', Tenerife Espacio de las Artes, Tenerife, ES; 8th Mercosul Biennial, Porto Alegre, BR • 2010 29th São Paulo Biennial, São Paulo, BR; 'Para ser Construidos', MUSAC, Léon, ES • 2008 'Color into Light', Museum of Fine Arts Huston, Houston, USA

Fernanda D'Agostino, 'Marcius Galan', *Flash Art International*, no. 260, May–June 2008.
Fabio Cypriano, 'Marcius Galan', *Frieze*, no. 115, May 2008, p. 168.

Adrian Ghenie
born 1977 in Baia Mare, Romania

Solo Exhibitions: 2013 'New Paintings', Pace Gallery, New York, USA • 2012 'Pie Fights and Pathos', Museum for Contemporary Art Denver, USA • 2011 Haunch of Venison, London, UK • 2010 S.M.A.K., Ghent, BE • 2009 National Museum of Contemporary Art, Bucharest, RO

Group Exhibitions: 2012 'Six Lines of Flight', SFMoMA, San Francisco, USA • 2011 'The World Belongs to You', Francois Pinault Collection, Palazzo Grassi Venice, IT; 'Communism Never Happened', Charim Galerie, Vienna, AT • 2010 'Romanian Cultural Resolution', Spinnerei, Leipzig, DE; 'The Crystal Hypothesis', GAMeC, Bergamo, IT • 2009 4th Prague Biennial, Prague, CZ

Jos Van den Bergh, 'Adrian Ghenie: SMAK', *Artforum International*, vol. 49, no. 7, March 2011.
Marie Maertens, 'L'ecole de Cluj', *Artpress*, no. 365, March 2010, pp.58–64.

Nilbar Güreş
born 1977 in Istanbul, Turkey

Solo Exhibitions: 2011 Rampa, Istanbul, TR; 'Self-Defloration', Künstlerhaus Stuttgart, Stuttgart, DE • 2010 'Unknown Sports: Indoor Exercises', Salzbuger Kunstverein, Salzburg, AT

Group Exhibitions: 2012 'Desiring the Real', Museum of Contemporary Art Belgrade, Belgrade, CS • 2010 6th Berlin Biennial, Berlin, DE; 'Where Do We Go From Here?', Secession, Vienna, AT; 'Tactics of Invisibility', TBA21, Vienna, AT, Arter, Istanbul, TR and Tanas, Berlin, DE • 2009 11th International Istanbul Biennial, Istanbul, TR

Nicholas Hlobo
born 1975 in Cape Town, South Africa

Solo Exhibitions: 2011 National Museum of Art, Architecture and Design, Oslo, NO • 2010 'Umtshotsho', Oliewenhuis Art Museum, Bloomfontein, Standard Bank Gallery, Johannesburg and Iziko South African National Gallery, Cape Town, ZA • 2008 'Uhambo', Level 2 Gallery, Tate Modern, London, UK; 'Momentum 11', ICA Boston, Boston, USA • 2007 'Umakadenethwa engenadyasi', Galeria Extraspazio, Rome, IT

Group Exhibitions: 2012 18th Sydney Biennial, Sydney, AU; 'Intense Proximity', Paris Triennial, Palais de Tokyo, Paris, FR • 2011 'The World Belongs To You', Palazzo Grassi, Venice, IT; 54th Venice Biennale, Venice, IT • 2010 6th Liverpool Biennial, Liverpool, UK; Future Generation Art Prize, Pinchuk Art Centre, Kiev, UA • 2009 'Dada South?', Iziko South African National Gallery, Cape Town, ZA; 10th Havana Biennial, Havana, CU

Hans Ulrich Obrist, 'Nicholas Hlobo: Writing in Space', *Flash Art International*, October 2012, pp. 86–9.
Lauren Dyer Amazeen, 'Nicholas Hlobo', *Artforum*, vol. 49, no. 2, October 2010, p. 291.

Ho Tzu Nyen
born 1976 in Singapore

Solo Exhibitions: 2012 MAM Project #16, Mori Art Museum, Tokyo, JP; 'The Cloud of Unknowing', Gillman Barracks, Singapore • 2011 Singapore Pavilion, 54th Venice Biennale, Venice, IT; 'Earth', Artspace, Sydney Arts Fest-ival, Sydney, AU • 2007 'The Bohemian Rhapsody Project', CACSA, Adelaide, AU • 2005 '4 × 4: Episodes of Singapore Art', Arts Central national television broadcast, Singapore • 2003 'Utama', The Substation, Singapore

Group Exhibitions: 2012 'Prompts and Triggers', Witte de With, Rotterdam, NL; New Frontier, Sundance Film Festival, Park City, USA • 2011 'The Grip', Kadist Foundation, Paris, FR • 2010 6th Liverpool Biennial, Liverpool, UK; 39th International Film Festival Rotterdam, Rotterdam, NL • 2009 6th Asia Pacific Triennial of Contemporary Art, Queensland, AU; Dojima River Biennial, Osaka, JP; 66th Venice International Film Festival, Venice, IT • 2007 'Soft Power', Zendai Museum of Modern Art, Shanghai, CN; 'Thermocline of Art: New Asian Waves', ZKM, Karlsruhe, DE

Karlo Andrei Ibarra
born 1982 in San Juan, Puerto Rico

Solo Exhibitions: 2012 'The Die is Cast', Area, Caguas, PR • 2011 'Until Victory Lies!', Rica Gallery, San Juan, PR • 2009 'Souvenir Stories', Photo Miami, Miami, USA

• 2007 'Each City Can be Another', Museo de Arte Contemporáneo, San Juan, PR

Group Exhibitions: 2012 'Novo Museo Tropical', Teorética, San José, CR; 3rd Poly/Graphic Triennial, San Juan, PR • 2011 6th Video Art Biennial, Museum of Contemporary Art and Design, San José, CR; Optic Nerve XIII, MOCA North Miami, Miami, USA; 'Patria Libertad!', Cobra Museum of Modern Art, Amsterdam, NL and MOCCA, Toronto, CA; 'Triangle CSC', Museum Ex-Teresa de Arte Actual, Mexico City, MX • 2010 'The Map: Critical Cartographies of the Present', Banco de la República, Bogotá and Museum of Modern Art, Medellín, CO; Biennial of the Americas, Denver, USA; 2nd Moscow Biennial, Moscow, RU • 2008 3rd Bucharest Biennial, Bucharest, RO

Leyra Gonzalez, 'Con la isla en una maleta', *El Nuevo Dia*, 20 July 2010.

Inder Salim
born 1965 in Kashmir

A mentor in the 'City as Studio' programme at Sarai/CSDS, Inder initiated Harkat@Sarai in 2011 to extend action-oriented performance art to students affiliated with different Delhi institutions and independent practitioners.

Grants and Projects: 2011 Kashmir.Points.Charlie (with Silke Kästner), Berlin, DE • 2010 Art Karavan International, Shantiniketan, Kolkata, Ranchi, Patna, Lucknow, Shimla, Jammu, Srinagar and Delhi, IN • 2006–07 Sarai Independent Research Fellowship

Amar Kanwar
born 1964 in New Delhi, India

Solo Exhibitions: 2013 Yorkshire Sculpture Park, Wakefield, UK • 2012 'Evidence', Fotomuseum Winterthur, Winterthur, CH • 2011 'A Love Story', Babel Art Space, Trondheim, NO • 2010 Marian Goodman Gallery, New York, USA • 2009 Filmhuis Den Haag, The Hague, NL • 2008 'The Torn First Pages', Haus der Kunst, Munich, DE and Stedelijk Museum, Amsterdam, NL • 2007 Whitechapel Art Gallery, London, UK

Group Exhibitions: 2013 Sharjah Biennial 11, Sharjah, UAE • 2012 Documenta 13, Kassel, DE; 1st Kochi Biennial, Kochi, IN; 'Being Singular Plural', Guggenheim Museum, New York, USA • 2011 'Paris-Delhi-Bombay', Pompidou Centre, Paris, FR; 'Artist Films', Singapore Art Museum, SG; 53rd October Salon, Belgrade, CS • 2008 'Indian Highway', Serpentine Gallery, London, UK

Gülsün Karamustafa
born 1946 in Ankara, Turkey

Solo Exhibitions: 2012 'The Apartment Building', National Museum of Contemporary Art, Athens, GR • 2011 'Etiquette', ifa Gallery, Berlin, DE; 'The Monument and the Child', Academy of Fine Arts, Vienna, AT • 2009 'Opening', Rodeo Gallery, Istanbul, TR • 2008 'Mobile Stages', Salzburger Kunstverein, Salzburg, AT; 'Bosphorus 1954', Kunstmuseum Bonn, Bonn, DE • 2007 'sineması/cinemasi', Kâzım Taşkent Gallery, Istanbul, TR

Group Exhibitions: 2012 1st Kiev Biennial, Kiev, UA • 2011 3rd Singapore Biennial, SG; 'Modern Essays 3', SALT Galata, Istanbul, TR • 2010 'Live Cinema/In the Round', Philadelphia Museum of Art, Philadelphia, USA • 2009 'Tarjama/Translation', Queens Museum of Art, New York, USA; 'Rebelle', Museum Voor Moderne Kunst, Arnhem, NL

Sabine Vogel, 'Die Zähmung des Orients', *Berliner Zeit-ung*, 7 May 2011.
Marek Bartelik, 'Gülsün Karamustafa', *Artforum*, vol. 43, February 2005, pp. 183–5.

Sonia Khurana
born 1968 in Saharanpur, India

Solo Exhibitions: 2009 Goethe-Institut, Delhi, IN; Studio Teresa Sapey, Madrid, ES • 2007 'Still Moving Image', Galerie Jousse Enterprise, Paris, FR • 2006 'The Performative Self', Apeejay Media Gallery, Delhi, IN • 2000 'Lone Women Don't Lie', British Council and Goethe-Institut, Delhi, IN

Group Exhibitions: 2012 'How am I?', Kastrupgård Collection, Copenhagen, DK and Lalit Kala Akademi, Delhi, IN; 'Re-picturing the Feminine', Kochi Biennial collateral event, Kochi, IN; 'Video Wednesday', Gallery Espace, Delhi, IN • 2011 'Your Name is Different There', Volte Gallery, Mumbai, IN; 'Paris-Delhi-Bombay', Pompidou Centre, Paris, FR; 'Artist Films', Singapore Art Museum, SG • 2010 6th Liverpool Biennial, Liverpool, UK; Aichi Triennial, Nagoya, JP; 'Where Three Dreams Cross', Whitechapel Gallery, London, UK • 2009 'Elles@Pompidou', Pompidou Centre, Paris, FR • 2008 7th Gwangju Biennial, Gwangju, KR; 'Global Feminisms', Brooklyn Museum, New York, USA

Hodeuk Kim
born 1950 in Daegu, Korea

Solo Exhibitions: 2012 Leeahn Gallery, Daegu and Seoul, KR • 2011 Gallery 604, Busan and Space Hongji, Seoul, KR • 2010 Bongsan Cultural Center, Daegu, KR • 2009 'Shaking, Suddenly I Feel the Space', Cyan Museum of Art, Yeongcheon, KR • 2008 Hakgojae Gallery, Seoul, KR • 2006 Gallery Bundo, Daegu, Korea • 2004 Dong San Bang Gallery, Seoul, KR; Chosun Ilbo Gallery, Seoul, KR

Group Exhibitions: 2010 'Mind Drawing', Gana Art Center, Seoul, KR • 2008 'True-view Landscape', Goyang Cultural Foundation, Aram Art Gallery, Goyang, KR • 2007 'Critical Perspective', INSA Art Center, Seoul, KR; 'Homage 100: Korea Modern Art 1970–2007', Korea Art Center, Busan, KR • 2006 'Drawn to Drawing', SOMA, Seoul, KR; 'The Scent of Korea', Daegu Culture & Arts Center, Daegu, KR • 2005 'Cool & Warm', Sungkok Museum, Seoul, KR, 'Beyond Repetition', Seoul Museum of Art, Seoul, KR • 2004 'Vent d'Est', Chapelle de la Sorbonne, Paris, FR

Runo Lagomarsino
born 1977 in Lund, Sweden

Solo Exhibitions: 2012 'Even Heroes Grow Old', Index, Stockholm, SE • 2011 'OtherWhere', Nils Stærk, Copenhagen, DK; 'Hay siempre un día mas lejos', Galeria Luisa Strina, São Paulo, BR; 'Trans Atlantic', Art Statements, Basel, CH • 2010 'Las Casas is Not a Home', Elastic, Malmö, SE

Group Exhibitions: 2012 30th São Paulo Biennial, São Paulo, BR; 7th Liverpool Biennial, Liverpool, UK • 2011 12th Istanbul Biennial, Istanbul, TR; Danish Pavilion, 54th Venice Biennale, Venice, IT; 5th Prague Biennial, Prague, CZ • 2010 'The Moderna Exhibition 2010', Museum of Modern Art, Stockholm, SE • 2009 'Report on Probability', Kunsthalle Basel, Basel, CH; 31st Panorama of Brazilian Art, MAM-SP, São Paulo, BR • 2008 'Try Again, Fail Again, Fail Better', Budapest Kunsthalle, Budapest, HU

Matthew Rana, 'Runo Lagomarsino', *Frieze*, no. 147, May 2012.
Cecilia Grönberg, 'En bok skriven med objekt', *Kunstkritikk.se*, 10 February 2012.

Miler Lagos
born 1973 in Bogotá, Colombia

Solo Exhibitions: 2012 'Arqueologia del Deseo', Galeria Enrique Guerrero, Mexico City, MX • 2011 'Home', Magnan Metz Gallery, New York, USA • 2010 'Harmonizing Forces', AB Projects, Toronto, CA • 2008 'El Papel lo Aguanta Todo', Nueveochenta Arte Contemporáneo, Bogotá, CO

Group Exhibitions: 2012 11th Havana Biennial, Havana, CU • 2011 'Sounds Good', Location One, New York, USA • 2010 Biennial of the Americas, Denver, USA; Philagrafika, Philadelphia, USA; 'Valparaíso: Intervenciones', Valparaíso, CL • 2009 'Everything Has a Name, or the Potential to be Named', Gasworks, London, UK; 2nd Poly/Graphic Triennial, San Juan, Puerto Rico

Yandro Miralles, 'Miler Lagos and the Key to Demolishing Appearances', *Arte al Día*, no. 137, December 2012.
Jaime Cerón, 'Miler Lagos', *Art Nexus*, September–November 2010.

Moshekwa Langa
born 1975 in Bakenberg, South Africa

Solo Exhibitions: 2013 'Counterpoint: Moshekwa Langa, In and Out of Africa', Krannert Art Museum, University of Illinois at Urbana-Champaign, Champaign, USA • 2012 'Ramokone', Goodman Gallery Johannesburg, ZA • 2011 'Marhumbini: In An Other Time', Kunsthalle Bern, Bern, CH • 2010 'Black Maria', Galerie Mikael Andersen, Copenhagen, DK

Group Exhibitions: 2011 11th Lyon Biennial, Lyon, FR • 2010 29th São Paulo Biennial, São Paulo, BR • 2009 53rd Venice Biennale, Venice, IT; 'Hypocrisy: The Site-specificity of Morality', The Museum of Contemporary Art, Oslo, NO

Peju Layiwola
born 1967 in Benin City, Nigeria

Solo Exhibitions: 2010 'Benin1897.com', University of Lagos, Lagos and University of Ibadan, Ibadan, NG • 2003 Mbari Mbayo Institute, Washington DC, USA; 'Of Bronzes and Prints', with Princess Elizabeth Olowu, Goethe-Institut, Lagos, NG

Group Exhibitions: 2006 'Not An Ocean Between Us', Diggs Gallery, Winston-Salem State University, Winston-Salem, USA • 2004 'African Art, African Voices', Philadelphia Museum of Art, PA, USA; 'Out of Bounds', University of New England Art Gallery, WestbrookCollege, Portland, ME, USA

Kazeem Adeleke, 'Peju Layiwola', *In a New Light: Conversations with Nine Nigerian Artists and Curators*, PublishAmerica, Baltimore, 2011, pp. 72–87.

Jooyoung Lee
born 1971 in Daegu, Korea

Solo Exhibitions: 2007 'It's All an Adventure', Gertrude Contemporary, Melbourne, AU • 2006 'Lost in Language', Gallery Factory, Seoul, KR • 2004 'Radio Hue', with Danger Museum, Art Space Hue, Seoul, KR

Group Exhibitions: 2012 'The Real DMZ Project', Cheorwon-gun, KR • 2011 'City Within the City', Art Sonje Center, Seoul, KR and Gertrude Contemporary, Melbourne, AU; 'Conversations with Yi Sang', National Trust for Cultural Heritage, Seoul, KR • 2010 'Ghost Bar', Okin Open Site, Okin Apartments, Seoul, KR; 'Random Access', Nam June Paik Art Centre, Yongin, KR • 2009 3rd Marrakech Biennial, Marrakech, MA • 2008 'De: Place, Re:Place', Seoul Design Olympiad, Seoul, KR • 2007 'Where Euclid Walked', Seoul Museum of Art, Seoul, KR

Jonggil Gim, 'Bonjour Monsieur Courbet', *Art in Culture*, December 2010, p. 181.

Charles Lim
born 1973 in Singapore

Solo Exhibitions: 2012 Future Perfect, SG Group Exhibitions: 2012 40th International Film Festival Rotterdam, Rotterdam, NL; 68th Venice International Film Festival, Venice, IT; 12th Tribeca Film Festival, New York, USA; 'Yonder', West End Gallery, Perth, AU • 2011 3rd Singapore Biennial, SG • 2008 Manifesta 7, Bolzano, IT; 7th Shanghai Biennial, Shanghai, CN • 2005 President's Young Talents Award Exhibition, Singapore Art Museum, SG

Marybeth Stock, 'Sea State 2: As Evil Disappears', *ArtAsiaPacific*, 11 Dec 2012.
Pauline J. Yao, '2011 Singapore Biennale', *Art-Agenda*, 18 March 2011.

Michael Linares
born 1979 in Bayamón, Puerto Rico

Solo Exhibitions: 2013 'Was it a rat I saw?', ltd los angeles, Los Angeles, USA • 2009 'Found & Lost', Museo de Arte Contemporáneo, San Juan, PR • 2006 'Tu y Yo en una Isla para Dos sentados mirando el Sol...', Galeria Comercial, San Juan, PR; 'Lawrimore Loves Painting', Lawrimore Project, Seattle, USA

Group Exhibitions: 2012 'Temporary Contemporary', Bass Museum of Art, Miami, FL; 3rd Poly/Graphic Triennial, San Juan, PR • 2011 'Paraiso', Roberto Paradise, San Juan, PR and ltd los angeles, Los Angeles, USA • 2010 1st Tropical Biennial, San Juan, PR • 2007 'Crimes of Omission'; Institute of Contemporary Art Philadelphia, Philadelphia, USA

Adriana Herrera Téllez, 'Panorama of Emerging Latin American Art', *Arte al Día International*, no. 131, 8 June 2010, pp. 50–61.
R.C. Baker 'Michael D. Linares', *The Village Voice*, 17 July 2007.

Matéo Lopez
born 1978 in Bogotá, Colombia

Solo Exhibitions: 2012 'Avenida primavera, casa número dos', Casas Riegner, Bogotá, CO; 'Irregular Hexagon: Colombian Art in Residence', Jerusalem Center for the Visual Arts, Jerusalem, IL • 2011 'Maio', Galeria Luisa Strina, São Paulo, BR • 2010 'Made to Measure', Gasworks, London, UK • 2009 'Deriva', MUSAC, León, ES • 2007 'Topografía Anecdótica', Casas Riegner, Bogotá, CO; 'Motorcycle Diaries', Museo de Arte Moderno de Medellín, Medellín and Jenny Vilá Arte Contemporáneo, Cali, CO

Group Exhibitions: 2012 'Imaginary Homelands', The Art Gallery of York University, Toronto, CA; 'Rotary Connection', Casey Kaplan Gallery, New York, USA • 2011 'The Peripatetic School', Drawing Room, London, UK; 8th Mercosul Biennial, Porto Alegre, BR • 2010 'To Draw is to Write, to Write is to Draw', Casas Riegner, Bogotá, CO; 29th São Paulo Biennial, São Paulo, BR; 'Panamericana', Kurimanzutto, Mexico City, MX • 2009 2nd Poly/Graphic Triennial, San Juan, Puerto Rico

Paula Bossa and Erika Martínez, ' Tropicality: More than Parrots and Banana Trees', *Flash Art International*, no. 272, May–June 2010, p. 94–7.

Victor Man
born 1977 in Baia Mare, Romania

Solo Exhibitions: 2013 'Szindbád', Gladstone Gallery, Brussels, BE • 2012 'The White Shadow of His Talent', Blum & Poe, Los Angeles, CA, USA • 2012 'Victor Man', MUDAM, LU • 2011 'Lazarus Protocol', Transmission, Glasgow, UK • 2010 'The Dust of Others', Galleria Zero, Milan, IT

Group Exhibitions: 2012 'Intense Proximity', Paris Triennial, Palais de Tokyo, Paris, FR; 'Six Lines of Flight', SFMoMA, San Francisco, USA • 2011 'Un'Espressione Geografica', Fondazione Sandretto Re Rebaudengo, Turin, IT • 2010 'Tanzimat', Belvedere Museum, Vienna, AT • 2009 'Sequelism', Arnolfini, Bristol, UK • 2007 'Low-Budget Monuments', Romanian Pavilion, 52nd Venice Biennale, Venice, IT

Léa Bismuth, 'Victor Man dans le nuit du non-savoir', *Artpress*, no. 388, April 2012, pp. 45–8.
Martin Herbert, 'Victor Man', *Vitamin P2*, Phaidon Press, London, 2011, pp. 204–7.
Yilmaz Dziewior and Tom Morton, *Victor Man*, JRP Ringier, Zürich, 2008.

Melvin Martínez
born 1976 in San Juan, Puerto Rico

Solo Exhibitions: 2013 'Melvin Martínez', David Castillo Gallery, Miami, USA • 2011 'El Material', Trailer Park Proyects, San Juan, PR • 2010 'Melvin Martínez', Flying Circus Gallery, Mexico City, MX • 2008 'Demo-Gracias', Wolfsonian Museum, Miami Beach, USA • 2007 'Fresh Paint', Yvon Lambert Gallery, New York, USA • 2006 'Melvin Martínez', Alcorcon Art Center, Madrid, ES

Group Exhibitions: 2013 'On Painting', CAAM, Gran Canaria, ES • 2012 'Y Picasso cogió Su Ipad', Galeria Trama, Barcelona, ES; 'Dark Flow Lurking', David Castillo Gallery, Miami, USA • 2009 'Global Caribbean', Haitian Cultural Art Center, Miami, FL and Museo de Arte Contemporáneo, San Juan, PR • 2008 'Nature Morte', Rohrer Fine Art, Laguna Beach, USA • 2006 'Tribute to Cezanne', Yvon Lambert Gallery, New York, USA; 'Kitsch Utopia', Düsseldorf Quadriennial, Düsseldorf, DE

Barry Schwabsky, 'Material Sensations and the Artificial Flesh of Colour', *Art Pulse*, 2011.
Martha Schwendener, 'Melvin Martínez at Fresh Paint', *The New York Times*, 22 June 2007.

Alex Mirutziu
born 1981 in Sibiu, Romania

Solo Exhibitions and Performances: 2011 'Time's Own Insult', The Glass Factory Lab, Boda, SE; 'Pending Works & Scotopolitic Object', Rüdiger Schöttle Gallery, Munich, DE; *Action is Guilt*, Spazio Vault, Prato, IT • 2010 'Critique on How Temples Move Faster Than Their Shadows', Mihai Nicodim Gallery, Los Angeles, USA; *Feeding the Horses of all Heroes*, Romanian Institute, Rome, IT • 2009 'Manifest of Flaw', Sabot Gallery, Cluj, RO

Group Exhibitions: 2012 'European Travellers', Kunsthalle Budapest, Budapest, HU • 2011 'Rearview Mirror', The Power Plant, Toronto, CA; 'Ars Homo Erotica', National Museum of Warsaw, Warsaw, PL • 2010 'Il Caos', San Servolo, Venice, IT • 2008 *Leave Gordon Brown Alone*, East Street Arts, Leeds, UK

Anne Martens, 'Alex Mirutziu', *Flash Art International*, March–April 2011, p. 124.
Barbara Gartner, 'Watchlist', *Monopol*, April 2010, p. 29.

Gareth Moore
born 1975 in Matsqui, Canada

Solo Exhibitions: 2013 'Dialogues with Emily', Vancouver Art Gallery and Catriona Jeffries, Vancouver, CA • 2009 'Rocks on a Clock, Some Photos of Ducks, A Collection of Masks and a Post to Touch', Lüttgenmeijer, Berlin, DE; 'Selected Chapters from Uncertain Pilgrimage...', Catriona Jeffries, Vancouver, CA • 2008 CCA Wattis Institute, San Francisco, USA; 'As a Wild Boar Passes Water', Witte de With, Rotterdam, NL • 2007 'St. George

Marsh Denaturalized', with Jacob Gleeson, Belkin Satellite, Vancouver, CA

Group Exhibitions: 2012 Documenta 13, Kassel, DE • 2010 'It Is What It Is', National Gallery of Canada, Ottawa, CA • 2009 'Nothing to Declare', The Power Plant, Toronto, CA; 'Every Version Belongs to the Myth', Project Arts Centre, Dublin, IR • 2007 'What Will be Told of Today Tomorrow', Daniel Buchholz and European Kunsthalle, Cologne, DE

Adam Carr, 'Deferred Interview', *Mousse*, no. 27, Feburary 2011.
Zoe Gray, 'Gareth Moore', *As a Wild Boar Passes Water*, Witte de With, Rotterdam, 2008.

Rabih Mroué
born 1967 in Beirut, Lebanon

An actor, director and playwright, Mroué is a founder and executive board member of the Beirut Art Center and a fellow of the International Research Centre 'Interweaving Performance Cultures' at the Freie Universität Berlin, Berlin, DE.

Grants and Prizes: 2011 Prince Claus Award, Amsterdam, NL • 2010 The Spalding Gray Award, New York, USA; Grant for Performing Arts, Foundation for Contemporary Arts, New York, USA

Ciprian Mureşan
born 1977 in Dej, Romania

Solo Exhibitions: 2012 'Stage and Twist', with Anna Molska, Tate Modern Project Space, London, UK • 2011 'Recycled Playground', FRAC Champagne-Ardenne, Reims, FR and Centre d'Art Contemporaine, Geneva, CH • 2010 Neuer Berliner Kunstverein, Berlin, DE

Group Exhibitions: 2012 'Déjà-vu?', Staatliche Kunsthalle, Karlsruhe, DE; 'European Travellers', Kunsthalle Budapest, Budapest, HU • 2011 'Genius Without Talent', De Appel Arts Centre, Amsterdam, NL; 'Rearview Mirror', The Power Plant, Toronto, CA • 2010 1st Ural Industrial Biennial, Yekaterinburg, RU; 'Les Promesses du passé', Pompidou Centre, Paris, FR • 2009 'Younger Than Jesus', 1st New Museum Triennial, New Museum, New York, USA; Romanian Pavilion, 53rd Venice Biennale, Venice, IT

Holland Cotter, 'Ciprian Mureşan', *The New York Times*, 21 July 2011.
Piotr Piotrowski, *Agoraphilia. Art and Democracy in Post-Communist Europe*, Wydawnictwo Rebis, Poznań, 2010.

Jesús 'Bubu' Negrón
born 1975 in Barceloneta, Puerto Rico

Solo Exhibitions: 2012 'Encuentro Folclórico Loiza-Zurich, Christinger de Mayo, Zürich, CH;
'Jackpot Series', Roberto Paradise, San Juan, PR

Group Exhibitions: 2011 1st Tropical Biennial, San Juan, Puerto Rico; 'Crisisss', Palacio de Bellas Artes, Mexico City, MX • 2009 2nd Poly/Graphic Triennial, San Juan, PR • 2008 'An Unruly History of the Readymade', Jumex Collection, Mexico City, MX • 2007 Sharjah Biennial 8, Sharjah, UAE • 2006 Whitney Biennial 2006, Whitney Museum of American Art, New York, USA • 2005 1st Turin Triennial, Turin, IT; 'Tropical Abstraction', Stedelijk Bureau Museum, Amsterdam, NL

Daniel Fermín, 'Jesús Negrón quiere retratar el mundo de espaldas', *El Universal*, 3 July 2012.
Manuel Álvarez Lezama, 'Jesús Bubu Negrón', *Art-Nexus*, no. 84, September–November 2011.

Angelika Burtscher and Judith Wielander, ed., *Visible*, Sternberg Press, Berlin, 2010.

Serge Alain Nitegeka
born 1983 in Bujumbura, Burundi

Solo Exhibitions: 2013 'Black Cargo', Stevenson, Cape Town, ZA • 2012 'Structural-Response 1', Institut Français, Dakar, SN; 'Black Lines', Stevenson, Johannesburg, ZA • 2011 '...and walk in my shoes.', National Arts Festival, Grahamstown, ZA

Group Exhibitions: 2011 'Process This', Michaelis Galleries, University of Cape Town, ZA; 'Geography of Somewhere', Stevenson, Johannesburg, ZA • 2010 9th Dakar Biennial, Dakar, SN; 'Time's Arrow', Johannesburg Art Gallery, Johannesburg, ZA

Rita Kersting and Bettina Malcomess, *Serge Alain Nitegeka: Black Subject/s*, Stevenson, Johannesburg, 2012.
Percy Zvomuya, 'Nitegeka's Bundles of Baggage', *Mail & Guardian*, 2 March 2012.

Jungho Oak
born 1974 in Busan, Korea

Solo Exhibitions: 2011 'The Holy Landscape', Art Space Pool, Seoul, KR • 2006 'Free Plastic', Gallery 175, Seoul, KR • 2005 Insa Art Space, Seoul, KR

Group Exhibitions: 2012 'Art Spectrum 2012', Leeum, Samsung Museum of Art, Seoul, KR • 2010 'Oh! Masterpieces', Gyeonggi Museum of Modern Art, Gyeonggi-do, KR • 2009 'New Political Art in Korea', Gyeonggi Museum of Modern Art, Gyeonggi-do, KR • 2008 'Come Back to Harbor Busan', Busan Museum of Modern Art, Busan, KR • 2007 'Peppermint Candy: Contemporary Korean Art', Museo de Arte Contemporaneo, Santiago, CL, Museo Nacional De Bellas Artes, Buenos Aires, AR and National Museum of Contemporary Art, Gwacheon, KR • 2007 'Service Station', The Walsh Gallery, Chicago, USA

Emeka Ogboh
born 1977 in Enugu, Nigeria

Group Exhibitions: 2012 'African Art and the Shape of Time', University of Michigan Museum of Art, Ann Arbor, USA; 'We Face Forward', Manchester City Gallery and Whitworth Gallery, Manchester, UK; 'Invisible Cities', Mass MoCA, Boston, USA • 2011 'The Mystical Self', Veneto Regional Archive of Video Art, Verona, IT; 'ARS 11', Museum of Contemporary Art Kiasma, Helsinki, FI • 2010 'Afropolis: City, Media, Art', Rautenstrauch-Joest Museum, Cologne and Iwalewa-Haus, Beyreuth, DE; 'Localities', Museum of Contemporary Arts, Roskilde, DK • 2009 'Identity: an Imagined State', CCA, Lagos, NG

Massa Lemu, *Molue and the Afropolitian Experience in Emeka Ogboh's Soundscapes*, Glassell School of Art, Museum of Fine Arts, Houston, 2012.
Terh Agbedeh, 'Documenting Through Sound', *National Mirror*, 20 April 2011.

Abraham Oghobase
born 1979 in Lagos, Nigeria

Solo Exhibitions: 2008 'Lost in Transit', Goethe-Institut, Lagos, NG

Group Exhibitions: 2012 'We Face Forward', Manchester Art Gallery and Whitworth Gallery, Manchester, UK; 'Eyes Closed, Eyes Open', Studio 41, Glasgow, UK; 'Synchronicity II', Tiwani Contemporary Gallery, London, UK • 2011 'Témoin/Witness', Medina Gallery, Bamako, ML; 'Synchronicity', Baudoin Lebon Gallery, Paris, FR; 'ARS 11', Museum of Contemporary Art Kiasma, Helsinki, FI

• 2009 8th African Photography Encounters Biennial, Bamako, ML

Uche James Iroha, *Unifying Africa*, Photo.Garage, Lagos, 2010.
Olakunle Tejuoso, *Lagos: A City At Work*, Glendora Books, Lagos, 2007.

Temitayo Ogunbiyi
born 1984 in Rochester, NY, USA

Solo Exhibitions: 2012 'My Lagos in Fragments', Wheatbaker Hotel, Lagos, NG; 'Am I a Thief', Freies Museum, Berlin, DE and Perm Museum of Contemporary Art, Perm, RU • 2010 'Branded', Black Ink Gallery, New York City, USA • 2006 'Extended Extensions', Lucas Gallery, Princeton University, Princeton, USA

Group Exhibitions: 2012 'The Progress of Love', CCA, Lagos, NG, The Pulitzer Foundation for the Arts, St. Louis, USA and The Menil Collection, Houston, USA; 'Nigeria House', Theater Royal Stratford East, London, UK • 2011 'Documenting Changes in our Nation', Civic Centre, Lagos, NG; 'A Kilo of Hope', Yusuf Grillo Gallery, Lagos, NG • 2010 'Do it Yourself', The Dash Gallery, New York City, USA; 'Life After Death', Caribbean Cultural Center African Diaspora Institute, New York, USA

Bisi Silva and Kristina Van Dyke, ed., *The Progress of Love*, Menil Foundation and Pulitzer Foundation for the Arts, Houston and St. Louis, 2012.
Omiko Awa, 'Ogunbiyi Links Freedom', *The Guardian*, 1 April 2012, p. 6.

Ahmet Öğüt
born 1981 in Diyarbakir, Turkey

Solo Exhibitions: 2012 'This Exhibition's Factual Accuracy May be Compromised Due to its Practical Nature', Künstlerhaus Stuttgart, Stuttgart, DE • 2011 'Modern Essays 1', SALT Beyoğlu, Istanbul, TR • 2010 'Informal Incidents', Stedelijk Museum Bureau Amsterdam, Amsterdam, NL; 'Speculative Social Fantasies', Artspace Visual Arts Centre, Sydney, AU • 2008 'Mutual Issues, Inventive Acts', Kunsthalle Basel, Basel, CH

Group Exhibitions: 2012 7th Liverpool Biennial, Liverpool, UK; 53rd October Salon, Belgrade, CS; Future Generation Art Prize, Pinchuk Art Centre, Kiev, UA; 'Unrest', Apexart, New York, USA; 5th Bucharest Biennial, Bucharest, RO • 2011 12th Istanbul Biennial, Istanbul, TR • 2010 'Trickster Makes This World', Nam June Paik Art Center, KR; 'When Ideas Become Crime', Depo, Istanbul, TR; 'Tactics of Invisibility', TBA21, Vienna, AT, Arter, Istanbul, TR and Tanas, Berlin, DE • 2009 Turkish Pavilion, 53rd Venice Biennale, Venice, IT

Berin Golonu, 'Between the Scaffold and the Ruin', *Fillip*, no. 14, Summer 2011.
Vincenzo de Bellis, 'Ahmet Öğüt: Mind the Gap', *Mousse Magazine*, no. 15, September 2008

Charles Okereke
born 1966 in Kano, Nigeria

A member of the Black Box collective, Okereke is a founding member of Invisible Borders.

Group Exhibitions: 2012 'Ungovernables', 2nd New Museum Triennial, New Museum, New York, USA; 'We Face Forward', Manchester City Gallery and Whitworth Gallery, Manchester, UK • 2011 9th African Photography Encounters Biennial, Bamako, ML; 'Mapping the Flâneur', Format International Festival, Derby, UK • 2010 World Black Arts Festival, Dakar, SN; 'The Idea of Africa (re-invented)', Kunstalle Bern, Bern, CH • 2009 8th African Photography Encounters Biennial, Bamako, ML

Okin Collective
Established 2009

Shiu Jin, born 1975 in Seoul, South Korea
Hwayong Kim, born 1979 in Incheon, South Korea
Joungmin Yi, born 1971 in Seoul, South Korea

Solo Exhibitions: 2010 'Okin OPEN SITE', Okin Apartments Demolition Site, Seoul, KR; 'Concrete Island', Takeout Drawing, Seoul, KR

Group Exhibitions: 2012 'Road to 12,104 Miles', Placio Nacional de las Artes, Buenos Aires, AR; 'Truth is Concrete', Steirischer Herbst, Graz, AT; 'Aerofloat Project', Seoul Art Space Geumcheon, Seoul, KR; 'General Strike: Stop the City, Take the Street', Seoul Art Space Seokyo, Seoul, KR • 2011 'Life, No Peace, Only Adventure', Busan Museum of Art, Busan, KR • 2010 'The 1st Public Discourse Sphere', Alternative Space Loop, Seoul, KR; 'Panic Room: As You Like It', Jeju Human Rights Conference, Jeju, KR; 'Okin Manifesto: 5 Minute Revolution', Nam June Paik Art Center, Yongin, KR • 2009 'Okin Apartments Project', Okin Apartments Demolition Site, Seoul, KR

Haejoo Kim, '19-minute Performance Opens up a New Horizon for Multidisciplinary Arts', *Art in Culture*, December 2011, pp. 144–7.
Woosung Lee, 'Politics & Art: Okin Collective', *Dazed and Confused*, January 2011, pp. 72–7.

Donna Ong
born 1978 in Singapore

Exhibitions: 2012 'Diversecity', Singapore Art Museum, SG; Opening Exhibition, Gillman Barracks, SG; 'Home Again: 10 Artists Who Have Experienced Japan', Hara Museum, Tokyo, JP; 'Come Away With Me', Institute of Contemporary Arts Singapore, SG • 2011 'Fatto a Mano for the Future', Fendi Boutique, Takashimaya Shopping Centre, SG; 'Donna Ong, Jane Lee, Wilson Chieh', Eslite Gallery, Taipei, ROC • 2010 'Dust on the Mirror', Djanogly Art Gallery, Nottingham, UK and Institute of Contemporary Arts Singapore, SG • 2009 'Photographer Unknown' Monash University Museum of Art, Melbourne, AU; 13th Jakarta Biennial, Jarkarta, ID • 2008 First Kuandu Biennale, Kuandu Museum, Taipei, ROC; 'Coffee, Cigarettes and Pad Thai', Eslite Gallery, Taipei, ROC; 'Always Here But Not Always Present: Art In A Senseless World', Singapore Management University, SG • 2007 'Hybricity: Singapore', 798 Art District, Beijing CN; 2nd Moscow Biennial, Moscow, RU

Kainebi Osahenye
born 1964 in Agbor, Nigeria

Solo Exhibitions: 2009 'Trash-ing', CCA, Lagos, NG • 2006 'Erasures', Didi Museum, Lagos, NG

Group Exhibitions: 2010 'Afropolis: City, Media, Art', Rautenstrauch-Joest Museum, Cologne and Iwalewa-Haus, Bayreuth, DE; 'Selection 2010', Skoto Gallery, New York, USA; 'Trends', Dak'Art OFF, Dakar, SN • 2008 'Lagos', E-werk, Freiburg, DE • 2004 'Without Borders', Pan African University, Lagos, NG

Sylvester Okwunodu Ogbechie, 'Kainebi Osahenye and the Conundrum of Contemporary Painting', *Trashing*, CCA, Lagos, 2009.
Bisi Silva, 'The 'New' Face of Contemporary Nigerian Painting?', *NEXT*, 20 September 2009, pp. 40–41.
Okwui Enwezor and Chika Okeke-Agulu, *Contemporary African Art Since 1980*, Damiani, Bologna, 2009.

Part-time Suite
Established 2003

Byungjae Lee, born 1982 in Seoul, Korea

Miyeon Lee, born 1978 in Seoul, Korea
Jaeyoung Park, born 1984 in Nonsan, Korea

Solo Projects and Exhibitions: 2011 'Multi Purpose Base Camp', Seoul Art Space: Mullae, Seoul, KR • 2010 'Drop by Then', itinerant project to the northern region, including civilian-restricted areas, KR • 2009 'Loop the Loop', Jongno-gu Yeonji-dong and Doo-san Gallery, Seoul, KR; 'Off-off-stage', Jongno-gu Sinmun-ro, Seoul, KR; 'Under Interior', Seodaemun-gu Choongjung-ro, Seoul, Korea

Group Exhibitions: 2012 'Play Time', Cultural Station Seoul 284, Seoul, KR; 'What Should I do to Live in Your Life?', Sharjah Art Foundation, Sharjah, UAE • 2011 'City within the City', Artsonje Center, Seoul, KR and Gertrude Contemporary, Melbourne, AU; Hermès Foundation Missulsang Exhibition, Atelier Hermès, Seoul, KR

Jangun Kim, 'Post-untitled or titled', *On the Shores of Art and Politics*, Hyeonsil Munhwa Yeongu, Seoul, December 2012.
Daebum Lee, 'A Quiet Commotion in an Anonymous Space, and Utterance', *Article*, no. 10, May 2012.

Isabelle Pauwels
born 1975 in Kortrijk, Belgium

Solo Exhibitions: 2012 *LIKE…/AND, LIKE/ YOU KNOW/ TOTALLY/RIGHT.*, Western Front, Vancouver, CA • 2010 Tatjana Pieters, Ghent, BE; 'Isabelle Pauwels: Incredibly, unbelievably/The complete ordered field', Henry Art Gallery, Seattle, USA • 2009 'June 30', CSA Space, Vancouver, CA; Presentation House Gallery, North Vancouver, CA • 2008 'Triple Bill', Blackwood Gallery, Mississauga and Artspeak, Vancouver, CA • 2003 'Unfurnished Apartment for Rent', Contemporary Art Gallery, Vancouver, CA

Group Exhibitions: 2012 'Moveable Facture', VIVO Media Arts Centre, Vancouver, CA • 2011 'The Plot', The Power Plant, Toronto, CA; 'The Distance Between You and Me', Vancouver Art Gallery, Vancouver, CA • 2009 'Morality: Act II', Witte De With, Rotterdam, NL; '101', Ottawa, CA • 2008 'Keep the IS in FEMINISM', Contemporary Art Gallery, Vancouver, CA; 'Exponential Future', Morris and Helen Belkin Art Gallery, Vancouver, CA • 2007 'Twenty-fourseven', Signal, Malmö, SE; 'The Lotus Eaters', Western Front, Vancouver, CA

Raqs Media Collective
Established 1992

Jeebesh Bagchi, born 1965 in Delhi, India
Monica Narula, born 1969 in Delhi, India
Shuddhabrata Senguota, born 1968 in Delhi, India

Solo Exhibitions: 2012 'The Great Bare Mat & Constellation', Isabella Stewart Gardner Museum, Boston, USA; 'An Afternoon Unregistered on the Richter Scale, The Photographers' Gallery, London, UK • 2011 'Reading Light', Festival d'Automne, Paris, FR; 'Surjection', Art Gallery of York University, Toronto, CA • 2010 'The Things That Happen When Falling in Love', Baltic, Gateshead, UK; 'The Capital of Accumulation', HAU, Berlin, DE, Museum of Modern Art, Warsaw, PL and Project 88, Mumbai, IN • 2009 'The Surface of Each Day is a Different Planet', Tate Britain, London, UK

Group Exhibitions: 2012 Manifesta 9, Genk, BE • 2011 'The Global Contemporary: Art Worlds After 1989', ZKM, Karlsruhe, DE; 'Against All Odds', Lalit Kala Akademi, Delhi, IN; 'Paris-Delhi-Bombay', Pompidou Centre, Paris, FR • 2008 'Indian Highway', Serpentine Gallery, London, UK; 'Chalo India', Mori ArtMuseum, Tokyo, JP

Pamela M. Lee, 'How to Be a Collective in the Age of the Consumer Sovereign', *Artforum*, vol. 47, no. 2, October 2009, pp. 185–9.

Francesco Manacorda, 'Whirling Dervishes and Urban Design', *Frieze*, no. 108, June–August 2007.

José Alejandro Restrepo
born 1959 in Bogotá, Colombia

Solo Exhibitions: 2012 'Variaciones sobre El Sacrificio', Ignacio Liprandi Arte Contemporáneo, Buenos Aires, AR • 2011 'Variaciones sobre El Purgatorio', Museo de Arte de la Universidad Nacional de Colombia, Bogotá, CO

Group Exhibitions: 2011 8th Mercosul Biennial, Porto Alegre, BR; 11th Lyon Biennial, Lyon, FR • 2009 2nd Thessaloniki Biennial of Contemporary Art, Thessaloniki, GR • 2007 52nd Venice Biennale, Venice, IT • 2006 'In the Poem About Love You Don't Write the Word Love', Artists Space, New York, USA • 2004 'Botánica Política', Sala Montcada de la Fundación la Caixa, Barcelona, ES

Andres Garcia Larotta, Bruno Mazzoldi, Cuauhtémoc Medina and José Alejandro Restrepo, *Religión Católica*, Universidad Nacional de Colombia, Bogotá, 2012.
Paulo Herkenhoff, 'José Alejandro Restrepo: The Economy of Video', *Atlas America*, Oi Futuro, Rio de Janeiro, 2008.

Marina Rheingantz
born 1983 in Araraquara, Brazil

Solo Exhibitions: 2012 Centro Cultural São Paulo, São Paulo, BR • 2011 'Everybody Knows This is Nowhere', Centro Universitário Maria Antonia USP, São Paulo, BR • 2010 'Camping', Galeria Fortes Vilaça, São Paulo, BR • 2008 'Algum Dia', Galpão Fortes Vilaça, São Paulo, BR; 'Marina Rheingantz and Marcos Brias', Escola São Paulo, São Paulo, BR

Group Exhibitions: 2013 'Nowhere', Instituto Moreira Salles, Rio de Janeiro, BR • 2012 'The First Ten Years', Instituto Tomie Othake, São Paulo, BR • 2011 6th Curitiba Biennial, Curitiba, BR; 'Mythologies', Cité des Arts, Paris, FR • 2010 'Heaven Can Wait', Tinderbox Gallery, Hamburg, DE • 2008 '2000 e oito', SESC Pinheiros, São Paulo and Museu Vitor Meirelles, Florianópolis, BR • 2007 'Naturalmente Artificial', Museu de Arte Brasileira, São Paulo, BR

Camila Belchior, 'Memórias a óleo', *Bamboo*, no. 13, May 2012, p. 52.
Frederico Coelho and Isabel Diegues, *Pintura Brasileira século XXI*, Editora Cobogó, Rio de Janeiro, 2011.

Jae Oon Rho
born 1971 in Daegu, Korea

Solo Exhibitions: 2011 'Mulian Mulian', Atelier Hermès, Seoul, KR • 2009 'About Time', Gallery Plant, Seoul, KR • 2006 'Black Gold in Switzerland', Art Space Pool, Seoul, KR

Group Exhibitions: 2012 8th Busan Biennial, Busan, KR • 2011 'Space Study', Plateau, Seoul, KR • 2009 Hermès Foundation Missulsang Exhibition, Atelier Hermès, Seoul, KR • 2008 'A Walk to Remember, A Walk to Envision', New Museum, New York, USA • 2007 'Fast Break', PKM Gallery Beijing, Beijing, CN • 2006 6th Gwangju Biennial, Gwangju, KR; 'On Difference #2', Kunstverein Stuttgart, Stuttgart, DE

Jee-Sook Beck, 'Good Sleep, Bad Sleep and Bizzare Sleep', *Mulian Mulian*, Fondation d'entreprise Hermès, Seoul, 2012, pp. 68–75.
Young Min Moon, 'Fatal Beauty: Rho Jae Oon's Interventions in the Realm of Hypernarrative', *Incongruent: Contemporary Art from South Korea*, Hyunsil Cultural Studies, Seoul, 2006, pp. 141–8.

Chemi Rosado-Seijo
born 1973 in Vega Alta, Puerto Rico

Solo Exhibitions: 2013 '365 Dias en el Bosque Tropical', San Juan, PR; 'Muestra de (S)Obras', Chemi Room, San Juan, PR • 2006 'Liming: Still Pan Set', CAC7, Port of Spain, TT • 2005 'Manhattan Skateboartists Map', Art in General, New York, USA

Group Exhibitions: 2012 'Art/Community/Life', Petach Tikva Museum of Art, Petach Tikva, IL; 1st Tropical Biennial, San Juan, PR • 2011 'Living as Form', Creative Time, New York, USA; 'Monopatín', 787 Studios, San Juan, PR • 2010 'Ultra Puñeta', Proyectos Ultravioleta, Guatemala City, GT; 31st Pontevedra Biennial, Villagarcia, ES • 2009 2nd Poly/Graphic Triennial, San Juan, PR • 2008 'En sus Marcas', Museo de Arte Contemporáneo, San Juan, PR • 2006 9th Havana Biennial, Havana, CU • 2005 2nd Prague Biennial, Prague, CZ

Nato Thompson, *Living as Form: Socially Engaged Art from 1991–2011*, Creative Time Books & MIT Press, New York, Cambridge, MA and London, 2012.
Holland Cotter, 'Comercial (Puerto Rico)', *The New York Times*, 6 July 2007.

Tracey Rose
born 1974 in Durban, South Africa

Solo Exhibitions: 2011 'Rose O'Grady', with Lorraine O'Grady, Goodman Gallery, Johannesburg, ZA; 'Waiting for God', Johannesburg Art Gallery, Johannesburg, ZA and Bildmuseet, Umeå University, Umeå, SE • 2008 'The Cockpit', MC Kunst, Los Angeles, CA; 'Plantation Lullabies', Goodman Gallery, Johannesburg, ZA

Group Exhibitions: 2011 11th Lyon Biennial, Lyon, FR; '(Re)constructions', Museu de Arte Contemporânea, Niteroi, BR • 2010 'An Unspardonable Sin', castillo/corrales, Paris, FR; 'Afro Modern', Tate Liverpool, Liverpool, UK • 2009 'Adding Substractions', The Bag Factory, Johannesburg, ZA; 'Rebelle', Museum voor Moderne Kunst, Arnhem, NL • 2007 'Apartheid', Centre de Cultura Contemporània, Barcelona, ES; 1st Thessaloniki Biennial, Thessaloniki, GR; 'Global Feminisms', Brooklyn Museum of Art, New York City, USA • 2006 Perfect Performance, Moderna Museet, Stockholm, SE • 2001 49th Venice Biennale, Venice, IT

Beatriz Santiago Muñoz
born 1972 in San Juan, Puerto Rico

Solo Exhibitions: 2013 'The Black Cave', Gasworks, London, UK • 2010 'Distributed Gallery', Telic Arts Exchange, Los Angeles, USA • 2008 'Flowers of Antimony', CCA Wattis, San Francisco, USA; 'Beatriz Santiago Muñoz', Espacio 1414, San Juan, PR

Group Exhibitions: 2012 3rd Poly/Graphic Triennial, San Juan, PR • 2011 8th Mercosul Biennial, Porto Alegre, BR; 'Incidents of Travel in Mexico', Museo Rufino, Tamayo, MX • 2010 'Panamericana', Kurimanzutto, Mexico, MX; 'Fourth Wall', Vox Populi, Philadelphia, USA • 2008 'A Sketch for the Creation of a Future Society', Laboratorio 060, Mexico City, MX • 2007 Encuentro Internacional Medellín, Medellín, CO

Claire Fitzsimmons, Julieta González and Jens Hoffmann, *Beatriz Santiago Muñoz: Capp Street Project*, Wattis Institute, San Francisco, 2008.
Todd Carmody and Heather Love, 'Try Anything', *Crit-icism*, vol. 50, no. 1, Winter 2008, pp. 133–146.

Serban Savu
born 1978 in Sighisoara, Romania

Solo Exhibitions: 2012 'Daily Practice for the End of the World', Plan B Gallery, Berlin, DE • 2011 'Close to Nature',

David Nolan Gallery, New York, USA; 'Under the Radar', PM Gallery & House, London, UK • 2010 'Unimportant Stories', Nicodim Gallery, Los Angeles, USA; 'Essay on Limits', Galerie Hussenot, Paris, FR

Group Exhibitions: 2012 'European Travellers', Kunsthalle Budapest, Budapest, HU • 2010 'After the Fall', Hudson Valley Center for Contemporary Art, Peekskill, USA; 'Romanian Cultural Resolution', Spinnerei, Leipzig, DE; 'Mircea Pinte Collection', Museum of Art, Cluj, RO • 2009 'Invisible Body, Conspicuous Mind', Luckman Gallery, Los Angeles, USA • 2007 3rd Prague Biennial, Prague, CZ

Lloyd Wise, 'Serban Savu', *Artforum International*, vol. 50, no. 4, December 2011.
Raluca Voinea, 'No Train Coming', *IDEA arts + society*, no. 35, 2010.
Holland Cotter, 'Serban Savu: The Edge of the Empire', *The New York Times*, 5 March 2009.

Gigi Scaria
born 1973 in Kothanalloor, India

Solo Exhibitions: 2009 'Amusement Park', Gallery Chemould, Mumbai, India • 2008 'Site Under Construction', Video Space, Budapest, HU; 'Triviality of Everyday Existence', Changdong National Art Studio, Seoul, KR • 2007 'Absence of an Architect', Palette Art Gallery, Delhi, IN

Group Exhibitions: 2012 'Cynical Love', Kiran Nadar Museum of Art, Delhi, IN • 2011 'Side by Side', Centro Cultural Banco do Brasil, Rio de Janeiro, BR; India Pavilion, 54th Venice Biennale, Venice, IT; 3rd Singapore Biennial, SG • 2010 'Finding India', Museum of Contemporary Art, Taipei, ROC; 'Samtidigt', Helsinki City Art Museum, Helsinki, FI • 2008 'Video Zone', 4th International Video Art Biennial, Tel Aviv, IL; 'Chalo India', Mori Art Museum, Tokyo, JP • 2006 'Impossible India', Frankfurter Kunstverein, Frankfurt, DE

Nancy Adajania, 'The Unbearable Heaviness of Being', *Gigi Scaria: Amusement Park*, Chemould Prescott Road, Mumbai, 2009.
Satyanand Mohan, 'The Archaeology of Urban Life', *Gigi Scaria*, Palette Art Gallery, Delhi, 2008.

Kevin Schmidt
born 1972 in Ottawa, Canada

Solo Exhibitions: 2013 Fogo Island Arts, Fogo Island, CA • 2011 'Subjective Projections', Bielefelder Kunstverein, Bielefeld, DE; 'Don't Stop Believing', Justina M.Barnicke Gallery, University of Toronto, Toronto, CA; 'Epic Journey', Musée d'art contemporain de Montréal, Montreal, CA • 2010 Catriona Jeffries, Vancouver, CA • 2009 Galerie van der Mieden, Antwerp, BE; 'Wild Signals', Galerie Barbara Thumm, Berlin, DE

Group Exhibitions: 2013 Montreal Biennial, Montreal, CA • 2012 'Untrue North', Yukon Arts Centre, Whitehorse, CA; 'True North', Anchorage Museum, Anchorage, USA • 2011 'Up North', Art Gallery of Alberta, Edmonton, CA • 2010 'Magnetic Norths', Concordia University, Montreal, CA • 2008 'Psychology of a Pawn', Participant Inc, New York, USA; 'Exponential Future', Morris and Helen Belkin Art Gallery, Vancouver, CA

John Motley, 'Kevin Schmidt', *Frieze*, no. 137, March 2011.

Mithu Sen
born 1971 in Burdwan, India

Solo Exhibitions: 2012 'In House Adoption', Galerie Steph and Nature Morte, SG • 2011 'In Transit', Espace Louis Vuitton, Taipei, ROC; 'Black Candy', Chemould Gallery, Mumbai, IN • 2010 'Nothing Lost in Translation', Nature

Morte, Berlin, DE • 2009 'Me Two', Krinzinger Project, Vienna, AT; 'Free Mithu', Khoj, Delhi, IN • 2008 'I Dig, I Look Down', Albion Gallery, London, UK

Group Exhibitions: 2012 'Terrestrial Bodies', 1x1 Art Gallery, Dubai, UAE; 'Slipping Through the Cracks', Latitude 28, Delhi, IN; 'Cynical Love', Kiran Nadar Museum of Art, Delhi, IN • 2011 'Generation in Transition', National Gallery of Art, Warsaw, PL and CAC, Vilnius, LT; 'Home Spun', Devi Art Foundation, Delhi, IN; 'Against All Odds', Lalit Kala Akademi, Delhi, IN • 2009 'Abstract Cabinet', Eastside Projects, Birmingham, UK; 'India Xianzai', Museum of Contemporary Art Shanghai, Shanghai, CN • 2008 'Emotional Drawing', National Museum of Modern Art, Tokyo, JP

Gabriel Sierra
born 1975 in San Juan Nepomuceno, Colombia

Solo Exhibitions: 2012 Kadist Art Foundation, San Francisco, USA • 2011 'A trip to Vienna like Bruno Munari', Galería Martin Janda, Vienna, AT • 2010 'Art Positions', Art Basel Miami Beach, Miami, USA • 2009 'Sem título', Galeria Luisa Strina, São Paulo, BR • 2008 'Apéndice', Casas Riegner, Bogotá, CO

Group Exhibitions: 2012 'K', CCA Wattis, San Francisco, USA; 'Ungovernables', 2nd New Museum Triennial, New Museum, New York, USA • 2011 12th Istanbul Biennial, Istanbul, TR; 11th Lyon Biennial, Lyon, FR • 2010 'Panamericana', Kurimanzutto, Mexico City, MX; 'Under the Same Roof', Hessel Museum, CCS Bard, Annandale-on-Hudson, USA • 2009 'Everything Has a Name, or the Potential to be Named', Gasworks, London, UK • 2008 28th São Paulo Biennial, São Paulo, BR

Bettina Bruner, 'Gabriel Sierra', Frieze d/e, no. 1, summer 2011.
Adriano Pedrosa, 'Openings: Gabriel Sierra', Artforum, vol. 48, no. 3, November 2009.

Dayanita Singh
born 1961 in New Delhi, India

Solo Exhibitions: 2011 'Dayanita Singh', Museum of Modern Art, Bogotá, CO; 'House of Love', Peabody Museum, Boston, USA • 2010 'Dayanita Singh', Huis Marseille Museum for Photography, Amsterdam, NL • 2009 'Blue Book', Nature Morte, Delhi, IN • 2008 'Sent a Letter,' Alliance Francaise Delhi, Delhi, Satram Das Jewellers, Kolkata and NGMA, Mumbai, IN; 'Dream Villa', Frith Street Gallery, London, UK • 2006 'Go Away Closer', Nature Morte, Delhi, IN • 2005 'Chairs', Isabella Stewart Gardner Museum, Boston, USA

Group Exhibitions: 2013 German Pavilion, 55th Venice Biennale, Venice, IT • 2011 54th Venice Biennale, Venice, IT; 'Paris-Delhi-Bombay', Pompidou Centre, Paris, FR • 2008 Manifesta 7, Bolzano, IT; 7th Gwangju Biennial, Gwangju, KR; 'Indian Highway', Serpentine Gallery, London, UK • 2006 'Sub-Contingent', Fondazione Sandretto Re Rebaudengo, Turin, IT; 'The Eighth Square', Ludwig Museum, Cologne, DE

Mounira Al Solh
born 1978 in Beirut, Lebanon

Solo Exhibitions: 2011 'Mounira Al Solh, René Daniels, Bassam Ramlawi', Stedelijk Museum Bureau Amsterdam, Amsterdam, NL • 2010 'Exhibition 17', Sfeir-Semler Gallery, Beirut, LB; 'The Sea Is a Stereo', Kunsthalle Lisbon, Lisbon, PT

Group Exhibitions: 2012 'Ungovernables', 2nd New Museum Triennial, New Museum, New York, USA; 'Dinosaurs', Art in General, New York, USA; 5th Bucharest Biennial, Bucharest, RO • 2011 'I decided not to Save the

World', Tate Modern, London, UK and SALT, Istanbul, TR • 2010 'The Future of Tradition, the Tradition of Future', Haus der Kunst, Munich, DE; Manifesta 8, Murcia, SP

Rachel Spence, 'In The Line of Fire', Financial Times, 30 September 2011.
Charles Esche, 'Mounira Al Solh, Work in Progress', Bidoun, Spring 2009, p. 48.

Rayyane Tabet
born 1983 in Ashqout, Lebanon

Solo Exhibitions:
2013 'The Shortest Distance Between Two Points', Gallery Sfeir-Semler, Beirut, LB

Group Exhibitions: 2013 Abraaj Capital Art Prize, Dubai, UAE; Khalid Shoman Foundation 25th Anniversary exhibition, Darat Al Funun, Amman, JO • 2012 'Ungovernables', 2nd New Museum Triennial, New Museum, New York, USA; 'Future Generation Art Prize 2012', Pinchuk Art Centre, Kiev, UA • 2011 Sharjah Biennial 10, Sharjah, UAE • 2010 'Noise', Gallery Sfeir-Semler, Beirut, LB • 2006 'Moving Homes', Gallery Sfeir-Semler, Beirut, LB

Jim Quilty, 'Works Metallic, Minor, Lost, Forgotten', The Daily Star, 27 March 2013.
Kaelen Wilson-Goldie, 'Openings: Rayyane Tabet', Artforum, vol. 51, no. 5, January 2013, pp. 192–5.

Ron Tran
born 1972 in Saigon, Vietnam

Solo Exhibitions: 2011 'Away To Go', Contemporary Art Gallery, Vancouver, CA; 'It Knows Not What It Is', Charles H. Scott Gallery, Vancouver, CA • 2009 'Stranger Circumstances', Crawl Space, Seattle, USA • 2008 'And You Can Do Anything With Them Under Such Circumstances…', Lawrence Eng Gallery, Vancouver, CA • 2007 'Distance From A Table To A Chair, The Village And Other Things', Neon Gallery, Brösarp, SE

Group Exhibitions: 2012 'Phantasmagoria', Presentation House Gallery, Vancouver, CA • 2010 6th Berlin Biennial, Berlin, DE; 'Triumphant Carrot: The Persistence of Still Life', Contemporary Art Gallery, Vancouver, CA • 2009 'Thermostat: Video and the Pacific Northwest', Seattle Art Museum, Seattle, USA • 2007 EAST International, Norwich Gallery, Norwich, UK

Minnete Vári
born 1968 in Pretoria, South Africa

Solo Exhibitions: 2012 'Revenant', Goodman Gallery Cape, ZA • 2010 'Parallax', Goodman Gallery Johannesburg, ZA • 2007 'Vigil', Elga Wimmer Gallery, New York, USA • 2004 'Minnette Vári', Kunstmuseum Luzern, Lucerne, CH

Group Exhibitions: 2010 'Afropolis: City, Media, Art', Rautenstrauch-Joest Museum, Cologne and Iwalewa-Haus, Beyreuth, DE • 2009 10th Havana Biennial, Havana, CU • 2008 5th Seoul International Media Art Biennial, Seoul, KR • 2007 African Pavilion, 52nd Venice Biennale, Venice, IT • 2004 'Personal Affects: Power and Poetics in Contemporary South African Art', The Museum for African Art and the Cathedral Church of St. John the Divine, New York, USA

Sue Williamson, South African Art Now, Harper-Collins, New York, 2009.

Vertical Submarine
Established 2003

Solo Exhibitions: 2012 'Landed Property', People's Association commission, Bishan Park, SG • 2011 'Under

Writer's Table', Singapore Art Museum, SG • 2008 'Decomposition II: Publication is Prostitution', The Substation, SG

Group Exhibitions: 2011 'A View with a Room', The Invisible Dog, New York, USA; 'Incendiary Texts', Institute of Contemporary Arts Singapore, SG; 'Asia: Looking South', Arndt Contemporary Art, Berlin, DE • 2010 'Simulacro Naturale', Ex Teresa Arte Actual, Mexico City, MX; 2nd Kuandu Biennial, Kuandu Museum, Taipei, ROC; Night Festival 2010, Singapore Art Museum, SG; 'The Garden of Forking Paths', Grey Projects, SG • 2009 'Nature Borne', Singapore Botanic Gardens, SG; President's Young Talents Award Exhibition, 8Q Singapore Art Museum, Singapore; 'Shopping for a Personal Letter', with Kooy Siew Yen and He Yue, Wheelock Art Gallery, SG

Deepika Shetty, 'Submarine Makes Waves', The Straits Times, 19 April 2012.
Sonia Kolesnikov Jessop, 'In Singapore, Nature Reborn as Art', The New York Times, 10 November 2009.

Erika Verzutti
born 1971 in São Paulo, Brazil

Solo Exhibitions: 2012 Centro Cultural São Paulo, São Paulo, BR • 2011 'Missionary', Galpão Fortes Vilaça, São Paulo, BR • 2010 'Bicho de Sete Cabeças', with Efrain Almeida, Carlos Bevilacqua, Ernesto Neto, Alexandre da Cunha, Jac Leirner, Damián Ortega, Adriana Varejão and Nuno Ramos, Galpão Fortes Vilaça, São Paulo, BR; 'Chopping Board', Misako & Rosen Gallery, Tokyo, JP • 2008 'Pet Cemetery', Galpão Fortes Vilaça, São Paulo, BR

Group Exhibitions: 2012 'Home Again', Hara Museum of Contemporary Art, Tokyo, JP; 'Lilliput', High Line, New York, USA • 2011 'Mythologies', Cité Internationale des Arts, Paris, FR; 11th Lyon Biennial, Lyon, FR; 'Law of the Jungle', Lehmann Maupin Gallery, New York, USA • 2009 'Studio Voltaire', BolteLang, Zürich, CH • 2008 'Martian Museum of Terrestrial Art', Barbican Centre, London, UK

Alexandre Murucci, Nova Escultura Brasileira: Heranças e Diversidades, Conjunto da Caixa Cultural, Rio de Janeiro, 2011.
Mauro Ventura, 'Artistas interpretam o espaço intimo do devaneio e do aprisionamento', O Globo, 6 July 2009, p. 2.

Kemang Wa Lehulere
born 1984 in Cape Town, South Africa

Solo Exhibitions: 2013 'Sleep is for the Gifted', Lombard-Freid Projects, New York, USA • 2012 'Some Deleted Scenes Too', Stevenson, Johannesburg, ZA • 2011 'Thirty Minutes of Amnesia: Act 1', Goethe-Institut, Johannesburg, ZA • 2009 'Ubontsi: Sharp sharp!', AVA Gallery, Cape Town, ZA

Group Exhibitions: 2013 'My Joburg', la maison rouge, Paris, FR; South African Pavilion, 55th Venice Biennale, Venice, IT; 'Center for Historical Reenactments: After-After Tears', New Museum, New York, USA • 2012 'Fiction as Fiction (Or, A Ninth Johannesburg Biennale)', Stevenson, Cape Town, ZA; 'Ungovernables', 2nd New Museum Triennial, New Museum, New York, USA • 2011 11th Lyon Biennial, Lyon, FR • 2010 MTN New Contemporaries Award 2010, KZNSA Gallery, Durban, ZA • 2009 'Dada South?', Iziko South African National Gallery, Cape Town, ZA; 'Identity: An Imagined State', CCA, Lagos, NG

Ian Woo
born 1967 in Singapore

Solo Exhibitions: 2013 'Ian Woo: How I Forgot to be Happy', Tomio Koyama Gallery, SG • 2011 'Ian Woo: A Review, 1995–2011', Institute of Contemporary Arts

Singapore, Singapore, SG • 2009 'Flux Technicolour', Watergate Gallery, Seoul, KR and HT Contemporary Space, SG • 2008 'The Thing It Saw', Plastique Kinetic Worms, SG • 2006 'Everything That Went Before This', The Substation, SG

Group Exhibitions: 2013 'Collection', Tomio Koyama Gallery, SG; 'Island Vernacular', Peninsula Arts Gallery, Plymouth, UK • 2012 'Marcel Duchamp in Southeast Asia', Equator Art Projects, SG; 'Panorama: Recent Art From Contemporary Asia', Singapore Art Museum, SG • 2011 'Nine', Institute of Contemporary Arts Singapore, SG • 2009 'Space for Perspective', Chang Art Gallery, Beijing, CN • 2008 'Always Here But Not Always Present: Art In A Senseless World', Singapore Management University, SG

Charles Merewether and Guo-Liang Tan, *Ian Woo: A Review, 1995–2011*, Institute of Contemporary Arts Singapore, Singapore, 2012.
Gunalan Nadarajan, Russell Storer and Eugene Tan, *Contemporary Art in Singapore*, Institute of Contemporary Arts Singapore, LASALLE College of the Arts, 2007, p. 162.

Raed Yassin
born 1976 in Beirut, Lebanon

Solo Exhibitions: 2011 'Disco Tonight', Kalfayan Galleries, Athens, GR; 'The Best of Sammy Clark', Delfina Foundation, London, UK

Group Exhibitions: 2012 'New Positions', Art Cologne, Cologne, DE; Abraaj Capital Art Prize, Art Dubai, Dubai, UAE; 'Museum as Hub: Beirut Art Center', New Museum, New York, USA • 2011 'Facing Mirrors', Museum of Photography, Thessaloniki, GR; 'Beyrouth ô Beyrouth', Centre Pompidou, Paris, FR; Sharjah Biennial 10, Sharjah, UAE; Manifesta 8, Murcia, ES • 2010 'Offspring MMX', De Ateliers, Amsterdam, NL; Home Works V, Beirut, LB • 2009 'Sonic Traces', Zentrum Paul Klee, Bern, CH; 'Exposure', Beirut Art Center, Beirut, LB • 2008 'The Long Shortcut', Photo Cairo 4, Cairo, EG

Jim Quilty, Reducing Civil War to Porcelain, *The Daily Star*, 24 March 2012.
Kaelen Wilson-Goldie, 'Raed Yassin: Memories are fiction', *The National*, 4 March 2011.

Dongchun Yoon
born 1957 in Kyeonggido, Korea

Solo Exhibitions: 2012 'Tools', Gallery Houmura, Sapporo, JP • 2011 'Muddy Stream', OCI Museum of Art, Seoul, KR

Group Exhibitions: 2012 'Hidden Track', Seoul Museum of Art, Seoul, KR; 'Bond the Moment', Alternative Space Loop, Seoul, KR • 2011 'Tell Me Tell Me', National Art School Gallery, Sydney, AU • 2010 'Convergence', William Tower Gallery, Texas Tech University, Lubbock, USA; 'Eternal Blinking', University of Hawaii Art Gallery, Honolulu, USA • 2009 'Drawing of the World, World of Drawing', Museum of Art, Seoul National University, Seoul, KR; 'Portraits of a Water Vein', Hokkaido Museum of Modern Art, Sapporo, JP • 2008 'Spectrum of the Korean Contemporary Print', Novosibirsk State Art Museum, Novosibirsk, RU

Shim Sangyong, 'Making Art Ordinary', *Korean Artists Today*, Art Council Korea, Seoul, 2011.
Hyun Jung, 'Observing a Shared Social Domain', *Space Magazine*, vol. 482, January 2008.

Akram Zaatari
born 1966 in Saida, Lebanon

Solo Exhibitions: 2013 Lebanese Pavilion, 55th Venice Biennale, Venice, IT • 2011 'Composition for Two Wings', Kunstnernes Hus, Oslo, NO; 'The Uneasy Subject',

MUSAC, Léon, ES • 2009 'Earth of Endless Secrets', Kunstverein München, Munich, DE • 2006 'Hashem el Madani: Promenades and Studio Practices' CaixaForum, Barcelona, ES

Group Exhibitions: 2012 Documenta13, Kassel, DE • 2011 'New Documentary Forms', Tate Modern, London, UK; 12th Istanbul Biennial, Istanbul, TR • 2010 'Told/Untold/Retold', Mathaf, Doha, QA; 'Future of Tradition/Tradition of the Future', Haus der Kunst, Munich, DE • 2008 'Les Inquiets', Centre Pompidou, Paris, FR; 2nd Turin Triennial, Turin, IT • 2006 'Out of Beirut', Modern Art Oxford, Oxford, UK

Juan Vicente Aliaga, Stuart Comer and Mark Westmoreland, *Akram Zaatari: The Uneasy Subject*, Charta, Milan 2011.
Suzanne Cotter, 'Akram Zaatari: This Day,' *Defining Contemporary Art*, Phaidon, London 2011, pp. 342–3.
Kaelen Wilson-Goldie, 'Akram Zaatari', *Artforum*, vol. 48, no. 5, January 2010, pp. 186–198.

Carla Zaccagnini
born 1973 in Buenos Aires, Argentina

Solo Exhibitions: 2011 'Sobre um mesmo plano', Galeria Vermelho, São Paulo, BR; 'Plano de falla', Ignácio Liprandi Arte Contemporâneo, Buenos Aires, AR • 2010 'Imposible pero necesario', Galeria Joan Prats, Barcelona, ES; 'Chain Reaction with Variable Effect', MUSAC, León, ES • 2008 'No, it is Opposition', Art Gallery of York University, Toronto, CA • 2007 'Museu das Vistas', Nationalmuseum, Stockholm, SE

Group Exhibitions: 2012 'Planos de Fuga', Centro Cultural Banco do Brasil, São Paulo, BR; 9th Shanghai Biennial, Shanghai, CN • 2011 17th SESC VideoBrasil, São Paolo, BR • 2010 'Panamericana', Kurimanzutto, Mexico City, MX • 2009 31st Panorama of Brazilian Art, MAM-SP, São Paulo, BR; 2nd Poly/Graphic Triennial, San Juan, PR • 2008 28th São Paulo Biennial, São Paulo, BR • 2007 Encuentro Internacional Medellín, Medellín, CO

Xander Karksens, 'A Chain Reaction With Variable Effect', *Metropolis M*, no. 3, June–July 2009.
Fabio Cypriano, 'Carla Zaccagnini', *Frieze*, no. 116, June–August, 2008.

Zhao Renhui
born 1983 in Singapore

Solo Exhibitions: 2012 'The Institute of Critical Zoologists', Chapter Arts Centre, Cardiff, UK • 2011 'The Land Archive', Institute of Contemporary Arts Singapore, SG • 2010 'The Whiteness of a Whale', Jendela Gallery, SG • 2009 'If a Tree Falls in the Forest', The Substation, SG

Group Exhibitions: 2012 'The Singapore Show: FutureProf', Singapore Art Museum, SG; 19th Noorderlicht International Photofestival, Friesland, NL; 'Edit, Image Phobia and Fetish', ShangART, Shanghai, CN; 'Earthworks', P.P.O.W. Gallery, New York, USA; 'Future Map', Zabludowicz Collection, London, UK • 2010 'Emerging Wave', Seoul Arts Center, Seoul and GoEun Museum of Photography, Busan, KR • 2008 Photo Levallois Festival, Levallois-Perret, FR

Jeffrey Kastner, 'Openings: Zhao Renhui', *Artforum*, vol. 50, no. 8, April 2012, pp. 198–201.
Deepika Shetty, 'Beauty in the Beasts', *The Straits Times*, 29 March 2012.

Acknowledgements

The publishers are grateful to the 12 authors and 96 artists and would like to thank Craig Garrett for originally commissioning the title, Kari Rittenbach for managing the project and shaping and guiding the book through its many stages, Elvira Dyangani Ose for sound advice, Sarah Boris for perseverance, Jonah Gray, Celina Nogueras and Marina Reyes Franco for their research assistance, Sunhye Hwang for her translations from Korean into English, and Charles Gute and Fiona Gilsenan for their help with the texts.

We would also like to thank the following individuals and organizations:
Agial Art Gallery, Beirut; Allora & Calzadilla; Alternative Space Loop, Seoul; Halil Altındere; Arquivo Histórico Wanda Svevo/Fundação Bienal de São Paulo; Art Space Pool, Seoul; Artist Proof Studio, Johannesburg; Artspeak, Vancouver; Ashkal Alwan; BAS, Istanbul; Zander Blom/Avant Car Guard; Casa Triangulo, São Paulo; Casas Riegner, Bogotá; Catriona Jeffries, Vancouver; CCA, Lagos; Marcelo Cidade; Collection of the Morris/Trasov Archive, Morris and Helen Belkin Art Gallery, The University of British Columbia; Culture Station Seoul 284; Escola São Paulo; Galeria Fortes Vilaça, São Paulo; Galeria Vermelho, São Paulo; Galerie Janine Rubeiz, Beirut; Gallery Sfeir-Semler, Beirut-Hamburg; Gladstone Gallery, New York and Brussels; Goodman Gallery, Johannesburg; IKSV Archives, Istanbul; Institute of Contemporary Arts Singapore; Istanbul Modern; Johannesburg Art Gallery; Khoj: International Artists' Association, Dehli; Krannert Art Museum, University of Illinois at Urbana-Champaign; La Cooperativa, Bogotá; LASALLE College of the Arts, Singapore; Jooyoung Lee; Leeum, Samsung Museum of Art, Seoul; Lisette Lagnado; Michy Marxuach/Beta-Local, San Juan; Mendes Wood, São Paulo; Paulo Monteiro; The Morris and Helen Belkin Art Gallery, The University of British Columbia; Ciprian Mureşan; Museo de Arte del Banco de la República, Bogotá; Museo de Arte Moderno, Bogotá; Muuaaa, San Juan; Nam June Paik Art Center; National Gallery of Modern Art, New Delhi; NC-Arte, Bogotá; Serge Alain Nitegeka; Oficina Informal La Agencia Idartes; Emeka Okereke/Invisible Borders; Park Chang-kyoung; Part-time Suite; Pilot Galeri, Istanbul; Mihai Pop; Rampa, Istanbul; Rennie Collection, Vancouver; José Alejandro Restrepo; Roberto Paradise, San Juan; Rodeo, Istanbul; Chemi Rosado-Seijo; Sahmat, Dehli; SALT, Istanbul, image © Iwan Baan; Sarai/CSDS, Dehli; Gigi Scaria; Singapore Art Museum; Singapore Economic Development Board; Singapore Tourism Board; Stevenson, Cape Town and Johannesburg; The Substation, Singapore; Attila Tordai S; Universidad Jorge Tadeo Lozano-IDARTES, Bogotá; Valenzuela Klenner Galeria, Bogotá; Vancouver Art Gallery; VIVO Media Arts Centre, Vancouver; Kemang Wa Lehulere/The Center for Historical Reenactments; Wits Art Museum, Johannesburg; Wits School of Arts, University of the Witwatersrand, Johannesburg; Akram Zaatari.

And the following photographers:
Jude Anogwih, Iwan Baan, Gabriele Basilico, Ricardo Bassetti, Marius Bercea, Mark Blower, Taki Bluesinger, Jerry Buhari, Lard Buurman, Blaine Campbell, Hadiye Cangökçe, Jaemin Cha, Astha Chauhan, Gerardo Contreras, Danny Croucher, Graham Dalik, Samit Das, Soibiffa Dokubo, Matias Eli, Leo Eloy, Andrew Esiebo, Fotograffiti, Edouard Fraipont, Dario Garafalo, Murat Germen, Roke Gezuraga, Gustavo Gutiérrez, Serge Hasenböhler, He Yue, John Hodgkiss, Timothy Hursley, Taiye Idahor, Ingrid Jejina, Gülsün Karamustafa, Ruhani Kaur, Kong Chong Yew, Kooy Siew Na, Jeroen Kramer, Dinesh Kumar, Runo Lagomarsino, Pablo Léon de la Barra, Lia Lowenthal, Evariste Maiga, Scott Massey/SITE photography, Kiki Mazzucchelli, Houssam Mchaiemch, Priscilla Mercedes, Trevor Mills, Camilo Monsalve, Oscar Monsalve, Pedro Motta, Mariana Murcia, Ding Musa, Taylan Mutaf, Boru O'Brien O'Connell, Emeka Ogboh, Temitayo Ogunbiyi, Oh Sukkuhn, Kei Okano, Emma Ologeh, Eduardo Ortega, Benoit Paillet, Naadira Patel, Santiago Piñol, Pix Asia, Clemencia Poveda, Prakash Rao, Ian Reeves, Kari Rittenbach, Guillermo Santos, Kevin Schmidt, Tejal Shah, Satish Sharma, Christian Sievers, Hemant Sreekumar, Mircea Suciu, Anders Sune Berg, Serkan Taycan, Martin Tessler, Mario Todeschini, Ron Tran, Serkan Tunç, Diego Uribe, Uwe Walter, Muammer Yanmaz, Yeon Seo Jin, Zhao Renhui, Andreas Zimmermann.

Phaidon Press Limited
Regent's Wharf
All Saints Street
London N1 9PA

Phaidon Press Inc.
180 Varick Street
New York, NY 10014

www.phaidon.com

First published 2013
© Phaidon Press Limited 2013
All works are © the artists unless otherwise stated.

ISBN 978 0 7148 6536 2

A CIP record of this book is available from the British Library.

Designed by Matthew Fenton and Haakon Spencer.

Printed in China.